I enjoy sharing my books as I do my friends, asking only that you treat them well and see them safely home

Jane Fair

Books by Nancy Hale

The Young Die Good

Never Any More

The Earliest Dreams

The Prodigal Women

Between the Dark and the Daylight

The Sign of Jonah

The Empress's Ring

Heaven and Hardpan Farm

A New England Girlhood

Dear Beast

The Pattern of Perfection

The Realities of Fiction

Black Summer

New England Discovery

The Life in the Studio

Secrets

Mary Cassatt

Mary Cassatt

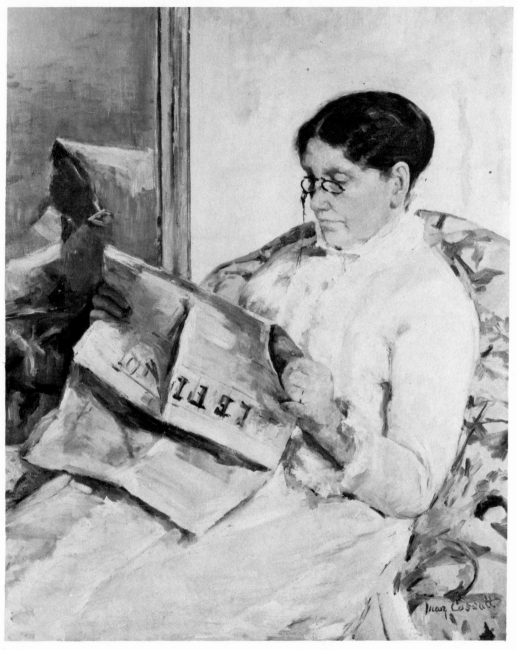

Reading "Le Figaro" by Mary Cassatt. PRIVATELY OWNED.
When this portrait of the artist's mother—once "that unspeakably exquisite haven"—was painted in Paris, c. 1883, Mrs. Cassatt was about sixty-seven.

Mary Cassatt

by NANCY HALE

Doubleday & Company, Inc., Garden City, New York 1975

Library of Congress Cataloging in Publication Data

Hale, Nancy, 1908–
 Mary Cassatt.

 Bibliography: p. 293
 Includes index.
 1. Cassatt, Mary, 1844–1926. I. Title.
ND237.C3H3 759.13 [B]
ISBN 0-385-00486-9
Library of Congress Catalog Card Number 74–18805

Material from *The World Through Blunted Sight* by Patrick Trevor-Roper, reprinted by permission of Bobbs-Merrill Co., Inc., Indianapolis, 1970; and Thames & Hudson International Ltd., London.

Material from *Philadelphia Perspective, The Diary of Sidney George Fisher*, reprinted by permission of the Historical Society of Pennsylvania.

Material from *The Graphic Work of Mary Cassatt, A Catalogue Raisonné* by Adelyn Breeskin, H. Bittner & Co., New York, 1948, reprinted by permission of Adelyn Breeskin.

Material from *My Friend Degas* by Daniel Halévy, translated and edited by Mina Curtiss, reprinted by permission of Wesleyan University Press, copyright © 1964 by Wesleyan University.

Material from *Miss Mary Cassatt, Impressionist from Pennsylvania* by Frederick A. Sweet, copyright 1966 by the University of Oklahoma Press. Reprinted by permission.

Letter from Mary Cassatt to George Lucas, written about 1890. From the George A. Lucas Collection, on indefinite loan to the Baltimore Museum of Art from Maryland Institute College of Art, Baltimore, Maryland. Reprinted by permission.

Material from *An American Artist's Story* by George Biddle, reprinted by permission of Harold Ober Associates Incorporated. Copyright © 1939 by George Biddle. Renewed.

Material from An unpublished account of Mary Cassatt by Mrs. H. O. Havemeyer, reprinted by permission of Electra W. Bostwick.

Material from *Images and Shadows* by Iris Origo, reprinted by permission of Harcourt Brace Jovanovich, Inc.

Material from *Journals* by E. and J. Goncourt, edited and translated by Robert Baldwick, Oxford University Press, reprinted by permission of David Higham Associates, Ltd.

Dedicated
with love and gratitude
to the memory of
Mary Frazier Cash
and
Catherine Drinker Bowen

Dans le vieux parc solitaire et glacé,
Deux formes ont tout à l'heure passé.

Leurs yeux sont morts et leurs lèvres sont molles,
Et l'on entend à peine leurs paroles.

Dans le vieux parc solitaire et glacé
Deux spectres ont evoqué le passé . . .

 PAUL VERLAINE (1844–1896)

In the old park, solitary and vast,
Over the frozen ground two forms once passed.

Their lips were languid and their eyes were dead,
And hardly could be heard the words they said.

In the old park, solitary and vast,
Two ghosts once met to summon up the past . . .

 Translation by ARTHUR SYMONS

ACKNOWLEDGMENTS

WHEN I LOOK back over my past four years—the first two spent gathering materials for the present book, the latter two writing it (although the two processes were inextricably intertwined)—it sometimes seems as if every living soul I met in that time helped me toward the goal of acquiring knowledge and understanding of Mary Cassatt. I think of Hyatt Mayor—at that time Curator of Prints and Drawings at the Metropolitan—telling me one night at dinner what a sculptor told him, of Mary Cassatt's high standing with the politicos of Oise, where her château was. Or of Dr. William Craddock passing just as I was about to enter his X-Ray Department at the University of Virginia Hospital and, in reply to my question, saying, "Certainly radium treatments can cause cataract!" Or of Claud Domec—when I exclaimed at an elderly French gentleman who'd told me Mary Cassatt looked like a Red Indian—laughing as he explained that the European tour of Buffalo Bill and his Indians around the turn of the century made a profound effect on little French boys growing up then.

Dozens of other people, through my importunateness or their own kindness, supplied material without which I could not have written this book. Sometimes I wake in the night suddenly remembering a man or woman who answered some then-burning question, or made just the right suggestion, and I blush with horror in the darkness lest I have forgotten still other people, equally generous.

For them all I would like to put up not so much a covering umbrella, as a huge marquee, striped, perhaps pink-and-white like a gala tent in an Impressionist painting, under whose shade I could gather them and offer refreshments—the best French champagne, pâté of the best Strasbourg geese. Certain people stand out in the throng, among them Margaret Cousins, whose idea the book was; Dorothy Olding, my agent; John Walker, Director Emeritus of the National Gallery; and above all two principal Mary Cassatt authorities: Adelyn D. Breeskin, Curator of Contemporary Art at the National Collection of Art, Smithsonian Institution, and author of two indispensable *catalogues raisonnés*; and Frederick A. Sweet, former director of the Chicago Art Institute and author of *Miss Mary Cassatt*, who simply handed over to me his own files, containing many unpublished letters, my use of which is hereby gratefully acknowledged. Also sipping champagne is the invaluable Kate Medina, my editor, with helpful researcher Gillian G. M. Kyles.

Joan St. C. Crane, Rare Books Bibliographer at the University of Virginia Library, heads brilliantly the list of resourceful librarians: the women behind the desk at the Sawyer Free Library, Gloucester, Massachusetts; Elizabeth Duvall, former Bibliographer of the Sophia Smith Collection, Smith College Library; John Simmons, Librarian of All Souls, Oxford; Francis James Dallett, University Archivist, University of Pennsylvania; the librarians of the University of Virginia Medical Library; the librarians of the Bodleian Library and of the British Museum, and of every library I came anywhere near in those four years. The University of Virginia Library had Xeroxed for my use the Metropolitan Museum's copy of Louisine Havemeyer's *Sixteen to Sixty*, hereby gratefully acknowledged; its Reference Room has been my mainstay.

In another quarter of my tent a group is chattering in French—those who helped me abroad, led by Mme. Liliane Ziegel, research assistant extraordinary; Alice-Leone Moats, who gave help of every sort; Mme. Beverley Gordey; Mme. Matière, Directrice of the Moulin Vert, Mesnil-Théribus; Mrs. Richard Selle; Mme. William Murray; Mme. Armand de Lille; Mme. Stuart Gilbert; M. Dupays, Directeur Générale of the Moulin Vert; M. Charles Durand-Ruel; M. Jean de Sailly; Mme. Adhémar, Directrice of the Orangerie, Louvre; M. Denis Rouart; M. Jacques Dupont, then Ministère des Affaires Culturelles; M. et Mme. Pierre Louis-Dreyfus; Mme. François Huet; Mme. Hélène Baltrusaitis of the American Embassy; Miss Janet Flanner; Mme. Henri Riché; Signor Evan Fotos, of the U. S. Consulate in Milan; Mlle. Françoise Nora; Baronne Philippe de Rothschild.

Speaking in English accents, as they sip bubbly, stands Lord Clark, with John Sparrow, Warden of All Souls, who indirectly made it possible for me to complete the writing of my book in the idyllic surroundings of Oxford.

Between the French and the English sally back and forth those who helped me in the task of moving from French into English and back again: John Frederick Nims, who translated Degas' sonnet especially for this book, and Jean Seznec and Professor Harry Levin, who made suggestions for it; Mrs. Leon Kroll; Francis Steegmuller, for steering me to Mme. Ziegel; Lady Hadow, who not only acted as interpreter on my first, reconnoitering trip to Paris, but supplied me with infant memories of Paris in the last century, incorporated into Chapter Two; Miss Mary Faith Pusey; Nicholas Mann, Fellow of Pembroke College, Oxford; Professor Roger Shattuck; Professor Lester Crocker.

Another group at my party would be composed of unfailingly kind museum men and art historians, among them E. John Bullard, Agnes Mangan, Elizabeth Mangan, Curator, Smith College Museum, Kneeland

McNulty, Curator of Prints and Drawings, Philadelphia Museum of Art, and that Museum's Joseph Rishel and Mrs. Suzanne Lindsay, Department of Paintings; John Maxon, Vice-President for Collections and Exhibitions, Helen Lethert, Publicity, and Harold Joachim and Anselmo Carini of the Print Department, all of the Art Institute of Chicago; Mrs. Lucretia H. Giese, Department of Paintings, Museum of Fine Arts, Boston; George L. Weston, Hill-Stead Museum, Hartford; J. M. Edelstein of the National Gallery of Art in Washington; Mr. Howat, Mrs. Mellon, and Miss Spassky of the Metropolitan Museum.

A large group of Philadelphians helped me toward this life of someone who was herself not exactly a Philadelphian, at least in her own eyes: Nicholas B. Wainwright, Director of the Historical Society of Pennsylvania; Mrs. John B. Thayer, Mrs. Percy C. Madeira, Jr., and Mrs. Eric de Spoelberch, relatives of the late Miss Cassatt, also Mary Cassatt's nephews Alexander J. Cassatt and the late Anthony Cassatt; R. Sturgis Ingersoll and Mrs. Ingersoll, and Miss Anna Ingersoll; Mrs. Edmund Purvis, of Washington, D.C.; Mr. and Mrs. George Roberts; Miss Sheila Biddle of New York; Miss Lydia S. M. Robinson; the late George Biddle; Orville Bullitt.

In the end, categories fail. I invite into the striped tent many, many others who out of expertise, or special knowledge, or goodheartedness, or simple courtesy, were indispensable to me, in particular but not limited to Dr. Wilfred Abse, Mrs. Dunbar Bostwick, John Canaday, Mrs. Daniel Davis, Betty Diehl, the late George Demetrios, the late Leon Kroll, William Maxwell, Sara Henderson Hay, William B. O'Neal, André Meyer, Russell Lynes, Betty Prashker, Hartwell Priest; Professor Frederick D. Nichols, Professor Theodore Reff, Margery Ryerson—to whom use of the Helen Walcott letter is gratefully acknowledged—Conrad Spohnholz, Chauncey Stillman, for unique information on James Stillman, Benjamin Sonnenberg, Dr. George D. Spence, the late William Sloane, Professor William Weedon, Deborah Winn, Ellen Wilson, author of *American Painter in Paris, A Life of Mary Cassatt*; J. Harris Whittemore, the Hon. Stanley Woodward.

Lastly I would acknowledge the unfailing support and help of my husband, Fredson Bowers, scholar and textual critic, who might be called godfather of this book.

CONTENTS

LIST OF ILLUSTRATIONS

(Frontispiece) *Reading "Le Figaro"* by Mary Cassatt, c. 1883.

PROLOGUE

THE PAINTER Sargent—whom, I later learned, Mary Cassatt could not abide—once summed up portrait painting with the resignation of long experience: "A portrait is a picture with something the matter with the mouth." When I was a child growing up in a family of painters it was still true; families of sitters always had their hearts set on getting a photographic likeness, or rather—since a good photograph is far more than a likeness—their idea of a photographic likeness. From the painter's point of view, all that could reasonably be expected by someone commissioning a portrait was his particular view of that particular sitter. To painters I knew, "a likeness" seemed the least of their concerns; they would, moreover, do anything to avoid a commission that meant literally working from photographs, as with portraits of dead people. Even the finest photograph, after all, is not alive; and for portraits, working from life has no substitute.

After I had accepted a commission to write the life of America's most celebrated woman painter, I was filled with consternation when I realized that I would have to work from, so to speak, photographs; from records of the dead. I couldn't see how else it could be done; Mary Cassatt died in 1926, the year I graduated from school. I had been chosen for the job because of my book, *The Life in the Studio*, about my parents who, though not Mary Cassatt's contemporaries, had in my father's case been an art student in Paris all through the eighties and nineties of the last century: her period. I thought I discerned, among those commissioning the life, a notion that my father's discipleship to Impressionism would constitute a sort of laying-on of hands. What I wrote about him, however, was from memory and out of feeling—without which even the truest, most indispensable fact is lifeless. I had no memory of Mary Cassatt whatsoever; and the only feeling I had was for her pictures. I realized that my portrait of her, like any other portrait, would not get off the ground unless it tapped some living source. Her letters were my hope.

I admired my subject's work, but all I knew about her life was what everybody knew—that she was a rich Philadelphian who spent her life in Paris where she was a pupil of Degas' with whom she probably had an affair. (Among other things, I was to learn that, of these assumptions, at least four are false.) On my way to France to start interviewing people still living who might have known her, I stopped off in Washington to see the comprehensive exhibition of her work that had just

opened at the National Gallery. Its organizer, Adelyn D. Breeskin, a principal authority on the art of Mary Cassatt, kindly arranged for me to lunch at the Gallery beforehand, with her and several 'museum men'; she is Curator of Contemporary Art at the National Collection of Art, Smithsonian Institution. There were the golden Frederick A. Sweet, also an authority, and author of the definitive Cassatt biography; E. John Bullard, who hung the present show and was to publish a wonderful Cassatt picture book; and several other art-history luminaries.

All I knew of *their* approach to pictures was somewhere in memories of the days when I went to the courses in history of art my father gave at Boston University. As we sat sipping sherry in the deep leather chairs of a private room, I wondered just what my own approach to art did consist of. Listening to the exchange of expertise on something they called the spatial dynamism of the whites, in Mary Cassatt's great painting of her mother called *Reading "Le Figaro,"* my mind went back to my own mother—a painter who used, when working from a sitter, to open her eyes so wide you could see the whites above the pupils. Apparently she really could see more that way. When it came to making a portrait in words, when it came to taking on a dead-and-buried Mary Cassatt as a sitter, what kind of eyes could you open that wide?

In the room the conversation switched to the mass of letters Mary Cassatt had written to Mrs. H. O. Havemeyer that are housed in the National Gallery. A sweet-faced young man, whose name I never did learn, turned to me to say, "Do you know, even more than her pictures, I see the real value of Mary Cassatt's life in terms of the enormous benefit to mankind in her helping to create an art collection like the Havemeyers'."

I was filled with an unreasonable rage. I wanted to cry, "Painting just one picture is more important than collecting a hundred of them." I wanted to say, "How can you have any collections at all, unless you first have pictures?" But my anger felt too unwieldy to be appropriate. You couldn't say things like that to an art historian. He wouldn't understand.

The young man was telling me that, in the Havemeyer letters, Mary Cassatt—even after years of close friendship and travel together to buy pictures—always referred to her friend's husband as "Mr. Havemeyer." "That's true!" cried the young man, enchanted. "Imagine!"

"My grandmother always called my grandfather Mr. Westcott to the day of her death," I replied.

"Really?" he said politely. Then he returned to the fray. "What fun you're going to have digging up the facts!"

"Yes," I said. "My grandmother died in 1931, at the age of eighty-six. She was born in—"

"1845! Same year as Mary Cassatt!" the young man pointed out, transported by the coincidence. (As a matter of fact his date, I later found, is one more of the general misapprehensions about Mary Cassatt.)

"I saw a lot of my grandmother when I was little," I went on. "She read the entire Bible to me, beginning at the beginning. At the time I nearly died of boredom."

The young man's eyes were glazing over. "You must have known her well."

"I did. Intimately. And my grandfather on the other side was born in 1822," I said.

"What long generations," he remarked, shifting about.

"So that's why she sounds so natural," I said.

"Who does?" he said, startled.

"Mary Cassatt."

He looked at me doubtfully; then, crinkling his eyes in an effort at empathy, he said, "I understand you're a novelist. I'm so interested in your getting interested in writing about truth."

Fury returned to me, full blast; in my writing, I have never been interested in anything else. "If you're talking about *facts*," I said, "facts are fine, if there are enough of them, and if they all add up to something that *is* true." Then I felt a cross-grained old thing.

As at crucial moments in plays, luncheon was announced. We ate it in another private room. Museum men do themselves well—the lunch was delicious. All around me big art doings were being discussed—recent gallery acquisitions; prices fetched yesterday at the London Sotheby's; outstanding canvases by one painter, important examples of another's. As I ate my dessert I reflected on how strange is the language of the art expert, not so much to me—a writer's language has to be more or less that of anybody he writes about—but to painters. No painter ever said in my hearing that a picture was "important"; I never heard a painter call a picture a canvas, either. Canvases were what pictures were painted on. As far as I knew painters didn't have anything against those words. They just didn't use them. They were art experts' words.

After lunch I was lucky enough to be given a conducted tour of the exhibition by the beautiful, white-haired Mrs. Breeskin. Moving slowly from one picture to the next, she let drop bits of fascinating, sometimes eerie information, as about one study painted when the artist returned to America for the duration of the Franco-Prussian War, of a dusky Mrs. Currey who worked for the Cassatt family, and discovered

years and years later in the ex-domestic's attic by her art-student lodger. It was only partly finished (or, as Mrs. Breeskin put it, "brushed in"), and if you tipped your head and looked at the picture upside down, a wraithlike face with a white beard looked out at you: Mary Cassatt's father. Of all the various paintings and pastels of décolletée ladies seated in boxes at the Paris Opéra, only one, of a lady all in black, renders the actual Opera House beyond; in the others it is shown reflected in a looking-glass. The big painting called "The Blue Room" was submitted by Mary Cassatt to the American section of the 1878 Paris Exposition and was rejected. Years later, telling the dealer Ambroise Vollard how angry this made her, she explained it was partly because Degas himself had worked on parts of it—something painters in recent times almost never do to the work of another—and partly because, of the three-man jury rejecting it, one was a pharmacist.

Successive galleries opened out into one another, and at the same time opened up, chronologically, the story of Mary Cassatt. What she was like in her beginning days. Years of a growing ability, as in "The Blue Room" and the earliest of the maternity pictures. Then a veritable sunburst of virtuoso powers—one first-rate picture coming off after another like a series of miracles. It was staggering to confront all of the painter's work, all at one time, as if she and I faced each other, head on, both of us defenseless. More, it was a shock to come upon—in among the finest work—a portrait of Mary Cassatt's brother, Alexander J. Cassatt: stiff, wooden, unfelt. It was hard to take in that the same eyes saw it, the same hands painted it. A different kind of shock was the handsome painting "Lady at the Tea-Table." The sitter looked, not wooden, but brutal, her very hands moving among the tea things like claws. It was not only that the painting seemed of a cruel and brutal woman; the sitter's nose seemed—intentionally?—brutally out of drawing.

Mrs. Breeskin and I rounded the corner into the last galleries. In the first, almost all the paintings were of children alone, or mothers with children, or children posed together, on and on. What made the painter sink from those brilliant heights to this—groove? Mrs. Breeskin was saying how, about this period, Mary Cassatt was losing her eyesight. But Degas, too, went blind; and his work never got in a rut . . . The last gallery of all held paintings and pastels of a fumbling sleaziness that seemed a parody of Mary Cassatt's manner: a sorrow to behold.

As we retraced our steps to the entrance, "This show *is* a biography!" I exclaimed. "There is nothing to say about Mary Cassatt that isn't here."

Perhaps Mrs. Breeskin thought I meant I was discouraged; she smiled and made a deprecating gesture. Actually I had just realized

what I could try for, in my book about Mary Cassatt. I could try to put
in words what I saw in the pictures. It has long been my belief that an
artist's work is not merely like his life; it is his life. If this were true,
why not translate? I didn't know what technique would be needed,
what medium used, or how I could render the rest of the artist's life—
the part that did not paint.

Again my mind went back to my mother and how, until death
forced on me a physical and emotional distance, I could never under-
stand why that feeling woman could yet be so cold; how she, whose
work never ceased to flower, was in life so parsimonious. I tried to see
her pictures in the light of her history as if they were dreams, the way
stories are: of a special kind, like race dreams, that other people share.
Gradually I found to my surprise that the principle of a dream's re-
vealing, not the dreamer's conscious mind but his psychological situation,
held just as true of this painter who had been so scornful of paintings
with "meanings"; that "told stories." It was not that her pictures told
about her, so much as that they *were* her; just as the other side of the
moon, hidden, is still the moon. Gradually I came to understand the
place of all that snow in her drawings, falling around lonely New
England churches; all those eager little boys she painted, with their
vulnerable baby necks. I understood enough so that I was able to write
about her; and that, for a writer, is the test of knowing.

In the present book I could try a similar if reversed process. In-
stead of analyzing Mary Cassatt's history to come at her pictures, I
could start with the pictures and work back to the life. The rigor mortis
of working from photographs might be avoided through my feeling
for these pictures that were so far from dead. If I could not hope now
for memory to speak, I could analyze the pictures—like dreams I did
thus share—to guess (the word Frost used to use, for knowing about
people) how Mary Cassatt felt. As for the place of the facts of her life,
I began to see that facts were the myriad tiny touches of pure color
which, in an Impressionist painting, reassemble in the viewer's eye to
render light falling on the object.

I spent the rest of the afternoon alone, going back and forth from
gallery to gallery and from picture to picture. Just before closing time
I ran into an old friend—a professor of chemistry who happens to love
pictures—under the wonderful painting of a disconsolate little girl in
pinafore and big straw hat, who faced the entrance as though she had
been sent to greet company. After we admired the show's scope, praised
one picture and another, I asked him what he made of the artist.

"Melancholy," he said. "Filled with regret."

"Oh I don't *think* so," I said. "She was violently positive." Then,

fearing I might cork off this taciturn man, I added, "How about all those babies wallowing in their mothers' arms?"

"Scene she loved," he agreed. "Her view of life. Maybe happy babies made up for that one," he said, nodding up at the child in the pinafore. "Supersensitive."

"If you mean Mary Cassatt," I said, "she was supposed to have been domineering."

"Mm. *Supposed . . .*"

As one we turned and looked up at the face of the little girl again—surely the saddest little face in the world.

When I went to bed in my hotel that night, I went on with one of the books that my carry-on bag was stuffed with—Achille Segard, Mary Cassatt's first biographer and the only one to see her in the flesh. As a critic he hardly rates today, and he is wildly unreliable; but he had the inestimable advantage of working from life. "If by chance she tried to paint from a model who only half pleased her, she was annoyed, affected, and did not do her best," I read.

Involuntarily I thought of the wooden portrait of the artist's brother; did *he* not please her? "The best of the portraits are obviously those which correspond most narrowly to the particular nuance of her sensibility . . . a sort of secret instinct warned her that she could make a beautiful work only if she were united with the model by a certain community of taste and sentiments." "Lady at the Tea-Table" sprang to mind; Mary Cassatt united in taste and sentiment with *that*? "Miss Cassatt also did a portrait of Degas."

I sat up straight in bed; I hadn't known there was one. "One can hardly believe that she could translate with intensity all the bitterness and disillusion in this misanthropic face. I have not had a chance to see this portrait. It must have been destroyed or stolen . . ."

Another mental connection made me reach for another book: *My Friend Degas*—Daniel Halévy's recollections, edited by Mina Curtiss. I was looking for a conversation about, of all things, photography, with which Degas was then experimenting. Degas tells Halévy his sitters always complain, " 'You haven't caught my expression!' . . . And he laughed some more. 'As for me, I find I have too nice an expression.'

" 'But you have a nice expression.'

" 'But I want to have a fierce one.'

" 'Then you must make a face.'

" 'But without making a face.'

" 'Then you will have a very nice expression.'

" 'You mean I am nice?' he exclaimed, and laughed uproariously."

It was typical of an artist. I thought of my father taking the train

each week from Boston to teach painting at the Pennsylvania Academy, how he would put on his derby and say, "Personally I'm a cold, stern man. Don't you think I look like a stockbroker with this hat on?" I wondered if, like my father's coldness and sternness, Degas' "bitterness and disillusion" were not chiefly directed at himself. Artists could be so destructive . . .

Yet, "Miss Mary Cassatt devoted herself to art as to a religion," I read on, in Segard. "She had the eyes of a painter and . . . the mentality of a sister of charity . . . She devoted herself to children as certain missionary souls." I was so sleepy my eyes skipped, and slipped down the page. "One feels she had the profoundest sentiment that the child in society is of limitless importance since he is the present and the future . . . Having limited herself . . . to . . . maternal love, she knew all the same . . . how to see the life of humanity . . ." The generalizations were too much, and I groped for the light-switch above my head.

Pictures I had been looking at all that long day drifted before me: radiant mothers . . . babies in bliss . . . the ordered gardens of that day of France where I had never been . . . which yet, before my closed eyes, were real . . . and green . . .

PART I

Beginnings

ONE

IN MARY CASSATT'S end was her beginning. Her life was what she made out of her earliest years, and from those years there emerges above all the overwhelming sense of relief she felt when, at the age of seven, she was taken abroad to Paris. It took what was, to a little girl, a desperate situation, to make her so frantic to escape.

Yet in 1844, when she was born, no happier, more enterprising young family was living in the twenty-six United States than that of Robert Simpson Cassatt of Pittsburgh. While still spelling his name Cassat he had married Katherine Kelso Johnston on January 22, 1835, at Trinity Church—close to where they were living and bringing up children. The day after the wedding Robert took his bride to live on Liberty Street in Pittsburgh, where a little Katherine Kelso Cassat was born on December 30, only to die before the day was out. Grief may possibly have occasioned their move soon after to a house Robert built at the corner of Penn Avenue and Hay Street, where Lydia Simpson Cassat was born on July 23, 1837; and lived. Two years later, in the same house, on December 17, 1839, Alexander Johnston Cassat not only survived birth but, characteristically, throve.

The following year the family moved across the river to a still newer house—one of the several Robert built as a real estate venture on Rebecca Street, Allegheny City; this move established Robert's inclination, amounting to a passion, for clearing out of where he was and going somewhere else, somewhere pleasanter. He even took his young wife to Cuba that year to visit her brother. In those days Allegheny City, situated on the banks of the Ohio River, was quite pleasant enough. Today, incorporated into Pittsburgh, it verges on slumminess; but then the "Old North side," with streets running up to the bluff over the river, was an improvement over Pittsburgh, although the young Cassatts felt no need to climb up anywhere.

Their fourth child, Robert Kelso Cassatt, born on June 5, 1842, was followed (still in the Rebecca Street house, though it was now four whole years since they moved in) by an arrival recorded, like the others, in the long, involved, family history Robert kept, not in a Bible, but in a notebook:

Mary Stevenson Cassatt, daughter of Robert and Katherine K. Cassatt, was born in Allegheny City, Allegheny County, Penna., in the house built by her father on Rebecca Street on Wednesday night, May 22nd, A.D. 1844 at 55 minutes past eleven o'clock.

Although often Robert's accuracy, like his syntax and his ego, left something to be desired, it can be assumed he did know when his own little girl was born better than Trinity Church did. In recording her baptism two years later, the church records gave the birth-date as May 23. Myth and hearsay, furthermore, have held that Mary Cassatt was born in 1845; but it couldn't have been in 1845, because, for one thing, by May 22, 1845, her mother was expecting another baby. George Johnston Cassatt (his father stuck to the new spelling that he had originated) was born on January 22, 1846, only to fill another of that century's innumerable infant graves.

It was the year of the great fire, which burned Pittsburgh practically to ashes. From across the river the Cassatts watched while a thousand houses, at a loss of five million dollars, went up in smoke—the kind of catastrophe a child is told in later years that it witnessed, even though the child may have been, as Mary was, still in arms.

By that time Robert had become Mayor of Allegheny City; during 1847 and 1848 he was President of its Select Council. In the latter year, his itchy foot reasserting itself, the family moved back into Pittsburgh to the corner of Penn Avenue and what was then Marbury Street, near Robert's brokerage office in Wood Street. Soon afterward Robert invested in a country place way to the east, not far from Lancaster, near where some of his forebears had lived before coming west. The seventh Cassatt child, Joseph Gardner, was born on January 13, 1849, at the new house they called Hardwick. Although it was primarily intended for their summers, Hardwick did make the fifth separate house the Cassatts had moved into since their marriage fourteen years before. Robert's restlessness was like that of men still doggedly pushing west, but with a difference. It was as if men like Robert, Henry James men, sensed, as instinctively as an animal, that after 1849 the westward urge was spent; they had the counter urge to turn and conquer at last an East they had run from.

The only person who didn't care for all this peripeteia, Katherine Cassatt, forever having to abandon nests she had only just made, was after all a woman, and women were always unreasonable. It was Robert's opinion, stated years later, that women were deficient in good sense (it was his habitat he liked to change, not his mind). Women, whose tendency was to resist the counsel of men's wiser heads, were especially

stubborn when maintaining their opinions about matters of which they knew nothing. Women tried Robert's patience. It was proof of his love that, for all such grievous weaknesses in her, he dearly loved his ten-years-younger wife.

There was much to love. Gentle, serene, tractable except on those inexplicable occasions when stubborn, Katherine lent a certain tone to the ménage by her unusual cultivation. Part of her education was received from a lady who had attended Madame Campan's select establishment in Paris where were enrolled, Katherine told her fascinated children, girls of the Imperial aristocracy. This lady on returning to Pittsburgh accepted, as she put it, a few pupils. From her Katherine Johnston learned the purest Touraine accent; at the age of twelve her French, testified to in an old letter her children came on, was already irreproachable. Katherine Cassatt possessed accomplishments—just the thing for a woman *to* possess—and made a perfect balance to restless, touchy, proud, enterprising Robert, his sights set eastward. Between them they had everything, and to a child starting life, of course, parents *are* everything.

For one thing they had position. To tell it as it was in the nineteenth century requires an understanding of what "position," even in Pittsburgh, meant. It had only incidentally to do with money. Money was useful in keeping up position, but it was not position. Position was like the Rock of Ages—one could rest oneself on it. Position meant who a person was, and who he was meant what he was born. What the young Cassatts were born went, on both sides, deep into the roots of the Republic.

On Robert's side were French Huguenot Cossarts (only one thirty-second of his inheritance) who settled in New Amsterdam and repeatedly married into Dutch families. The first in his line to move to Pennsylvania distinguished himself as a member of the Committee of Correspondence, a delegate to the Convention of 1776, a member of the Provisional Assembly, and one of the framers of the state constitution. His son, a member of the Pennsylvania Legislature, started spelling Cossart "Cassat," married a Scotch-Irish woman named Lydia Simpson in Pittsburgh, and died penniless. They were the parents of Robert Simpson Cassatt and his sister Mary, who married a Dr. Frank Gardner who like so many other Pittsburghers came from Chester County on the borders of Philadelphia.

Katherine's family traced itself to Alexander Johnston, born in 1706 in Ireland, who served as an attorney for George Washington in disposing of the land Washington received in compensation for surveying labors in Pennsylvania in his youth. One of Alexander's sons, Colonel

Francis, spent the whole winter at Valley Forge under the command of Mad Anthony Wayne.

Backbone of the country on both sides, and more than backbone—flesh and blood. Katherine's grandfather, Colonel James Johnston who'd lived with them, according to the hospitable family custom of those days, in the first two of their houses until he died in 1842, had fought in the Revolution. Hunterstown, in Adams County, Pennsylvania—near Gettysburg—has many Cassat graves in its small, "low Dutch," burying-ground up a dirt road. Although the younger generation of distant cousins still living out there pronounce the name Cassatt as it is done in Philadelphia, an older generation, even now, says Cassatt. In the sound is the faintest echo of a long-ago "Cossart."

During Robert's lifetime those graves were neglected. "You could hardly find the gate," a distant Hunterstown relation says of the graveyard's condition. The push westward, in America, was made most often by those without "position" or else indifferent to it; yet the corresponding eastward push was not always accompanied by the ancestor-worship that might be expected—in contrast to more than one family in the far West that keeps up close ties with fifth and sixth cousins back in Vermont or Virginia. Those who pushed east again were more apt to use ancestors as currency, if sound. Birth into an old, "good," family was their payment for position. When a lady wailed, "I have no position here!" it was genuine tragedy because it would take a minimum of two generations to achieve one. By today's standards such a value is trivial; by any standards it is shallow, though it is more related to breeding character traits than money is.

The same year Robert Cassatt began edging eastward with the purchase of Hardwick, his brother-in-law, Dr. Gardner, after whom the new baby was named, died, and his widow left Pittsburgh to live in the doctor's native Chester County. By November 19 of the same year the directors of the Atheneum in Philadelphia are to be found approving the admission of Robert Simpson Cassatt to membership in that ancient subscription library, described as "stately, high-ceilinged, brownstone . . . usually empty"; by regulation he had to pay for a share on the market. Membership in the Atheneum seems a logical first step in accepting and being accepted in a new community—especially since Atheneum shareholders usually belonged by descent. For Robert had by then made his move, however reluctant Katherine was to make it. His life being hers, she lived it. The enterprising, confident young Pittsburghers were by then established in a rented house at 408 Chestnut Street, the heart of Philadelphia.

Any trek east was a move not to be undertaken lightly, even on a physical level. Philadelphia had always been so sure of its quintessential

importance, so convinced there was nothing to go west *for*, that until 1834 the only way for a traveler from that city to reach Pittsburgh was by using the stagecoach. In 1825 the opening of the Erie Canal had rendered the West able to ship its bounty to New York as well as down the river to New Orleans and, by a new macadamized National Road, over the mountains to Baltimore; but not to Philadelphia. It took a severe financial depression in the 1840s to make Philadelphia stop ruminating on itself long enough to figure out how to get the West's riches (the West, one had to admit, was rich) over those trying mountains, through which, for example, you could not dig a canal.

They tried "inclined planes," which were just what they sound like. Cargoes were transferred from canal barges, hitched to cables, and dragged up mountains on rails. Hitching and unhitching took forever, and between Harrisburg and Pittsburgh alone there were ten such inclined planes between level sections of track. Not until 1852 would a traveler be able to get straight through to Pittsburgh on a train, and not until 1861 would the Pennsylvania Railroad make the trip all on its own tracks, using its own cars.

In 1849 people in Pittsburgh had to really want to go to Philadelphia to get there. Any trip Robert and Katherine Cassatt took, whether to Hardwick or to Philadelphia, accompanied by Lydia, aged twelve, Alexander, ten, Robbie, seven, and two-year-old baby Gardner with his nurse, involved traveling from Pittsburgh to Johnstown by canal boat; from Johnstown to Hollidaysburg by the Allegheny Portage's steam engines with auxiliary horses; from Hollidaysburg to Columbia by canal boat again, and so to Philadelphia on a train. They arrived in the station at Broad and Vine streets as from a major hegira. Indeed, almost any Victorian family travel was an ordeal. Arriving with clothes mussed was the least of its trials; even safe at home, people had nowhere to put their clothes when they took them off, except in clothes-presses, horizontally (which is why subjects of Victorian photography, like Lincoln, always look so rumpled), until, in the 1870s and from France, where they do these things better, they took the armoire.

Of the party was also, of course, little Mary, as always a special case. When the fateful move was made she was still two years less than seven; and the Jesuits, who say so much that is wise, say that if they can have a child for his first seven years, they have him for life. The pattern of her nature was in the process of formation—like a little oyster growing inside its pristine shell. Lydia and Alexander were already, by that time, set. Robbie had just finished setting, and the baby was still hardly more than an adjunct of his mother. The day the Cassatts completed the trek east-

ward, Mary—with her sharp, dancing eyes, her pointed chin—was wide open to every impression.

She was a passionate child, full of love and anger—sturdier than Lydia, less steady than Aleck. Her mother called her May, her father Mame. She lived in the sensuous pleasures of her world—the birds and radiant sunshine of waking, the taste of scrapple at breakfast, of milk warm from the cow at Hardwick, of the pleasantly swaying bell skirt of the nurse walking beside her down Pittsburgh's Marbury Street pushing Gardner in the perambulator, and the bliss of early-evening returns to her mother's arms, when that unspeakably exquisite haven was, before the younger children came, her own. She was filled with marvelous curiosity about each new little boy the material being miraculously brought forth, satisfied, with inexpressible pleasure, by touching a minute pink foot, a wisp of hair soft as milkweed. There was something else—something of pain—connected with the great mystery, but the answer to that, it seemed, was to push it away, never think of it again; just love the new baby. That was how you deal with *that*.

There was also an uneasy feeling because, in the eyes of the other half of Mary's world—her father—the miraculously bountiful half was not, after all, perfect. She was a woman and inferior—deficient in good sense; forever sticking up for something about which she knew nothing; unreasonable. Fear lurked within the feeling, for *how much did her mother not know about Mary herself?* There was an answer to this, too. Her father, stronger, harder, mysteriously superior, did know everything. He was tall! He was Mayor! He had a beard! And he rode horses, great creatures whose rippling muscles moved powerfully under glistening chestnut coats as they galloped, galloped, across the fields. She would learn to ride too—fast, far; feel the pulsating muscles working under her too; be brave as her father was, strong as her father was, *not* deficient . . . *not* inferior; perfect, as her father was perfect. It lay ahead; tomorrow. On a horse she could ride out to tomorrow, far out into the not-here, the not-now, world.

It was the fate of the Cassatts, however, to move in 1849 into a city described by its historian Nathaniel Burt as even today "owned and managed for (not by) one of the few, still-established hereditary oligarchies in America . . . whose tenure extends without any real break from the early eighteenth century." Hereditary is the key word. Mere possession of Revolutionary ancestors was microscopically small potatoes here. "The Old Philadelphia gentry is . . . the real owner and ruler of the city . . . the most important factor in the city. No one, of course, is more serenely aware than the Old Philadelphian himself . . . [of] this venerable Position, into which he is born . . . 'People know who he is,'

as Philadelphians would put it . . . It is sense of Position that gives to so many Philadelphians that air of condescension . . . which continually tends to peep out from under the good humor and the good manners . . . These people consider themselves, and refer to each other, not as 'Old Philadelphians' of course, but as just plain Philadelphians. The Philadelphians. When they refer to someone as a Philadelphian . . . they mean one of their thousand friends, connections, relations. As far as they are concerned, there are no other *real* Philadelphians.

"As for the West, to Philadelphians, of course, it remains a stranger that has not been properly introduced and therefore does not exist. The Far West, the Wyoming of Wister and *The Virginian* is loved . . . but the Midwest is just a blank.

"Acceptance or non-acceptance . . . is abnormally important in Philadelphia . . . An anonymous Nebraskan was moved to Philadelphia as president of a Philadelphia branch of a great national company. A party was given for him and his wife. The party was a great success, but nobody spoke to the guests of honor, who went home, packed up and took the plane back to Omaha . . . Bostonians and Southerners with the right kind of social and college backgrounds are assimilated so quickly that they are inclined to believe that the fabled crustiness of Philadelphia . . . is a myth . . . [But] one still hears people say things like, 'Of course, there's nothing west of the Schuylkill.' "

This scene was drawn in 1963. In 1849 an almost exact contemporary of Robert Cassatt's, Sidney George Fisher, was keeping a diary in which he recorded the passage of everyday life—that is to say everyday Philadelphia life—from 1834 until his death in 1871; this diary mentions practically every event and everybody who mattered in Philadelphia during those years. It does not mention Robert Cassatt. Fisher was fond of delivering himself of sweeping statements which also reflect the temper of that life, those times. "Luckily my fortune small as it is and my social position command respect from the mass"; and, "I am somewhat proud of my family, as on both sides my ancestors for five or six generations have held the stations of gentlemen and men of property and education—which is something in this country of parvenus"; and, "My hatred of democracy is stronger than my love of country . . . I always vote against the popular side on principle." And, of 1842, that year when a depression in Philadelphia started transport moving between Pittsburgh and Philadelphia, "Nothing but a village in the West can be more stupid, triste, and villagelike than Philadelphia now."

Although Fisher occasionally tore out passages from those, in the end, seventy-nine volumes, it is quite clear he wanted the record preserved. This is how he felt about Philadelphia, comparing it with "the vulgarity,

meanness and ostentatious parade" of the parvenuism of New York in 1837:

"Unpretending, elegant, cordial and friendly, containing many people not rich, but few whose family have not held some station for several generations, which circumstance has produced an air of refinement, dignity and simplicity of manner wanting in New York and also a great degree of intimacy among the different families who compose our society as their fathers and grandfathers knew each other." Into this demi-Paradise, this fortress built by Nature for herself and nobody else, came, however, "vulgar, nouveau riche people . . . The good, respectable old-family society is fast disappearing and persons of low origins and vulgar habits are introduced because they are rich . . . If they were agreeable, cultivated, intelligent or beautiful there would be some compensations, but they are all commonplace and uninteresting, many of them vulgar, stupid and ugly."

The new arrivals from Pittsburgh brought with them, at least, the virtue of not being rich. Robert, son of a penniless father, combined with real-estate speculations the mildest of interests in stock-broking. Well-off they possibly could be called, comfortable certainly, but never rich. The myth that held otherwise results from modern illusions as to what, in the nineteenth century, was considered rich. People of far more modest means than the Cassatts, for example, could and did afford summer houses in addition to winter ones and anywhere up to five servants. An income of $20,000 was considered rich. Even after Alexander Cassatt had not only survived but had thrived in Philadelphia, although he became President of the Pennsylvania Railroad he kept his riches within bound. An old Philadelphian recalls this "great parvenu," as Burt calls him, thus: "Aleck Cassatt was just respectably rich, not stinking rich. Or ostentatious like the Stotesburys."

Enterprisingness like Robert's, on the part of an outsider, was not considered a virtue, in Philadelphia. On the contrary. Neither was being footloose. It is too strong to say the Robert Cassatts were rejected; they were accepted as from Pittsburgh. They had good connections in Chester County—Johnstons and Simpsons who had at least a peek-in at Philadelphia; and the Philadelphians were, usually, too well-bred to snub anybody. The Cassatts just did not matter the way they had mattered in Pittsburgh. Nobody mattered in Philadelphia except Philadelphians. An echo persists: ask an old Philadelphian today what he knows about the Cassatts, and his first response will be, "They came from Pittsburgh."

Proud Robert and cultivated Katherine felt that to let such snobbery affect them was beneath their dignity; but to the child hovering on the brink of a new world, it was its very air. As lately as 1971 the wife of a

certifiably old Philadelphian, George Roberts (whose father was President of the Pennsylvania Railroad before Aleck was), said, seated in the sitting room of her delightful house near Rittenhouse Square, "I was brought to Philadelphia as a very little girl, and I was never allowed to forget—by anybody—for one instant—that I came from somewhere else. That I was an outsider from Baltimore. —Not that it made me too awfully unhappy," she added, with the faint smile of one with roots in another old social network; even Philadelphia cannot brush off Baltimore. Pittsburgh was, and is, something else again. "Pittsburgh is not exactly what we call upstate, in Philadelphia," Mrs. Roberts remarked thoughtfully. "Pittsburgh is more out West."

In 1849 the little girl was made to feel an outsider, and was stricken by a gradual association of ideas with knowledge that not only was her marvelous mother not perfect, but he who had judged her mother inferior was not perfect either, in the eyes of a world. The Cassatt family— hitherto central to the universe—was displaced by Philadelphia. Was Philadelphia, then, perfect? Something had to be perfect; a child's nature requires it. The Cassatts' church-going was far too perfunctory to have ever made Mary perceive the Deity as anything very fascinating; but she, even more than most children, had drunk the milk of Paradise.

Like other Victorian little girls she had been told to love her father. What she really felt for him—for both her parents—was passionate loyalty. What kind of a way does a little girl love? When she was in one of her rages, Mary didn't love anybody. As Aleck remembered later, "We used to have plenty of fights, for she had a quick temper . . . but we soon made friends again." When she was loving again, she was at five like a little reproducing machine, busily turning out copies; that was how she learned. Her feeling for her father was not anything resembling a bridge over to him—it was quite simply and briskly imagining being him. A look at her father's traits and attitudes is therefore a look at hers.

Actually her mother was much her father's superior, intellectually and in the quality of her feelings. She was remarkably well read, as well as an admirable housekeeper, and people who met her even when she was an old lady thought it evident that both Mary and Aleck had inherited their ability from her—and from her alone, one witness insisted. Mrs. Cassatt's wide interest in general affairs, unusual in a woman at that time, was conveyed with more real charm than her artist daughter would ever possess, for Mary was half her father.

He was stubborn and irascible. Large areas of interest and experience were forever closed to him. In the manner of the peasant riding the donkey while his wife walks behind, he let Katherine bear the burden of such qualities as he failed to recognize in himself. It was a common

enough trick of Victorian husbands, and quite unconscious in one noted for his courtesy to women, his chivalrous military bearing. Robert's strong points were courage and hardihood. The only times he felt sorry for himself were when, as he often thought, his women were making common cause against him. He did not feel sorry for himself vis-à-vis Philadelphia. If he felt pain he would have died rather than admit it, and he never tried to force his way into anything; the Atheneum was his first and last membership in any of Philadelphia's innumerable institutions, and the Atheneum is not properly a club. In the year 1971 his descendant Mrs. John B. Thayer, a beautiful old lady seated square on the Main Line among French furniture and Mary Cassatt paintings, could say, "My great-grandfather was a Pennsylvanian, not a Philadelphian. He had no Phildelphia ties at all." The late Anthony Cassatt, the painter's great-nephew, wrote shortly before his death when asked for memorabilia of Mary's childhood, "Unfortunately from our viewpoint Mary Cassatt's childhood was spent in Pittsburgh."

Robert Cassatt, however, would have preferred to be remembered as a Pennsylvanian. The one good picture his daughter was to paint of him (as opposed to good portrait), in 1877, reveals him looking a bit like Robert E. Lee: fine and high-minded but rather stupid. Mrs. Cassatt was no saint, either. The even earlier portrait of her by Mary, done in 1873, shows her as a sharp, a *tart*, woman—the dimple in her left cheek not wholly pleasant. She looks like a dissatisfied school-teacher, hair crimped from a center part, head tipped critically; she shows little trace of the benign resignation that appears in later good portraits, and better paintings, Mary did of her.

Robert Cassatt's lack of any importance in the Philadelphia of 1849 was experienced less by him than by the tiny organism hitherto hermetically sealed in its not yet seven-year-old shell. Into it the shock of the parents' encounter with an alien world introduced a diamond-sharp cutting grain as of sand. Mary could not expel it; she never did expel it. She could only apply to this pain an earlier lesson, on woman's pain: push it out of sight, never reflect on it. Hidden wounds can be succumbed to, endured, or utilized. While the choice was being fought out in her, Mary's suffering was of a kind only children know, and they can't tell. Later they won't, no matter how many times they unwittingly recapitulate the past in ways other than telling.

No child, of course, has the patience to endure a life all pain. He will find some comfort, however humble, or die. Lydia's pattern of response was set at a period when to be a woman and inferior was the worst thing a Cassatt child had to face. Her comfort lay in a gentle succumbing

to the maternal domesticity—new dresses, sewing, "sitting a while"—
but without her mother's wider interests.

It was not in Mary to be gentle. She sought, now, infancy's old, wild,
sensuous joys, finding them at Hardwick. Horses were in complete con-
tradiction to all helplessness. Her father might no longer be a Mayor,
here in Philadelphia, but his horsemanship was, as ever, perfection. Later
in life a jealous in-law said about Mary Cassatt, "The only being she
seems to think of is her father."

At Hardwick the images from her earliest dreams came true. A
glorious father did teach her to ride, on a pony, out and away across the
broad fields; she was starting to canter. She did learn from him how to
sit in delicious control over the shining, muscled animal underneath
her; with a little whip she did flick away the flies clustering along her
pony's mane. From that time on horses were the only expression of her
original dream of riding unstoppably out into life, only now horses were
a bond to her father as well.

In the second year of the Philadelphia captivity things happened that
settled Mary's choice of responses. It was in 1851 (the same year in which
baby Gardner was christened at the Church of the Epiphany—which
means to manifest, show forth, a saviour) that Robert Cassatt commis-
sioned a portrait of his three sons. The artist was James Reid Lambdin,
originally of Pittsburgh, who had been East to study with the prolific
and charming Thomas Sully, before returning to Pittsburgh to open
the first Gallery of Fine Arts in the West. In 1838 he had moved back
to Philadelphia, where Robert came upon this old friend of his boyhood.

The painting Lambdin executed lacks Sully's charm, but what Robert
was really seeking was Lambdin. About art Robert was, and remained
for a lifetime, not only ignorant but indifferent. In the portrait the set,
wooden faces of the children are almost those in a primitive, for all
Lambdin's training. As likenesses, however, they satisfied the family.
Aleck's intent forcefulness was there, and the curiously shrewd expression
already in baby Gardner's features; in later years the haunting melancholy
in Robbie's face would come to seem prescient. Even more than the
painting, what pleased the Cassatts, and not only Robert, was the painter.
The girls had not been included in the group which was to be—as
people said in Victoria's early reign—an amber immortalization; but
that left lively Mary's curiosity all the freer to observe what was going on,
in the process of painting it. And to observe the painter—this entirely
new kind of being. He too "came from Pittsburgh," yet in Philadelphia
he had a special place of his own, a place different from other people's.
What he did was paint pictures. They called him an artist.

Philadelphia, then as now, was no heaven for artists. Burt comments

on the oligarchy's somewhat condescending patronage of the Muses. There are few if any American cities where the connections between art and the aristocrats have been so close, not always to their mutual benefit. Yet in general, there is no place where the arts have been generally regarded with less esteem. The only really respectable approach to art is by way of the boards of institutions . . . The figure of the dilettante gentleman who, often at the expense of his talents, occupies a place at the center of the Philadelphia Web, is so common . . . he might be taken as one of the Ideal Prototypes of Philadelphianism . . . Sidney Fisher [had] a strong dash of the disappointed-gentleman-dilettante in him." On the other hand the outlander and journeyman Lambdin, by utilizing every bit of his small talent, was in, if not of, this Web of perfectly good souls only doing what felt to them like minding their own business, quite unaware that by doing so they were causing pain.

Not long after the completion of the portrait deprived him of Lambdin's company, Robert Cassatt's pattern of response, his own mode of dealing with what life dealt him, reasserted itself. He picked up his family again, to clear out of where he was and go somewhere else, somewhere pleasanter. To Mary, in her duress, anywhere else would have seemed pleasanter. What her father had decided on was to take them all to Europe for what was called an extended stay.

Not only did relief and joy descend on Mary like showers, there seemed too a mysterious rightness about the decision. It made a family compromise that fused elements otherwise disparate. Her mother's usual reluctance to move, her father's lack of speaking familiarity with the tongue of diplomats, were now entirely altered by this process of going abroad on purpose to *be* outsiders; this knowing nothing about what they were doing but aiming to find out. All was transformed into a fresh start. To set off for Paris in the fall of 1851 was, as a solution to the dilemma they had got into, the apotheosis of the Cassatts; but especially of Mary, who had just turned seven.

TWO

THE SHIP! The ship! New, strong air even in the harbor. The sea gulls crying and diving for bits of food thrown from the high sides of the vessel. The gangplank; the porters carrying their boxes, cloaks, carpet sacks; the cries of goodbye from on deck; the steward who led them down tunnels past agitated ladies in dignified traveling bonnets, to their cabin—with portholes! And berths one never tired of climbing into!

This was to be home for, it was promised, a mere twelve days. How enchanting the ship was! She wanted to be everywhere at once between breakfast at ten and dinner at five. Racing down the corridors with her brothers, hearing and feeling the rhythmic vibrations of the ship's engines; then struck suddenly quiet, as she watched, on deck, the great waves continually blowing toward Europe; saw them slowly blotted out by deep fog . . . The fog bell ringing . . .

It was late fall and drizzling a little when they landed at the French port. Enchanting, the confusion of people on the docks and in the customs shed; the sound of bewildering French words all these people understood so well; the continual chorus of little exclamatory cries like twittering birds. On the long train trip to Paris they passed fields like one long garden, and long white country roads. Finally—at last—Paris!

Choosing fiacres for themselves and their belongings they clop-clopped a long way, through streets broad and narrow, with only a twinkle of light here, a twinkle there, to that strange and mysterious thing, a hotel. It was foggy and damp when Mary had her first whiff of Paris, a mixture of cheese, chicory, wine spilt on sawdust, and old houses. "*Quelque chose pour le pauvre garçon,*" said the driver of a coupé already at the hotel entrance, holding out his hand to the gentleman getting out. "Must I give him something?" the gentleman said, to his wife, in an American accent. "Yes . . . No . . . if you want to. Do as you please," she said. "Obnoxious system!" he exclaimed.

Next morning Mary ran from one to another of the Cassatts' rooms. All was as different as if another world; it *was* another world. The elegant French beds with tented hangings, the uncarpeted floors polished until they looked like marble, the mirrors and scenic paintings on the walls, the carved ceilings; all the rooms had little marble mantel-pieces surmounted by a mass of gilt candelabra, vases, and racks to hold calling cards, with always a little French clock ticking away in the center. To order for

breakfast there was bread and butter, a fowl, a beefsteak, and more bread and butter. Wonderful bread; but Mary could hardly wait to get outdoors.

Shortly after the Cassatts' arrival they moved into furnished apartments, first on the Rue Monceau, later in the nearby Avenue Marbeuf. Both apartments were near the Champs Élysées, and fascinating people constantly passed. Gentlemen in top hats and ladies with large, swaying skirts and vast shawls, feathers and lace dripping from their meekly parted coiffures, stepped out of glass coaches, sometimes with a footman to hold the door dressed in white stockings and court costume. Mary could see, when twilight fell—pressing her nose against the apartment window— the lamplighters coming down the street carrying their ladders; a few minutes more and it was dark. The streets then took on a delicious look of mystery, the only patches of light shining from the lamps, and out from the concierge's basement. Something she didn't see was the chiffoniers, ragpickers. They only came out after midnight and before dawn, baskets on backs, to scrounge in the gutters. There were twenty thousand of them in Paris.

Since the Revolution of February, in 1848, visitors were no longer admitted to the Parc de Monceau, and for exercise and fresh air the best place, the loveliest, was the Tuileries Gardens, particularly "La Petite Province" at the southwestern end, where children and old people swarmed like bees on a sunny day since it had a southern exposure and was sheltered on all sides. Sometimes it was fun just to drop down on one of the benches near the fountains, panting, and look. In the background, against the sky, was the immensely impressive façade of the Tuileries, looking every inch the Palace it was. All around, broad, winding paths were interrupted by fountains with mythological marble figures— Mercury and Fame had horses, with wings! They spilled their water into basins in a variety of intriguing ways, but the sweet sound of water falling was swallowed up when the military band struck up.

There were hundreds of children with their nurses. One nurse often looked after children from more than one family. On bright days there were always a few very old gentlemen in top hats, leaning on their sticks, dreaming perhaps of those dark doings in the great square behind them, now called the Place de la Concorde. One or two old ladies in shawls, with lace caps like confections, would be there, pushed in a rolling chair by a manservant or else some meek relative. It was clear the French loved uniforms and it added to the excitement to see not only soldiers and sailors, but servants, porters, coachmen, concierges from the grand houses, all wearing the costume of their calling. You could tell a bricklayer or a postman or a butcher a quarter of a mile away, by his clothes.

In the Gardens was always a great deal of chattering and calling out;

laughter and usually tears; many little joyous cries but never, it seemed, anything noisy or disturbing. Swans on the little lake sailed serenely, drifting back and forth. When spring came, along the shady streets the children passed houses of well-to-do families, not grand, but with big gardens behind high walls and iron gates, where the entire neighborhood was made fragrant with lilacs. The bushes flowered high up, above the walls, and leaned over them, so as almost to touch with their sprays the passing children. Through iron-grilled gateways they could glimpse the great lavender masses of blossoms swaying gently in the spring wind.

Later along the Champs Élysées the chestnut trees, from the Arc de Triomphe at the end all the way down the wide, beautiful avenue, bloomed with pink and rose flowers that scented the air intoxicatingly. Warm days brought out the chairs and tables of little cafés along the Boulevards—and it was all right for a lady, for one's governess, to go! As she couldn't have done in England!

Everywhere, it seemed, was cheerfulness, gaiety, and delight in wit and the right word, even if it was only two coach-drivers arguing about the other's impossible driving. They were all so quick to find the most expressive insult to fit the occasion. The apt word! It meant everything to the French, it added to the clarity of life. They seldom seemed mixed up about what their thoughts and emotions were.

The Paris that Mary Cassatt saw in the winter of 1851 and 1852 was the Paris she needed. She needed it so much she never noticed the dark side, expressed, in the Cassatts' Paris, by hundreds and hundreds of street organs. To hear the tune of "Jeannette and Jeannot" or "Valentino" was to mean some horrible deformity was approaching—sightless eyes, a man without legs, a mutilated child. For the poor this winter was, like all their winters, disastrous—bread dear, fuel scarce. Police regulations, and their own shame at *being* poor, kept them from attracting the public notice, except for those street-organ players, but they were always present. A sick old woman, huddled against the snow, sold oranges in the bitter cold. A boy of ten, blue with starvation, clothes soaked with snow, was unable to sell a single one of his stock of withered, decayed apples. It was all there, the other side, but in the overwhelming impression that Paris made on Mary Cassatt, the dark side did not enter as a factor until she had been for some time grown up.

Another facet of the excitement was supplied by Mary's first experience of a great political event. Early on the morning of December 2, her father went out into the streets, returning almost at once to tell his family they must all stay indoors: something was up. He, of course, being Robert Cassatt, went right out again. When he came back he walked into the salon and exclaimed, "Well, Louis's done it!"

Louis Napoleon, up to then President, had brought off the coup d'état and dissolution of the Assemblée Legislative that one year later culminated in his being proclaimed Emperor, by plebiscite, to reign as Napoleon III. It was an event precipitating vast changes in France, Paris in particular, changes in architecture, street planning, and sanitation that had been brewing ever since the cholera epidemic of 1849 first got Louis stirred up. Change was in the very smell of Paris, along with the wine, the cheese, and the drains.

To a child one thing seemed no more improbable than another. Simply, Paris was once more demonstrated to be a wonderful place where tremendous upheavals habitually occurred, habitually for the better. Best and most fortifying of all was that, in Paris, all was well with the Cassatt family. Robert was happy. His modest income went further here, and inconveniences merely challenged his ingenuity. He, with Aleck, must have been fascinated by the engineering innovations of a M. Andraud, near the Rond Point, who had made a model for a railroad system using compressed air for propulsion, claiming for it a tremendous saving in operating expenses as well as the absence of all danger from explosion.

In this foreign land, moreover, there was no relevant society to challenge Robert's role as master of all he surveyed. For him to be otherwise was a bad dream dreamed in another country. Katherine Cassatt was happy to be able to give her children the advantages of foreign residence and education and hearing their French accents improve, with the mild gratification of hearing her own praised: "Vous parlez, madame, absolument comme une Française!" Lydia was, in her gentle way, happy; Aleck was happy being outstanding at the school he went to, run by a M. Gachotte. Gardner was happy toddling in the Tuileries Gardens. Even Robbie, although under the care of Paris doctors for the knee joint disease which had been part of his father's justification for clearing out of where he was and coming somewhere pleasanter, was happy. As for Mary, Paris was a relief to her so profound that she could not accept it as hers, but made it an attribute of Paris: Paris is the place where people are happy.

For some personalities, if one thing is good more of it must be better. Robert Cassatt may have figured that if travel brought about such a state of mutual domestic satisfaction, further travel could only enhance it. In any case, he decided that Aleck, whose teachers agreed with his own high estimate of the boy's talents along technical lines, must go to school in Germany, where technical subjects were much stressed. He was, in fact, right: Aleck did benefit. Once again Robert picked up his entire family, cleared out of where he was, and went somewhere else—Heidelberg, where Aleck was popped into an excellent boarding-school.

Aleck was thus not at home, to be included in a new family group

portrait his father commissioned in Heidelberg in 1854. This time Mary was, but Lydia and Mrs. Cassatt were left out, and it would not be like them to have objected. The artist whom Mary had a chance to observe was, this time, Peter Baumgaertner. This time what she observed was the art of drawing in pencil.

The finished product is full of illuminating Victorian detail, like the Paisley shawl used as a tablecloth over the round table on which stands the oddly high board before which Mr. Cassatt sits at chess with his son Robbie, who looks as if he were losing. Perhaps it is only that in his face are traces of the pain he endured. A chocolate cup is poised close to the board—precariously, in view of the way Robert Cassatt, as ever inconsiderate, has bunched the cloth up with one elbow. He himself is drawn profile, hair falling across his temple like Lord Tennyson's, looking amiable but a little crazy. His cheeks are too flat and boneless, and he hasn't enough back to his head—it is shallow like a dish. This backlessness was noted not only by Baumgaertner. Thirty years later Mary, by then an artist in her own right, recorded it again in a sketch of her father.

The baby of the family, Gardner, stands slightly in front and to the left of the table, bright as a button at five years old. He wears the sort of Tartan dress with a lace collar that little boys did wear, or endure, in those days, made more tolerable by the perky cockade in his Scotch bonnet. Behind the table stands Mary, giving the strong impression that she is keeping still only for one minute, as she leans slantwise as if on the wind, toward seated Robbie. Her restlessness is fascinating to note in one who was so intolerant of children who wiggled, when she in turn came to pose them. In other ways than this she reveals inconsistencies still visible in the person she became in old age.

The primness of her hair, parted in the middle and tied back with two bows, could be laid to the artist's Victorian style, but the look of reserve in the eyes is seen only in children who have been badly hurt. There is something painful against which she is measuring new experience; judging it. Yet, as though wryly resigned to whatever comes, the small, pointed face is open to experience still; no defenses are visible.

This thoroughly academic specimen of Victorian portrait-drawing includes one curious aberration: the figure of Robbie, though actually placed farther back in the room than that of Gardner, is drawn rather larger. It is an error in perspective, or else a flash of melancholy prescience about Robbie on the part of the artist, reminiscent of how the saints in Italian primitives are painted larger than ordinary folk. "Knowing deformation" had little place in the approved draftsmanship of 1854.

Not content with Heidelberg, Robert Cassatt soon moved his family out of Baden into Hesse, to the delightful town of Darmstadt, situated

within a circle formed by the Rhine, Neckar, and Main rivers. For a bit it seemed as if he might be right—that travel, continued travel, did make things only get better and better and better. Aleck right away distinguished himself at the Technische Hochschule, one of the foremost technical universities in all Germany. New delights could be experienced in exploring streets as ancient as in Paris; the open countryside was close at hand. Then fate struck.

Robert Cassatt later set down the facts of the second major shock in Mary's life (together with due mention of the part he himself played in it) in the notebook he kept for family records. On page 36 it reads:

> Robert Kelso Cassatt died at Darmstadt the capital of the Grand Duchy of Hesse Darmstadt in Germany on Friday the twenty-fifth day of May A.D. 1855 at 5 o'clock P.M. He is interred in the Cemetery belonging to the corporation of Darmstadt in lot No. [blank space] purchased for the purpose by his father—It being the intention of his parents to have his remains brought to the United States as soon as practicable, a simple gravestone is placed over his grave in Darmstadt merely recording his name and country. For almost five years previous to his death Robert had been afflicted with disease of knee joint. He suffered very severely at times. He was a model of fortitude and patience. Dear, dear Boy! how gentle and good he was!

Years would pass before Mary, by then an old lady, and under the most difficult of conditions, went alone to fetch back the little body to lie with the rest of the family, by then dead too; only in French soil. None of them ever forgot Robbie. Mary's journey all those years later is a token of how a little boy who had survived the perils of being a Victorian baby, and had grown up to be a person in his own right before being, as they said then, torn from their bosoms, lived on in his family's hearts forever. Robbie's little tricks of behavior and ways of saying things, the very braided jacket he wore to sit for Baumgaertner—now discarded forever—such memories in a Victorian family were carriers of unbearable sentiment. *Dear, dear Boy!* The jacket, the white collar that went with it, might be given away to the poor but the little ways, the traces of baby talk—these were passed on into later generations.

It was the first of Mary Cassatt's experiences of losing a brother, and set the pattern for an always shattering event. Occurring as it did, far from what could reasonably be called home, the disaster might have had an effect on the Cassatts that such disasters often did have on travelers —make them superstitiously wary of ever going abroad again. "*He died far from home*" . . . To the pattern shaping in Mary Cassatt it was important that, in fact, the Cassatts did just the opposite. They stayed

abroad. Not for quite a while did they go home, or rather back, to Philadelphia.

The saddened months in Germany could even be felt to have a brighter side: the benefit to Aleck's development, the children's acquiring German. About Mary's taking that trip as an old lady, her young friend George Biddle said later, "She was capable of anything. Capable of staying up three nights running, with her brother's body in her own luggage, in order to get it out of Germany. Of course," Biddle added, "she spoke perfect German, which was more than she did French. She often used to quote German poetry to me."

The itch inevitably overtook Robert Cassatt, and he moved his family out of Darmstadt. But it was to Paris they returned after Robbie's death, as to a refuge. To love for it was added the gratification of re-experience. Since Mary's first sight of the city the vast changes undertaken by Napoleon III were well under way. Whole masses of houses, vast sweeps of twisting old streets, were being demolished to make way for "broad boulevards, spacious squares, and palatial edifices," as grown-up people said when they talked about the changes—which was constantly. "Public works of colossal magnificence" was another favorite phrase, and "works commenced in former reigns are being brought to a successful completion." Public parks and gardens were being, people remarked, "embellished." And Napoleon was doing something about the drains.

Mary had loved Paris on sight; now she was able to feel proprietary. "That wasn't there, when I first came," she could say, and point out, "Did you see the Boulevard de la Madeleine? It's almost done." All along the Boulevard Beaumarchais, houses people said were "handsome and tasteful" were springing up. But there had been something *about* those crooked houses of the old Paris . . . To proprietorship could be added the joys of nostalgia. Eleven-year-old disapproval of "tasteful dwellings" could be accompanied by delight in the workmen of the quarter, the Faubourg St. Antoine in this case, in their uniform blue blouse and printed jacket. The old Hôtel des Affaires Étrangères on the Rue Neuve des Capucines, familiar to all Americans, had entirely disappeared, and there was a new one on the Quai d'Orsay. Mary was able not only to love Paris, but to feel a delicious plum on the palate: it was her Paris.

Also in Paris there were, as usual, great excitements. To celebrate his 1852 accession, the advent of which the Cassatts (*Robbie too*) had witnessed, Napoleon III caused to be held an immense World's Fair, the Exposition Universelle de 1855. Since Louis Napoleon planned it to demonstrate all that he was accomplishing in a hundred fields as well as to revive the glory of the old Empire, there was included for

the first time an international art section, with paintings that represented the last sweet word in artistic taste.

"The most discussed French artists of the time," writes F. A. Sweet, "were Ingres, with forty canvases . . . and Delacroix with thirty-five. Which was more important, line or color? Which trend should one follow, the classic or the romantic? One faction supported Ingres with his clean-cut line, orderly static compositions, which were classical in their composure; others championed Delacroix, alive with color, action, and dynamic qualities that broke every rule of tradition and bespoke the romantic movement." Meanwhile, outside the official show, a painter named Gustave Courbet exhibited his pictures in his own "Pavillon de Réalisme." *Realism?* All Paris was taking part in the art quarrels—they were in the air, the magic smell, of Paris. Art! Artists! More than merely different, they were important here in Paris: place of refuge from sorrow, place where people were happy.

The Exposition was a marvelous spectacle. At least a million people thronged the streets, from railroad station to Palais de St. Cloud, when Victoria—Queen of England and, although not till 1876 Empress of India, already the century's reigning female deity—came: a distance of ten miles, lined the entire way with a double row of soldiers. With her, her handsome consort, German Albert, came. The Princess Royal and the Prince of Wales came. The elaborately mustached Louis Napoleon of course came, repeatedly, accompanied by his lovely Empress, Eugénie, whose costumes it was said he selected, whose coiffures he superintended. Prince Napoleon, heir-apparent, came. The world came. It was all enormously gay, lively, and French. Flags hung from houses in every quarter of Paris.

The artists constantly came, and the students on their way to becoming artists. Camille Pissarro, aged twenty-five, Jimmy Whistler and Edgar Degas, both twenty-one that year, came. It would be agreeable and not unreasonable to imagine the little girl who, with all her family (*except Robbie*) came, singled out for the dark, saturnine regard of the young Frenchman who had just attained his majority. She and her destiny were in the same place at the same time. In fact, most of her future colleagues, dressed in their best (tight trousers strapped under instep; swallow-tailed coats; stiff high collars that bit into their chins) with luxuriant locks about their ears, were strolling through the galleries, looking at pictures with the mingled eagerness and disapprobation of any rising art generation. The Courbets were what really excited them. Art! It mattered.

On earlier trips to the museums of the Louvre and the Luxembourg that were part of the advantages of foreign residence Mrs. Cassatt sought

for her children, Mary had often enough seen students in smocks, seated on high stools, copying the old masters in a state of extraordinary concentration, as though oblivious of the world that peered and peeked over their shoulders as they set down on the canvas a stroke of the color they intently mixed on enormous wooden palettes. The meaning of that puzzling concentration was made obvious in the context of the Exposition; here the apotheosis of the students' overriding purpose—the making of new art—hung on the walls for the world to marvel at.

Not by Mary, however. What she chiefly marveled at in those days, always and by instinct, were concrete, physical sights and sounds, the magnificence of the show. During their earlier stay, there had been held an evening in honor of Napoleon the Great, when lights had blazed all the way from the Palace of the Tuileries to the Arc de Triomphe, falling on the faces of thousands of men, women, children, and dogs (every young or middle-aged woman in Paris, had, it seemed, a dog). The faces looked, moreover, quite sensible and controlled, not seeming in the least overwhelmed by any Emperor, past or present, but—even with their constant rushing to and fro—unmoved; unmoved even by the fairy splendor of fireworks. Oh, Paris! City of light, and the tart word!

It was from scenes like these that the Cassatts went home to Philadelphia late in 1855. The outward reach of Mary's pattern had been established, its eastern limit set: so far and no further. As yet it had not found bottom. She was still only eleven: not a child but not yet a young girl. She would never again look at Paris with eyes as purely crystal clear, for this move, which was to her in effect leaving Paradise to re-enter hell, did not go unresented. It was unthinkable in that era that a little girl should even admit to harboring resentment of what her parents in their wisdom saw fit to do. Like the poverty, the degrading beggary and awful suffering that were in Paris whether she saw them or not, her boiling anger at having to return to Philadelphia was concealed even from herself. It was there, however, like rust on a mirror. When she did at last see Paris again, it was no longer only with love, but to make something of it.

Pittsburgh from the Soldiers' Monument, 1872.
COURTESY OF THE NEW YORK PUBLIC LIBRARY.
Pittsburgh viewed from Allegheny City, whence in 1846 the Cassatts had watched the city burn.

Scenes in Philadelphia in 1872.
COURTESY OF THE NEW YORK PUBLIC LIBRARY.
"It was the fate of the Cassatts to move in 1849
into a city described as one of the few hereditary
oligarchies in America."

The Merchants' Exchange and Girard's Bank, Philadelphia.
"The new arrivals from Pittsburgh brought with them at least the virtue of not being rich." This Exchange building was not opened until 1836, setting an approximate date for the picture.

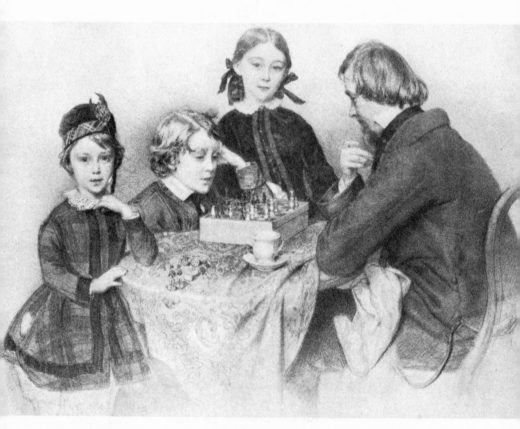

Mary Cassatt and Her Brothers Robbie (left) and Gardner, with Their Father
by Peter Baumgaertner, Heidelberg, 1854.
The engraving that was made during Mary Cassatt's first trip abroad, that includes the brother who died. Note the back of Mr. Cassatt's head, and compare with *Portrait of Her Father*.

Mary Cassatt (right), Inez Lewis, Miss Welch, Eliza Haldeman, and Dr. Edmund Smith, 1862.
Eliza Haldeman, Mary Cassatt's closest friend while studying at the Pennsylvania Academy, wrote her father, "Miss Cassatt and I are . . . the head of the ladies."

Paris.

How the Palace of the Tuileries looked when Mary Cassatt saw it in 1851. It was burned by the Commune in 1871 as part of their "diabolical scheme" to destroy Paris buildings. Later a Corsican family, in vendetta with the Bonapartes, used stones from the ruins to build a château.

Le déjeuner sur l'herbe by Édouard Manet, 1863.

"No Victorian mother wanted her daughter alone with a man who could visualize scenes even faintly resembling Titian's, let alone Manet's."

Art Students and Copyists at the Louvre by Winslow Homer. Mary Cassatt, "even more than most students, spent time at the Louvre, copying."

The Holy Night by Correggio, c. 1530. PUBLIC ART COLLECTION OF DRESDEN, GALLERY OF OLD MASTERS, No. 152. "Those Correggio flying cupids—they're Mary Cassatt's kind of babies." The artist spent 1871–72 in Parma, studying the old master.

Paris
COURTESY OF
THE NEW YORK PUBLIC LIBRARY.
A nineteenth-century view down the Seine from the Pont Neuf, showing the statue of Henri IV ordered by Louis XVIII, after the Terror, to replace the one commissioned by Henri's widow, Marie de Médicis.

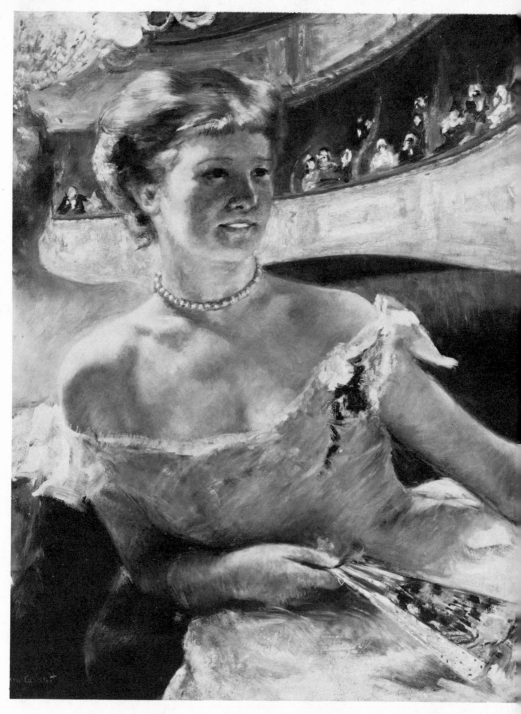

Lydia in a Loge Wearing a Pearl Necklace by Mary Cassatt, 1879.
PRIVATELY OWNED.
"I admired Manet, Courbet, and Degas. I hated conventional art. I began to live." This painting of the artist's sister has been called one of the greatest Impressionist pictures.

*Cathédrale de Rouen,
Harmonie brune* by
Claude Monet, 1892–94.
PHOTOGRAPH COURTESY OF
THE MUSÉES NATIONAUX DE FRANCE.

A discussion of Monet's cathedral series
is found in the chapters
on Impressionist painting.

*Lydia Leaning on Her Arms
Seated in a Loge*
Mary Cassatt, 1879. PRIVATELY OWNED.
The pose taken by Lydia Cassatt here
resembles the pose in Degas'
Portrait of Mary Cassatt, to which
Mary was later to object so strenuously.

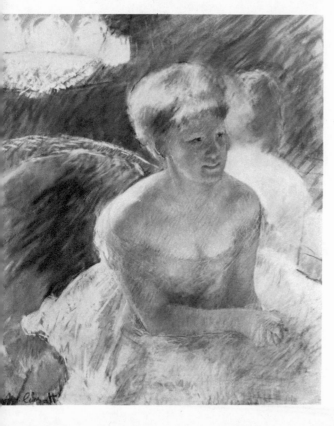

Au Louvre by Edgar Degas, 1885.
One of a series of etchings Degas made
of Mary Cassatt, with and without her
sister Lydia, that were intended for a
periodical Cassatt and Degas were in-
terested in putting out together, which
never in fact appeared.

THREE

BACK IN THE morass of Philadelphia, Sidney Fisher was still at his journal; still busily going on about all the right people. His own family connections included Cadwaladers, Whartons, and Wistars, and among his acquaintances were Biddles, Markoes, Wisters, Hares, Smiths, Bories. His was actually a first-rate record of what rather exceptionally liberal opinion was, in the only Philadelphia he or anybody else thought counted.

Nothing could divert Fisher from making his daily report—not even the death of his best-beloved brother Henry (which on March 10, 1862, required the one, astounded, line, "At 3 o'clock this morning I saw my brother *die*."). Only his marriage to an Ingersoll seemed an event of such Philadelphia—if not world-shaking—proportions as to bring about a halt in his journal from the wedding day in June 1851 to December 1852, by which time the glory was presumably assimilated.

Although there were dinners, parties, and balls, nothing much of outside importance happened in Philadelphia, if one excepts the continuing hooraw over the wicked and fascinating Pierce Butler the planter —he who married Fanny Kemble—of whose scandalous doings the Philadelphians had been talking since at least 1848 and would continue to talk for years; and the rumblings of the approaching internecine struggle. In the course of Fisher's ruminations, however, there emerge revelations, surprising or reprehensible today, of important attitudes that were then a matter of course.

Fisher was personally sensitive, cultivated as anybody in his city, and was shocked one day in 1858 when, visiting his farm in Maryland, he just missed the ferry but managed to secure a ride in a tavern-keeper's cart. As they drove along, this worthy disclosed that he eked out his meager take by serving as constable, which paid about $500 a year. Pointing to a small house they were passing, he remarked, "I had a great frolic at that house night before last."

"What was that?" Fisher asked. " 'I found,' said he, 'twenty or thirty niggers, dancing and singing and cutting up. I got . . . 5 or 6 men to help me and took the whole lot of them and gave them a good warming.' 'What do you mean?' said I. 'Why,' he said, 'I tied them one by one to the fence post and flogged them.' 'Men and women both?' 'Yes.' 'What did you whip them with?' 'With this,' said he, pulling from under the seat a formidable looking whip of plaited leather. 'How many lashes

did you give them?' 'Ten each.' 'Were they slaves or free?' 'Both.' 'But
does the law permit this to free Negroes?' 'Yes, indeed,' said he. 'It is the
duty of a constable, whenever he finds a party of niggers assembled at
night, to flog them and disperse them. We get $8 a year for doing this.'
'But . . . a bad man might practice a great deal of cruelty if that be the
case.' 'Oh, no,' he answered, 'the law says not less than nine, nor more
than twenty-nine lashes, so I gave them ten. But if they resist, then you
may put it to them as much as you like.' 'Did these resist?' 'No,
indeed one old man next the door said to me, "Well, Mr. Richards,
you may as well begin with me as I am the nearest to you." ' "

Besides his sympathy with anti-slavery, which provoked from him
many high-minded statements, Fisher was sensitive to other excesses
that a "real man" of those days rather enjoyed. About a visit to Brook-
wood, the country place of his brother Henry, who, though a Fisher,
really *was* rich, Sidney wrote in 1857, "Henry's establishment very lux-
urious & perfect . . . The effect of so many large apartments with hand-
some furniture & flowers is very agreeable. The dinner was elegant &
luxurious as it is every day. Three or four unexpected guests make no
difference to them . . . There is always the same display of silver, china,
glass, light, three or four courses, an elaborate dessert, and profusion of
the choicest wines. They have a French cook with a salary of $600 a
year, & two waiters are always at dinner. He keeps 10 or 12 horses, all
very costly . . . carriages, coachmen . . . then there is greenhouse &
grapery and kept grounds with 6 or 8 gardeners besides the farm. Alto-
gether . . . kept up at a cost of $40 or 50,000 per annum. And for what
purpose?" asks Fisher, rhetorically. "No rational one that I can see, for
the same degree of comfort & elegance could be attained at a fourth the
cost, and what is of more consequence, a fourth of the trouble. It is im-
possible to have such an establishment without a vast deal of trouble,
without devoting to its management a great deal of thought that might
be better employed. Sarah Ann [Henry's wife] does all this," Fisher
continues, in spite of Victorian attitudes. "She has much energy &
seems to like it, but I think she would be better pleased if she had less
to do."

When Sarah Ann died the following year, of childbed fever after
having borne six children, Fisher, who had gone to comfort the stricken
husband and father, after praising the latter's masterly control of his
feelings, describes his own: "I saw her remains. They were in the icebox
& the face was not natural . . . The woman who had performed the
necessary offices which the dead required came into the room & began
to talk about those offices, about her body, in a way that shocked me,
tho she did not mean to do so. Her language was professional & tech-

nical, but I could not bear it. We cannot govern our thoughts, and the scene in *Hamlet* where the gravediggers are talking about Ophelia came into my head & with it the thought that here before me was a proof of how true Shakespeare is to nature." "Calm" Henry, not literary Sidney, typified the contemporary masculine response to that manner of death.

Fisher could also find fault with what he was a shade too sophisticated to call the fair sex. In March 1856, the husband of five years wrote, "At 11 o'clock went [alone] to the Bachelors' Ball at the Musical Fund Hall. It was very well got up. Talked with Mrs. Harris, Mrs. Wm. Biddle, Mrs. P. McCall [another old Philadelphia name] &c. Clark Hare there. Was struck by the remarkable deficiency of female beauty. Small, thin, undeveloped creatures, they do not seem fit to become mothers. The race is certainly degenerating here. Saw but one handsome woman." Fisher, by implication preening himself on the condition of his own wife, safely at home two months pregnant after having twice miscarried, was the more gratified now because, as he had written of her eleven years before the wedding, "She has but little beauty."

Fisher was nevertheless an exceptionally tenderhearted and admiring husband. Slavery was a fact. Childbearing was a fact. They had to be accepted, however distasteful. High-minded Fisher, teetering on the brink of outright abolitionism in a city where sympathy for the South was general, felt otherwise when the going got rough. In March 1856 he wrote, "Greatly annoyed by hearing from Bet [his wife] that Elizabeth, an excellent servant, on whom Bet had relied for assistance during her now nearly approaching confinement, is going to leave us. It is a serious thing at this moment. Servants are the plague of life and are getting worse every year. Slavery is not without its merits."

Robert Cassatt cannot be compared to Sidney Fisher, though both were living at the same time in the same city with roughly the same financial status (it never ceased to rankle, with Fisher, that he was to some extent dependent upon his Ingersoll in-laws). Robert was not nearly as cultivated, well-read, or sensitive as Fisher, but his roots lay in a Scotch-Irish, valley background which prevented his identifying with slaveholding interests. His view on women was something else again and, like Fisher's, had an unassailable foundation in biological fact.

Reduced to its elements, this view was based on woman's central importance to society as perpetuator of the race and carrier of the supreme value of maternal love. Man's role was to protect and serve her in this capacity. To fail it, whether through prostitution, race-mingling, abortion, or voluntary celibacy, was to offend. Inadequacies in it, lack of charm, beauty, and docility in a woman—or of strength, confidence, and chivalry in a man—were to be deplored. The concept was honest

enough; woman was—still is—the fleshly crucible in which the future is hatched; for its conception requiring man. Men felt that, far from de-meaning a woman, such a view exalted her, and it is true that the slavery under which a woman of the nineteenth century labored was less bond-age to her husband than to the demands of instinct. Like everything else instinctive their positions were ambiguous: woman at once slave and goddess, man both overseer and worshiper. Against such inarguable reali-ties individual tendencies and desires did not stand a chance.

It is an interesting if melancholy fact that much more can be learned about the education of Aleck Cassatt than about Mary's in the years following their return to Philadelphia, and during the opening years of the Civil War. People did not dwell, in act or in letters, on the education of their daughters as they did, lovingly, upon their sons. Taken in reverse, the hiatus of information about those years of Mary's life is positive information. Nothing could better tell the story of a girl between the ages of eleven and seventeen in the Fifties and Sixties than that the records concern her brother's life, not hers. It is of signifi-cance, too, that Mary herself did not later reminisce about whatever school it was she went to. That she never had a beau in her growing-up years is unanimously asserted by all her descendants. Such lack of in-terest in ordinary gaieties came to be a familiar sign in the forming characters of such last-century young ladies as solved the problem of their womanhood by way of art—choosing its, rather than society's, aims for themselves. Mary Cassatt once remarked, later, that she knew her having been plain was hard on her father, who had hoped, like most fathers, for beautiful daughters.

Besides the details of Aleck's educational prowess (in January 1857 he entered the Rensselaer Polytechnic in Troy, New York, where he graduated in 1859 as a civil engineer) there are voluminous records of Robert Cassatt's undiminished peripeteia. Before they went abroad he enjoyed staying with his sister Mary Gardner at her house in West Chester, whence, moreover, his wife's ancestors had sprung. It was twenty-five miles away from Philadelphia; even before they sailed he had invested in an acre and a half there, and announced he was going to build a house on it—whether, from standing facing Fortress Phila-delphia, his feet were getting cold, or merely because they were, as usual, itchy. When they sailed home he did stow his family in West Chester, first in a rented house at the corner of High and Minor streets, later in another rented house, near Philadelphia friends, the Dalletts (Old Philadelphia friends), who summered there; but he sold that acre and a half, and put $2,200 into ten acres on New Street.

He never built the house, however. Instead, in 1858, he turned

around and moved to a boardinghouse on the corner of Olive and Fifteenth streets in Philadelphia, on what was soon to be named South Penn Square, a beautiful four-story brick house. (During the twentieth-century degeneration of that section of town, it was stuccoed yellow, and occupied by a café.) To relate that the Cassatts remained in this house until 1863 is not to say Robert stopped fidgeting. Deed books teem with his real estate activities. Between 1849 and 1870 there are no less than seventeen citations, as well as the records of tax assessments for property he already owned. In 1856, for instance, "Robert S. Cassatt, Gentleman" was taxed on the first undeveloped West Chester lot, assessed at $1,000 as well as on "Money at interest $3,000, Stock in other States $4,527, Stock in this State $7,025, Gold lever Watch, a total of $15,552."

In 1860 the Cassatts once more shook the dust of Philadelphia from their feet, moving this time to the country. Selling the ten acres in West Chester, Robert found some land described in the Chester County Deed Book: "Robert S. Cassatt, of the City of Philadelphia, purchased for $3,232.47 from Wellington and Jane H. Hickman, of Thornbury Twp. Chester County, Pa., a tract of land, 37 acres and 159 perches [a perch was a measure of land amounting to a rod] in Thornbury Township, beginning in the middle of the line of West Chester and Philadelphia R.R. Co., with a right of way through Eber Townsend's land on the North side of the R.R., with the privilege of building a water wheel in Chester Creek, at or near the present ford now used . . ."

The year after he bought the setting for these enticing rights, Robert built a simple stone farmhouse of the type familiar in eighteenth-century Pennsylvania, with a Victorian porch and round-topped windows added, for the family to week-end in. In 1863 he sold the Philadelphia house (for $7,500, making a profit) and they moved out for good—insofar as any of Robert's moves were for good; for good until 1866. The Atheneum's records note that a Mrs. Ellen Waln Morris Manganaro, of Wexford, Westtown P.O. "a property adjoining the Cassatt place . . . knew all about the Cassatt residence . . . says that the country workmen still do too, having heard the name from the last generation who worked for Mr. Cassatt . . . Mrs. Manganaro says that Mr. Cassatt was not just a 'weekend farmer, but took it very seriously . . . he was a quiet, retiring man who got on well with all the country people.'" In 1861 this land was valued for taxation, at $2,960; one horse, $20, 2 cattle, $80, 1 carriage $20, a total of $3,080. (By 1864 it had become two horses, $80, two cattle $40, furniture $200, carriage $50, one dog, and that gold lever watch of his, a total of $3,330.)

Although Robert S. Cassatt, Gentleman, and onetime Mayor of Allegheny City, maintained rather lackadaisically a brokerage office in Phil-

adelphia, he took no part, as a former Atheneum librarian, now University Archivist, University of Pennsylvania, Francis James Dallett, one of *those* Dalletts, notes, "in civic or public affairs, and belonged only to the Atheneum, and not to the Philadelphia Club (which his two sons joined in the middle of the seventies) nor to the Union League, the Musical Fund Society, or the Philadelphia Society for the Promotion of Agriculture, the organizations which attracted so many of his wealthy business contemporaries."

Nathaniel Burt defines these institutions more bluntly. Of the Philadelphia Club: "bits of broken hearts litter the pavement in front of the . . . door . . . memorial to those who tried to get in and couldn't. More than any other single institution except the Dancing Assembly, the Philadelphia Club has stood and still stands as the Gibraltar of social order, defending the purity of Philadelphia blood-lines against the nouveaux riches." Of the Union League: "In Old Philadelphia circles it is understood that though it is very honorable and important, it is not really socially flawless [though] a great many Old Philadelphians belong to it." Of the Musical Fund Society, founded in the eighteenth century: "It was the ingenious thought of combining concerts and good works that made of the fund Philadelphia's most enduring institution." As for the Philadelphia Society for the Promoting of Agriculture: "It . . . is [first and oldest of its kind in the country]; only just, however. It was founded in February, 1785, and a similar society was founded in Charleston, S.C., in August of the same year. A close shave, that one."

Records reveal moreover that Robert Cassatt was dropped from his one and only membership, in the Atheneum—not properly a club at that—in 1869, for nonpayment of dues, "after due notice having been given repeatedly." It is fairly obvious that Robert "held himself above" belonging to it or to any of those other institutions so desirable to "his wealthy business associates"; perhaps with the Atheneum he was exhibiting his pattern of preferring to reject, rather than risk being rejected. If he had wanted to work at breaking into Philadelphia society he could have made it. His sons did. Men from remoter boondocks than even Pittsburgh have got into the Union League, if not the Philadelphia Club.

Robert Cassatt was, instead, a gentleman content not to struggle; who instead planted his ambitions upon the persons of his children. Children are an extension of their parents, and parents can, in any epoch, be observed going to lengths of selfishness or even cupidity quite incompatible with their private standards if it is "for the sake of the children." Robert Cassatt was not all that unaware; neither was he as self-centered as the smugness of his letters might suggest. He was one of those Victorian patres familias who—for all their propensity for drag-

ging up corners of tablecloths with their elbows, threatening delicate china whose fragments someone else will have to pick up—truly did live for their children, whether that was a good idea or a bad.

His incessant moving around is accountable for, when "the good of the children" is seen as its cause. Paris for their French, Germany for Aleck's technical education, the peace of West Chester as a surcease from the Continent, the country for fresh air and exercise—such motives are impeccable. There remains what it was he hoped for in all those moves into Philadelphia, in view of how soon he always got out again. An answer is supplied by the social (and financial) success in Philadelphia that did come to Gardner and especially Aleck. Robert's sons really did repay his ambitions, whether or not these ambitions were the real reason for his peripeteia.

The family was living in the country (post-office address Cheyney) when in 1861 Mary began going in to the Pennsylvania Academy of the Fine Arts. Her father too went in to his Philadelphia office, and it is easy to visualize them standing together on a country platform, in the high, fresh, early morning air, waiting for the train. The father wears a high-standing collar that props up the chin to his insufficiently-backed head; the bulky collar of his coat comes up high around it. His daughter, hair drawn high in the mode of the time, a fringe (as they used to call bangs) under her hat, wears long, flowing skirts. Women's dresses required more than one petticoat to hold them into the desired bell shape (an open bell in those days: only later did bustles alter the shape to a dinner bell's). Dresses themselves were stiffened with crinoline—no longer *a* crinoline, but the material, crinoline, or else buckram, lined the skirts, with, at the bottom, a dust ruffle. For a great lady, the ultimate in elegance was to cross a street without feeling the necessity of lifting her skirt, in sublime disregard of dirt.

Mary was not in those days a great lady, but she already had a great lady's determined look. She looked too eager to look great, and she did not look dissatisfied; on the contrary. She had done something new and daring for a woman: followed the road shown when instinct was diverted to art instead of biology. Much has been made of the remark her father made when she announced her intention of making painting her profession: "I would almost rather see you dead." His words hurt her, adoring him as she did; what he *did*, however, was supportive. As was ever his way, he backed this child of his, allowed ambition to burn within her breast, not his. He did allow Mary to become professional. In view of the temper of the times, in view of his own almost total incomprehension of art, it is to his credit that he did not stand in her way,

no matter what he may have said. He was one whose actions spoke louder, also more coherently, than his words.

Years later when Mary was a recognized artist and the crisis of her life had arisen over her relationship to Degas, the damper that her father put on the relationship cannot be said, either, to make him responsible for ruining his daughter's life. He had his own problems, his own pattern; he could not help being who he was. He could not be expected to have understood or liked Degas. That he would not have stopped her if she had chosen to do other than she did, seems likely because of his not stopping her from becoming a professional artist. If ruined her life was, she ruined it herself.

Back in 1861, however, no urgency about professionalism had arisen. Being an art student was miles from being a professional painter. Many girls from the "nicest" families in Philadelphia, Boston, New York, out West in Pittsburgh, Chicago, Buffalo, were "taking up" art, even entertaining the notion of the trek to Europe that was in the air—to study in Paris, Rome, Düsseldorf, or Munich. In studying art at the Pennsylvania Academy, there was no danger of being exposed to anything as questionable as mixed life classes. It was an acceptable thing for a nice girl to do, yet innovative and adventurous.

Mary had been planning to study art for some time, and she too was hostess to the new contagion, for by November 17, 1860, Aleck Cassatt was writing to his father, "In three years Mary will want to go to Rome to study, and by that time our vineyard would be in bearing and you could all afford to go and leave me here to work for you." The letter was written from Dalton, Georgia, where presumably those vineyards were; presumably another of Robert's short-lived projects that came to nothing. Aleck had already graduated from Rensselaer Polytechnic, and in his letter he strikes the closest to a rebellious or bitter note any child of Robert Cassatt's ever expressed. Indeed, he was moving toward the time when he would break away if only to become engaged.

Mary Cassatt's biographers have tended to feel how uninspiring it was for a girl of talent and spirit to have to draw from the antique— prescribed since the time of Colbert; to copy such dreary old masters as were left after the Academy's 1845 fire—for example, the enormous *Deliverance of Leyden* by Johann Bernard Wittcamp. The curriculum was not in fact all that dreary, in view of what was available. Beginning with drawing from antique casts, moving on to life class and then to making copies of any paintings at all, made a life that gave pleasure to anyone who lived through his eyes. The Academy's system was the same system, albeit more humble, as that used in European schools. Those painters who would be known as Impressionists—Degas, Renoir, Manet,

Monet—benefited from a similarly pedantic training in the technical aspects of draftsmanship and painting. Thomas Eakins, on his return from the Paris ateliers, threw out the class in the antique at the Pennsylvania Academy, instituting an all life-drawing curriculum; but even drawing from casts had, still has, its value especially if taught after, not before drawing from life. "Before students have drawn from life," asserted the late George Demetrios, sculptor and teacher, "they can't appreciate the beauty of the antique."

It is unrealistic to suppose that this pedestrian system never produced a great artist. Great artists obviously did emerge from it, even emerged (like Eakins, a great technician and perhaps America's greatest painter) from the Pennsylvania Academy. It is true the system could hardly inspire anybody, but it was not intended to inspire. It was intended to train in technique, on the theory that inspiration—if there was going to be any inspiration—must be self-generating. It is also true that to any artist, as to any child, it is an inestimable boon to have a background against which to rebel. There would have been no Impressionism if there had been no French Academy.

On the other hand, lack of training was the ruin of more talented beginners than talented beginners were ruined by training. An even obliquely representative painter was hamstrung who attempted a subject only to find himself unequipped to execute it. The early paintings of Degas reveal how he barely skirted the verge of failure. Degas, Manet, even Cézanne, even Picasso, had training in technique which then became theirs to use or to knowingly abuse. Mary Cassatt would not have begun to attract the attention of Degas in the Paris Salon, as she did attract it, if she had not known the grammar of art and its vocabulary: how to set up a figure anatomically, how to draw accurately, in perspective and foreshortening, how to choose, mix, and apply paint, how to prepare canvas, handle charcoal and pastel. Matter-of-fact equipment, and insufficient for getting beyond first base as an artist; but for want of these nails many a horse that might have been winged was lost. Conversely an untalented painter, though he may have indeed—like a voice—remained "fresher" without training, was never stronger, for lack of knowledge of what he was doing.

Verities reborn again and again in the history of art. "An artist has to train his responses more than other people do," said the painter Wayne Thiebaud in 1973. "He has to be as disciplined as a mathematician. Discipline is not a restriction but an aid to freedom. It prepares an artist to choose his own limitations . . . An artist needs the best studio instruction, the most rigorous demands, and the toughest criticism in order to tune up his sensibilities. And especially," warns Thiebaud, "an artist

has to be careful not to cut a coat to the measure of his own ignorance." Words that would have sounded wholly reasonable to the Impressionists.

"Mary Cassatt was not a very inventive painter, and could prosper only when she was surrounded by strong influences," states F. A. Sweet, a proponent of the theory that in the Pennsylvania Academy's curriculum, in America, Mary was wasting her time. Even if she had been in Europe in those years, however, Mary Cassatt had to be trained to find the Impressionists and, more importantly, she had to become—somewhere, anywhere—a painter the Impressionists could find. If one is to speak about "inspiration," about "the muse" (always represented for the male artist as a female figure), a woman artist's muse must, by psychological logic, be male; be Apollo. Mary Cassatt's muse was to find its mortal tenement in many "strong influences," but principally in Degas. In the 1860s she was not ready to recognize him nor he her.

For it needs to be added that the world of art is not only a place different from, though resembling, the physical world, and that not only are the artists who operate in it slightly different from the selves that go shopping or pour out tea (as is obvious every time an art connoisseur exclaims, say "Why, there's old Renoir!"; Lord Clark, entering an unfamiliar roomful of pictures, cried out at a red chalk drawing across the room, not "There's a Rothenstein!" but "There's Will!"). The language spoken by these personalities, in this world, though it does not use words, also grows with succeeding generations in the way French or English grows: adds new expressions, rejects old ones, invents new slang, finds old slang boring. One reason musicians began composing the new music is they got bored with composing the old. Not that the old was not good. Just that it had been done.

This language has to be learned by any beginning artist as children learn, with differing success, their mother tongue. In the 1860s those rules, as though of grammar, had to be acquired in order to communicate at all, not only with an artist's putative public, but with anyone he hoped to have for a compeer. Not to have respected those rules would have made a beginner seem ridiculous, a lightweight, not to say despicably pretentious. Talented art students, like verbal-minded children, are always quick at picking up their mother tongue—way ahead of the art experts who in any period are a little behind in fluency, never quite up on nuances, pounding the rostrum for usages that have already begun to seem passé. Only another artist can, so to say, speak art.

Four years of the Pennsylvania Academy of the Fine Arts filled a niche in Mary Cassatt's development. She sought it, she stayed with it, she graduated from it in 1865, and, in view of subsequent proof of her instinct for what she needed, there is every reason to think she needed

it and knew she needed it. Old photographs, Victorian engravings and pencil drawings, show the art school ateliers of the period: high north light in the background, students standing before their easeled drawing-boards, young ladies in long aprons to protect their bell-shaped skirts, men in their life classes even gone so far in unconventionality as to have taken off their jackets. The atmosphere compounded of charcoal-smudged, earnest young faces, of the model standing shivering on the model stand in the cold, wintry light, of the glow from the stove that was supposed to keep the model warm, the very look of the paper the students drew on—this was Mary Cassatt's atmosphere for those four years, as well as how the light fell on those faces by daylight and by gaslight; and how the early dusk crept on altering the aspect of everything, whether the roomful of students or of some huge, dark painting she might be engaged in copying.

There was an esprit de corps among the students, a special camaraderie existing only in art schools. Polite badinage with the model, squabbles over setting the pose and trying to get the model to hold it (models were understandably reluctant to take poses that strained their muscles, but those were the interesting poses); rests, usually for five minutes out of every twenty-five—some student had to be appointed to keep time or else, in their absorption in work, the students were capable of letting the model faint dead away from fatigue; a long rest for stretching the legs, in the middle of the morning: such a routine, usually building up to a contest when the best work was judged, made life pleasant because special. It meant having something of one's own.

Mary Cassatt enjoyed the friendships she made at art school, the closest with Eliza Haldeman, who wrote to her father in the course of 1861, "We have several new pupils, both male and female, but Miss Cassatt and I are still the head [of the ladies]." Another letter of Eliza's to her papa, the following year, reflects the pride felt within this special society: "We had some fun about a week ago. Miss Welch, one of our amateur students—that is to say she don't intend to become an artist," explained Miss Haldeman, politely scornful, "wanted to cast the hand of a friend of hers, a gentleman. So they came down one morning and commenced. As she did not know the first thing about casting, you may know how she proceeded. Miss Cassatt and I went in to look at her, and asked Why don't you do this? How will that come out? You have too much undercasting there . . . So she finally found it would be as well to have some assistance, introduced us to the gentleman, and asked us to help her. Which we did, making an excellent cast, and flattering the specimen of Genus Homo exceedingly. His experience of artist life was so pleasant that he begged if we were willing to send for a photographer,

and have the whole scene taken just as we were. We consented, and got Mr. Cope's [Philadelphia Cope] permission to go in the galleries, and had it taken there, with the Gates of Pisa or Paradise for the background, and the little bust of Palm Springs and another on each side. [In the photograph] Miss Welch had a hammer and chisel, knocking off the plaster. Miss C. had the plaster dish and spoon which we had used before. Inez Lewis [Philadelphia Lewis?] was knocking also. I had a spoon helping Miss C. . . . Dr. Smith, the owner of the hand in question, was behind. It was an excellent picture, and he is going to present us each with one when they are finished."

Besides its information, Eliza's letter is an illustration of how inept painters are verbally. It was necessary to edit the letter to make it clear Miss Welch did not spend her entire afternoon knocking off plaster. Painters are often as poor at making themselves clear verbally as the verbal-minded are at grasping the way the painter's mind works. Eliza's is a visual letter.

The difference between the two modes of perception accounts for a myriad of misunderstandings over the centuries. Mary's future colleague, Édouard Manet, painted his *Gare St. Lazare* from something other than verbal ideas. Mary's future friend, the Miss Elder who when she became Mrs. Henry O. Havemeyer bought, with her husband, this picture for their collection, wrote of it in her memoirs, "You ask me how we could have bought such a portrait? . . . What caused us to forgive Manet that we should never see the child's face? . . . You tell us that the child is not even pretty and that the mother is positively ugly . . . that even the doggie is unattractive . . . I answer, art, art, art . . . You must see with Manet's eyes and comprehend how he can make a chef d'oeuvre out of a homely story." For all Manet had not the remotest notion of making a chef d'oeuvre or anything else out of "a homely story"; for all he would probably have reacted as a modern reader does to "art, art, art" and "doggie," Mrs. Havemeyer had more of a glimmer of the difference between his kind of seeing and her own—more different than night and day—than many "art experts" of her day.

In this age of post-objective art the proof of a painting is still in the seeing. Harold Rosenberg says, "The artist and his audience confront each other directly. To be complete, the artist's act requires to be seen." The artist, that is, today demands his public see him seeing. The artist begins life visual-minded, but so do some inventors, some mystics. The minds of inventors and mystics, however, teem with verbal associations; whereas to Impressionists, for example, the object and the way the light fell on the object constituted all that mattered on the ever-changing screen of their minds. It would be hard for the verbal-minded to accept as existing, let alone conceive of, a screen so void of words, so crowded with sights; but

anyone who has lived around painters can, by an effort of will, free his mind of associations long enough to catch a glimpse of it.

If a non-painter will assemble the meager group of objects that have impressed themselves on his vision in the last half-hour, strain out of them all meaning (he won't be able to, entirely), and imagine that these objects, taken together, do say something, though not in words, which, if he were a painter he would apprehend—he may catch a glimpse of the language of art, tantamount to hearing with one's own ears Chinese being spoken when one does not understand Chinese.

One reason why "serious artists" (a manner of speaking, because the most serious artists are often the gayest) generally refer with a certain contempt to illustrators is that art is not illustrating anything, at least in the outside world. It illustrates that it *is*. The greater part of those viewing a given exhibition of pictures, including some art connoisseurs, assume the pictures to be illustrating at the very least verbal ideas, and meanings entertained by the artists beforehand. It is true, there have been painters who painted verbally expressible ideas (say, Daumier) but in their work there were other elements also, that escape the earnest searcher for a story. With great painters throughout the ages it was generally a matter of indifference what their subjects "meant." What did matter was shapes, colors, the relation of objects to adjoining objects, the values; of lighted objects as against those less lighted. How the object looked was its story and its only story. A twentieth-century painter, Leon Kroll, used to say, "Great paintings have always been basically abstractions."

They are abstractions because they are founded upon something in the eye of the painter which sees truth the way Beethoven heard truth. "These truths [seen under mescaline] that underlie our known world," writes the British oculist Patrick Trevor-Roper, "and which we habitually ignore, are indeed the stock in trade of many great painters who have not needed mescaline to disclose what is there . . . The brilliant and contrasting shadow-colors [of mescaline-induced states] have been deployed by Impressionists and Post-Impressionists for nearly a century. The heightened sense of perspective that gives a three-dimensional quality . . . has been utilized at any rate since the Renaissance by painters like Bronzino . . . The emphasis on contours and structural content recalls particularly some contemporary paintings . . . The jazzy repetitions and the whirling movements of the images recall the vorticism of Wyndham Lewis." To try to look as a painter would look at, say, an octagonal white thing (a jar) filled with sticks (pencils) is to see simply the way the light falls on the varying planes, how the thing merges into another thing (a table) and moreover to derive wonder and pleasure from so doing. This is as close as a non-painter can get to what is sometimes called the innocent eye.

The notion of the innocent eye, asserts Trevor-Roper, is diagnostically accurate. He further cites a painter, Pieter Brueghel the Elder, as "arch-diagnostician of eye-ailments"; Brueghel himself suffered severe eye disease. He painted in the figures of his parable of the blind, the oculist reports, recognizable cases of five eye ailments with names like "ocular pemphigus with secondary corneal opacities." Lest such a diagnostic faculty be laid to mere photographic representation, there is also the story of how the (Old Philadelphia) psychiatrist Weir Mitchell went to an exhibition of Sargent's paintings, which included a portrait of a patient of Mitchell's who had died since it was painted. After studying it for a long time, with much care, Mitchell said, "Now I understand for the first time what was the matter with him." Not all visual-minded people by any means turn out to have the innocent eye, but painters with the innocent eye all began being visual-minded.

The work of the great painters looks new as on the first day of creation on account of this seeing without association or meaning. It is like a turning back to vision's sources that antedates *any* kind of mindedness, when a baby sees the world for the first time. Because it is contained and controlled by art, it is not a regression to infancy; rather, along with its subjectivity goes a greatly heightened objectivity. It would be interesting to know whether there is any substance, in the painter's body chemistry, like mescaline, which drug, Trevor-Roper tells us, causes "an interruption of the 'association-fibers' in the posterior lobe of the brain, which molds the unconscious cerebral image of the seen world into the conscious percept . . . Mescaline thus allows us to see a far truer image than the ordered stereotype that our association-fibers normally permit us to apprehend." What is it that interrupts the painter's association fibers? Is it, as with mystics, his discipline? The artist, as though naturally psychedelic, does not require a drug, which does suggest a certain psychic split.

Not inconceivably the painter's childhood memories of feeling different from other children, whatever may then have seemed its reason, are related to the difference in his mode of perception. To a child any kind of difference is a liability. To make an analogy between visual-minded and verbal-minded, just as the poet is one early wounded by words (in despite of "Sticks and stones . . .") yet through them enabled to heal himself, so the painter's wound is to the eye.

"Repetitive dreams in color," says Trevor-Roper, "are said to be related to traumatic events . . . and . . . creative artists achieve mastery simply by re-projecting this scene in its associative colors . . . [Color in dreams] is more often mentioned spontaneously by women and by neurotics; in fact, it is reckoned that since we rarely take notice of colors in daily life, since we are essentially concerned with what things mean for us, color is not im-

portant in our conceptual thinking and light sleep." The theories of one analyst, Alfred Adler, concern in part inferior organs whose weaknesses, reflected in the psyche, produce not only neurotic symptoms but cultural products, through what Adler called the masculine protest of the ego.

The eye of a potential painter can be viewed as inferior, abnormal, if what is average is taken for the standard of normality. A child caught saying that what everybody knows is a green field is purple (in shadow, it is) would for example get teased; get called queer. In view of the pictures Mary Cassatt later painted, her feeling of difference may have gone even further back than the vicarious suffering of her parents' encounter with Philadelphia, to an inherent trait interpretable as a weakness (also in view of what happened to her). Eye abnormality, however, never made a painter. What makes a painter is living in and by his eyes. Nobody else in Mary Cassatt's immediate family seems to have been visual-minded.

The years Mary spent at the Pennsylvania Academy were not wasted. The impatience art historians impute to her is their own. They want her to hurry out of that certainly banal milieu, and on to her best work, as is only right for them to want. For Mary herself, the Civil War years passed, as time does pass for young people, slowly. No doubt she complained bitterly of the school; high-spirited students always do complain of school, especially art school. Increasingly, however, she could feel, watch, the emergence of visual powers within her, under the control of art. They had been growing for years, like the pearl the grain of sand begins. Now she could do things other people, even other art students, could not; she was the head of the girls. The sureness of herself, that Eliza Haldeman's letter describes, was the assumption of a natural superiority.

When a young artist's feeling of superiority does begin to surface, it feels like one of those quasi-miraculous reversals-into-the-opposite noted by William James in *Varieties of Religious Experience*. The old sense of being unpleasantly different begins to be something superbly pleasant. His art feels to him not egotistical but the very redemption of ego—the bad eggs of his childhood's basket transformed into golden ones; his old resentments turned to delight. The feeling is the measure of the artist's self-recognition. Those who do recognize themselves, moreover, recognize each other. Schools of art (not art schools, in this case) are like saints in a communion where art has given the solution to the insoluble.

Artists, in the broad sense, are even united by a mysterious awareness of arts other than their own. This is synaesthesia, the spilling over from one of ·the senses to another, which caused Rimbaud to see words in color, and made Rimski-Korsakov color each of his musical tones differently. It is what makes the writer able to guess at the painter's truths, even though he approaches them by analogy, with the meanings and symbols of

his own craft. The painter's indifference to meaning, the unsentimentality of his vision, even bring him close to the creative scientist.

In the photograph that Eliza Haldeman describes, the four girls with the young doctor are gathered around a high armature-stand, on which sits the cloth-wrapped plaster cast of his hand. Though the skirts of all the girls sweep to the floor and their hair is drawn demurely over their ears, their sloping shoulders droop meekly, Mary Cassatt looks different. She has the same sway-backed bend to the waist then in fashion, but her neck's bend does not suggest submission. She appears bigger, taller, in some way more conspicuous than the others. As she stands holding the plaster dish and spoon she is overtopped only by the cock-of-the-walk in the background: the luxuriantly whiskered doctor, gazing over the heads of his assembled hens with the air, ubiquitous in gentlemen of his day, of a Civil War general.

Mary Cassatt displays, too, an elegance the others lack: a facet to her personality that was to characterize her manner and dress until almost the end of her life. How upstanding, how independent she looks! Her nature took to superiority like a duck to water. She always had warm friendships, and family feeling to a fault, but it was on that mysterious, indisputable sense of superiority that she operated for the rest of her life. And how innocent and provincial she looks! Once having got her foot inside the door of art, she ever after remained in its province, even when blindness stopped her practice of it. In 1865, however, the only darkness in her life was the past: dead as a doornail. Ahead lay art, life, Paris.

FOUR

On April 18, 1866, Robert Cassatt inserted an advertisement in the West Chester *Village Record* to announce the sale of farm stock and furniture from his place at Cheyney P.O. The house and land was sold on April 23, for $10,000 to a Mr. Addinell Hewson (Old Philadelphia Hewson). The Cassatts then went abroad, to settle Mary in Paris, but they were soon back in Pennsylvania, where Aleck's life, too, had reached a turning point.

In autumn of 1867, at the time he was stationed as branch superintendent of the Pennsylvania Railroad at Irvineton (where many well-off Pittsburghers spent their summers in the cool of the mountains) he became engaged to Lois Buchanan, niece of James Buchanan, the Democratic President who directly preceded Lincoln. If that sounds an important match, one need only turn to Sidney George Fisher to find how an Old Philadelphian felt about the Executive from his own state. "The incompetency and entire want of principle of Buchanan," Fisher observed in 1858, a congressional election year, "have been fully shown & he has been signally defeated in his own state, at the first occasion after he was made President when an expression of public sentiment could be made. The probability is that the same sentiment will be exhibited throughout the North whenever an opportunity arises and that he will break down in disgrace before the end of his term." (He didn't.) Samuel Eliot Morison sums him up as being able; of lowly origin but ingratiating of phrase; a good man, "tearful and prayerful." One Old Philadelphian referred to Lois as "that little nobody, a niece of President Buchanan."

Yet it is typical of Aleck's strong, positive, triumphant personality that he managed to win Lois at all. Difficult was the word for Lois while she was courted. Even after they were engaged she kept Aleck on tenterhooks for months over announcing it. Before a formal engagement, of course, was the last time a young lady could hold the reins in her own hands. Although, as they used to like to say about saying Yes to a proposal, "the citadel surrendered" in October, when Aleck took his fiancée back to Irvineton to meet his parents and sister Lydia, it was almost a year before, on August 31, 1868, Mrs. Cassatt could write a letter to Lois that said, "We have just had a visit from Aleck who tells me that after all the delays and impediments which have postponed the announcement of your engagement, I may now address you as *almost* one of our family. I hope

you will now do your best to enable me soon to call you altogether one of us. I am selfish enough to wish for this on Aleck's account, who I know will be so much happier and more comfortable when married and who really ought to be settled down soon. Now won't you be a very good girl and arrange so that I may soon have the pleasure of wishing you all the happiness I dare say you both anticipate in your own house? Also that I may be able to say that I have three daughters instead of two . . . Mary in her last letter says she is only waiting for permission to write to you. She congratulates him heartily." (Brides were never, never congratulated; they were felicitated.)

On November 25, 1868, the young couple was at last united at Oxford, Pennsylvania, by the bride's father, the Reverend Edward Buchanan, an Episcopalian minister with rigid Presbyterian forebears, whose father and the President's had kept a store. His wife took her uprightness so seriously as to chide Lois for what she considered "chasing after" rich Pittsburghers who hadn't yet called, once the young couple were settled in Altoona (within Pittsburgh's ambiance) where Aleck was transferred by the Railroad in 1867. The letter in which he told his fiancée the likelihood of the transfer had added, "Father and Mother are thinking of moving to Philadelphia. They certainly will if I am transferred. Gard [his brother] will be through that school by spring and intends going into a Banking House in Philadelphia and Mother would of course like to be near him. I don't know why, but Gard has a great fancy for being a banker, and does not want to be a Railroad man at all, he says."

No family could have welcomed a new member more cordially than the Cassatts; but "one of them" Lois never truly became. The relationship took off to a bad start when for some unknown reason Lydia failed to receive an invitation to her own brother's wedding—a slight to any Victorian; to gentle Lydia, undying mortification. Lois' thorny personality defeated herself, quite as often as it did other people, and an irritability she shared with other women of her generation kept her on the outs with people who only wanted to be friends. Lois' granddaughter, Mrs. Thayer—who loved her—remembers her as "a very prickly person."

Between the lines of Lois' diary it is easy to hear an emancipated woman of the future screaming to get out of that conventional, prudish, inhibited, huffy, pathetic creature. She had sensed, as an animal sniffs danger, that once she said the word and married, all hope for consideration of her own tastes was over. Not that Aleck was unreasonable or demanding by Victorian standards. Victorian standards conspired to make all husbands demanding. It was biology—instinct—that, in effect, was demanding.

Aleck did everything to build a bridge of affection between his wife

and his family, including Mary, of whom he often wrote to Lois while they were engaged. "Mary was always a great favorite of mine, I suppose because our tastes were a good deal alike. Whenever it was a question of a walk, or a ride, or a gallop on horseback, Mary was always ready," he writes innocently on November 27, 1867, "so when I was at home we were together a great deal." On January 16, 1868, "Mary's [letter to him] I will show you when I see you. I want you to know her, and as she is likely to remain in France another year, you can only become acquainted with her through the medium of her letters." August 24, after Lois consented to the announcement: "I also had a letter from Mary today she sends her love to you and wants to know what has become of that photograph of you that I was to send her. She asks me whether she may not soon write to you. I shall tell her that she can do so at once. She has sent home two of her pictures. I expect they will be here in a few days; and talks of painting another, subject *Mariana of the Moated Grange*. The lines always struck me as very pretty. Mary is an enthusiastic admirer of Tennyson, and she always said she would paint a picture of Mariana." It seems a curious choice of subjects to have interested the energetic and independent Miss Cassatt, for the refrain to each stanza of Tennyson's ballad runs, "'My life is dreary. He cometh not,' she said. She said, 'I am aweary, aweary. I would that I were dead.'"

From Lois' point of view, as her prison gates swung shut, it is easy to see how that galloping on horseback, that remaining in France, that picture-painting would do anything but endear Mary to her. The very earliest letter of Mary's to Lois that is preserved is written August 1, 1869, and compounded the antagonism. Dated Beaufort sur Doron, Savoie, France, it reads:

My dear Lois,

I am here with my friend Miss Gordon from Philadelphia, and we are roughing it most artistically . . . although my friend calls herself a painter she is only an amateur and you must know we professionals despise amateurs, so as Aix was too gay . . . we came here. The place is all that we could desire as regards scenery but could be vastly improved as regards accommodations, however as the costumes and surroundings are good for painters we have concluded to put up with all discomforts for a time . . . We are just on the borders of Italy, we took a mountain excursion the other day and waded up to our ankles in snow, but were rewarded by a magnificent view of Mont Blanc and the St. Bernard, however we think we will rest content with that and not try it again as we had to walk some twelve hours.

Now my dear Lois I expect to have a long letter from you soon, in-

deed I don't know whether it is indiscreet but I expect a very very interesting piece of news from Altoona before long, it will give me sincere pleasure to hear that it is all satisfactorily over and I may venture to congratulate you beforehand [Upon the birth of babies, one did congratulate ladies] for my part I want a nephew. [She got one; Edward Buchanan Cassatt was born August 25, 1869.] Give my love to Aleck and believe me, very affectionately your sister,

Mary S. Cassatt

Lois never believed her anything of the kind. To her, all that about roughing it sounded patronizing and superior, and "we professionals" struck a note unendurable to one bent under twin yokes of wife and motherhood. To her tortured personality the life of the ebullient and increasingly fulfilled Mary stood out in unbearable contrast. It always would be hard for Lois to be reminded of this mysterious thing, artistic talent; the key to so much freedom, the escape from so much suffering. Lois' Presbyterian-minded Episcopalian family had brought her up to consider art (including opera and the theater, which Aleck loved) only slightly less suspect than cards, which country people called "the devil's books." For many years she resisted having her own portrait painted at all, and even Mary—"in the family"—was only allowed to paint it once.

Executed in 1883, after Lois had been married fifteen years, that portrait shows a tight-lipped lady wearing a blue evening dress and a thimble, as she works on a tapestry. It possesses little of the allure of Mary's other paintings, in this her most delicious period. The sitter looks rigid; doubtless was. The picture hangs in the dining room of the present-day Lois, Mrs. Thayer, although Lois specified in her will that it was to be destroyed. By 1928, when Lois died, however, the Cassatts were beginning to know enough to ignore such a direction. As other Philadelphians say, the Cassatts brought their Aunt Mary's pictures down from the attic one story at a time. Mrs. Thayer tells it on herself that she had no notion of the value of what she owned until the conductor Leopold Stokowski, dining at her house in the course of his long association with the Philadelphia Orchestra, asked how she came to own so many fine paintings. Finding she didn't know, he insisted she look up their history before he came to dinner again. They turned out to be mostly Mary Cassatts, or else bought by her.

"I had never known my Aunt Mary well," Mrs. Thayer adds, "because of the feud between her and my grandmother [who brought the younger Lois up]. My grandfather, Aleck, was first engaged to somebody else; not Lois but her sister. Perhaps that had something to do with it all." Lois' sister, Henrietta, went on December 10, 1870, to see the Cassatts, who were then living in Philadelphia; but related of the call that Lydia was too un-

well to come down, and Mary—home temporarily from the Franco-Prussian War—out. "Mary is something of a genius," Henrietta added. Genius? It was too much. What was this thing other women, just as intelligent and much more dutiful, didn't have, that an artist should get all the praise? Throughout Lois' letters and diary runs the undercurrent of misunderstanding and resentment.

Aleck's wife is worth dwelling on because Aleck—in fact both Mary's brothers—was such an important part of Mary's makeup, and not merely from their example of activity, though Mary had followed that example from the time she was a tomboy riding horses at Hardwick. She felt with them and, through her feeling, *was* them, through that tendency to reproduce whatever she felt for, which made her a painter. When, years later, first one brother, then the other died, great pieces fell out of Mary. When her sister Lydia died, she was able merely to feel grief and sorrow for Lydia herself—for a woman's patient suffering (something Mary was determined not to experience herself) who had not even had the prize of a child to show for it. Mary's feelings were like those of a young boy with bits of girl peering through. The jealousy of Mary that Mrs. Thayer remembers in Lois was one more fruit, a sour one, of Mary's shaking off the standard pattern of womanhood.

After the Civil War, however, American girls were more and more going abroad to study art, more and more to Paris; until by the turn of the century the trend was almost a mass movement. In 1921, an old, blind, solitary Mary Cassatt received with acerbity at her Paris apartment young Miss Anna Ingersoll (Old Philadelphia Ingersoll) with the advice that the Rue de Rennes on the Left Bank was no place for a nice girl to be living. Anna had no business studying art in Paris anyway, she said; she ought to have stayed in America, not come over to degenerate France. When Miss Ingersoll said she was copying Cézannes, Miss Cassatt showed no interest (although she had been one of the first to buy Cézanne's paintings, only selling them to buy her real admiration, Courbet). Instead, she pulled out a copy of a Frans Hals she had painted in Holland in 1873, and made it clear how much more stock she put in students copying the old masters than their contemporaries.

That much of the queerly contrary-minded old Miss Cassatt was present in the young Mary who, full of hope and joy, first came to Paris. She, even more than most students, spent time at the Louvre, copying. For young men this was often a way to eke out meager funds by selling the results to voyagers who wanted old masters but were unwilling or unable to pay the price of originals. For young ladies with family support, it could be a mode of learning to paint by affinity. Just as the young painter recognized the like-minded among her peers, she could recognize like

vision among departed saints in art. Learning by copying did develop personal taste, style, in a young painter, more than training under some one master who asserted his own manner and technique. The weakness of copying could be that it was so much a matter of affinity as not to develop other, more reluctant facets of the whole painter.

The varied real estate activities of Robert Cassatt at this time suggest that when their Mame went to Paris to live, the Cassatts went to get her settled. In the next ten years they returned often, to visit and to survey her way of life; often Lydia came too. When her family was not in Paris, Mary lived with family friends. The ever-increasing influx of American lady students did not bring with it any relaxing of chaperonage. If the Victorians are viewed as they were, those parents may be excused their alarms and excursions, for the old masters they saw, if only in reproduction, in more and more American homes depicted scenes to alarm any parent. It was true their student children insisted art was different from life, but those subjects *had* been visualized by those painters. No mother would want her daughter alone with a man who visualized scenes even faintly resembling, say, Titian's, let alone Manet's.

Often young American ladies had no contact whatever with the French outside the ateliers. They lived with friends or friends of friends; they were chaperoned if they went out in the evening. It was a truism that a girl from Boston could study in Paris for years without making a single friend not from Boston as well. The same was almost as true of nice girls from Philadelphia and Chicago. Letters of one young lady-student of the period reveal that to move from the Paris apartment of one set of family friends, to live at the apartment of another set of family friends, she had to write for and to receive permission from her father in America: a minimum of two weeks each way.

In fairness to the parents it has to be added that their daughters by no means wanted to lunch naked on Titian's—to say nothing of Manet's—grass, either. It was not wholly fantasy that in Victorian Paris an unprotected girl could fall prey to the unscrupulous. Henry James, with the character of his American, Christopher Newman, exhibits the ruin wrought by Parisians on a middle-aged, able-bodied male innocent. What might happen to a young American female at the same period was not pleasant. The wonder is less that American girls lived such a sheltered life in Paris than that their parents allowed them to come at all. That ancient city, compact of fascinations, electric with life, was charged throughout with the unspoken, unrecognized influence of sex; to an American girl, unspoken and unthinkable. Unthinkable even to many young American men, who, in the nineteenth century, were given to promising their mothers to keep pure for their wives. For a well-bred girl, Paris implied temptations so formida-

ble that they automatically ruled themselves out. It would have been inconceivable that a Mary Cassatt should "fall."

What the Americans were after was not naughtiness; it was art. Art was more and more finding its focus in Paris, where it remained. The young girls who descended on Paris were like the young Middle-Westerners who descended on New York in the 1920s: they were seeking something larger, freer, truer to a dimly sensed reality than existed at home, but, for those girls, not in life; in art. The Paris influx was a genuine movement toward liberation, that for many remained within the hermetic vessel of a symbol.

Mary was a special kind of student. More gifted and less frivolous than her compatriots, she was a rare but already-recognizable type, the young woman artist who scorned the biological fate of her sex and was indifferent to "attention." Art had received the full force of Mary's strongly emotional nature when it was deflected from instinctive goals. Letters from her family reveal they quite realized she was not interested in the pomps and vanities, but it was not merely for this reason that they trusted her. People used to say "trust," when their daughters did not attract beaux. They trusted Lydia, too.

On her own in Paris as much as any girl in the 1860s could be, what Mary went in for was men friends. She preferred men's society to that of women, although Eliza Haldeman, who preceded her to Paris, did remain close. The long, easy association with her brothers set the pattern for easy companionship with male art students, among others Walter Gay, later a well-known illustrator, and Alfred Q. Collins, to whom she presented some small studies in oil. Having felt with her brothers, Mary could feel with these friends; see art and its problems from the man's point of view. It was this kind of feeling-with that led people to imagine she had "a man's mind." Mary's paintings in this period include not only sentimental oil paintings and pastels of children, but some crisp, charming small landscapes with young women, sketching or sitting on the grass, that bring to mind the letter to Lois telling about staying, with Miss Gordon, in the Savoie.

With the crisis of August 1870, Mary was forced back to Philadelphia for one of her always reluctant returns: the pattern of escape, set in her father's footsteps, was firmly established. She was determined to remain there only for the war's duration, and to spend as much of her time as possible painting. From that duration survives the promising study *Baby Boy Wearing a Bib*, which shows she was already interested in painting babies, though not yet with their mothers, and the painting of the Cassatts' domestic, Mrs. Currey, turned up by an art student many years later in the

attic of the dark lady, the painting with the start for a portrait of Mr. Cassatt gazing out upside down from the same canvas.

Also attributed to these war years is a portrait of that first baby of Lois' who turned out to be a boy, signed "Eddie/from/Aunt Mary." More than one thing is strange about the portrait. Dressed in the height of Lord Fauntleroy splendor in a dark-red velvet suit with white lace ruffles, sash, a velvet hat over long curls, Eddie appears, doubtless was, deeply oppressed; but he also appears at least five years old, which, from his birthday, August 25, 1869, he couldn't have been. His daughter, Mrs. Thayer, was always told her father was between four and six when it was painted, but the principal authority on Mary Cassatt's work places it in 1872, making him three. Purely as painting, the picture goes to show what a lot Mary still had to learn about rendering children. It was one coat she cut to the measure of her own ignorance.

In the autumn of 1871 she and her mother went to Pittsburgh to visit relatives. Two of the cousins, Minnie and Aleck Johnston, took Mary with them on a trip from there to Chicago—head on into the great Chicago Fire. Mary had brought some pictures with her, hoping to make Middle-Western sales, but, though the baggage they brought was saved, the pictures were lost. Her brother Aleck's reaction to *which* was lost should not surprise, only enlighten: "I am glad," he wrote to his "dear little wife" on October 12, four days after the fire, "they got off so easily."

The Aleck Cassatts were just then on the point of leaving Altoona and moving into Philadelphia; they took up residence at 2035 Walnut Street in December. The following year they moved to 2030 DeLancey Place—a way-station to an eventual Rittenhouse Square house—and bought a large tract of land in Haverford where they built a country house, Cheswold. Unlike his father's hurried forays into Fortress Philadelphia, Aleck's entry was something of a triumph. The sacred Philadelphia Assembly (admission to which was supposed to be strictly hereditary in the male line), founded in 1748, attended by President Washington, its only rivals Charleston's St. Cecilia and Baltimore's Bachelor's Cotillion, yet carries on its rolls the name of Mrs. Alexander J. Cassatt as a Patron as early as 1870.

In the early seventies the Pennsylvania Railroad built the Bryn Mawr Hotel, an immense Victorian structure, to attract settlers and summer people to this newly developed stretch of its Main Line. Among the earliest visitors, says J. W. Townsend's *The Old Main Line*, were "Vice-President Cassatt's parents and artist sister, the elder Mr. Cassatt was a 'gentleman of the old school,' tall and dignified, dressed in summer in an immaculately clean white linen suit." Aleck was already considered a colorful personality. In the early seventies, a free-wheeling decade, he and some friends bought up some fifteen miles of the Lancaster Pike between Bryn

Mawr and Paoli and macadamized it, keeping it up by charging a toll, to accommodate the carriage-driving which was one of Aleck's favorite sports; he often drove a coach and four. Noting that the Pennsylvania Railroad "has always been a very Proper Philadelphian enterprise," *The Philadelphia Gentlemen*, by E. Digby Baltzell, reports Cheswold a show place of Haverford, along that Main Line where "all presidents of the Pennsylvania Railroad, since George B. Roberts, have lived"; Nathaniel Burt says Aleck was, "as bon viveur and connoisseur of horse-flesh . . . embraced by society with open arms . . . a model of the kind of out-of-towner Philadelphians love" (though, naturally, an out-of-towner forever). Race horses, and the highest of high living, were now added to the cross of wickednesses—dancing, opera, theater, picture-painting—that Lois had to bear through marrying into the Cassatts. For Aleck the battle of Philadelphia was all but won; he remained calm, and, as Burt observes, casual. Mary could have accepted what was a family victory, but she always had to fight her own battles her own way.

If, however, Aleck really was Vice-President of the Railroad when Mary visited the Bryn Mawr Hotel, it would mean two things. It would mean she went there not earlier than 1874, for only then was Aleck made a Vice-President (a third one, to begin with), and that she had thus made another return to Philadelphia. She certainly sailed for Europe in 1872. Any 1874 return is undocumented, except for that portrait of Eddie Cassatt. If Mary did go in 1874 to the Bryn Mawr Hotel it would explain why the little boy in the picture looks five and not three.

Not later than 1872, as soon as the conclusion of the European hostilities, Mary Cassatt quitted Philadelphia for the world of art, this time in Italy. Italy's most important effect on her was the influence of Correggio in his home city of Parma—built all of "Veronese rose" brick, except for the twelfth-century octagonal Baptistery, incredibly sophisticated in pink marble. The dome inside the naïvely reverent eleventh-century Cathedral had been frescoed by Correggio with an ascending Virgin surrounded by flying infants; the dome of the fifteenth-century Church of St. John the Evangelist with a flying, receding Vision of St. John of Patmos. Other Correggios that used to be in the churches and the monastery have been removed to Parma's museum, where they can today be viewed to incomparably better advantage—even though those dark domes can now be electrically lit; but in Mary's day she had to get up into the highest choir galleries to see anything at all.

From Correggio she learned how to paint babies. He was an affinity: across the centuries she recognized him as one who felt as she did. Stendhal, who not only wrote *La Chartreuse* in Parma, but lived there, wrote, "Correggio combines forms more grandiose, perhaps, than Raphael's, with

a suavity and tenderness no painter before him had achieved. He wished to charm in every possible way, and even before appealing to the soul he wishes his pictures to gratify the eye." To all of that—tenderness, charm, the eye gratified before the soul—Mary Cassatt was the direct heir. Such an exchange across time and space could be called a dialogue except that it is in another language, the one the visual-minded speak. The architectural historian William B. O'Neal, hearing that Mary Cassatt studied in Parma, exclaimed, "Of course! Those flying cupids of Correggio's—they're Mary Cassatt's kind of babies" (and indeed, Correggio's are the most flesh-and-blood, down-to-earth of little angels). In like manner, when Edgar Degas, with his friend Tourny, visited the 1874 Paris Salon and viewed the portrait called *Ida* by a Mary Cassatt he had never met, he in turn exclaimed, "C'est vrai. Voilà quelqu'un qui sent comme moi."

"It's true. There is someone who feels as I do." Correggio felt as Raphael felt and as Mantegna felt. Four hundred years later Mary Cassatt felt with Correggio. In Correggio were aspects, noted by the Italian critic Adolfo Venturi, of fascination with effects of light, as in the Ascending Virgin in the Cathedral dome; his grasp of chiaroscuro (literally, the clear and the obscure; in short, light and shade) and the amazing effects he achieved through light playing upon color. Now, amazing effects of light playing upon color became almost the whole concern of Impressionist art. In 1872 and 1873 Mary Cassatt did not realize she was an Impressionist; simply, by instinct, she was training herself to be one.

For Correggio another affinity was with Leonardo, whose discoveries in the field of aerial perspective and the gradual diminution of color values as they recede were, in the supremer artist, a way of expressing an intellectual ideal. Although, as Venturi points out, Correggio did not deny himself the fruit of Leonardo's discoveries, he "treated as ends what Leonardo used as means." Mary's affinity was with sensuous Correggio, not with Leonardo. Only much later, when she had turned to Japanese-inspired dry points and aquatints (using the knowledge of process she learned in Parma), can her work be said to express a sort of intellectuality.

Mary Cassatt's nature took from Correggio exactly what she needed; a step beyond "becoming" her parents and her brothers; an individual acquisition for herself. Art experts sometimes speak as though influence were a weak thing—suggestibility, lack of center. On the contrary influence and being influenced suggest that the artist's deepest nature plunders the field of art for private and inscrutable requirements. Even an artist in real life generous and tenderhearted—and Mary was both—can be, in this ravishing process, relentless; he has to be. To take, to possess, is the way the artist grows, in that element which, to him, *is* life.

It took Mary Cassatt a long time to find and take what she needed.

F. A. Sweet observes that even by 1877, when at last she met Degas, she had not yet "evolved a mode of painting in any way personal. She deliberately chose the long and difficult way . . . Above all, she felt that a painter should immerse himself in the old masters . . . study, copy, emulate." Avoiding the ateliers "kept her from becoming set in her ways at an early age, but . . . it took her years to master the technique of painting." Nevertheless this process was anything but timid or hesitant—it was not that kind of uncertainty. Simply the pearl, nacreous and hard, which served Mary for a center, was growing, and Correggio, in Parma, was there to be plundered.

The paintings of Mary's which survive from the Parma stay include *The Bajadere* (also called *Bacchante*), still academic, and proving that she had not yet found her eye in the sense that a poet finds his voice. Besides Correggio, she studied Parma's other Renaissance painter, Parmigianino; and also with Carlo Raimondi, head of the engraving department at the Art Academy of Parma. Raimondi's own manner was dry and conventional, nevertheless to him she owed the sound technical training evident in her later graphic work, mercifully without Raimondi's style. In gratitude she inscribed a painting she gave him, "à mon ami C. Raimondi."

All this sounds and was splendid in terms of Mary's emergence from studenthood into being an artist, but it is easy to forget at what a price such freedoms are won. Years later Mary told Mrs. Havemeyer, "I felt I needed Correggio and I went to Parma. A friend went with me. She did not remain, but I stayed there for two years, lonely as it was. [So she *did* manage to live alone.] I had my work and the few friends I made. I was so tired when my day was done that I had little desire for pleasure."

Old Parma is one of those small Italian cities which, for the English-speaking, evoke Shakespeare. One can readily visualize *Romeo and Juliet* being enacted in its streets. Its magnificent pink brick palazzos have massive double doors, closed, secretive; occasionally one is left open, and affords a glimpse of alluring courtyards, leading back into still inner courts, to some eventual heart of the house. For the foreigner, it would not be an easy heart to reach. Although the Parmigianos are noted throughout Italy for their gentle and courteous manners, loneliness in Parma would be inevitable. How ever to meet anyone? At best a visiting compatriot might arrive bringing letters of introduction. In 1872 and 1873, it would be all very well for a young woman to exchange fragmentary Italian with other residents of her pensione, but opportunities for real entrée would not have been available. In view of Mary Cassatt's French, all her life the object of more or less polite derogation by French friends, her Italian is unlikely to have been more than fluent, if that.

In cold fact she could not have been in Parma for two whole years.

At some point she went to Spain, for from Rome she submitted to the 1872 Paris Salon a painting of two shawled Spanish women, one flirtatiously looking over her shoulder at a dark man, called *During the Carnival*. Although it is signed, probably later, *M.S.C./1872, à Seville*, in the Salon catalogue its painter appears by her middle name, Mary Stevenson (the name that Mary at first used) with a Rue de Laval address in Paris. It was customary for an unknown painter to list sponsors for Salon submissions, who were frequently his teachers. Mary listed Soyer and C. Bellay. Since her only teachers hung on gallery walls, these men were most probably the Paris artists Paul Constant Soyer and Charles Alphonse Bellay, who also showed in the 1872 Salon, and were perhaps members of the Salon jury. For Mary, this was her first Salon acceptance.

To modern eyes, *Pendant la Carnaval* is an appalling picture—sentimental, storytelling—but the Salon liked it. There is almost no modern equivalent for the stranglehold the Salon—administered by the French Academy—had over the acceptance of art at that time. The nearest equivalent is those universities in Germany where a junior faculty member must have his chairman's permission even to deliver a lecture at another university, let alone ask for another job. The rigid conventionality, the conformity, of the Salon had for years been building up tension which exploded in the Impressionist movement, most of whose members were sufferers at the Salon's hands.

On the Balcony was the painting of which Aleck wrote to Lois, "I received a letter from Mary the other day. She is in high spirits as her picture has been accepted for the annual exhibition in Paris. This you must understand is a great honor for a young artist and not only has it been accepted but it has been hung on the 'line.' I don't know exactly what that means myself but suppose it means it has been hung in a favorable position. Mary's art name is 'Mary Stevenson' under which name I suppose she expects to become famous, poor child." Perhaps 'poor child' was a sop to Lois, in its assumption that such were vain hopes; but Lois would not have cared even for its implied sympathy with Mary. ("On the line," in fact, meant the picture was hung on eye level instead of way up yonder in the tiers upon tiers, then the favored mode of exhibiting pictures.)

Mary stayed in Rome, in the course of those two years, enough to have painted *Roman Girl*. The year 1873 is moreover the date attributed to the Spanish *Offrant le Pañal au Toréro* and *Toréador* (for which she used the same bullfighter as a model). In Madrid she, like other American student pilgrims, immersed herself in the incredible riches of the Prado—copying Velázquez, Goya, Rubens; these two paintings of hers were the

fruits; *Offrant le Pañal* was accepted by the Salon for 1873. In these two pictures is suddenly expressed a definite visual personality, though a less subtle one than in Mary's maturer work. Gone are the sleazy, washed-out colors of her early pictures. The bullfighter lighting his cigarette is especially emphatic, the composition freed of complication and clutter. It portrays forthrightly a handsome, virile man, the sort Mariana might have pined for in her moated grange.

Although the light falling on the colors in these paintings renders them richer and more brilliant than she had seen color before seeing Rubens, however, they are conventional colors. As far as drawing goes, the knuckles of the hand holding the Toreador's match are depressed at a point where knuckles simply do not cave in. Hands remained for Mary a stumbling block (hands and ears are among the hardest parts of the body to draw) almost as much as for Berthe Morisot. These painters, like many another painter who was male, often fell back on the device of having the model sit on or otherwise conceal the hands, as Degas never needed to do.

Rubens led Mary onward to Antwerp, to continue in her absorption in the painter who had made her see color differently—the way Tiepolo makes skies look forever different, or Tintoretto the muscles in a man's back. In Holland, Mary's mother visited her, for the tart-looking portrait of Mrs. Cassatt with the red flower in her bonnet is signed (no doubt later) by Mary, "M. S. Cassatt/Antwerp/1873." In Haarlem, Mary made the copy of Frans Hals's *Meeting of the Officers of the Cluveniers-Doelen, 1633* that she set forth as such an improving example to young Anna Ingersoll, almost fifty years later.

The Paris addresses Mary gave on the entry cards she affixed to the backs of her Salon pictures, in her years of perigrination, witness that she never ceased using Paris for home base. She was now almost ready to settle down in that place of freedom and happiness. The Netherlands, Spain, the Italian countryside with its rose-red cities, all came too late to give her the sense of refuge Paris did. Her character, moreover, had many points in common with the French; those scathing criticisms she leveled at them in her old age are like externalizations of self-criticism. She admired in the French those things that she trusted in herself, hated what were her own failings. She, like the French, always knew the value of a franc; valued wit above humor, intellect above sentiment—even though the course of her whole life was in the end determined by feeling, good or bad.

Few events, but much growth, took place for her up to the crucial year 1877, if meeting certain new friends is excepted. J. Alden Weir, one of the more original of the American painters, was asked in 1873 by a

godmother to look up Mary. "If you ever meet a Miss Mary Cassatt," Mrs.
B. R. Alden had written, "quite a successful young artist I hear, I wish you
would make her acquaintance by mentioning us. Her father was a cousin
of my mother's and it seems she has developed this talent and is improving
it abroad."

This talent . . . when calling on a friend in Paris—the Italian Mad-
ame Marie Del Sarte who ran a boarding school for young ladies—Mary
was introduced to Mary Ellison and to a girl named Louise Waldron
Elder. When this girl was an old lady named Mrs. Henry O. Havemeyer
(who signed checks Louisine W. Havemeyer to distinguish herself from
her husband's first wife) she wrote in her memoirs, "I remember that when
I was . . . scarcely more than fifteen years old [she was in fact seven-
teen] a lady came to . . . where I was a pensionnaire, and I heard her say
she could not remain to tea because she was going to Courbet's studio
to see a picture he had just completed and then she spoke of him as a
painter of such great ability that I at once conceived a curiosity to see
some of his pictures."

Mary was the elder by more than ten years, but she was drawn to Miss
Elder as to few females because of that curiosity about art that made
them sisters in a world where age is one of the things that does not matter.
She used to take the schoolgirl on outings; one day, looking together into
an art shop window, they saw a pastel about which Miss Cassatt became so
admiring, so excited, that Miss Elder took a long breath, marched in, and
paid out her total spending money for it—500 francs, in 1873 about a hun-
dred dollars. The picture, Degas' *La Répétition de Ballet*, thus became the
nucleus of what was going to be the Havemeyer Collection, with which
Mary Cassatt continued to have everything to do. In 1965 Mrs. Have-
meyer's grandson, George Frelinghuysen, disposed of it at the Parke
Bernet Galleries for $410,000; so the episode forms also the nucleus of
Mary's later involvement with art as acquisition and investment. It is, in
addition, the first record of her enthusiasm for Degas.

Another enthusiasm of the two young women's, mentioned in the
Havemeyer memoirs, was "Whistler—not . . . his works but . . . Whistler
himself . . . The year after I bought my first Monet and my first Degas,
I was passing the season in London with my mother and a friend of her,s
and we visited an exhibition . . . It was the first time I saw Whistler's
work and I cannot recall all the portraits or nocturnes he exhibited . . .
but . . . I was deeply impressed by the portrait *Little Miss Alexander*,
which I believe was shown . . . for the first time. The picture created a
furore with the public and the critics [unfavorable] and also with me."
She wrote straight off to Whistler, asking to visit his studio, and when she
arrived came to the point.

"I have thirty pounds to spend and, Mr. Whistler, oh indeed! [cried she, Victorian heroine] I should like something of yours."

He stood and looked at me, and I looked at the white lock in his intensely black hair. "Why do you want something of mine?"

"Because I have seen your exhibition and—because Miss Cassatt likes your etchings."

"Do you know Miss Cassatt?" he asked quickly.

"Indeed I do," I answered. "She is my best friend and I owe it to her that I have a Pissarro, a Monet, and a Degas."

"You have a Degas?" he asked looking at me curiously.

"Yes," I said . . .

For her thirty pounds Whistler let her have five pastels which she treasured but which, as Mrs. Havemeyer, she eventually donated to the Freer Gallery in Washington.

Thus, in art's underground, Mary was aware of Degas and Whistler, and Whistler was aware of Mary. In 1874 Degas became aware of her too, with that remark about her portrait of *Ida* in the Salon (a painting which displays Mary's awareness of Courbet) to his companion Tourny: "C'est vrai. Voilà quelqu'un qui sent comme moi." Something unwritten had taken the place of letters of introduction, when these artists did physically meet. They already knew each other's credentials.

Mary was becoming known back at home, too—whether she would admit it or not. Another young painter in her consciousness was the American John Singer Sargent who in 1874 began working at the École des Beaux Arts, later at the atelier of "Carolus," as the students used to call Carolus Duran. Later Mary *stopped* being aware of Sargent, when she thought he had become vitiated by fashionable commissions, but at this time they were each aware of the other. In 1874, too, Mary sent to the National Academy of Design in New York the *Offering the Pañal to the Bullfighter* and *Balcony in Seville* which had been at the Salon. In the National Academy's catalogue for this show, Mary's address is listed as Rome, so she was still roving.

The year 1875 saw Mary submitting to the Salon a painting generally called *The Young Bride* which was rejected on grounds of being too bright. The kick was a boost: tongue in cheek, Mary did "tone it down," submitted it in 1876, and had it accepted. She was disgusted; and the cynicism of the young about society is as nothing to the cynicism of young artists for the art establishment. After submitting in 1877 to the Salon, and again being rejected, Mary shook the Salon's dust from her feet. Not that she felt herself a finished artist; on the contrary; 1875 was probably the year in which her family persuaded her to study for a time at the atelier of the

"Suave, luxurious" painter Charles Chaplin (rhymes in French with "Ta pin"). From that experience survives a banal, academically painted nude.

To have hung in the sacred Salon, and for five consecutive years, however, was a feather in any painter's cap; for an American, spectacular. Mary's disgust had to do with the formation of her own tastes; and her tastes were for a new style of art, being met in Paris more often with boos than with cheers. Its proponents, who also had revolted against the Salon, first exhibited as a group in 1874, under the name "La Société Anonyme des Artistes, peintres, sculpteurs, graveurs, etc.," and were called Impressionists, from a word used in contempt by one of the critics of Monet's *Impression: Sunrise*. Toward them Mary was in an entirely receptive frame of mind; about her, they had already received those unwritten letters of introduction. On the afternoon when a not-very-important artist, Tourny, played the important role of bringing Edgar Degas to call at Mary Cassatt's Paris studio they knew about each other. In fact, in one of his notebooks, Degas mentioned Mary Cassatt as a possible contributor to an exhibition before he even met her.

Before he left, Degas had invited Mary to exhibit with the new group. Years later Mary told how she felt: "I had already recognized who were my true masters. I admired Manet, Courbet, and Degas. I hated conventional art. I began to live." Not to paint; she said to live. Thus was born not only a new Impressionist, but a new relationship. Ambiguous and inscrutable in all its implications, it nonetheless strikes sparks wherever it is touched—of attraction, antagonism, affinity, stimulation, and a kind of love.

PART II
Art and Degas

FIVE

ANYONE WHO ENJOYS making imaginary pictures of the way things happened is in a good position to do so with Mary Cassatt and Degas. They painted themselves just as they looked around then, and they painted each other. The fact that Mary in later life did her best to consign to oblivion a portrait Degas did of her, and that a portrait she did of him was either lost or destroyed, only makes them more fascinating to imagine. Throughout both their lives the real record of what and who they were lies less in what they did than what they said; less in what they said than what they painted. They put themselves into their art in forms that everyone can recognize—things originally personal but raised to the level of the beautiful because true. This kind of recognizing is not the same as that which hunts a date for one picture, assigns a sitter to another. It is a search for feelings, for impressions; hints, clues that bridge the gulf that separates people.

Around the time of their meeting Degas painted one of many self-portraits, which could not fit the occasion better if it had been painted to illustrate it. He stands, dark, bearded, Proustian, holding a silk hat he has just taken off, gazing ahead with melancholy, dreamy eyes. His trousers are light-colored and tight-fitting; he wears the bat-wing collar ("great high stand-up collars about three inches deep," one of George Moore's non-heroines describes them. "When they were the fashion men could hardly move their necks") and a big dark cravat. In short, he was wearing the clothes of a gentleman—not the flowing hair and slouch hat of an artist—the day he came to call with Tourny—that friend whose very function seemed to bring those two together, for it had been he to whom Degas turned from the portrait of *Ida* at the Salon, to say, "It's true, there *is* someone . . ."

The other principal to the event is illustrated by her contemporary gouache self-portrait. She sits, leaning askew on one elbow—that characteristic askew-leaning—against one of those stuffed cushions she loved to paint, gazing off with the same kind of abstraction as his: the abstraction of the artist who sees only in part what is outside, who consults another vision. The young woman in the picture (Mary was thirty-three in 1877, Degas ten years older) wears a white dress and a poke bonnet with red flowers, tied with long red streamers under her chin. It could have been that very bonnet Mary was wearing when Degas called; ladies did wear

bonnets in their own houses and especially when receiving. Mrs. George Agassiz of Boston (to whom Mary Cassatt gave one of her most charming pastels, of a baby) always wore, up to the Second World War, a hat when she gave a lunch-party. The expression on Mary's face is down-cast—the only thing in this picture that is not true to the day of which she said "I began to live." It was, however, not painted until the following year; by that time there were several things that had changed, for the slender, girlish, above all fundamentally shy Miss Cassett in the picture.

That afternoon Mary can be visualized radiant. Her caller epitomized everything she admired and wanted in the Paris painting world, a world itself visualizable as pulsating, bursting its Salon seams. After years of pressing her nose, as she put it, against the windows of picture dealers to absorb all she could of Degas' art, she now, and through him, saw art as she wanted to see it.

Degas was paying his call in the Montmartre street where Mary had her studio. The quarter, cheerful and unpretentious, was the center for artists, in the days before artists moved over on the other side of Paris to Montparnasse. The high, sunny Butte, where the foundations for an as yet unbuilt church of Sacré-Coeur had been laid in 1874, looked out over all Paris. Descending to the Place Pigalle, one entered the Boulevard Clichy, where Mary, and near where Degas, worked. The Café Nouvelle Athènes was nearby, that hotbed of the Impressionist conspiracy. Mont-martre, light, gay, and relaxed even today, is easy to visualize as a seed-bed for the unconventional art that, at its height, expressed the beauty of the real world in full sunlight. It is an appealing fact that the World War I statesman Clemenceau was once Mayor of Montmartre; he seems its ap-propriately jovial, outgoing representative.

In another, equally realistic sense, the scene of Mary Cassatt's and Degas' meeting was not quite Paris. They met and communicated in a world where both lived, the world of art—which is not the same place at all as the world of picture galleries. In this world Tourny, who can be visualized as a small, chatty presence, may or may not have joined them; more curious things than the exclusion of persons physically present can happen in that world, things like virgin births, deaths-in-life, fertilizations without so much as the touch of a hand.

Mary's life up to then had described a circle that enclosed her just as Degas' past life enclosed him. It helps in visualizing the encounter of these two separate, yet incorporeal, entities, to make a model of "the whole man." Imagine a circle bisected horizontally and vertically. Assign the two lower quadrants to the state of being a little girl or a little boy, each child possessing traits in common with the other (as with the tomboy girl, the dreamy boy). The two upper quadrants of the circle would represent

the state of being a full-grown man or a woman. The ideal human would bring into harmony elements of all four quadrants; would have, say, a father's judgment, a mother's warmth, the imagination and originality of a child.

Imagine arrows pointing up from childhood's quadrants into the grown-up realms above. This is the path a growing child follows, ending up on top. Obstacles may, however, block or divert his way, as Philadelphia blocked Mary, as Paris diverted her. Mary was now grown up not only in how she looked and behaved but in the manner in which her art could make up for any lacks or frustrations. The thing that made this substitution possible, however, was that part of her heart still occupied the quadrants of childhood—moved in childhood's landscape to a degree not noticeable to the beholder, but which, if she had not been a painter, might have jarred.

This is not to say she lived in memories of childhood; far from it. She had forgotten her childhood and was thankful to have done so. Not her own childhood, but the scenery that bounds childhood was the setting for an inside life where she was increasingly granted access to the innocent eye. In this deep center of gravity she was now impinged on by a man, someone who "felt like her," who faced her back from like depths of his own. Other men and women have met and had a sense of accord, but not from this special vantage point, or lack of one.

What Mary needed from Degas she herself described. "I hated conventional art. I began to live." To her, life meant art. Conventional art stood for the kind of life she had always despised—"I had recognized my true masters. Courbet, Manet, Degas . . ." Courbet died that year, 1877. Manet was not far from his premature death. In Degas, Mary, who had never had a beau, found what she wanted in the only world that mattered to her; not precisely a beau, although her pictures after meeting him do suddenly take on aspects of frivolity, but a master; someone she was satisfied would lead her toward that dream of her youth, riding out unstoppably into life. For this life, a winged horse was more suitable than the real horse she really rode in the real Bois de Boulogne. "Degas," she summed up, "persuaded me . . . to show with my friends in the group of Impressionists. I accepted with joy. I could work with absolute independence." It made for her a whole, a circle—including the ambition of a young boy to get away from home and family.

Some knowledge of Degas family history is needed to understand where Mary impinged, in turn, upon his circle; what he made of her. *De Gas,* was the way everyone in the family had always spelled it, until Hilaire-Germain-Edgar democratized it by assimilating the aristocratic "de". Because of its source in the South the name was, properly, pronounced de

Gas, the "s" almost a "z" (as in the Société Anonyme de Gas de Paris). The family history, even in times more recent than its thirteenth-century origins, is romantic.

Edgar's grandfather, Hilaire René, on the royalist side in the Revolution, fled the Terror to settle in Naples. There he reconstituted what had been the family's Paris banking firm, married Antoinette Frappa who was, we are assured by Jeanne Fèvre in her memoir *Mon Oncle Degas*, of excellent Neapolitan family, and turned Bonapartist. His oldest daughter, Rosa, who became the Duchess of Morbilli, passed on to her niece Jeanne, when she was little, family stories of the bad old days.

Complicated old days as well. In Naples, Hilaire René had harrowing adventures, with a hairbreadth escape from, this time, the Royalists. The Duchess said her father never forgot the face of "le roi Murat," hero-general of Austerlitz, Jena, Friedland, who married Napoleon's sister and was by him installed as King of Naples with Caroline Bonaparte his Queen. Another sight Hilaire René never forgot was the Terror. Years later, when he would return to Paris for a visit, he could never cross the Place de la Concorde, for it was there, in that peaceful square where American travelers loved to promenade, that the tall, dark silhouette of the Guillotine had loomed.

His son, René Auguste Hyacinthe de Gas, carried the family firm back to Paris, where he met and married Mlle. Célestine Musson, daughter of a creole—a Frenchman from New Orleans. The world today knows René Auguste's face because his son painted him as a sad old man who with bent head listened to the guitar music of the Spanish singer Lorenzo Pagans; but to that son, Edgar, born the nineteenth of July, 1834, he was a formidable force, blocking the path.

Edgar lived his entire life within the same quarter of Paris, the 9th Arrondissement. Born at 8 rue de St. Georges, he died blind eighty-three years later at 6 Boulevard de Clichy, with intermediate addresses that included the house in the rue Blanche that he loved and from which he was forced to move, to say nothing of those Impressionist homes-away-from-home, the Cafés Guerbois and Nouvelle Athènes. His biographer, Pierre Cabanne, points out that such a setting means "little Edgar had a most bourgeois infancy," using bourgeois in opposition to artist or bohemian. (Before 1830 the word meant only citizen of a free city.) "Once Edgar had his *bacho*," Cabanne goes on, "he turned seriously to drawing, and, his family not objecting, put himself under Lamothe at the École des Beaux Arts." The reader is thus teleported over what were actually the years of greatest stress, of bloodiest internal warfare: the artist's youth.

He grew up "sheltered," in Cabanne's word for it. "His father was an

amateur of the arts, enlightened about painting, passionate toward music. He surrounded himself with distinguished guests. Thanks to him the young Edgar met the collector La Caze 'an enthusiastic talker on painting' according to the Goncourts, at whose house he was able to admire Watteau, Velázquez, Rubens, Fragonard, and other marvels. It was also thanks to his father that Degas knew the Valpinçons, great amateurs of art . . . It was M. Valpinçon who in 1855 led him to Ingres.

"Degas grew up thus in a milieu where painting was honored as well as music. He enriched his spirit thanks to the company of men of taste (Achille Deveria, Conservateur of the Bureau des Étampes, where Degas often went to draw, did not disdain to be kind) and trained his eye by admiring masterpieces." All quite true, and sounds easy as pie; but Jeanne Fèvre supplies a framework with more real bone and muscle. For all her sentimentality about the family's aristocratic connection, for all her refusal to attribute any faults whatsoever to her beloved uncle, she was at least a member of the family and as such equipped with one great essential—family stories.

She relates that when the young Edgar, "surrounded with a life filled with respect for the arts," announced to his father that he meant to become, not the lawyer his father intended, but an artist, René Auguste made the classic scene. He cast Edgar out, threatened to cut him off "without a sou" (in those days there really were sous). Degas père, explains Jeanne, enjoyed art, understood it, but looked upon it in the light of a "simple distraction" (in the French sense, of recreation). It would have been like telling an artist his art is an "activity." Degas, under the threat of disinheritance, left home and went to live in an attic. In later years, his niece says, he never discussed this period; only " 'in that attic,' he would say, 'is where I caught cold in my eyes.' "

For a time, according to Fèvre, the estrangement was complete. Edgar "suffered a sad heart, thinking often of his mother," dead since he was thirteen, says Jeanne; seventeen, says Edgar's much-younger friend Daniel Halévy; Cabanne is, this time, on Jeanne Fèvre's side. Halévy's version of what was unquestionably a struggle is that the father did not like what the son painted, so, since Edgar had great respect for his father's taste, the disapproval deeply discouraged him. "The father did not even want to see his son's work. But one day he came back from . . . the Salon. 'I saw a very remarkable painting,' he said to his son. 'A portrait hung very high in such-and-such a room. I couldn't see the artist's name. Do you know?' It was by Degas. What joy for him!" exclaims Halévy. The two stories are not at all points mutually exclusive.

Jeanne goes on to say that Degas' exile was so complete that the banker father had to ask around even to find what manner of life his son

was living. That life, he learned, was exemplary—"dure et noble." The art student never, for instance, went to "places of pleasure." His inquiries completed, the banker sent for the art student, and "in a beautiful gesture of tenderness, father and son fell one into the arms of the other." That's as may be, but his missing his dead mother, and the cold caught in his eyes in that attic, carry the ring of truth. After the falling into each other's arms, if any, Degas continued to maintain a separate, if warmer, apartment in the rue de Laval—plainly, to Jeanne's sentimental heart, a great pity.

Degas found, however, a spiritual father in the old painter Ingres— of all draftsmen the greatest, whose very face evokes the Consulate and the Empire. Degas, to whom he meant so much, once described him as "a man who will shut himself up all his life to do nothing but indicate fingernails, he finds the hand so lovely, so difficult to render." That was how to think of art! Simple distraction indeed! The difference lay in the approach. To a critical temperament like the elder Degas, it was aesthetic. To an artist, art was approached as a physical act—making it, like a box.

In Jeanne Fèvre's account M. Valpinçon—connoisseur of simple distractions whose collection included many of Ingres' pale, strong drawings —took the young man calling on the old. Degas' admiration for Ingres was already so great that he had studied in Lamothe's atelier before going on to the Beaux Arts where he was now enrolled, simply because Lamothe had been a student of Ingres's. The call was thus another of those culminations of one artist's longing to meet another for burning and inexpressible reasons. Ingres, in leaving his apartment at the same time as his callers, slipped and fell. Young Degas lifted him and carried him back in to Mme. Ingres, laying him on a sofa. Always thereafter, says Jeanne Fèvre, "Degas would say with pride and emotion, 'I held Ingres in my arms!'"

The Halévy version of Degas' version of this visit, and not necessarily more reliable, was that, Valpinçon having refused to lend Ingres the painter's *Odalisque Nue* for an exhibition, Degas chided him: "One does not refuse M. Ingres the loan of one of his own paintings!" The Degas who told Halévy this story, by then aged seventy-eight, had come to believe that the distinguished Valpinçon was at this so abashed that he wrote a remorseful letter for Degas to take to Ingres, who found Ingres standing on a ladder in his studio. In climbing down he fell, in this way making it possible for the younger artist to hold the older in his arms after all.

Degas once told still another version, at a dinner for four artists the Halévys gave. When a question arose about the relative meaning of "good" and "brilliant," "Do you want me to tell you a little story about the word good?" Degas asked. "It was the only time I ever talked to Ingres. I was sent to go and ask him for the loan of a picture for an

exhibition. And I took advantage of the opportunity to tell him I was do-
ing some painting, that I was in love with art and would like his advice.
The pictures that hung in his studio are still photographed in my mind.
'Draw lines, young man,' he said to me, 'draw lines; whether from memory
or after nature. Then you will be a good artist.'"

"Is that the only time you saw him?" asked somebody at the dinner.
"No, but the only time he spoke to me. I saw him again at one of his
exhibitions . . . In front of a classical painting [an] old man said, 'Still
in love with antiquity, M. Ingres?' Ingres remained impassive. 'Yes.'
Then they stopped in front of . . . an odalisque. 'And now for the pleas-
ing subject, eh, M. Ingres?' 'Yes,' replied Ingres, still imperturbable, 'I
have more than one brush.'" Though Degas' memory may have been
faulty, the view into the difference between artists and amateurs is im-
memorial.

"At the bottom of Degas you find Ingres," wrote Royal Cortissoz, a
perceptive American art critic of the early twentieth century, "which is not
imitation of a style, but the application of a principle. It is an instance of
the thinking artist, a rare type always, the man whose hand is fed by his
brain, who . . . is open to other impressions, allowing them to fertilize his
genius without governing it."

The meeting with Ingres, whatever its form, took place in 1855. The
year before that, Degas visited the Neapolitan branch of his family—the
first of repeated trips to Italy. In 1857 he made one of a group of young
painters at the Villa Medici in Rome, that included Gustave Moreau,
Bizet, Binnat, and Tourny—some of them painters whom he, as an Im-
pressionist, later denounced. These visits culminated in Degas' earliest
masterpiece, *The Belleli Family*, now in the Louvre. In the genesis and
completion of this picture can first be observed the characteristic struggle
that preceded all the greatest work of this thinking artist.

Italy had made Degas blissful—not so much eager to paint, as to
make notes for painting. He merely sketched it, feeling that memory
would serve him better for the rest. He wrote in his journal that he was
soon bored observing nature; that inwardly he never left his studio.
"Assisi, which I find so seductive, I want to escape for that very thing.
Perhaps," he burst out suddenly, "I will be happy there some day . . .
Could I find a good wife, simple, tranquil, who understood my mental
follies and with whom I could pass a modest working life?" The misread-
ing of Degas' nature which later gave him the reputation of a misogynist,
could not have been credible at that time. When he was twenty he was
seriously in love with a Mlle. Volkonsa, who rejected him; later with
Marie, sister of the bassoonist, Désiré Dihau, who made the focal point
in the composition of his 1868 painting of the Paris Opera orchestra. He

was intimate with the Dihau family and painted Marie twice, once at the piano, in this period of his painting musical pictures. Since he called her, in a letter to his brother, "my cruel friend" it seems this love was in vain also.

"I'm returning to Paris," the Italian notebook continues. "Who knows what may happen? But I'll always be—" There is no precise English equivalent for "honnête homme." In the eighteenth century it would have meant "I'll always be an aristocrat, well-bred"; today it would mean "always trustworthy, four-square"; Cabanne's use of "bourgeois" also approaches it. In any case it is in opposition to bohemian, and was a part of the principles by which—like his father, though reacting against him—Degas lived. It was also a trait that made him reassuring to Mary Cassatt.

Out of his rejection of the present Italy, for a future, dream Italy, out of his yearning for a wife coupled with continued evasion of marital ties, came the marvelous *Portrait de Famille*. In it, his father's sister Laure and her husband the Neapolitan Baron Belleli stand with their two little girls, the Baroness once more pregnant. The painting expresses everything the young Degas, he who had "suffered a sad heart, thinking often of his mother," privately thought about men, women, marriage. The turned back of the dominating father (artistically a triumph of composition), the impassive, stoic face of the mother, the two little girls, one still cheeky, the other already, like her mother, subdued—*Portrait de Famille* is Degas' thought made, not flesh, but paint.

"Simple, tranquil" females were not really to Degas' taste. He loved little girls to be cheeky. As early as 1860, before any of his great pictures, he epitomized cheekiness in his *Jeunes Filles Spartiates*, at a period when he was still painting the quasi-historical, allegorical subjects that were de rigueur. In it young, almost nude Spartan girls are provoking Spartan boys to a contest of strength. The stance of the girls, their gaily defiant expressions, express not only cheekiness but equality. Behind them stands a group of watching figures: the dark cloaked forms of the mothers and of Lycurgus, "the law-giver."

Watching figures, and also menacing. Up until somewhere between 736–716 B.C. Sparta possessed an artistic culture the equal of any in Greece, but around 610 B.C. she was reorganized along military lines; boys were enlisted in the army at the age of seven. The "reforms" were traditionally attributed to Lycurgus, a semi-mythical hero of the ninth century B.C., probably because the new laws were placed under his tutelary protection. Girl babies, unless selected for future breeders of the race, were now disposed of at birth, sometimes by being thrown off just such a high rock as appears in the Degas painting, to the left of the elders that stand viewing the still-surviving challenge of boys by girls. It is an allegory of the coming of

sexual darkness, about which Degas once reflected, "By this horrible prac-
tice [of throwing babies off the rock] the Spartans [the Spartan women]
evaded a life of suffering and shame."

The long thoughts of his dead mother had been rooted in memories
of her suffering under the paternal domination which he too had en-
dured. He was haunted by the conventional degradation of women and
by their own cooperation in it. *The Spartan Girls* renders both his ideal
and the threat to it. He so loved this picture of his immaturity that long
years later, in his old age, he always showed it in his studio set on an
easel, in the place of honor.

During the 1860s he was frequenting the Café Guerbois—that nest to
hatch Impressionists—along with Manet, the novelist Zola, Renoir, Monet,
and the critic Duranty, who later supported Degas' work. In the long, long
conversations, artists smarting from the spikes that topped the Salon's
fence discussed what they could do to evade or defy it. Manet, their first
leader, had received repeatedly rejections from the Salon; when his great
Déjeuner sur l'Herbe was shown there it proved an offense in the nostrils
of both Academicians and the public. His masterpiece *Olympe* created, in
1865, an even louder outcry. The thing about it that so scandalized was less
the realism with which the courtesan's charms are displayed, and less that
the painter did not show the proper sentiments toward his subject, as that
he didn't display any sentiments at all. He just painted it. The picture
was there for what it was, with all Manet's genius for looking at a thing
and rendering it in paint.

At the café, kept by M. Guerbois—an elderly Parisian type they
painted, with his handlebar mustaches and large paunch—Degas joined in
the talk and was sympathetic to it. After the banner of the Impressionist
movement dropped from Manet's hands he picked it up and carried it. He
was not, however, by temperament a frequenter of cafés; Pierre Cabanne
exclaims, not wholly in praise, "He was the only reasonable one among
them." When he clashed with the others it was on moral issues—his
principles; mostly he sat, silent, pondering what was said and carrying it
away to work out alone at home. He was, nevertheless, the most faithful of
the Impressionists, the most loyal. Again it was a matter of principle. Al-
though he sometimes quit them, it was never the way the others did, over
mere personal vanity.

At this juncture of his life Degas was a sociable being. He entertained
in his rue Blanche house. The number of his acquaintances was simply
enormous, and his engagements would fill even a layman's social calendar.
Just his intimate friends make up a good list: Ludovic Halévy, opera libret-
tist and father of Daniel, the brothers Alexis and Henri Rouart with whom
he'd gone to school, the sculptor Bartholomé, the painter Georges Jean-

niot, Braquaval, with whom he often stayed at St.-Valéry-sur-Somme, Vicomte Lepic, painter and engraver, and Évariste de Valernes. Also he was welcome in the salons of the Faubourg St. Germain. It is hard to imagine how he could have seen anyone more and still got any work done.

During the 1870 struggle, Degas fought a hard war. He served in an artillery unit of the Garde Nationale for the entire duration, and one account has it that sleeping in cold barracks was where he caught the cold that damaged his eyes. During the Communist violence following, when over twenty-five public buildings as well as the Library of the Louvre and parts of the Palace of the Tuileries were destroyed, he took refuge in the country with the Valpinçons, where he painted the children of the house. In 1869 he had done the portrait of the cheekiest of all his cheeky little girls, Hortense Valpinçon, in a round straw hat—none too pleased to be interrupted eating an apple.

Eighteen seventy-two was the date of the journey Degas made, with his brother René who had been on a visit in Paris, back to New Orleans, where his brothers were engaged in the cotton business. He adored America from the moment he landed in New York. In the letters he wrote home can be observed, however, the same pattern of rejection of reality for the abstract idea of it, coupled with a reiterated desire for marriage, which earlier issued in the great Belleli family picture. It happened again.

This time, on December 5, he had written to Henri Rouart, "This [a plan to return to Paris] is the choice I have made and a little more. Manet would see beautiful things here; he would not be at a disadvantage [as I am]. One does not love," he confesses, "and one gives to art what one gives by habit. I don't even regard a wife as the enemy of . . . a new way of life. A few children—mine and by me—is that also too much to ask? No. I dream of something well-made, a well-ordered whole . . . This is the right moment. Otherwise, ordering life would be less gay, less respectable, and full of regrets." He meant order in a real married life; but what the coupling of despair of his powers and longing for union brought forth was, not action in the world, but what for an artist is action. His longing for marriage, brought on by the spectacle of his brother René's domestic happiness and his admiration for René's charming, gentle, blind wife, was abortive; the moment passed. Yet Degas did not, after all, return to Paris. He remained in New Orleans until April, stricken with last-minute vision, a painter's vision: his brothers' cotton-broking firm.

Bureau de Coton, with *Portrait de Famille* ten years before, demonstrate the same pattern: out of dead-ends in life, despair, dryness, Degas' genius could bring forth a new thing. Simultaneously they reveal a re-enactment of that moment of rupture, never made complete in life, with his family. Primitive rites of initiation vividly illustrate the subjective ex-

perience of such a break; to become a man, even to try to, hurts as much as any initiation. It is not, of course, painting itself that causes suffering to a painter; painting can be purest pleasure. It is the tension before the painting, the despair, the feeling of loss of everything, even faith, the breaking through inertia—these are the suffering. Just before each of his greatest tours de force Degas' life experience reproduces itself, art recapitulating ontogeny. Instead of satisfying his conscious desire for a wife, the inner war, or coitus, brought forth from a divided nature the unified work of art, displaying all Degas' old traits and problems, newly resolved.

The bringing to life of the *Bureau de Coton*, which, like the *Famille*, he painted from studies in his studio, was made possible by Degas' mastery of technique, that ceaseless "drawing lines," ever more lines. Degas' technique was like an athlete's muscular coordination; in fact Walter Sickert, a disciple of Degas' who lived until 1942, wrote of his work that it possessed "the good nature and high spirits that attend a sense of great power, exercised in the proper channel—a boxer who gets in blow after blow exactly as he intends." Examine the least of Degas' drawings, say the one of a man, thumbs in waistcoat pockets, lolling in a chair, and there is the elation of witnessing something done supremely well. Each line, even the barely indicated hands, convey the élan of virtuosity. Royal Cortissoz said of Degas, "it is foolish to think of tradition as an academic formula. It is the tribute the . . . artist pays to the wisdom of the free spirits of art of all ages. Degas, tradition in his blood, proceeded in perfect freedom to express himself." This laying on of hands by painters of earlier centuries, on a wider scale than Mary's affinity with Correggio and Rubens, made Degas able to express in technical virtuosity the power that he lacked (or felt he lacked) in life, and which caused his frequent despairing outcries.

Because of his executing a work of art on purpose, by an act of will not a stroke of luck, Degas—as Jean Renoir wrote a hundred years later about his father—had turned from being a mere worshiper of nature to being her master. Such mastery solved artistic problems as they came up, freeing Degas for the inevitable next. On the level of art, at least, he never got stuck in one theme the way Mary Cassatt later got stuck: after their break, after her fall. The progression from pure energy, expressed in paintings of horses; to precise discipline, expressed in paintings of ballet dancers, to ceaseless drudgery, expressed in weary laundresses, to his deep disillusion about those girls of whom he dreamed in *The Spartan Girls*, expressed in magnificently rendered, fat, pink nudes absorbed in their toilet, portray a full life: Degas and his development.

Of course, even for Degas art was ultimately mysterious, unbiddable as the wind. Technique simply brought it nearer, taming its savage and ungrateful nature, of which Degas again and again expresses himself keenly

aware. As in other mystic techniques—as in eating the bread and drinking the wine of fellowship—Degas, alone with technique, "did this," and the rest was always added, unto him who remained, in part, a child. He so loved the art of drawing that with time he, like Ingres, became an "old man who shuts himself up . . . in order to indicate fingernails," but in 1877 he was only forty-three and his despair and desire were not yet solely internal. The union of the two could have blossomed in real life, as well as under the masks of art.

Toward women, carriers of his mother's image, Degas was tender when they retained what he considered their self-respect, contemptuous when he felt they had lost it; for he was thoroughly a bourgeois, an *honnête homme*. Relations with his fellow painter Berthe Morisot, Manet's disciple, for instance, were excellent. Almost every one of Berthe's letters to her sister, in the earlier years, mentions Degas affectionately, quoting him, praising him; in 1870, after Varnishing Day at the Salon, Berthe suddenly bursts out in anguish, "M. Degas has a governing misunderstanding of all I am able to do!" He never deeply admired her work, although he did say, "Her painting, a little vaporous, hides drawing that is of the surest." No woman before Mary Cassatt had seemed to Degas a real painter, a real draftsman. He once said about Berthe, "She makes pictures the way one would make a hat," although for a painter that is less mocking than for a layman who still believes in inspiration.

His tenderness for certain women, deriving from the mother he had lost, was accompanied by extreme sensitivity about any bereavement at all. From the time of that great loss, his father had turned into the old man listening to Pagans; that mourning brought out a curiously feminine trait in Degas—he rushed to the side of any mourning friend. For him, loss meant mother meant yearning. Frustration meant his father meant the fury in him, which, in 1877, had not yet burst out as intemperately as it would. Already his anger, by reason of its ungovernable nature, had begun to earn him an undeserved reputation for ferocity. Only the easily wounded know how to wound easily.

In the autumn of 1873 the old Opera House where Degas had loved to study ballet dancers, burned down; and in December his father, who had gone to Italy, fell seriously ill in Turin. Degas hurried to his bedside. In February 1874, in Naples, the old man died and the bank which he had controlled was discovered, to everyone's surprise, to be in bad shape. The situation did not prevent Degas' taking a leading part in organizing what had so often been talked of and so often delayed, a show of the younger, dissident painters' work.

The group at the Café Guerbois had resumed their sessions after the War, at the Nouvelle Athènes, joined by the Anglo-Irish writer George

Moore, who had aspirations to be a painter which the painters themselves found a trifle absurd. He could, however, describe the new gathering-spot, visually: "A partition rising a few feet or more over the hats of the men sitting at the usual marble tables, separated the glass front from the main body of the café; two tables in the right-hand corner were reserved for Manet and Degas and for their circle of admirers." Moore, who preferred Manet to Degas, whom he considered overintellectual, goes on, "In the days of the Nouvelle Athènes we used to repeat Degas' witticisms, how he once said to Whistler, 'Whistler, if you were not a genius you would be the most ridiculous man in Paris.' And, 'Anyone can have talent when he is five-and-twenty; the thing is to have talent when you are fifty.' And, of a huge painting by the now-forgotten painter, Roll, with innumerable figures, 'One doesn't make a crowd with fifty figures, one makes a crowd with five.'" Wit burst out of Degas uncontrollably. Often he bitterly regretted its cutting edges. It was as if the sore spot at his core sent out the witticisms, beyond his control.

The group now pulled itself together and, though Manet was still intent on the Salon and did not join them, held the *Première Exposition des artistes peintres, sculpteurs, graveurs,* which opened April 15 in the studio of the photographer Nadar, Boulevard des Capucines. Its reception, both critically and from the public, can be summed up by a cartoon it provoked: the police are trying to bar a pregnant woman from the exhibition lest her unborn child be marked by the experience. *Sic intrat gloria mundae.* The painters that this year composed the group which in 1877 Mary Cassatt joined, were Astruc, Attendu, Beliard, Guillaumin, Latouche, Lepic, Lépine, Levert, Meyer, De Molins, Monet, Morisot (separating herself momentarily from her mentor, Manet, to join), Mulot-Durivage, De Nittis, A. Ottin, L. Ottin, Pissarro, Renoir, Robert, Rouart, and Sisley. In view of the rage for Impressionism in the present century, it is interesting how few of the names are familiar.

Also in 1874 Degas painted a picture which suggests his current feelings on the subject of sex: *Rape.* A painter cannot paint well what he does not believe in, for feelings are the facts of his vision. The painting was at one time thought to illustrate Zola's *Madeleine Ferat.* In that novel, the newly married pair arrive at a hotel and Madeleine, weeping, says, "I suffer, for you love me and I cannot be yours." Degas painted a delicate, refined-looking woman crouching at the far end of a hotel bedroom from a man who stands displaying—legs, straddled, hands thrust deep into pockets— an air of brutality and ruthlessness which bely the attribution. What the picture does convey is horror at the heartless side of sex. Mary Cassatt later said Degas told her *Rape* represented moral rape. As usual Degas was expressing all of himself: his mother's tender heart, his father's ruthless mind,

and in between, the art of Degas, born once more. (When, years after Degas died in 1917, the picture was up before the purchase committee of the Museum of Fine Arts, Boston, certain female members opposed buying it, since, they pointed out, the single bed in the room proved the couple was not married; hence it was an immoral picture.)

In 1874, too, Edmond de Goncourt wrote in his Journal for February 13: "Yesterday I spent the day in the atelier of a singular painter named Degas. After many trials and attempts, after chasing in every direction, he has fallen in love with the modern style, and, in the modern style, he casts his choice upon laundresses and dancers. Fundamentally the choice is not so bad. It comprises white and rose, female flesh in fine lawn and gauze—a charming pretext for fair and delicate coloration. [We are shown] laundresses in their poses and foreshortenings—laundresses speaking their own languages . . . Afterward the dancers filed by. It is the ballet green room, with, in the light from the window, the fantastic silhouette of dancers' legs descending a little stair, with the dazzling red spot of a tartan in the midst of all the swelling white clouds [of the tutus], with, for a riff-raff kind of contract, a ridiculous ballet master. And opposite them all . . . the graceful gestures of some little monkeys of females . . .

"An original boy, this Degas. A sickly fellow, a neurotic, ophthalmic to the point of fearing he will lose his sight; but beyond that, someone eminently sensitive to the harshnesses of reality. Thus far he is, of the men I have seen, the most trapped in the image of modern life—the very soul of that life.

"Will he ever realize anything of perfection? I doubt it. His spirit is too restless. Besides," Goncourt concludes, as ever snippy, "doesn't one sense in these productions, so delicately expressive of being and nature, that instead of bringing into them the harsh décor of the Opera green room, he ought to draw from the perspectives of Panini's architecture?"

In 1876 the Impressionists held a second showing, this time at the rue de Peletier galleries of Durand-Ruel, their lasting friend and supporter. This time the critics were as irritated, as outraged, as before, except that Duranty, who had sat in on sessions in the two cafés, wrote, apropos of the exhibition, a sympathetic booklet which singled out Degas, with twenty-four pictures in the show, for approbation.

Such was Degas' situation by 1877, deep in a struggle between heart and head from which he desperately cast about for rescue. He had art (or, as he sometimes felt, art had him). What he wanted outside was something he did not entirely believe in but had dreamed of: an equal, a cheeky girl who also understood art. These qualities Mary Cassatt, young, spunky, frank, decisive, modern, embodied; and as for her art, "I will not believe that a woman can draw so well!" Degas once exclaimed of her. The prob-

lems of the two were mirror-images of each other's, since society expected of him—all exploratory sensitivity—that he be masculine and assertive, and of Mary, a woman, expected tenderness, when the last thing in the world she wanted to be was one more wife and mother.

What each needed, the other had. They sensed it, as they faced each other, grown man and woman, above the unexplored wasteland of their hearts. Just as they had recognized each other's work, they recognized each other, and were sufficiently drawn together that it became right away noticeable to other people. It was a situation in which, for people of their upbringing and in their world, a proposal might have been looked for, except for drastic changes that had recently taken place in Degas' way of life.

In 1874, when his father died leaving the bank on shaky footing, Degas with his brother Achille asked René Degas, in New Orleans, to repay money they had lent him to found the cotton brokerage. They found he couldn't —that he himself was strapped financially. Edgar and his brother-in-law Fèvre (husband of his sister Marguerite, and father of the memoirist) refunded the loan out of their own pockets. Degas was legally obligated to repay a large sum owing to a bank in Antwerp. In order to do so, he had not only to make a forced sale of his own work, but to sell most of the collection of paintings, old and modern, that had been one of his principal joys, and which George Moore called the most interesting collection in Paris. He was, moreover, forced to move into cramped and inferior quarters.

As an old man Daniel Halévy recalled the way the story was told to him as a child. "In 1878 there was a pistol shot in the Bourse. The man who shot himself was a Degas who had gone bankrupt." Actually, financial reverses began long before 1878; about Degas' emotions, however, his younger friend is delicately perceptive. "To understand what followed we must remember Degas' intense sensitiveness. He accepted the complete responsibility for which he was in no way obligated. He paid the full amount of the debts. His way of life changed completely. He gave up everything he owned and rented a studio at the foot of an alley off the rue Pigalle." (So speaks memory; Pierre Cabanne says he moved in 1877.)

"I went there one morning with my father; the new dwelling repelled me and I felt that our friend had been in some way degraded. I asked my mother for an explanation. 'When a member of a family,' she explained, 'owes money and can't pay it, the honor of the family demands that his brothers pay.' My mother uttered these words so firmly that I didn't dare repeat the question though the answer left me disturbed. Not until fifteen years later was I able to question a friend who was working in a lawyer's office. My question astonished him. He replied that as far as he knew the practice of which I had spoken was no longer observed. Was it observed in 1880? I suspect that the only basis for that generosity to which I was wit-

ness when I was nine years old lay in the indomitable exigencies of Degas'
heart. He could not endure a stain on the honor of his family name. His
vision of the world darkened."

There was an additional change in Degas' changed life: the intro-
duction into it of the young woman from America who challenged the
boys. Cabanne, while professing the usual ignorance of the actual nature
of their friendship, writes that "a comparable intellectuality and predilec-
tion for drawing transformed an amiable relationship into a liaison the
duration and intensity of which, we know nothing of." Throughout all
masculine comment runs the same disclaimer of information, indeed of
definite opinion. Cabanne viewed the friendship from the standard French
masculine point of view; the French find it hard to conceive that a woman's
desire could be to become, not Degas' wife or mistress, but his professional
equal. They do not take into account Philadelphia, or Pittsburgh, or the
Cassatts, or Mary herself, and what part these played in making of Degas
a *mauvais caractère*.

SIX

FOR ONE THING, within the same autumn that Mary Cassatt met Degas, her parents descended upon her, bag and baggage, complete with unmarried Lydia, to stay for good. They had often enough visited Mary in the course of her independent life in Europe, but never before had they felt it necessary to ensconce themselves as permanent chaperons, as "background." Now, and for the next eighteen years, their presence in her life was a fixture.

Up to this moment the Cassatt family might as well have been, as far as imagining them today goes, mute. Suddenly, in the letters they now wrote home to Aleck, to Lois, to their children, their voices are audible; with the sound, their kind of life becomes visible. The letters are about the subjects that interested them: children, health, horses, and money, in more or less that order. "The Cassatts adored even the most repulsive children and babies," a niece once said. Their voices reward a careful listening to, for they were the voices Mary listened to. The endearing humdrum reflected in the letters gives a glimpse into the family arrangements in Paris.

As soon after their arrival as April 3, 1878, Robert Cassatt is writing to Aleck's oldest child, Edward Buchanan Cassatt (who, like the other grandchildren, was of course duly entered in Robert's records):

"Dear Eddie, Almost a week ago I received your letter of March 15 and you cannot think how pleased I was to recognize your handwriting again and to see how it had improved since your letter to your Grandmother . . . Oh! if I could only have you all over here for a while wouldn't we have the Champs Élysées parties? With its Theatre Guignol—goat carriages and races and other delights to say nothing of the crowds of merry children we should meet? Wouldn't Sister [Katherine Kelso Johnston Cassatt] and Robbie [Robert Kelso Cassatt] and Elsie [Elizabeth Foster Cassatt, the baby] dance with delight? . . . Some time ago I heard there was a *Journal des Enfants* published here & I have been intending to find it out and send you a copy in the hope that you might find it amusing and instructive & also a help to your French. Today I found the office & bought a number which I send by the mail, but it is not the sort of thing I expected—it looks as if it might be of more use to Mamma than to you. Kiss all the children for me and give my love to Mamma and Papa—I send you my blessing & hope & trust that you will grow up to be a good man a com-

fort to your parents & a good example & support to your brother and sisters—Aunt Mary is at her studio & Grandmamma & Aunt Lydia out and none of them know I am writing or they would send love too." The breathlessness of punctuation is typically Victorian (Victoria herself used dashes). A few are here retained for flavor. There is a P.S. "I enclose for Papa a likeness of Émile Zola the now celebrated author of the Assommoir." (What first made Zola celebrated was this very "saga of drink.")

July 2, 1878, Grandmamma Cassatt writes to the child next in age after Eddie—Sister, her namesake—from the new apartment at 13, Avenue Trudaine, where they remained for some time: "Yesterday I received your very nice letter which your Aunt Mary & I read over several times & which we thought extremely good for a little girl not yet seven years old.

"You cannot want to see me more than I wish to see you. It would be such a pleasure to take you out with us to see the many things there are here to amuse children—Especially on Sunday evening last we would have liked so much to have you all with us to see the beautiful fireworks & illuminations which were much finer than you can see in America [it was the year of the Great Exhibition]. You know we live up very high, higher than your house in town, but we have a balcony all along the front of the house from which we can see over the houses opposite, so that we had a magnificent view. If we could have had you all there and seen you enjoy the sight we would have liked it better than all the rockets & illuminations.

"Your Grandfather & Aunt Lydia have gone away for the summer & your Aunt Mary & I are to join them very soon [at Divonne, on the border of Switzerland]. Your poor Aunt Lydia has been very sick since you saw her but we hope she will get better this summer—I am going to send yours and Robbie's letters to your Grandfather & let him read them because I know how glad they will be to see that you can write so nicely—We talk of you all a great deal & wonder if you have changed much—I am sorry to hear that you have not been very well, but I dare say the country air and your rides on the pony will soon make you strong again—What a nice time you must have now that Robbie can ride & then there are three of you to go out together.

"As to Robbie's curls, I should be on Mamma's side, I would want to keep him pretty a year longer, I wouldn't have the courage to cut them off—though I dare say he would like to be like Eddie and have short hair, as all little boys like to imitate their big brothers.

"We thought it was very cunning of Elsie to recognize my photograph as she was not much more than two years old when I left you—she must be very sweet to make you all love her so much as you do—If you will all come over here next summer, what a grand holiday we shall have and how

glad we shall be to see you—I hope your Papa will not change his mind about it. [He did; the older Cassatts' yearning for little children was not gratified till the summer of 1880.]

"Give little Elsie a kiss for me—also Robbie & Eddy and Aunt Mary says 'give one all round for me too.' With the best love to your Mamma & Papa I am your affectionate Grandmother Cassatt."

It is all there, unchanged from Mary's childhood; the solicitude and delight in entertaining children, the importance to this of horses; as family circle, it was still, as ever, a child's paradise. Even when addressing grown-up members the level of interest is not much higher. Later in July Mrs. Cassatt wrote to Aleck about the same photograph, from the same address; she had not, after all, yet been able to get away. The new apartment, in unassuming Montmartre, was a block from the Boulevard de Rochechouart, which leads into the Place Pigalle, facing the entrance to the Boulevard de Clichy, where Mary's studio was at Number 6. The only real difference in Mrs. Cassatt's later letter is that with Aleck she can discuss the phenomenon of Robert Cassatt running true to form.

"Mary was very much pleased to hear that the children recognized the likeness and especially that Little Elsie should have done so. She must be like Eddie who recognized a photograph of his Aunt Mary after five months' absence, and when he was only two years and a half old—I think you will all like the picture as some people think it is the best portrait as far as likeness and color goes they ever saw." This "likeness" was a photograph of Mary's 1873 portrait of her mother, the one with the schoolmarm expression, and had been sent on ahead to herald the arrival of the painting itself.

"This morning I have a letter from your Father which has upset all our plans—Mary and I had decided to start for Divonne on Sunday evening, but he writes that the novelty of the thing having worn off he is tired of it and wants to come home—& is even in such a hurry that he says we had better telegraph as otherwise he will be here before we look for him. Now with his ideas of housekeeping I can't leave him with our cook alone—I must stay and superintend—and then another trouble is that he can't bear not to see everything finished about the house & owing to the exhibition & the fêtes it is impossible to get anything done; so we were glad to get him away until things were all in order. Now he comes back just as we are in the midst of work—He says Lydia looks a little better, but she has had two attacks since she has been there—I am quite sure that they have never found out what was the matter and shouldn't be surprised if it were the liver that is out of order—the Doctor frightened us out of our wits by suggesting Bright's disease of the kidneys [he was right] but he could [not] make up his mind even after analyzing the urine. It seems it is not so hard

to cure a sick person as it is to find out what is the matter," she observes sagely.

". . . We have had a week of quite warm weather cool nights though —and now it is cool again the fêtes came off very well everybody having contributed something toward embellishing their own street besides what the city does." The subscription was characteristically Montmartre.

On October 4 Robert wrote Aleck from the Avenue Trudaine:

"My dear Son, It is a long while since I have either received a letter from you or written you . . . your last, I believe was about your Mother's portrait and I must continue the subject in this, the portrait is now on the way to you, we sent it to the Red Star office on the 21st and it is to leave Antwerp per Switzerland on the 15th—It goes in a frame—Mame had a very fine one bought a bargain in Rome in which the picture was exhibited here & which suited it admirably so she thought it a pity to part them— and moreover wished you to have the first view of the portrait in a frame as a picture always appears to greater advantage framed etc etc." he writes impatiently. "The freight and charges will of course cost something more but not so much more than if you had had a frame to buy at home— Mame thinks also that the picture will carry better this way than if rolled —I ordered the picture insured for 2500 francs and the frame for 250 francs. The frame is partly of carved wood and would cost at home I suppose 100 to 120 dollars. Mame paid only 200 francs for it in Rome sec- ond hand then—and although she had it done up you may safely swear its value at 50 francs if there is any question about it—You should see that the box is opened with care at the Customs house and so that neither the frame nor picture receives injury—I enclose the canvas certificate & later will send the Bill of Lading for the box—I hope you will be pleased with the portrait—in fact I do not allow myself a doubt but that you will be, but hope all the same that you will 'speak right out in meeting' if you are not —here there is but one opinion as to its excellence—See that it is properly hung as to light, distance etc."

Attention to Customs details was perhaps necessary, but Robert does seem obsessed by that frame. Among artists in the last century there was a wry joke: a family very much like the Cassatts had a daughter whose artist beau presented her with one of his paintings, framed. A bit flattered when the girl's family would not allow her to accept such a valuable present from a man she was not engaged to, the poor wretch of an artist was less so when they said if he would remove the frame, she could accept the picture. Robert Cassatt continues:

"Mame is again at work as constantly as ever and is in very good spirits—she has recently sold one of her last pictures to a French amateur and collector and at the same time received an order from the same gen-

tleman for another, a *pendant* for the one purchased. Mrs. Mitchell took
some of Mary's pictures home with her in June last and some two or three
of them have received very flattering notices from the papers particularly
the Transcript [at the Thirteenth Exhibition of the Department of Fine
Arts at the Massachusetts Mechanic Association; these were *After the Bull-
Fight, The Music Lesson,* and a sketch called *At the Français,* the first two
at least belonging to the same period as the portrait of Mary's mother].
Williams [and Everett] the picture dealers have asked to have the agency
for her pictures in Boston . . . This brings me to speak of Mrs. Mitchell a
great admirer of Mame's. She is the wife of that Mitchell formerly a well
known merchant in Philadelphia who was killed some months ago by the
falling of a tree in Virginia—The family have been in reduced circum-
stances for several years and she has been struggling hard to make a living
for herself and younger children and among other means is trying to sell
pictures. I believe she and Teubner [a Philadelphia picture dealer] work in
each other's interest. —Well Mrs. Mitchell has some connections in Cali-
fornia & thinks she might be able to sell some pictures there if on the spot
—but unfortunately has not the money to pay passage etc. So she had writ-
ten to Mame to ask her to use her influence with you to get her a pass.
Mame has replied that she did not think you could give her a pass to San
Francisco, and that one over your line only, would not help her much—but
in the end I believe telling her she might call and see you about it—Now if
you can properly do anything in the way of a pass to help the poor woman
I wish you would—Your mother I believe at one time [has] written you not
to do anything of the kind but then she was under a wrong impression.

"Just now we are all very well—when I say all I must except Lydia but
she too is well for her—and we hope again that the doctors have been mis-
taken in their opinions of her case last summer—Certainly the dangerous
symptoms have disappeared in a great measure—she however still looks
thin and miserable yet has a good share of strength and a fair appetite and
also pretty good spirits.

"We are having delightful autumn weather. Paris is a wonder to be-
hold. Such universal movement in every part of the city I am sure does
not exist in any other city in the world not excepting London. The Exhibi-
tion is a continued success and its success has helped to establish the
Republic. The Monarchists can't conceal their spite at this—The fêtes pre-
paring for the closing hours are to eclipse all that has preceded them, and
wind up in a blaze of glory—In short the Republic is to show that there is
no need of a Monarchy to make Paris the gayest city in the world. How-
ever the revived Parisians are praying for the closing and we privately
join them. We are not altogether furnished yet and will not be I suppose
until the exhibition closes.

"We long to hear particularly of you all especially of the dear children, of their sayings and doings. By this time Elsie's prattle must be very amusing and we would like to hear some of it as well as some of Rob's. The other two are past that. Gard [Gardner, Aleck's brother] writes very meagre letters and never tells us anything of you except that you are well."

The complaint points up the compulsory quality of Victorian family togetherness, but though Gardner, as a son, could at least show his preference for a private life, a daughter was not granted that much eccentricity. Just as in the days of that earlier Paris Exposition, when the paterfamilias was also so eager to display its glories to the family's children, Mary was locked in an eternal, unending, family circle, within which closeness Lydia simply wilted. In the following letters, one hears how Mary's work could help occasion a saving anger. Mrs. Cassatt is writing to Aleck, on November 22, 1878:

"Your father wrote to Gard on Monday a long letter about Teubner and May's pictures which no doubt will bother him dreadfully and bore him as well, as he hates trouble—He was to show you the letter and ask your advice as to how he should proceed—From Mrs. Mitchell's postal card it is plain that she thinks he [Teubner] is not honest although it is she who recommended him—but she wrote the most mixed-up letter I ever read and she may be mistaken—There is one thing however which I don't like—he never answers letters—May has written to him over and over again and he has never troubled himself to reply but once, and then it was months after she had written. This is why I am obliged to trouble you and Gard—I think that Teubner has an idea that it is of no consequence to May whether she sells or not and so holds on for high prices in spite of all she says to him—Mrs. Mitchell says he wants to keep the *Musical Party* himself and pay for it out of commissions from the sale of the rest of the pictures. Now I can't bear to trouble you but we want to be done with this thing once and for all—May wants all her smaller pictures sold at auction either in New York or Philadelphia, two or three at a time at every important sale that may take place until they are all sold—The three or four larger ones—the *Musical Party*, the *Theatre*, and the *Woman With the Pink Veil* she says are good enough to bring high prices and if Teubner can't or won't sell them she will make arrangements to send them to somebody else—after they are sold she will never send anything except to New York where there is some chance and where she is known and acknowledged to have some talent—in Philadelphia it is the case of 'a prophet is never without honor, etc.' Now dear Aleck since Teubner won't write to me I am obliged to trouble you, and I am as sorry as I can be to do it, knowing that you are up to your eyes in business, but, this fuss over, I hope it will be the last. May has written to Teubner for an account of expenses

for frames etc., and he won't reply, whilst Mrs. Mitchell writes that he charges her with the transportation of Mrs. Ward's portrait from New York to Philadelphia, $10.00, what on earth she had to do with it I can't imagine.

"I had a telegram from Annie Scott from Antwerp telling me they will be in Paris tonight and will remain two days and asking me to call to see her at the Hotel Liverpool—I am going tomorrow morning—" She refers to Mrs. Thomas A. Scott and her mother Mrs. Robert Riddle (the latter Mrs. Cassatt's first cousin, Mary Johnston Dickinson). The two ladies later played a painful part in Mary's life and work. They recur in a December 13 letter of Mr. Cassatt's, which also suggests the direction in which Cassatt social life, such as it was, tended:

"Mame is working away as diligently as ever but she has not sold anything lately and her studio expenses with models from one to two francs an hour are heavy. Moreover," quoth the paterfamilias, "*I have said* [author's italics] "that the studio must at least support itself. This makes Mame very uneasy as she must either make sale of the pictures she has on hand or take to painting *pot boilers* as the artists say, a thing that she has never yet done and cannot bear the idea of being obliged to do. Teubner has fifteen of her paintings on hand unsold or had when last heard from. Now he is either scheming to tire her out and get the choice of them himself for nothing or else he is making such high prices as drive purchasers away. Mame offered through Mrs. Mitchell to take $700 clear for the lot but Teubner made no reply. I do not think there is any doubt but that they would sell for that money at public sale. The scamp would not even risk the framing himself but managed to get you to pay for it. I suppose you saw that the Boston paper gave Mame a silver medal. Her circle among artists and literary people is certainly extending and she enjoys a reputation among them not only as an artist but also for literary taste and knowledge, which moreover she deserves for she is uncommonly well read especially in French literature."

In a different letter to Aleck, Mr. Cassatt expands his views on Mary's literary taste: "I am not surprised you do not like the Russian books. I offered to bet Mame that you would not be able to read the last one [of 3 vols.] sent. What she found in them to be so pleased with I don't know. The description of the Battle of Borodine seemed to strike her as particularly fine but it is not to be compared to De Ségur." *War and Peace* is almost a litmus paper for whether someone is a reader or not.

"We rarely see any Americans, the Arnolds, Scotts, and lately young Covode. It is curious that at the Exposition I did not encounter a single American acquaintance. You see," Robert explained, "we do not go to either of the chapels or in any way court the [American] colony, and

from what we hear occasionally no doubt we thus escape a deal of very petty scandal."

However, within the charmed Cassatt circle any amount of well-meant bickering and hashing-over of each other's petty concerns went on, and on. Mary only avoided it by escaping to work in the Boulevard de Clichy. Her next few years witnessed a meteoric rise in production, accompanied by an equal rise in the quality of her work. From 1877, when she painted three pictures, it rose through seven paintings and pastels in 1878, to a record twenty-nine in 1880, the second year she showed with the Impressionists (the first was 1879). Her biographer, Achille Segard, has it that at the 1879 show Paul Gauguin, comparing her to Berthe Morisot, said, "Miss Cassatt has as much charm but more power" (since Morisot did not show in 1879, he may have said it in 1880). During the year of 1879 Mary finished fourteen paintings and pastels, including *La Loge*, portraying a radiant Lydia seated in a box at the Opera, which has been called the most distinguished picture of her career.

La Loge made Mary's name as an Impressionist (or, as the group was trying unsuccessfully to be called, Independent). Although in all Robert Cassatt's letters there is not one word of enjoyment or pleasure at anything Mary painted, he took pride in the praise of her. To Aleck, May 21, 1879, he wrote, "Her success has been more and more emphasized since I wrote and she even begins to tire of it—*The Artist* for May . . . contains an extremely flattering notice of her—and the *Review des Deux Mondes* [though] very hard on the independent artists generally makes an exception of Mr. Degas and Mame." The latter article had said, "M. Degas and Mlle. Cassatt are . . . the only artists who distinguish themselves in the group . . . and who offer some attraction and some excuse in this pretentious show of window-dressing and infantile daubing. . . . Both have a lively sense of luminous arrangements . . . both show unusual distinction in rendering the flesh tints of women fatigued by late nights and the shimmering light of fashionable gowns. M. Degas is more mature and able and is a more experienced draftsman." The liberal art critic Huysmans also praised Degas, together with "his pupil, Miss Mary Cassatt," though formally she never was that.

Their relationship is better suggested in a letter Degas wrote Bracquemond, the etcher, directing him to "Tell Haviland who was mad about a little picture by Mlle. Cassatt . . . and wants to know the price of it . . . it is a simple matter of 300 francs, that he reply to me if it is no go and to Mlle. Cassatt if it is a go." In other words, she was his protégée, and he shielded her. Mary, too, suggested the nature of their friendship by a letter she wrote, years later, to the dealer Vollard, concerning the conditions under which she painted her *The Blue Room*.

This exquisite picture, like *La Loge* painted at the beginning of Mary's association with the Impressionists, contains in essence almost every element of her talent. It is complete, speaking not only of its subject—a little girl sprawling luxuriously in an overstuffed blue chair—but of the little girl's painter, who felt with every particle of her. That little girl was in clover; blue clover. In every feature—the little dog in another blue chair opposite, the light coming in two long French windows in the background, the extraordinary elegance of the child's tartan sash with the white frock, her tartan socks and hair-bow—it constitutes one more of Mary's indirect self-portraits.

Of the picture Mary was to say to Vollard in 1900: "I did it in '78 or '79. It was the portrait of a child of a friend of Mr. Degas. I had done the child in the armchair and he found it good and advised me on the background and he even worked on it. I sent it to the American section of the big exposition '79 [actually the 1878 Great Exhibition]. They refused it. As Mr. Degas had found it to be good, I was furious, all the more so since he had worked on it . . . the jury consisted of three people of which one was a pharmacist!" Thus it appears Mary knew Degas' friends and their children, that he went so far as to work on one of her pictures (almost unheard of; even in the ateliers a master refrained from actually laying brush to a pupil's canvas, and if the attention had been undesired, it was cause for emotional holocaust); that she could (as ever) get mad, not only at slurs on herself but on Degas, and that her opinion of juried shows (especially ones that included druggists) was of the lowest, as was the official Impressionist position.

La Loge, too, holds up well. In 1971, M. Jacques Dupont, Ministère des Affaires Culturelles in Paris, and a nephew of the late M. Marcel Midy, who for a long time owned the picture, told of how he, Jacques Dupont, told his uncle that it would be folly, madness, to sell the painting —that he informed M. Midy he was an idiot!—but, alas, to no avail. "It is one of the great Impressionist pictures," M. Dupont declared.

The obvious thing today would be to assume Mary Cassatt's suddenly increased productivity during these years was the result of having an affair with Degas. It would be agreeable to imagine those two enjoying a little human pleasure; however, Mary was ever outspoken in her rejection of anything smacking of bohemian morals. She never mingled socially with the Impressionists. Those friends of Degas' whose children she might paint were not his painter friends; they were his bourgeois friends. While even the French bourgeois does not exactly condemn illicit relationships, there was another bar to an affair besides the two principals' often emphasized "respectability." If Mary had really been Philadelphian, she might have thrown her cap over the windmill—providing Degas, a gentleman, could

have dreamed of, in effect, seducing a young woman of good family. As Nathaniel Burt says, Philadelphia, unlike Boston, is not and never was puritanical about sex; it is how things of that kind *look* that matters beside the Schuylkill. Mary was, however, as she would have been the first to assert, not a Philadelphian; and, "out West," sterner reticences are built into their genes. George Moore, who would pin an affair on a woman if he possibly could, mentions of Mary that "she did not come to the Nouvelle Athènes." Going to a Montmartre café, for a lady, was tantamount to having an affair, for a Pittsburgher.

"Her studio was within a minute's walk of the Place Pigale [sic] and we used to see her every day," Moore reports, but the impression "see" gives, is of the nose-pressed-to-window variety, not one of intimacy. "Her art was derived from Degas as Madame Morizot's [sic] was derived from Manet. Mary Casat [sic] . . . is a rich woman." Although Moore wrote these words at the turn of the century, and by then Mary was considerably better heeled, she was never well enough off to be called rich. What Moore did was what many others did; what has been done ever since—take well-bred ways to denote wealth; a common misreading of social nuance. Her manner was actually part of her ingrained sense of decorum. Bohemianism was not in her.

In fact Robert Cassatt, on whom she depended as daughter of the house, was in those years even less well off than when he was running his desultory brokerage business in America. In Paris his was an extremely modest income. The only reason the Cassatts could consider keeping a carriage was that Aleck gave it to them. His mother's health had been demanding daily drives in the fresh air that Robert describes when he wrote thanking his son for offering the luxury: "She rides out every day . . . in a hack, but that is anything but pleasant and hardly safe. One feels pained and humiliated at having to ride behind such miserable brutes as Paris hack horses." Mary's earnings went to cover those studio expenses of hers, that her father laid down the law about as though his self-respect were threatened by this being-a-professional business. Otherwise, she lived like any daughter, off her family and with them, going along when, in summer, they resorted to one or another part of the country, at first to Divonne.

In the relation of Degas to the Jeune Fille Spartiate from America, sex, of course, played a part. Being who they were, artists, there was sex in everything they did; sex is in everything babies do, too. Art, however, happens to be one of the crucibles for converting sex into something else: like time, for converting babies into adults, or like the body (though that crucible is not generally so though of) for converting sex into babies. For artists, sex can be a force separate from the procreative act, because of this

ready-made container for sex, as with Keats, maddened by deprivation of Fanny Brawne; or Emily Dickinson, operating in what for anyone else would have been a vacuum. Meeting Degas did light in Mary fires of attraction, affinity, emulation, even hostility, that fed the creation of her many pictures up to that high of twenty-nine in 1880. The count reflects the intensity of the relationship.

What happens when the body is deprived of even a surrogate form of conversion? In his letter to Aleck about driving behind Paris hack horses, Robert Cassatt mentioned that "Mame's success is beginning to bore her." Bore her? Robert wrote to Aleck from Divonne on September 1st, 1879, that in spite of short trips—with family—to England and Italy, "Mame's health did not improve." Health? *Mary's?* Robert furnishes the standard parental diagnosis: "The fact is . . . she overworked herself last winter and the minute her [the Fourth Impressionist] exhibition was over she ought to have gone quietly to the country somewhere for a change of air and repose—When your Mother saw how miserable she looked at Lausanne [where the Italian trip ended] she at once decided to carry her back with her to Divonne where she seems to be already improving. She has been fretting over the fact that for three months she has not been doing any serious work and the next Annual Exhibition is already staring her in the face, and it is more incumbent than ever, after her . . . success, to have something good to present etc. etc."

Being at rest in the bosom of her family did restore her. It was, after all, the matrix within which the saving pearl had originally been formed. An artist's originality is balanced by a corresponding conservatism, a superstitiousness, about it; which might be boiled down to "What worked before will work again."

The choice that, from the modern point of view, was facing Mary— whether to retain the circumstances that originally produced the pearl and simply stay in the family circle, or to take the pearl and with it venture out on a new life—may not have existed in that form. There is no concrete evidence Degas ever asked to marry Mary (and none that he didn't, either). There is no proof about the physical extent of the relationship one way or the other. Mary burned all Degas' letters before she died and none from her to him have come to light. The closest to a statement with any authority is something Degas said to the art critic Forbes Watson, shortly before the former died.

Forbes Watson, who knew both Degas and Mary Cassatt, and grasped her complicated nature more profoundly than anybody, told the wife of the American painter Leon Kroll that once, after dining with Degas in a Paris café, he was galvanized to hear the old painter begin discussing his relations with Mary Cassatt. "I would have married her,"

Degas said, "but I could never have made love to her." (A few minutes later Degas, by then practically blind, complained of fatigue and left. Watson, disappointed at the revelation, called the waiter and consulted him on what to drink for a liqueur; "I feel depressed," he explained. "Drink champagne with your coffee," the waiter told him, "it is excellent for lightening the spirits.")

If the burning of Degas' letters suggests there was "something to hide," the suggestion is nullified by things Mary later said about sex and about Degas. Judgment on what their relationship in fact was must rest not only on the standards and mores of their time to the degree that they accepted them, not only on what they later said and did, but on the kind and quality of the emotion they put into their pictures, as into dreams. From the purity and force of feeling in Mary's, it is obvious that love was there, but love was the last thing she wanted. She wanted equality.

She is not only on record as lofty toward what Victorians deemed vulgar, hole-in-the-wall philanderings behind the backs of loving families; she was a truly devoted daughter. She had a full supply of that blind loyalty then considered the highest form of family love. Attachment to her family, identity with their interests, tended to move her into a position somewhere between two worlds. In Paris, by a curious reversal, and entirely unwittingly, the Cassatts, who had always been reserved, were taking on an attitude of exclusiveness that suggests the social arrogance these kindly, gentle people had experienced at the hands of the kindly, gentle, unwitting Philadelphians.

"We . . . make no acquaintances among the Americans who form the colony," Mrs. Cassatt writes to Aleck as early as December 23, 1881, "for as a rule they are people one wouldn't want to know at home, and yet they are received as specimens of the best society in America. The morning's paper mentions that Mrs. Mackay, wife of the California millionaire, and her mother and father and sister . . . have just dined with the ex-Queen of Spain, in company with the Minister from Spain and other dignitaries . . . They say [Mrs. Mackay's family] are as low and common as it is possible to be." Shades of Sidney Fisher! It might be wondered what an artist child of the Mackays might have made of that. The word "common," moreover, used about the Mackays is interesting in view of what Mary Cassatt is supposed to have replied late in life when asked if she had ever had an affair with Degas: "What! That common little man? What a repulsive idea." Her niece indignantly denied the story on grounds a lady would never have used that word. Yet Mary's adored, gentle mother did use it.

Of course the other group, Mary "and her mother and father and

sister," had no notion of passing themselves off as old Philadelphians. On the contrary. Simply they had brought with them and were now exercising mores and attitudes from the place they had just quitted. Emigrants always do. If the Cassatts had really been old Philadelphians, they might have had friends among the French. That they did not was the Pittsburgh, one step back, coming out in them. Among old, provincial, Revolutionary stock in America, "foreigners" remained, still remain in pockets of the Middle West, suspect, likely to be no better than adventurers. This suspiciousness is reflected in the characters of Henry James's novels. Cassatt family life was a bit like a little, privileged spot of rural Pennsylvania set down on the Seine.

It was, of course, not disagreeable, to find oneself in Paris in a position to exclude, instead of be excluded; not only to look askance at *nouveaux riches* and foreigners, but to be graciously at home to rootless trippers like the Scotts, to whom the Cassatts "showed attention." The Cassatts were, actually, in a position they had not enjoyed since the days of Allegheny City. They had an importance that, far from existing only in their own minds, is testified to even today by the French whom they impressed.

"Mary Cassatt came of a very aristocratic family," declared in 1971 Charles Durand-Ruel, then senior representative of the art dealers Mary was closely associated with throughout her career. "A very, very old family. She was the daughter of the President of an American Railway. Distinguished engineers, all her family." Allowing it to be true the Cassatts saw few people socially in Paris, he conjectured that they made friends among country neighbors, after Mary bought a château in the Département de l'Oise. "Mary Cassatt was of the same aristocratic class as Degas," M. Durand-Ruel continued, claiming it was this that formed the basis for their friendship. "Renoir, *par exemple*, couldn't handle his fork properly. The Cassatts were *tout à fait* rich American aristocrats."

It would have been agreeable to be so thought of, and agreeable for Mary too (although, as artist, she had no stake in Society, and was too honest for conscious snobbery). Simply, home, where she spent so much of her time, had become, as by a miracle, once more the self-contained drop of pure honey it was in her childhood. The family that had once fled to Paris from forbidden Philadelphia now, mysteriously, was equivalent to it: ideal, aristocratic, rich Americans, all of them engineers. It made a difference. More than ever Paris represented to Mary the place where people were happy. More than ever art was the pearl without price. More than ever Philadelphia was unpleasant; her back went up every time in her life Philadelphia was mentioned.

Her life was dividing itself between two worlds: her family, among

whom she moved vital, affectionate, sustained inwardly by a hard core of art; and the world of art where—as Madame Adhémar, Directrice of the Orangerie at the Louvre, puts the Impressionist feeling about her—she moved as a rich Society woman who by a fluke could paint, and paint well. All that was dark, dangerous, despicable was resident in Philadelphia —even in America, too; she sent pictures back to be exhibited with increasing acerbity. Her worlds only touched at the times "Mr. Degas" appeared in the Cassatt apartment, as duly noted in Robert Cassatt's letters; and when Mary's mother made her uncomprehending, or her father his inept, remarks about art and artists. Thus there are two stories of Mary Cassatt's next few years: the story of the American Family Cassatt, and the story of art and Degas.

SEVEN

1.

> Sweet day, so fair, so calm, so bright,
> The bridal of the earth and sky . . .

THE IMPRESSIONISTS' DAY, in which Mary Cassatt was living, is still there to be seen in Paris. Walk into the Jeu de Paume—that small building, part of the Louvre, balancing the Orangerie, where French kings used to play tennis—on any day, rainy or sunny. What hangs on the walls breaks forth in wondrous, beauteous light.

In the history of art there never was such a burst of light and it seems probable there never will be again. Before the Renaissance opened the world's eyes to the forbidden beauties of man and nature, Italian Primitives came close, with their jewel-pigments, to a comparable brilliance; but that brilliance bore little relation to real light. After the Primitives, for centuries the greatest painters painted with a fidelity to nature that increased as they mastered such technical difficulties as perspective and foreshortening; but if you go into the regular part of the Louvre, where the old masters hang, after exposure to the Jeu de Paume, even the greatest look dark.

There had been hints of the coming day. Some of Turner's pictures look as if painted within the Impressionist fold instead of years earlier. Impressionism's immediate lineal descent can be summed up: Ingres, the neo-classicist, was born in 1780; Delacroix, the romantic, was born in 1798; Courbet, the realist who influenced the Impressionists most, was born in 1819, and most of the Impressionists were born about twenty years after Courbet. The Impressionists were, even more, realists, but most important, they were the first painters ever to render light the way light looks.

Painters in the past had been under the impression that they *were* rendering light, but then science, in the early nineteenth century, came up with a theory of the composition of light, based on breaking down the spectrum into its component colors, red, orange, yellow, green, indigo, violet. The Impressionists, by literal application of this theory (artists are above all literal), tended to paint in separate touches of pure color, making it possible for the physical sensation of outdoor light to be re-experienced within the eye of the beholder. Once more, as in the Renaissance, science

released to art an illumination, before a new kind of darkness set in: the search into the inner state, instead of into the world, initiated by Cézanne —an Impressionist who was clumsy at the Impressionist skills. Looking within was, simply, what came next in art; it was perhaps not a coincidence that so many of the Impressionist painters went blind: Pissarro, Degas, Mary Cassatt, Renoir partly, Monet partly, as though the direction in which art was looking, shifted, beyond their control, away from what had at last been understood and conquered: the world.

Mystery and fascination draw painters to what they paint; and they cannot choose what will mystify and fascinate them. Even more than technical innovations, like pointillism; even more than that blaze of painted light, the Impressionists' answer to the challenge of the world's mystery was their subject matter. They painted the radiance in ordinary life. Once more artists were looking at what was right in front of them when everybody else was looking past or over it. They painted the blithe side of reality—the beach with its holiday-makers, bathing-machines, and rakish ships at sea, or a boating picnic beside the river of simple souls like themselves—and its dark side, too: prostitution, absinthe, and despair.

The public, dedicated solemnly to the status quo, wanted to be shown the world's glories, its allegorical significance, not its reality. As usual, the mean and the despised carried not only the ring of truth but the seed of the future. To the public, however, it seemed obvious these crackpots could be up to no good. Nobody, of course, likes to be hit in the eye (as painters call it), but one reason why it took so long for prejudice against Impressionism to subside was because of the confusion of its subject matter and morality. Artists had long been known as low fellows given to love affairs that differed from ordinary, decent love affairs in being openly conducted. Now they were getting really out of hand, with this depicting prostitutes without the proper sentiments, this painting woozy landscapes whose wooziness nevertheless hit a fellow in the eye. They were making black, white. Morality had always attached to the status quo, immorality to change. The Impressionists seemed on many counts to be doing wrong. They no more hesitated to paint the honest daylight in razzle-dazzle spots, than they concealed their amours.

Of them, Édouard Manet—painter of *Olympe*—who had really begun the movement during those long sessions at the Café Guerbois, carried on a long liaison with his piano teacher, by whom he had an illegitimate son. Not until his father died leaving him money did he marry her (after they were married the son was always referred to as her younger brother). Later Manet contracted another liaison, with a type described by one of his admirers as "a slightly demented muse," and yet Manet was,

with the exception of Mary Cassatt and Degas, the most bourgeois and respectable of the lot.

Claude Monet, angel in art and devil in sex, exploited his lovely model, later his wife, Camille Doncieux, for years: sleeping with her, impregnating her, exacting abortions of her, from the time she was eighteen till she died at about thirty, exhausted and no longer beautiful. Monet then went on living with a lady he had already taken up with, prosperous to boot; he later, after her husband died, married her.

Auguste Renoir for years had a liaison with his model Lise. (She never forgot him, and, after he died in 1922, burned all her mementos of him—except the pictures (including seven Cassatts, many of them now owned by Paul Mellon). Camille Pissarro, most mature of them all and father-confessor to most, lived with the mother of his child for years before they married, in his case less out of bohemianism than because of his advanced sociological views. From lives like these Mary Cassatt did not exactly recoil but held herself aloof.

Yet it is Mary Cassatt's distinction that when she arrived in Paris she, almost alone out of the American artists, recognized her great contemporaries. Her reaction to being asked to join the Impressionists—"I accepted with joy"—is in contrast to a letter from a woman artist of the same age, studying in Paris at the same time, that describes the 1880 Impressionist exhibition: "Dear me, how queer they are! And how unexpected, as startling as a Japanese work! Some of them seem to lack common sense. But one doesn't hate them, and there is something very refreshing about them. Still, you can see the painters weren't brought up to look for values since they were children, and that makes them a little queer now." To the hall of art fame, the name of its author is unknown.

The best work of artists in any age is the work of innocence liberated by technical knowledge. The laboratory experiments that led to the theory of pure color equipped the Impressionists to paint nature as if it had only just been created. Monet painted picture after picture of Rouen Cathedral—at six in the morning, at ten in the morning, at noon, in the afternoon—each an essentially different painting, demonstrating that what matters is how an object looks, not what it is. (A layman can catch a glimpse of this seeing freshly, if he will look at the room he is in, in a mirror, and see how the reversal of its contents makes the scene new, mysterious, intriguing.)

If Impressionist art could be nailed down to its most salient feature —of course it is impossible ever to nail art down—it might be the radiant knowledge that the object, in a different light, becomes a different object; which dawns also on the viewer of the pictures. The abstractionist painter Kandinsky, of another of Monet's series of paintings in differ-

ent lights—a haystack at different hours—explained one effect of this discovery: "Painting took on a fabulous strength and power . . . at the same time, unconsciously, the object was discredited as an indispensable element of the picture." The way was paved for the insights of nonrepresentational art, although it had been far from the Impressionists' desire to dispense with those objects that, to them, were so beautiful and so infinitely various.

In the eighties and nineties of the last century there were, instead, a fascination and a glamour about simply being a painter, one blessed with this new knowledge. Mystery that had been routed out of the immutable object now moved its magic into the subject, the one who saw the object. It really *was* glad confident morning, then. Never did painters have such a wonderful time painting; their happiness is there to see today, in Manet's beach, Degas' race track, Renoir's picnic, Monet's garden. In England, writing at the same time as the Impressionists were painting, and responding to the same *Zeitgeist* and the same inner discoveries, struggles, and forebodings, Matthew Arnold put the feeling that they expressed mutely but more clearly, "The sea of faith was once, too, at the full . . ."

This radiant life, to which meeting Degas gave Mary Cassatt the cachet, was reflected at once in her work, in a series of scenes at the Paris Opera—intoxicatingly gay, entirely unlike her hitherto soberly painted subjects, speaking of the excitements of the debutante leaning forward eagerly from her box. Mary *was* a debutante in Impressionism. In the brief years of her Paris Opera paintings she expressed not only her feeling for its elegance but a feeling for its frivolity, its pleasure, that she felt as a painter because she had experienced something akin. Nothing could better epitomize the world of Paris than the new Opera House, built 1861–75, as described in a contemporary guidebook:

"The new Opera on the Boulevard des Capucines' appearance, when all the gas-jets are lighted, is of a most gorgeous, character. The visitor is advised to sacrifice a whole act of the piece to inspecting the building. Nothing can surpass the magnificence of the materials with which the building is lavishly decorated and for which the whole of Europe has been held under contribution. Sweden and Scotland have yielded a supply of green and red granite . . . Italy yellow and white marble . . . Finland red porphyry . . . Spain 'brocatello' . . . Competitive plans sent in by the most eminent architects resolved that the edifice should in every respect be the most magnificent in the world, altogether unrivalled."

Among its other glories, the Opera contained a "magnificent and curiously-shaped lustre [chandelier] containing 340 burners [which] seen from below presents the appearance of a crown of pearls [See Mary's sketch for *Two Young Ladies in a Loge*.] The Grand Foyer extends the

whole length of the building, lighted by ten gilded lustres and huge candelabras as if made of solid gold, being relieved only by a huge mirror 23 feet in height, skilfully placed to prolong the hall *ad infinitum*. The visitor should not omit to place himself in one of the balconies for viewing the grand staircase where fifty persons can stand abreast . . . Government allots an annual subvention of 800,000 francs toward the support of the Opera. A good tenor receives a salary of 100–120,000 francs. Composers and authors of new pieces are each paid 500 francs . . . The seats are all comfortable. *Fauteuils d'orchestre* 13, *amphithéâtre* 15, *stalles de parterre* 7, *premières* 15, *deuxièmes* 12, *troisièmes* 8 francs." (The 100,000 francs for a tenor was the equivalent of $19,750.00, then a handsome salary.)

The woman who could paint *Two Young Ladies in a Loge* and the other Opera pictures, if she had been less complex, if she had not, paradoxically enough, been an artist, might have wanted to share this life in reality with Degas no matter what he was like. In fact, she began to share his life anyway, the part that mattered most to both of them: art. He came to her studio, and she went to—worked in—his, probably with Lydia as duenna, and with the presence, just around the corner, of heavy family chaperonage. Both worked from models, who were right there too. Their working together did not contravene their highly Victorian moral fealties, since what art represented in the artist mind and to some degree in others was not only the tales of wicked bohemianism but a growing belief in art as something separate, apart, "above all that," which the Victorians were subscribing to. Even some of the puritanical were willing to defend the purity of art. Anyone who looked askance at a nude, for example, was coming to be thought of as a philistine who didn't realize the nude was exalted; practically holy. To this belief Mary adhered, and she so far convinced her family of it as to allow her to go, as they did, to a man's studio. To them, art was so foreign that they could perhaps accept the purity concept as no queerer than the rest of it.

Mary Cassatt and Degas had a wonderful time working together; one of the pleasures of painting is its special fellowship. For Degas, a woman's company was comfort for the suffering in art of which he was so keenly aware. For Mary, who would not face suffering, even in art, a male presence furnished as ever the necessary stimulus to her inquiring artistic imagination. It was Degas who suggested to Mary Cassatt the maternal theme which was to occupy her talents to some degree for the rest of her career. The first mother-and-child picture she painted came in 1880—the pastel, *A Goodnight Hug*—and illustrates the obverse side of suffering: tenderness, compassion. Although Degas recommended the theme, as an unworked vein, it is as if the real-life Mary, having passed through being

the thrilled debutante to life, entered, with this, the next stage of a woman's development, maternity.

Degas painted a portrait of Mary in about 1884 that reflects what she had become. Gone is the shy girl of the 1878 self-portrait in the bonnet, leaning askew. Degas' woman, forthright, intense, energetic, leans forward in an almost masculine attitude, elbows on knees. Her eyes—still the artist's eyes—are somewhere else than on the cards she holds in her hands. Not so much a woman sits here, confidently considering, as an artist.

The portrait has many other associations besides the curious view of it Mary took in later life, which made her violently reject it. One common myth, misreading both her and the Cassatts, is that the cards she holds were playing cards, and that the reason she later tried to suppress any connection with the picture is that she was opposed to card-playing on religious grounds. Nothing could be further from Cassatt tradition, conventionally Episcopalian; their most prominent member was, in fact, active in American horse-racing circles. The cards, insofar as they are identifiable at all, may be cartes de visites—photographs mounted on stiff cardboard that the Victorians used to exchange with one another; or, even more likely, a group of pochades—small oil studies—that the artist is dreaming up plans for.

When the Impressionist exhibition of 1879, at which *La Loge* was shown, closed, it was with a profit of 6,000 francs which, divided among the contributors, gave each 439 francs. (In 1878 the value of the franc was 19.3 U.S. cents per franc.) With her share Mary bought a Monet and a Degas; by that time she already owned pictures of Pissarro, Renoir, Sisley, and Monet; her impulse, like Degas', was ever to put money not earmarked for necessities, into pictures.

The world of art opened its doors to Mary with increasing hospitality, not only in Paris. In 1876 she had shown at the Pennsylvania Academy for the first time, and again in 1878 and 1879. The pictures she sent belong to the pre-Degas period, and include the colorful but banal Spanish *Matador*, the immature *Mandolin Player*, and the 1873 portrait of her mother which—though not a patch on the later portraits of her—was the only one with much feeling. In 1878, Mary was represented at the Fifty-Third Annual Exhibition of the National Academy of Design in New York, then and long afterward a prestigious outfit, with a portrait of Mrs. W. B. Birney; and she sent three pictures to the 1878 Thirteenth Exhibition of the Department of Fine Arts of the Massachusetts Charitable Mechanics Association in Boston: *After the Bull-Fight*, *The Music Lesson*, and *At the Français*, a study. None was her best work, yet at

the Boston show she received those flattering notices in the *Transcript* that Mr. Cassatt wrote Aleck about.

J. Alden Weir, in Paris in 1878, sent an invitation to Mary to show with a new group in New York of independents, the Society of American Artists. She felt she must decline. She had been away when he wrote and the letter was not at once forwarded to her. On March 10, 1878, she made clear to him her Impressionist stand: "Thank you very much for all the kind things you say about my work. I only wish I deserved them. Your exhibition interests me very much. I wish I could have sent something . . . I am afraid it is too late now. We expect to have our annual [Impressionist] exhibition here and there are so few of us that we are each required to contribute all we have. You know how hard it is to inaugurate anything like independent action among French artists, and we are carrying on a despairing fight and need all our forces, as every year there are new deserters [in 1879 Renoir, Marcellin Desboutin, and Manet did not show] . . . I always have a hope that at some future time I shall see New York the artist's ground. I think you will create an American school . . . You have been so kind to me I feel thoroughly ashamed of myself for not having done something good enough to send you, next year I will do better, and I hope my artist friends here will send with me."

She was as good as her word. To the Society's Second Annual she sent two pictures. The art critic William C. Brownell wrote of them, "The portrait which Miss Mary S. Cassatt sent from Paris to the Second Exhibition of the Society of American Artists stimulates a lively regret that she should keep her countrymen in comparative ignorance of the work she is doing. If [the pictures she sent] seem to lack charm . . . in force few if any among American women-artists are her rivals. There is an intelligent directness in her touch and her entire attitude, besides which a good deal of the painting now abundantly admired seems amateur experimentation. Her work is a good example of the better sort of 'impressionism' and the sureness with which, contrary to the frequent notion of it, this proceeds; and perhaps it is especially successful in this because Miss Cassatt served an Academic apprenticeship, and 'went over' to Degas and the rest of the school, only after she had acquired her powers of expression."

This is not neglect, this is appreciation. Mary's had been, earlier, among the first Impressionist pictures America was exposed to; and it was their critical success that prompted Weir to ask Mary to become a member of the group. That invitation she accepted, and kept her membership, although on only one other occasion did she show with the group, a retrospective exhibition in 1892.

In 1880 Mary, moreover, contributed a picture lent by her friend Miss Elder's mother, to the Thirteenth Annual of the American Water Color

Society in New York, held at the National Academy of Design. American art held out its arms to her, certainly, but more and more she began to turn a cold shoulder on it, even though American recognition was what, more and more, she yearned for.

Mary spent much time working with Degas on a project he had thrown himself into, an art journal which was to have been called *Le Jour et la Nuit*. Expenses for publication, even at that time high, he planned to secure from the banker-collector Ernest May, and the well-heeled painter Gustave Caillebotte. In the end the project came to nothing, but the work intensified Mary's association with Degas. The plan was for her to submit a soft-ground etching and aquatint, with, as subject once more, a young girl at the Opera and a pastel that would be still another variation on the theme.

Degas was to contribute an etching and aquatint entitled *Au Louvre: Musée des Antiques*. Mary was the model. Like Mary's own contribution, it was one of a related group of pictures. The Degas etching of Mary standing in an identical pose, dressed in an elegantly tailored suit, leaning as usual askew on an umbrella as she regards an exhibition, is another of this group. What exhibit is being viewed, varies with the variations. In the aquatint, it is an Etruscan tomb in a glass case; nearby Lydia Cassatt, holding a catalogue, sits, in her probably eternal pose of duenna to them. In the etching which is entitled *Au Louvre: la Peinture*, it is a picture. There exist as well three pastel studies, of Mary alone, and of the two sisters together. In them all the standing figure is the dynamic one. Leaning her weight on the umbrella, tipping her head critically to one side, the elegantly dressed woman looks opinionated, cocky, nobody's inferior; looks, in fact, like what Degas liked—one of those Spartan girls, and taking just the sort of pose that broken-down models find hard to hold.

Degas' use of this theme entails a mystery. He told a friend that, in these studies of Miss Cassatt looking at exhibits, he wished to show woman's crushed respect and absence of all feeling in the presence of art. What did he mean, crushed? If anything was crushed, it was Degas' own tender feelings by his overbearing intellect. It is true the elegant costume, the fashionable stance with weight thrown on one hip, the critical gaze, suggest the type of society woman who would, very likely, have little respect or feeling for art. But *Mary Cassatt*, crushed in the presence of art? It is like a clue to something mysterious that was happening.

One thing that was happening was the growth of Degas' depression. Daniel Halévy tells how, after 1880, "his vision of the world darkened." Halévy lays this to the decline of Degas' financial fortunes, which the younger man misdates as not beginning till 1878. "The rather unsociable Degas whose image has persisted dates from that time," he continues. "I

think he had enjoyed receiving his friends in his pleasant house in the rue Blanche; I think the studio in the Cité Pigalle was the first refuge of his antisocial feelings. There he ceased to be an artist wealthy enough to choose his models. He became an impoverished painter who had to earn his living and support his brothers who had become poor like himself. However, he never tried in any way to please the public. His choice of new models was a sign of his depression. Formerly he had been preoccupied by ballet dancers and horses. Henceforth he would choose as models people exhausted by hard work or worn out by the routine of a life of shame"—or, perhaps, a society woman gazing critically, without respect, at exhibitions of art? Was there in this choice of a subject any reflection of the bitterness that would attend an inability to support such a woman in the style to which she was, or her father expected her to be, accustomed?

"Although thus cut off from society," Halévy goes on, "Degas did not abandon the Impressionist exhibitions that he himself had started . . . Indeed, he announced a new exhibition. Only the name was changed to the Exhibition of Independent Painters. [This later show took place in 1886.] The chief work that he showed was a series of seventeen drawings, an ensemble that impressed all visitors by the authority of their line. Huysmans admired these drawings, all of which show the nude in various intimate attitudes. He noted that there was no effort at grace, that the awkwardness was frequent and deliberate. Huysmans was astonished at [their] 'misogyny.' 'Misogyny," the word thus applied to the painter *for the first time* [italics the present author's] henceforth became the term that for many people characterized Degas." Could decline in the state of his finances be responsible for all that misogyny?

A story told by Halévy illustrates Degas' opinion of society and of fashionable women:

"One day at the Opera," Degas [said], "two ladies were resting their great, fat arms on the velvet railing of their box. Suddenly, from up in the gallery, came the cry, 'Down with that ham!' Nobody understood. Again the plaintive voice from the gallery, 'Down with that ham!' The audience began to whisper, trying to understand. Finally they caught sight of the fat arms and hooted. The ladies were forced to withdraw.

"What would an Oriental think, coming into a bourgeois salon and seeing naked cows sitting on chairs, while their husbands, who have made a neat little fortune in business, stand by half-hidden in doorways? The mere fact of being a woman's husband obliges him to haul her from one salon to another quite naked. —If you could have seen Madame de Fleury that year at Diennay! I sat next to

her at dinner one evening; she was décolletée! And even though I am rather surfeited with such things, I couldn't keep from looking at her arms, her shoulders, everything. —She said, 'Are you staring at me?'

" 'Good Lord, Madame,' I replied. 'I wish I could do otherwise.' It was a mixture of impertinence and flattery. And there, at the other end, sat Monsieur de Fleury who could say nothing because he had lost all his money gambling . . ."

At the same gathering where Degas told this tale, the Halévy account continues,

There was talk of the mistress of a Monsieur Cahen, a woman whom Degas had known slightly . . . [Degas] said enthusiastically, "She is common." And he added, "It is among the common people that you find grace."

It was with this period, and not before, that Degas began to earn his reputation for bad temper. His anger could light on any number of objects, oftenest and most reasonably on critics—not only the artist's bane, but to him incredible. One art critic who came around to Degas' studio said when the door opened, in an effort to ingratiate himself, "Bon jour, cher maître."

"There is no cher maître here!" cried Degas, slamming the door in his face. Turning to the model, he remarked, "One of those damned art critics." It infuriated him that anyone could imagine that they knew anything about art merely from thinking about it, or from aesthetic feelings. The English critic Wynford Dewhurst related that Degas threw another importunate critic who tried to visit his studio (could it have been Dewhurst himself? He certainly sounds disgruntled when he complains it was "extraordinary that a pupil of Ingres should create such appalling creatures . . . ladies of the lower class engaged in personal ablutions") down the stairs. "The journalists [who] annoy us with their articles, their comments," Degas said, "always . . . want to explain; they're forever explaining. There *is* nothing to explain. How stupid to make people come and see what we are doing—Beauty is a mystery."

If the choice to be artists in a world of non-artists sounds an easy or enviable one, Henry James's *The Tragic Muse* should dispel the illusion. Written about that very period, or even a trifle later, the novel reflects how ignoble, how shameful, how low, art seemed to upright members of society, when compared to what was called "a useful life," "a life of action." William Rothenstein, the English draftsman, in his *Men and Memories*, uttered a cry of the heart that could have been Degas':

"O collectors, O museum directors and other experts, your familiarity with art, the complacency and familiarity with which you speak of master-pieces, sometimes makes me long to say 'Down on your knees' before a work even by a good living artist. The essential difference between the artist and the student of art lies in this: the artist is, above all other men, a man of action. For he acts each day without any action being demanded of him; and the act of creation calls for supreme energy, will, and sustained effort; and this not for days, but for weeks, months, years —in fact for a lifetime. In comparison with this exercise of will, how rarely is the so-called man of action required to exercise all his faculties! It is not appreciation or industrious scholarship; it is creative energy alone which keeps beauty immortal. To know about things is less difficult than to do them." Degas would have agreed; one honest painting was worth a hundred critiques; he summed the matter up one day when standing with a group of writers who were talking journalistic shop. One of them, Alphonse Daudet, accused Degas, who had remained silent, of being scornful of him. "I'm scornful of you as a painter," Degas replied.

Other artists, not up to Degas' ideals of art, ran afoul of Degas' savage wit. Léon Bonnat proudly showed Degas a painting by one of his pupils depicting a warrior pulling a bow, and said without arrière pensée, "He aims well, doesn't he, Degas?" Degas said, "Yes. He aims at a medal" —for nothing enraged him more than historical paintings, once he was finished with doing them himself; always excepting the *Spartan Girls*. He called Meissonier "the giant of dwarfs," Helleu "the fuzzy Watteau," and Albert Besnard "the fireman who himself catches on fire." To Jean-François Raffaëlli, Degas made this prophecy: "In the days more or less far off, when we will be more or less forgotten, and there is no longer any question of your painting, if it should happen that your name comes up, they will still say, 'He was the one who did not understand Ingres.'"

Even painters of his own persuasion did not escape Degas' ire. He was enraged when Manet cut out from the portrait of the Manets Degas painted and presented to them the face of Madame Manet, because he felt it did not do her justice (a most unpainterly thing to do); he took it out of Manet's house and carried it away under his arm. He was furious with Renoir for selling another of Degas' presentation paintings. Toward them he preserved, together with unwavering admiration of their work, a certain animosity ever after (yet it was Degas who rescued the cut-up pieces of Manet's *Execution of Maximilian*). At the 1882 Varnishing Day at the Salon he remarked that Manet "played at being a painter" and, to Vollard, remarking "Poor Manet! Poor Manet!" added that his powers had sadly declined. He came closer to the mark when he said of

Renoir, "You've seen a cat playing with colored wools? Well, I'll show you a Renoir in my studio." Monet, purest exponent of Impressionist theory, Degas once threatened to shoot, brandishing his cane at him. After Monet sent two pictures to the wicked Salon, in 1880, Degas referred to the act as "frantic advertising" and stopped seeing him for a while.

When the term "misogynist" was first applied to Degas, in that criticism of the 1886 show, Huysmans found in Degas' series of drawings "a careful cruelty, a patient hate . . . he must have wished to hurl the most flagrant insult at his century by demolishing its most constantly enshrined idol, woman, whom he debases by showing her in her tub, in the humiliating positions of her intimate ablutions." A hundred years pass, and the light falls differently on the model. What seemed awkwardness is seen as truth; what seemed hate is seen as love; what seemed misogyny is revealed as a despairing plea in support of woman, and against her voluntary surrendering of her self-respect. It is a demonstration of the Impressionist discovery that the same object, seen at different times of the day, becomes a different object.

In the 1880 Impressionist show, the Fifth, held at 10, rue des Pyramides at the corner of the rue St. Honoré, Mary Cassatt had again taken part. That time Huysmans wrote: "It remains for me now, having arrived at the work of M. Degas, which I kept for the end, to speak of the two lady painters of the group. Miss Cassatt . . . pupil of Degas . . . is evidently also the pupil of English painters, for her excellent canvas, two women taking tea in an interior, makes me think of certain works shown in 1878 [at the Great Exhibition] in the English section.

"Here it is still the bourgeoisie, but . . . it is a world also at ease but more harmonious, more elegant. In spite of her personality, which is still not completely free," wrote the astute critic, "Miss Cassatt has nevertheless a curiosity, a special attraction, for a flutter of feminine nerves passes through her painting which is more poised, more calm, more able than that of Mme. Morizot [sic] a pupil of Manet."

The picture that Huysmans (Mr. Cassatt wrote to Aleck: "pronounced *Wismahn*") describes, conveys moreover the veritable atmosphere of the Victorian family Cassatt; the silver tea-service in it was in fact made for Mary's grandmother, Mary Stevenson, in 1813, and is still in the family. Red-haired Lydia, who posed, appears, if not ill, pensive; she has poured tea for a bonneted lady who is delicately sipping the last in her cup. This comfortable, decorous world, where Degas could feel at home, but not Renoir, was at once bond and barrier between Mary and Degas—bond because it was their native habitat,

barrier because, as things worked out, it would have been different for them if that world had been different.

There is a bond to something else, as well, in this well-known painting, now at the Museum of Fine Arts in Boston. "The composition is more carefully constructed than anything she had painted up to that time," writes Sweet. "Vertical lines in the wall paper give strong accents, while across the picture play various diagonals, formed by the side of the table, the back of the sofa, and the placing of the ladies' arms . . . How daring it was to obscure the greater part of the woman's face with a tea-cup, but how important this is in the design of the picture, for a diagonal tension is set up with the teacup on the tray, while the saucer suspended between the two becomes the anchoring point of the whole composition."

These diagonals constitute one of the main influences of Japanese art on almost every one of the Impressionists. Back in 1856 the painter Félix Bracquemond, friend of Degas, discovered a little volume of Hokusai prints that had been used as part of the packing material in a crate from Japan. Through this friend, Degas first met and was conquered by "Japonism." There was about that time a shop coming into favor with the intelligentsia, the Jonque Chinois, which showed Japanese prints; that was where Degas bought his own collection. The influence of the prints on his work is obvious in such pictures as *Femme aux Chrysanthèmes*— which has been called "all chrysanthemums and no woman"—a highly asymmetrical, diagonal composition seen from an unusual angle. (The Goncourts patronized the Jonque Chinois before Baudelaire did; then came the Impressionists; then all Paris. It can, of course, be safely left to the Goncourts to have claimed that they originally discovered Japonism in 1860, at the first show of Japanese prints held in Paris. Degas got his own back at Edmond Goncourt in comparing him to a pumpkin: "with the folds of [its] buttocks over [its] red loins. Goncourt thinks and writes in this manner.")

The Japanese influence changed the whole face of art. For a time it was such a rage that its last, faintly glowing embers still smolder today in old-fashioned houses on whose walls are choice Hokusai prints and shelves of blue and white china. Museums more formally preserve the prints that started the rage, as well as the results of the rage in the work of painters like Henri Fantin-Latour and, most conspicuously of all, James McNeill Whistler. Admirers of *Whistler's Mother*, as it is commonly called, are really admiring, whether they know it or not, Japanese principles of composition; the same is true in Whistler's *Portrait of Carlyle*. Whistler was also mad for the blue and white china the Jonque Chinois sold, and their Japanese costumes; he bought quantities of both to use in

pictures like the *Princesse du Pays de la Porcelaine,* for which his mistress, beautiful Jo, posed wearing a kimono.

Pissarro, Monet, and Degas all, to varying degrees, changed their ideas of composition after seeing the Japanese prints—incorporating the off-center arrangements, the modulated, varying line, the dramatic foreshortenings with the model seen from directly above, or from below, or some other surprising angle. These three painters did not, like Whistler, use actual Japanese elements except on occasion. They simply allowed their whole way of seeing to be revised. Through their eyes, the world's seeing was revised too. It is interesting, however, to note that Paul Cézanne, so much more admired today than, say, Whistler, whose pictures have been demoted in his London's Tate Gallery, was scarcely affected by the Japanese trend.

Mary Cassatt was greatly affected. Her paintings were; and especially her etchings, aquatints, and dry points. (The difference between an etching and a dry point is that etchings are drawn on a prepared surface that has been applied to a zinc or copper plate; the lines are then bitten, in a nitric acid bath, an ink-saturated roller applied, and printed. With dry points, the artist draws directly and irreversibly on the plate, with a diamond- or ruby-point pencil. An aquatint also uses a ground for the preliminary drawing-on, but is bitten in a reverse manner from etchings: the flat surfaces, not the lines, are printed, in colors applied to the plate before each of a number of superimposed impressions.) It was a combination of dry point etching, and aquatint, that Mary was getting ready for the abortive *Le Jour et la Nuit.* That was before new influences really took hold of her.

2.

THE ADVICE ON art-collecting that Mary gave her brother Aleck so generously really belongs to the other side of her story, but it affects the story of art and Degas in that at least part of Mary's generosity came from the desire to help her Impressionist colleagues. Aleck, a cautious man about betting on the unknown, missed many chances Mary gave him. During the summer of 1880, when Aleck was posing at Marly for one of her portraits of him, she wanted to secure for him what an art historian could call an "important" Degas, but the one she had in mind was unfinished. Degas declared he would have to repaint it entirely, something he did not want to bother to do. He added that after he was dead

the picture would very likely be bought by some artist who liked it and didn't care whether it was finished or not.

It is one more of those truths about art and artists, that Degas was as apt at throwing off as Robert Cassatt was inept at grasping. In general, collecting is pursued by men like Aleck Cassatt who want their pictures signed, who want them finished, who do not, really, know how they look, and even less whether they really like them. The bad Renoir in the Barnes collection is a product of this kind of collecting. There is absolutely no harm in such collecting, it has in fact been responsible for giving the public access to many a great picture which might otherwise have rotted among some artist's stacks of unsold work, but it has nothing to do with art itself. As Degas said, an artist—or a man who cares—will buy a picture simply because he likes it; a few great collectors like Mrs. Havemeyer and the Clarks did too.

That autumn of 1880, real tenderness and devotion to Mary breathes from a letter Degas wrote on October 26, 1880, to Henri Rouart: "The Cassatts have come back from Marly . . . Mlle. is installed in a studio on the street level which it seems to me is not very healthy. What she did in the country looks very well in studio light. It is much more firm and noble than what she did last year." One of the pictures he refers to is of Mrs. Cassatt, posed with three of Aleck's children, Sister, Robbie, and Elsie, which Mary finished in Paris in time for the opening of the Sixth Impressionist Exhibition of 1881 in the Boulevard des Capucines.

This show precipitated a conflict among the Impressionists. Degas—outraged by Monet and Renoir's defection in showing at the Salon again when it was an Impressionist tenet that juries were never to be submitted to—in turn enraged the Impressionists by inviting outsiders to show with the group, men like Félix Bracquemond and Federico Zandomeneghi who were in no sense Impressionists. This was the kind of row among artists that Mr. Cassatt loved to sneer at in his letters. Degas was not fighting because he was a selfish brute; he was fighting because his principles were involved; but to a born outsider like Robert Cassatt, those principles seemed, when not ridiculous, mere self-absorption.

Of Mary's pictures in the sixth show, Huysmans wrote she was now "an artist who owes nothing any longer to anyone, an artist wholly impressive and personal. Her exhibition is composed of portraits of children, interiors, gardens, and it is a miracle how in these subjects, so much cherished by the English . . . Miss Cassatt has known the way to escape from sentimentality, on which most of them have foundered, in all their work, written or painted . . .

"For the first time, thanks to Miss Cassatt, I have seen the likenesses of ravishing children, quiet, bourgeois scenes painted with a delicate and

charming tenderness. Furthermore, only a woman can paint infancy. There is a special feeling that a man cannot achieve . . . only a woman can pose a child, dress it, adjust pins without pricking themselves . . . This is family life painted with distinction and with love . . . Miss Cassatt, who is an American, paints us, the French; but upon these so-Parisian homes she sets the friendly look of 'at home.' She achieves something none of our painters could express—the happy contentment, the quiet friendliness, of an interior."

Talk of womanliness left Mary cold; it was this recognition of her achievement that pleased her. She was, in fact, being recognized on every hand. The redoubtable *Figaro*, bitter critic of most Impressionists, praised her; the *Parisian*, although organ of that American colony which resented the Cassatts' aloofness, praised her. She had, in effect, conquered, in the only realm where she cared about conquering. She was thoroughly entrenched as one of the Impressionists' own. Famous figures in the art world asked to be presented to her. She had made good sales out of the 1881 show. Her independence of the effusions of the critics she expressed boyishly: "Too much pudding."

Advising Aleck on buying pictures served as a sort of liaison between her two worlds. She bought for him a Pissarro and a Monet, for which she had to pay 800 francs. She usually complained of whatever Monet asked, disloyal as it was to a fellow artist—artists like Pissarro, for instance, made little enough for their heart's blood as it was. In a letter to Aleck dated April 18, 1881, Mr. Cassatt wrote, "You will probably be the only person in Philadelphia who owns a specimen of either of [these] Masters. Mame's friends the Elders have a Degas and a Pissarro, and Mame thinks there are no others in America."

He was right. Aleck was second only to the future Mrs. Havemeyer in buying French Impressionists. Mary tried again to get a Degas for him, but as usual Degas turned difficult, and no picture was forthcoming, although Degas was still strapped for money. It is an instance of an artist's disinterestedness: he did not sell because he did not want to sell, even when his friend Mary asked him to. After Degas' death in 1917 his dealer, Durand-Ruel, gave René Gimpel another point of view on such high-mindedness: "He was a dreadful creature. When he parted with a picture his dearest wish was that it shouldn't be sold and, given the chance, he wouldn't fail to speak disparagingly of it. For thirty years he wanted nothing to go out of his studio; occasionally we'd be allowed a study. When he came to see us, we had to watch that he didn't take anything off with him. He'd have been quite capable of taking back one of his canvasses on the pretext of improving it, and we'd have never

seen it again." Degas' friend Rouart chained his *Danseuses,* by Degas, to the wall.

Miss Elder and Aleck Cassatt constitute the vanguard of a passion for French Impressionism that still burns in American hearts. When John Hay Whitney was Ambassador to the Court of St. James's and hung his marvelous Impressionist pictures in the Regent's Park Ambassadorial residence, the ravished English could view some that had not been seen in Europe for years. If the well-off painter Gustave Caillebotte had not invested heavily in his friends' work and in 1894 bequeathed them to the French State (which took them none too eagerly: only forty of the sixty-five offered were accepted) the Jeu de Paume would not be the burst of pure light it is today.

That summer of 1881, the Cassatts spent at Louveciennes near Marly, for a second time; Mary (it always was Mary) after inspecting various places had settled on this one, where she was able to ride with her father —the old bond—on an elderly race-horse she had purchased which continues to be mentioned in Robert's letters for some time. Gardner Cassatt joined them, and in the course of the summer the whole family went to see the regatta at Trouville. Also that summer a big exhibition of Courbets was held at the Théâtre de la Gaieté in Paris; Mary took her young friend Miss Elder, who, after she was Mrs. Havemeyer, in her memoirs brought to life that day and, with it, Mary:

"I owe it to Miss Cassatt that I was able to see the Courbets. She took me there . . . explained Courbet to me, spoke of the great painter in her flowing and generous way, called my attention to his marvelous execution, to his color, above all to his realism, to that poignant palpitating medium of truth through which he sought expression . . . She led me to a lovely nude, the woman drawing the cherry tree down before her face and I recall her saying to me, 'Did you ever see such flesh painting? Look at that bosom, it lives, it is almost too real.' And she added, 'The Parisians don't care for him. You must have one of his half-lengths some day.'"

That picture was Courbet's *La Branche de Cerisiers.* After she was Mrs. Havemeyer, Mary's little friend did buy it, and it hangs, as her gift, in the Metropolitan Museum. Its composition is reflected in four of Mary's own paintings: the *Young Woman Picking Fruit* of 1891, the *Sketch of a Young Woman Picking Fruit* (not the same model or pose), part of the mural she did in 1891 for the Chicago Exposition which she called *Gathering Fruit,* and, painted in 1893, *Nude Baby Reaching for an Apple from His Mother's Arms.* Painters have of course painted models picking fruit before and since, but Mary never used that particular pose until after the day with Louisine at the Courbet show. Courbet was a

major influence on her. (Degas once said to someone who rebelled against the idea of being influenced, "Did you think you were born alone?")

That fall, back in the apartment in Paris, Mary finally did secure a Degas for Aleck's collection and sent it, together with photographs of three other pictures, hoping to awaken Aleck's continuing interest. The fall and winter Mary and Degas spent getting ready for the Seventh Impressionist Exhibition of 1882; but as it drew nearer there was renewed in-fighting—this time so intense it resulted in Degas' withdrawal from the show entirely. Mary went with him. It made talk in the art world. Berthe Morisot wrote her husband, Eugène [Manet's brother], "Have you seen Miss Cassatt? Why did she withdraw?" and he replied, "I have not been able to penetrate the secret of the retreat of Degas [and] Miss Cassatt. An idiotic Gamballiste paper (organ of a French political faction) said this evening that the Exhibition of Impressionists had been decapitated by this retreat . . . [But] Duret [friend and historian of the Impressionists], who knows these things so well, feels that this year's exhibition is the best the group has had." The reason for the withdrawal was similar to the differences of opinion that caused trouble before the sixth show; painters like Caillebotte resented Degas' wanting to include non-Impressionist contributors. Robert Cassatt's comment on the fracas was, as usual, horse-oriented. He called the warring artists "Kittle-cattle to shoe behind"—a Scotch expression meaning difficult.

For Mary the struggle gave an opportunity for the grand gesture she did make, expressing her allegiance to Degas by standing shoulder to shoulder with him against the painters and Durand-Ruel, who sponsored the exhibition and insisted the exhibitors be limited to Impressionists, thus taking sides against Degas. The withdrawal of the two painters brought about Mary's posing for Degas more frequently, notably for *At the Milliner's*. This charming painting illustrates that many, if not most, of the Degas' that Mary posed for were in no sense portraits; simply she could and would hold, as in this, difficult poses that professionals were too lazy to take. From other, real portraits of her, and from photographs, anyone can see that *At the Milliner's* is not a portrait at all.

Throughout the contretemps Mary continued advising Aleck on pictures; in those days, her energy knew no bounds. He invested in four Monet landscapes, including the *Stairs at Vertheuil*; Manet's *Vue en Hollande*; Berthe Morisot's *River Scene*; a Pissarro landscape; two Renoirs, and—most "important" of all—Degas' *Ballet Class*. The redoubtable Mrs. Jack Gardner, for all Bernard Berenson's professional assistance, never outdid, in her Italian paintings, the quality of Mary's good steers on

French Impressionists. As a collector Aleck was lackadaisical, however; he did not really see the point of Mary's enthusiasm, let alone of the pictures. A letter Mary wrote him, November 18, 1883, shows the way she strove to connect pictures with his special interests:

"Did you get the photographs I sent you? I only sent them to give you an idea of Degas' style. I don't like to buy anything for you without your having some idea of what it would be like. The pictures from which the photographs were taken have all been sold and Degas has but one racing picture finished and that is the large one; I was just thinking of buying you a smaller one of ladies and children on horseback when a dealer picked it up, and I don't see anything else in horse subjects that I can get for you just at present. I feel it almost too much of a responsibility, am afraid you won't like my selection; and Mother does not give me much encouragement as *au fond* I think she believes picture buying is an extravagance.

"I sent home a Diaz to the Elders, for Mrs. Havemeyer [Louisine married H. O. Havemeyer on August 22, 1883; it was the normal thing, for one lady to refer to another, even the closest of friends, by her title; even to address her by it at all times]. They are polite enough to say they were pleased. I hope they were," she adds, with a painter's rueful skepticism.

Gardner Cassatt, whom also Mary tried to advise on picture-buying, took even less interest. There is nothing wrong, of course, with not caring to own pictures; there is even something admirable about being above making a shrewd investment when it is offered. In one sense the brothers were only being honest—being themselves—when they admitted to Mary and eventually to the world the limits of their vision.

The greatest row of all over an Impressionist show preceded the Eighth and, as it proved, last, in 1886. Pissarro wrote, in a letter to Manet of March 5, 1886, "The exhibition is completely blocked . . . We shall try to get Degas to agree to showing in April, if not we will show without him. If we do not settle the whole thing in the next four or five days, it will be dropped altogether. Degas doesn't care, he doesn't have to sell, he will always have Miss Cassatt and not a few exhibitors outside our group, artists like Lepic [the wealthy artist-count]. If they have some success he will be satisfied. But what we [meaning himself and other impoverished bohemians] need is money, otherwise we could organize an exhibition ourselves. I shall find out what Madame Manet [Berthe Morisot] thinks, but I am afraid she will not want to appear with us if Degas does not. In that case the whole thing will be off—there won't be any exhibition, for to spend money exhibiting at the same time as the official Salon is to run the risk of selling nothing. Miss

Cassatt and Degas say this is no objection, but it's easy to talk when you don't have to wonder where your next meal will come from!"

They were more high-minded than Pissarro realized. It is true that both of them were sure of breakfast, lunch, and dinner and Pissarro wasn't, but his letter points up the difference between bohemian artistic materialism and bourgeois idealism. It also points up how the myth of Mary Cassatt's vast affluence was current even in her own time. Her father, on whom she partly depended, not only lived to the limit of his income, but was constantly borrowing from Aleck to eke out expenses. Besides Mary's studio expenses there was for her the upkeep of a horse and the purchase of horses; to say nothing of her clothes, which were becoming increasingly elegant, and purchased from more elegant establishments reflecting the success she had selling her work. Her work was where her money came from; for her advice on collecting she never, of course, received one penny.

As for Degas, he had an excellent reason for insisting upon the inclusion of non-Impressionists in the Impressionist show, men like Lepic, Rouart, and Zandomeneghi. His feeling was that they would tone down the shocking impression Impressionism still made on critics and public, thus rendering everyone's pictures more attractive to potential buyers. Such, however, was the hypnotic effect of Degas' reputation for general misanthropy, that nobody credited him with this altruistic motive. He was, moreover, still less than comfortably off, after stripping himself at the time of the bankruptcy. The myth of wealth, applied to Degas and Mary Cassatt, stemmed from a human tendency to equate social standing with riches. It seemed difficult to the point of impossibility for a bohemian to realize that a bourgeois could also feel the pinch—perhaps because the bourgeois did not, as the bohemian would have in his place, weep and gnash his teeth, but, like the inhibited Degas, merely endure.

Mary had enough left over from her earnings, after the various expenses of her way of life were paid for, to help finance this last of the Impressionist exhibitions—she had no dependents to support, as, say, Monet did. The very idea, however, that she was rich, and should therefore support the Impressionist group, made her angry as only Mary could get. It made an element in the building-up of resentment against the French that, as she grew older, became poisonous, within her who once considered them her saviors.

Mr. Cassatt defines Mary's actual part in the show in a letter to Aleck written on May 5: "Degas and his friend Lenoir, Madame Manet [Morisot] and Mame are the parties who put up the money [3000 francs] for the rent [in rooms over the Restaurant Dorée, 1, rue Lafitte, on the corner of the Boulevard des Italiens] and are responsible for all

deficiencies in expenses and entitled to all profits if there are any, and needless to say they do not hope for or expect any, the other exhibitors being admitted free. Mame has positively forbidden the appearance of her name in the advertisements [typical of the position Mary unconsciously assumed, of Victorian reserve. Well-bred families, even into this century, often refused to allow so much as an account of a daughter's wedding to appear in the public prints]. Nevertheless as you will see by the enclosed slip the papers have already got her name as one of the exhibitors but that is a different thing from being one of the getters-up of the affair. There are symptoms of trouble already appearing but there always are where artists are concerned," remarked, sagely, this gentleman who never caused an instant's trouble to anyone in his life, "so it may go off well enough."

The Eighth Impressionist Exhibition opened on May 15, 1886, with Mary Cassatt as an exhibitor, and Degas showing a group of the pastels for which Mary had posed during the time the two were separated from the group. Most spectacular among Mary's contributions was the *Girl Arranging Her Hair* of which Mr. Cassatt reported to Aleck on April 14, 1886, when she was still getting it ready, "Mame is feeling pretty well and working like a beaver . . . on a little red-headed girl in demi-costume, dressing her hair before a glass. The two or three experts and artists who have seen it praise it without stint. As for Degas, he was quite enthusiastic, for him." The genesis of this remarkable painting gives his last statement special significance.

Mary and Degas had had one of their increasingly frequent quarrels over what the word "style" meant, Degas asserting, with gathering misogyny, that women had no conception of style. Mary painted *Girl Arranging Her Hair* to prove she jolly well did have. Degas, as so often, entirely capitulated and in the end bought the picture to add to the collection he had begun after his earlier one was dispersed.

It is obvious his attitude to collecting would be quite different from that of the brothers Cassatt. Daniel Halévy tells of how Degas, in 1891, acquired some Ingres portraits. "I shall die in a poorhouse but that's a fine thing," he remarked; and, "I shall give the Ingres portraits to my country and then I shall go and sit in front of them and think about what a noble deed I have done." A few days later, while dining with the Halévys, Degas stayed after the other guests had left, "talking about his picture gallery, his difficulties with Zoë [his faithful and much-exploited maid] who demands blue aprons because her master buys Ingres'. Roaring with laughter he tells us of his quarrels with her. And still laughing he leans back in his chair and suddenly he says, 'To have no clothes and to own sublime objects—that will be my *chic!*'"

Mary's admiration for and loyalty to Degas did not include taking his moodiness meekly. John Rewald, in *The History of Impressionism*, claims that around 1884 or 1885 Degas made a remark to a visitor Mary sent around to his studio, about Mary's art, which embarrassed her unbearably, and that for a long time she stopped seeing him. A letter Degas wrote the Count de Lepic proves that by 1890 they were reconciled, for he refers to her as "a supplier of good days," meaning she had supplied them to himself; and as "a good painter, given particularly at this moment to studies of the reflections and shadows of the flesh or dresses, for which she had great feeling and understanding." There is a tinge of looking backward about this letter's tone; there is none in their collaboration in the Eighth Impressionist show of 1886; some time prior to 1890 something happened. Something besides Mary fell. A new element appears in their friendship, something not hitherto accounted for. The nature of the friendship must determine the nature of what disturbed it.

Male speculations on it sound baffled by the impenetrable barrier of a Victorian lady's reticence. Louisine Havemeyer, however, wrote in her memoirs what Mary herself said about it much later. She began with an interesting expansion of Degas family history that had his great-grandfather [as she called Hilaire-René] making his living, after fleeing to Naples, by selling pumice stone.

"Pumice stone?" cried Mrs. Havemeyer, apparently aghast.

"Yes, pumice stone," said Miss Cassatt.

She went on by saying that Degas' mother was the daughter of the Spanish governor of New Orleans, and her sister had married the Marquis de Rochefort. "Degas made fun of his noble cousins," Mrs. Havemeyer quotes Mary's saying, "and said that . . . the Marquis drew down the curtains of his bathroom so that he could have the pleasure of looking at a coronet while bathing."

The anecdote apparently did not seem funny to the ladies. Mrs. Havemeyer commented, as if clucking, "That was just like Degas."

> "Exactly," Miss Cassatt agreed. *"Bon diseur de mots,* my dear, *mauvais caractère . . ."* Miss Cassatt, probably feeling that she had brought the biography down to the present time, stopped, but I saw a look of reminiscence in her eyes . . . and I pleaded,
>
> "Tell me some more about him."
>
> "Oh, my dear, he is dreadful! He dissolves your will power," she said. "Even the painter Moreau said to Degas after years of friendship that he could no longer stand his attacks . . . Think of this: one day a young painter seeing Degas in a color shop begged the proprietor to introduce him . . . After a few moments' conversation Degas

turned to a picture which stood on an easel and said . . . 'Young man, did you do that?' 'Mais oui, monsieur,' replied the young fellow, delighted that Degas had noticed his canvas. 'I pity you,' [Degas said]."

"How could you get on with him?"

"Oh," she answered, "I am independent! I can live alone and I love to work. Sometimes it made him furious that he could not find a chink in my armor, and there would be months when we just could not see each other, and then something I painted would bring us to-gether again and he . . . would go to Durand-Ruel's and say some-thing nice about me or come to see me himself. When he saw my *Boy Before the Mirror* [of 1901] he said to Durand-Ruel, 'Where is she? I must see her at once. It is the greatest picture of the century.' When I saw him he went all over the details of the picture with me and expressed great admiration for it, and then, as if regretting what he had said, he relentlessly added, 'It has all your qualities and all your faults—it is the Infant Jesus with his English nurse.'"

No painter is good at laughing at his work, and it is too much to ex-pect Mary to have seen the quip not only as funny but apt. As for Degas' relentlessness—in a letter Degas wrote to his friend de Valernes in 1890, in the middle of being extremely funny about something else, he breaks off suddenly to ask forgiveness for that trait. "I was or I seemed to be hard with everyone, through a sort of passion for brutality, which came from my uncertainty and my [depression]. I felt myself so badly made, so badly equipped, so weak, whereas it seemed to me that my calculations were so right . . . I brooded against the whole world and against myself. I ask your pardon if, beneath the pretext of this damned art, I have wounded your intelligent and fine mind, perhaps even your heart." Degas could not have described better what intervened between his own two worlds.

His friendship with Mary had become something like what a modern writer has described in a wonderful title, *Being Geniuses Together*. United in the world of art, their life in it can be visualized as a living *Spartan Girls*, one challenging the other freely, equally, although, in the background, that ominous dark group did wait. Mary was not interested in being a woman with Degas, any more than she was interested in being a wife or mother. Superficially, Degas seemed interested in being a man, but that was the result of French breeding and environment. They came face to face more as wrestlers: give and take.

Mary cared most, with Degas, about absorbing his being, in the same way that she had learned to ride as a child by absorbing her father. Every-

thing she had learned had been through this artist's trick, this childlike faculty, of reproducing another, in instantaneous imagination, to a degree incomprehensible to someone who does not operate that way. The compelling drive of male artists (not that anyone thought then in terms of drives) was, of course, well-known: "The true artist will let his wife starve, his children go barefoot, his mother drudge for her living at seventy, sooner than work at anything but his art," Bernard Shaw wrote. The idea that a woman could possess the same drive would have scandalized the Victorians—and Mary too, if she had recognized it. Yet it was her ability to be independent of Degas, to separate her purposes from his, that she was proudest of. No attempt on her part to sympathize with or understand his torments under the blows of his "damned art" will be found, in any account of the friendship.

Her holding back was perhaps inevitable; given her history she could hardly have done otherwise. When Degas presented Mary with the maternity theme, he was giving her love; his most precious discovery— woman's powers of giving birth and of cherishing. Out of the death-struggle between his heart and mind this kind of love had repeatedly rescued him, as with *Portrait de Famille,* as with *Bureau de Coton.* Just so, but in the opposite direction, art had given Mary a masculine ability to liberate herself from the clutches of instinct; she was not about to sacrifice it. Not merely did she not take Degas' black moods lying down, she got her own back tartly. When she had had enough, she quit. She had taken from him not love, but the picture of love.

In a way, too, her being so forceful was what Degas wanted. As an old man he allowed himself to be dominated by a quite inferior woman artist, Suzanne Valadon, who chivvied him about, and moved him out of the studio he loved; whom he called "The Terrible Maria," and wrote humble letters, praising her not-very-good drawing. In a way, Mary and Degas merely reversed the roles society expected of them as man and woman. He enjoyed her boyishness; she was happy when he cherished her work. Each staked out in the other the roles they had turned against. Underneath the dynamic personalities that, from private hell-fires, each had forged, shrank naked organisms terrified of life's violence without art's clarifications; horrified of unartful, brute, sex.

By 1886, equality in the world of art was for Mary a fact. Degas was hardly better thought of than she by the general public; only by his special admirers. George Moore, a bellwether for public opinion of an aesthetic sort, in comparing Degas unfavorably with Manet wrote, "The intellectual pleasure that we receive from a mind so curiously critical, inquisitive, and mordant as Degas' withers . . . Of what value are Degas' descriptions of washer-woman and dancers and race-horses compared

[with a Manet]? His best pictures were painted before he began to think, when he was merely interested in nature. Then he could tell the story of a character."

Mary was receiving almost as much critical acceptance, and her sales, for an Impressionist, were impressive. Durand-Ruel handled them. Since the depression of 1882 the firm had suffered repeated financial reverses, and were at times on the verge of bankruptcy. Mary Cassatt had the magnanimity, in view of the split at the time of the Seventh Impressionist show, to lend it money that helped keep it afloat. The firm was moreover plagued with failure in ventures such as a show in London from which not a single picture was sold. Then, in the spring of 1886, they made an unexpected, lucky, and brilliant coup.

The Durand-Ruel exhibition that opened in New York on April 10 of that year brought Impressionism to America, insofar as anyone's paying any attention to Impressionism went. Even in France it was a long way from being accepted; and the engines of taste in America had, since the days of Copley and the painting Peales, been set at full speed astern. Isolated examples of Impressionism brought to America, such as Mary Cassatt's showings, made little impression. One lady opera singer who brought along Manet's *Shooting of Maximilian* as a side-attraction on an American tour, later sent a bill to Manet for the champagne refreshments she had laid on for a press that refused entirely to be won over.

A trial Impressionist balloon was sent up by Durand-Ruel in 1883 at Mechanics Hall in Boston, with two Manets, three Monets, six Pissarros, three Renoirs, and three Sisleys, but the show was scarcely noticed. In the same year, the hand of General Ulysses S. Grant opened the Pedestal Exhibition at the National Academy of Design in New York—proceeds for helping defray costs of a pedestal for the Statue of Liberty which had just been presented to the American people by the French Government. One of its organizers, the American painter William Merritt Chase, took care that none of the usual Salon pictures were included; there were Corots besides several Impressionists. Of these there was little public acceptance, either.

The 1886 Durand-Ruel show proved as important a landmark in art as the famous 1913 Armory Show. One unforeseen angle of its financial success was that, by virtue of the unvirtuous entrepreneurs who invited Durand-Ruel to put it on, who had an unearned name for being an educational institution to advance culture on a nonprofit basis, forty-three cases of Durand-Ruel pictures were let in through customs, duty free. The contents included fifteen Sisleys, seventeen Manets, twenty-three Degas', thirty-eight Renoirs, forty-two Pissarros, and paintings by Eugène Boudin and Berthe Morisot.

The show, first hung at the American Art Association in Jackson Square, was later moved to the National Academy, and twenty-one more Impressionist paintings added; making a total of 310. There were two Mary Cassatts—*Family Group* and *Portrait of a Lady*—both lent by Alexander J. Cassatt; the Americans Erwin Davis and H. O. Havemeyer also lent Impressionist art. About $18,000 worth of pictures were sold from this show on which Durand-Ruel paid $5,500 import duty. Impressionism had arrived.

That summer of 1886 Mary Cassatt found and took a house for the annual family hegira, at Arques-la-Bataille, four miles from Dieppe, in order to be near a friend who had married Paul Bérard, whose château was nearby; Renoir was a frequent visitor to the Bérards', where he painted in characteristic manner the children, Madame Bérard, and the château and countryside. It was also important in Mary's choice of a house that Arques-la-Bataille was at some distance from the sea. Too close, and it would have set up disquieting reminders of her tendency to a disabling seasickness that had never troubled her back in the days of that first, blissful voyage to France at seven. Nowadays it was as if, once afloat on the broad, changeful, undependable element, she were undone. Nothing rose to meet its heavings but deathly nausea. That summer what she did for exercise was, as usual, ride, with her father and alone. She rested from the winter's work, and renewed her strength to engage in another hunt —that autumn for a new apartment in Paris.

In 1884 the Cassatts had left the casual Montmartre quarter to be, as they put it, near to the center of Paris, in an apartment in the rue Pierre Charron. After long search Mary now found just what they had been hoping for, at 10, rue de Marignan, just off the Champs Élysées, near the Rond Point, into which they moved in March 1887. It answered all their requirements, possessing not only the elevator (unusual at the time) which Mrs. Cassatt's bad heart necessitated, but central heating, also unusual. The rooms were larger than those they had up to then, and there were more of them, so that Mary could work within what was to be their winter home for the rest of all their lives.

Climbing to it on foot, as servants and tradesmen were by lease required to, the apartment is up five long flights of stairs. From the ugly red marble of the stairwell a door opens on its wide hall, at right angles to another opening into the salon, a square room of comfortable dimensions. The ceiling is low since this is the uppermost of the building's apartments, each of which occupies an entire floor. From the salon's northern windows a view of the Tour Eiffel lies westward, and outside a narrow iron balcony traverses the front of the house.

Even decorated the way the Cassatts and Mary liked it (dark wall-

paper, dark Victorian furniture) the whole apartment was flooded with the wonderful light of Paris; sun streamed into the bedrooms from the southern exposure at the rear. Since light, in Mary's painting days, was a requisite for any Impressionist painter, one of the rooms facing the north was that which Mary used for a studio. In 1921, after Mary went blind, the sculptor Augustus Saint-Gaudens thought the salon "sombre"; but anything except a north light was forbidden in the Impressionist canon, as varying too much with the position of the sun. Light from slightly east of true north varies less than any other light, and because, to these artists, the light was what determined how a thing looked, hence what it was, a constant light would have been Mary's own principal requirement when she hunted for and found 10 rue de Marignan.

Its bedrooms, strung out in a row off a corridor at right angles to the hallway between salon and salle à manger, overlook a full, complicated panorama of Paris which used to include, when the Cassatts lived there, a garden behind No. 10. In addition to the central heating boasted in the lease, each room has its own open fireplace. Smaller bedrooms for servants included in the lease occupied an extension of this wing, and others were above, in the attics of the building.

The apartment, though good-sized, is by no means big. It has an air peaceful and spacious, as if it were someone's owned house. The building, seen from the street, is massively constructed of white stone, crossed by several iron balconies. As usual in Europe, the concierge's lodge is on the ground floor, inside the courtyard. One of a row of similar large, handsome, white residential buildings, it houses today an insurance company on its first floor.

The Cassatts kept four servants, considered a modest establishment. There was the coachman who drove the carriage Aleck paid for, there was a cook and a maid who did the chamberwork and waited on table, and then there was Mathilde. *Gouvernante,* as the French call housekeeper, Mathilde was also lady's maid and general factotum. She came to the family when the elder Cassatts first arrived in Paris for good, and she remained, weathering all changes except a World War's forcible separation, for forty-four years. She was Alsatian. Mary Cassatt never employed French servants, her niece Mrs. Madeira explains, because of her feeling about French laws forbidding dismissal of any French employee except for the most flagrant misdemeanor. Such restrictions on her freedom of action were, to Mary, intolerable.

From the new flat the family went once more, in the summer of 1887, to Arques-la-Bataille—so near Dieppe yet not too near. The Aleck Cassatts with their children also arrived, putting up for the season at the Hôtel Royal in Dieppe itself. Young Eddie Cassatt was studying with a view to

entering St. Cyr, the great French military academy, and Aleck rented a private hotel for the family in the rue Montaigne in Paris, sending Elsie and Sister to the École Monçeau.

This stay in Europe falls within an intriguing period of Aleck's life. Having by 1882 risen to being first vice-president of the Railroad, he suddenly retired and devoted himself to that ambitious horse-fancying to which the Cassatt letters so often refer. The rumor was he felt slighted because he had been passed over for president of the Railroad in favor of George Roberts. Nathaniel Burt describes how in 1899 he, as suddenly, "strolled into the office of the presidency, a commanding figure one always pictures in gray topper, with boutonnière and field glasses. It is ironic that he is now generally remembered as the brother of painter Mary. Things were certainly the other way about in 1900." Aleck's name does not today appear in most biographical sections of dictionaries, while Mary's does. The myth-makers have pickled his memory as though in brine, by bestowing the presidency of the Railroad on his father, and its emoluments on everybody in the Cassatt family including Mary. Aleck, however, was the rich Cassatt; the only really rich Cassatt.

His hotel in Dieppe was on the waterfront; but Lois was not one to imagine things about the ocean outside her windows, or its "melancholy long, withdrawing roar

>"Retreating, to the breath
>Of the night-wind, down the vast edges drear
>And naked shingles of the world . . ."

She never heard it "bring the eternal note of sadness in." In the luxurious hotel bedroom that she shared with Aleck, the ignorant armies of Lois' mind clashed vainly, fruitlessly, by night.

Her own old age would be sad indeed. From her house on Rittenhouse Square in Philadelphia (Aleck bought it for $110,000 during the time they were at Dieppe) she would have to watch her two little grandsons, Robbie's children, taken home every day at dusk by their nurse from playing in the Square, not allowed by a hostile mother to so much as wave at the old lady who sat alone in those upper windows. But that is part of the other side of the story, the story of the American Family Cassatt.

EIGHT

Throughout the Victorian era, respect for family ties to the point of reverence prevailed. Cecil Woodham-Smith, author of *The Reason Why*, told in an article called "They Went to Bed" the stories of six geniuses of that era, among them Florence Nightingale, Elizabeth Barrett Browning, and Charles Darwin, who, as enmeshed as everybody else in compulsory family togetherness, were mysteriously rescued by being, quite against their conscious will, brought to bed of illnesses which provided the solitude necessary for their life work.

Mary Cassatt spent her life with her parents: tending their illnesses, finding apartments for them, sharing her every thought, even sharing letters: in Victorian times it was considered antagonistic not to. The Cassatts, like other Victorians, balanced their violations of each other's privacy by an equally fearful concern over each other's health. Yet they were, for their time, unusually pleasant, gentle, kindly souls, of good will to the world, if not an active part of it; and, because of her painting, Mary was enjoying exceptional freedom for an unmarried woman.

Children, horses, health, money . . . Although in some ways Mary resembles a James heroine, the Cassatts were not at all Jamesian expatriates, avid for culture. Their interest in Mary's work hardly rose above its monetary value, not in deprecation of its artistic merit, but because they had no conception of what artistic merit was. For them, "Mame's work" was subsumed under the category "Money." To some degree Mary shared her family's financial hardheadedness; it was part of what made her such a useful adviser to collectors. About Aleck's portrait, later painted by Sargent (whom she detested partly because he declined to join the Impressionists when she asked him to), "Have you seen that thing he did of my brother Aleck?" she demanded. "And did you know the price he charged? I call it dishonesty." Later still, while immersed in counseling the Havemeyers on their collection, Mary made no bones about getting the artists to come down on their prices to her friends. It was unclear who *were* her friends. Artists or non-artists? In many ways she was her father's own child.

The Cassatts maintained that only Mary could "manage" Robert. Lois Buchanan Cassatt—that prickly character in their quiet annals—wrote her sister Harriet from the Hotel Meurice in Paris, where she and Aleck were staying, on August 6, 1880: ". . . the truth is I cannot abide

Mary and never will. I have never heard her criticize any human being but in the most disagreeable way. She is self-important and I can't put up with it. The only being she seems to think of is her Father."

Hers was not the only dissatisfaction expressed outside the immediate family circle. Mr. Cassatt wrote Aleck in sheer exasperation time after time; generally it was directed at Mrs. Cassatt's health. "August 2, 1882, . . . This last aggravation [she took purgatives, followed by a warm bath; the doctor was aghast] is at least partly owing to her continued imprudence and want of care of herself . . . This time she was seriously frightened and promises to be more careful in future but I despair of ever seeing her so for any considerable consecutive time." On July 18, 1883, he wrote Aleck, "Mame is lamentably deficient in good sense on some things, unfortunately the more deficient she is the more her Mother backs her up. It's the nature of women to make common cause against the males and to be especially stubborn in maintaining their opinions about matters of which they are ignorant. They try my patience to the last degree of endurance sometimes."

If Robert played paterfamilias, stamping and ranting about the domestic stage, Lois chose the role of long-suffering wife-and-mother. She, who had no ambitions other than social, kept a diary of a trip she, Aleck, and the children made to Europe in 1882 and 1883. The autumn day they left Cheswold, Aleck's stately pleasure-dome in Haverford, November 7, 1882, the sad news reached them that Aunt Lydia had died. It was not unexpected. Lydia's health had been sinking for years. In the enchanting paintings Mary so often did of her she appears progressively more and more pale and fragile; now death, her only suitor, did what the Victorians called "carrying her off."

Lois had interests other Cassatts didn't share; réclame was one. Her diary starts off with a detailed description of the private railroad car lent by George Roberts, president of the Railroad, to take them from Haverford to New York, where they lunched, she relates, at Delmonico's, before sailing on the *Servia*. They landed in England. Names mentioned so far were old Philadelphia ones like Yarnell, with a few minor nobilities thrown in; but later the diary is richly interlarded with titles.

As soon as they reached Paris the children were put into good schools, and daily rides in the Bois begun. November 30, 1882: "Aleck and I started for a ride on horseback. I felt very unwell and did not much enjoy the ride . . ." December 11: "Aleck and I went out for a ride as usual at 9.45. I was in a bad humor as I did not in the least wish to go, but I enjoyed it as much as any day."

La vie, in Paris, was dure, for Lois. December 2: "The hairdresser came at 9.30. Mrs. Cassatt and Mary and I went to Redfern's [a great

house in the *haute couture*] and ordered . . ." December 5: "Mary and
I went to Redfern to be fitted . . ." December 6: "Hairdresser came at
9.30 . . . Bought Christmas presents. Came back and found Mrs. C. and
Mary talking in the most solemn manner to Aleck . . ." (What did
she suspect? They were probably speaking of Lydia . . .) December 7:
"At 11 o'clock Mary and I went to Redfern to be fitted. After déjeuner
Challett came with Roman pearls. We selected some for Jennie [Eugenia
Carter of Virginia, who had married Gardner Cassatt in October] . . .
The weather is so horrible that I am getting very blue. The box of things
for home makes me a little more so. Aleck is all right for he sees his own
people every day." Aleck did something else that made Lois feel even
further left out. December 19: "Aleck and I went to Avenue Trudaine
for breakfast and Aleck sat for portrait."

Thereafter daily—even the day of Christmas Eve, after attending
the American Chapel, where "we had a very original service of which I
could make nothing—a sort of Methodist performance with the Apostles'
Creed"—Aleck posed for Mary. Christmas Eve something unexpectedly
pleasant did happen: late in the afternoon Lois put the presents in a
cab and went to the Cassatts' where her four children were waiting. "To
my great astonishment and delight Mr. C. gave me a lovely ring with
nine diamonds, and Mrs. C. gave me a beautiful lace scarf of point
appliqué. I am really delighted at this sign of good will toward me." The
poor, huffy creature describes her most "interesting day," January 2, 1883,
thus: "Aleck went out on horseback, I started to go to the Louvre and
became so much interested in shopping that we go to the Magazin instead.
After lunch [we] went to the . . . Cluny where we were perfectly de-
lighted with the museum . . . The old Roman baths, the church St.
Julian l'Épouvre [St. Julien le Pauvre], St. Séverin we also saw. Rob [her
son] is so lovely in sightseeing . . . After dinner Aleck and I took all the
children . . . to [the circus]. We did not get home till 11.15. Letters
came from Mrs. Hutchinson, Mrs. Evans, Alice and Harriet, and a card
from Emily Meredith."

Christmas well over, the Aleck Cassatts went back to a hotel in
London. At first only a "Mr. Schiff came . . . He was a school fellow in
Heidelberg and wrote Aleck a note to ask him if he was his friend
Cassatt . . ." The Cassatts dined at the Schiffs' on January 23; "Mr. S. a
very nice man but the Madame was rather common. They are evidently
very rich. They are Jews." Very soon, however, titles start proliferating.
Lois was happy, too, on the trip to Italy that followed; but on March 3
they were back in Paris and after that hardly a day passed without "Aleck
went as usual to sit for the portrait," "Aleck spent the day sitting again
till 4 o'clock," "Aleck went to Trudaine and spent the whole day until

5." Good Friday, "Aleck went to Trudaine and sat until twelve and then again at 2.30 and Sister and I went to church." Easter Sunday was a let-up; and on the Sunday after, April 1, "Aleck spent the whole day at his mother's and the picture is at last finished." A whole month gone, the tone is, and nothing to show for it!

Lois, not to be outdone, in fact to outdo, went the day after the Cassatts arrived in London, April 3, to "Mr. Whistler's studio, No. 13 Tite Street, Chelsea. We found the distinguished artist most polite and most curious-looking—he proposed to come the next morning and begin at once." Very likely Lois intended showing Mary she could get a better portrait, quicker, than what Aleck got from Mary. If so, she little reckoned with Whistler.

April 4: "Whistler came at 12 o'clock just one hour before [lunch]. He spent more than an hour deciding which dress I should wear in the portrait and finally after trying on five he decided in favor of the riding habit, much to my disappointment, I had thought I would like a nicer style of painting than that. Aleck likes it." She went almost daily to Whistler's studio, for shorter periods than Mary had exacted of Aleck— like eleven to eleven forty-five; ten-thirty to one-thirty. On April 9 she "went to the studio at 10.30 but the day was too dark to paint—a joy." April 14: "I was all ready to go with Aleck when I got a note from Whistler to come—Aleck and I drove there in a mail phaeton with a pair of horses on trial [to buy]. Mr. W. was an hour late." On April 23, however—less than three weeks after Whistler had begun—"I went to the studio at 10.30 and left at 7.15. Aleck brought Anna Longstreth to see the picture. The children came to see it, and Mrs. Scott and Mrs. Riddle also. After dinner we all went to the Gaiety Theatre and saw Blue Bussel. Mr. Whistler came to our box and is now at 12.30 sitting in this room talking and laughing." Perhaps Lois thought, from that, the portrait was hers.

On June 15 Mary wrote her, "Whistler told me he would have been glad of twenty-five minutes more on your portrait, he told me he did not make you stand much, you gave him but few sittings he said." In October Mary, while in England, went to Whistler's studio to see if the portrait were done. It wasn't. She gave Aleck her opinion of it: "a fine picture, the figure especially beautifully drawn. I don't think it is by any means a striking likeness, the head inferior to the rest, the face has no animation but that I believe he does on purpose, he does not talk to his sitters but sacrifices the head to the ensemble. He told Mother," Mary cannot resist adding, "he would have liked a few more sittings, that he felt as if he was working against time; that I suppose is true enough. After all I don't think you could have done better, it is a work of art, and as young

Rowers' Luncheon
by Auguste Renoir, 1879–80.
COURTESY OF
THE ART INSTITUTE OF CHICAGO.
One of many paintings that
record the lighthearted way of
life led by the Impressionists.

Mr. Robert S. Cassatt,
Father of the Artist
by Mary Cassatt, 1878.
OWNED BY MRS. PERCY C. MADEIRA.
A pastel demonstrating that Mary
Cassatt's father's horsemanship
really "was perfection."
"It was not surprising that old
Cassatt did not care
for 'Mr. Degas.'"

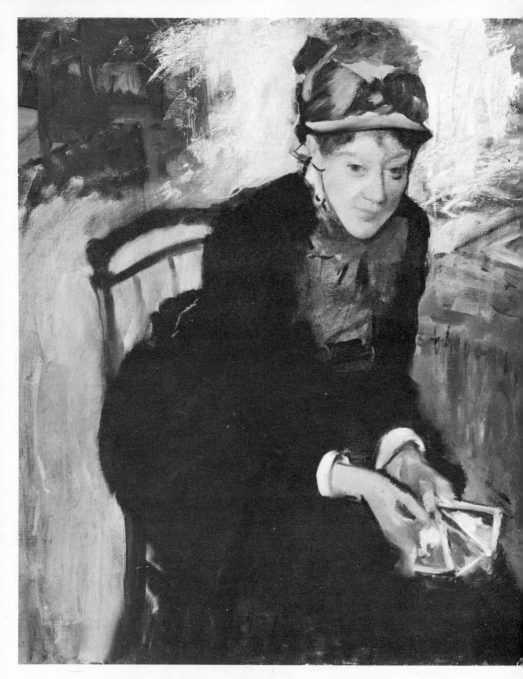

Portrait of Mary Cassatt by Edgar Degas.
COLLECTION OF MR. ANDRÉ MEYER.
Painted in about 1884, the likeness was later so much disliked by Mary Cassatt, to whom Degas had given it, that she sought anonymously to get rid of it.

La Famille Bellelli by Edgar Degas, 1860–62.
PHOTOGRAPH COURTESY OF THE MUSÉES NATIONAUX DE FRANCE.

The Cotton Brokers, New Orleans, by Edgar Degas.
PHOTOGRAPH COURTESY OF RENÉ PERONY, 8. RUE JEANNE-D'ALBRET, PAU, FRANCE.
For a discussion of this painting, which, in its genesis, along with that of *La Famille Bellelli*, is a revelation of the way in which art affected Degas, see the chapter on Degas.

The Duke and Duchess of Morbilli by Edgar Degas, 1865–67. COURTESY OF THE MUSEUM OF FINE ARTS, BOSTON. GIFT OF ROBERT TREAT PAINE II. "She had been accustomed to upper-class Philadelphians." One of Degas' portraits of his Italian connections; this couple, a paternal aunt with her husband.

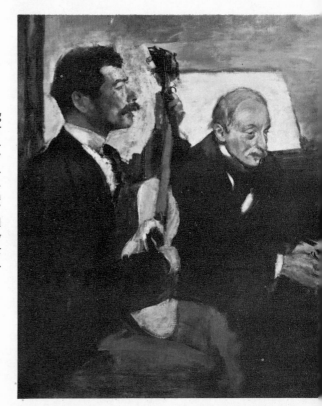

Degas' Father Listening to Pagans Playing the Guitar by Edgar Degas, 1869–72. COURTESY OF THE MUSEUM OF FINE ARTS, BOSTON. BEQUEST OF JOHN T. SPAULDING. After the death of his wife, when Degas was in his teens, Degas' father shut himself up against all but a few friends, mostly musicians. Pagans was noted for his playing of ancient Italian music.

Madame Louis-Nicolas-Marie Destouches by Ingres, 1815–16.
PHOTOGRAPH REPRINTED BY PERMISSION OF THE CABINET DES DESSINS MUSÉE DU LOUVRE, MUSÉES NATIONAUX. This is the way Ingres drew —exquisite, ineffable—and therefore the way Degas drew too (see following plate) before he assimilated Ingres' influence, following the master's tenet, expressed by Degas, that "You must do over the same subject ten times, a hundred times. In art nothing must appear accidental . . ." Each "time," moreover, represented a fresh start.

Monsieur et Madame Valpinçon by Edgar Degas, 1861.
PRIVATE COLLECTION. The distinguished collector, shown with his wife, through whom Degas at last met his hero and master, Ingres, whose influence is obvious here.

Little Girl
in a Blue Armchair
by Mary Cassatt, 1878.
COLLECTION OF
MR. AND MRS. PAUL MELLON.
The painting on which Degas,
who had met Mary Cassatt
the year before, most
uncharacteristically worked
(on part of the arm
of the chair).

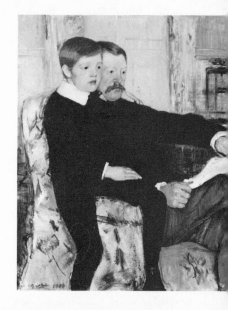

Alexander J. Cassatt and His Son,
Robert Kelso Cassatt
by Mary Cassatt, 1884.
THE PHILADELPHIA MUSEUM OF ART:
PURCHASED: THE W. P. WILSTACH COLLECTION AND
GIFT OF MRS. WILLIAM COXE WRIGHT.
"Aleck was an important part of Mary's
development." She painted this able and
successful brother with her favorite nephew,
Robbie, during one of many visitations
made by the Alexander Cassatt family.

Interior
by Edgar Degas, 1874.
HENRY P. MCILHENNY
COLLECTION,
PHILADELPHIA, PENNSYLVANIA.
Sometimes called *Rape*,
this painting was one of a
number of genre works that
Degas executed during the
seventies which "tell a
story" in the manner of
the Goncourts.

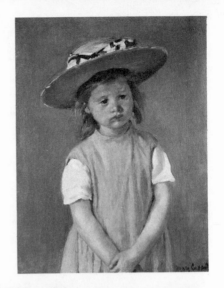

Child in a Straw Hat by Mary Cassatt, c. 1886.
OM THE COLLECTION OF MR. AND MRS. PAUL MELLON.
"From that disconsolate little face gazes
everything that Mary Cassatt felt about being
a . . . girl."

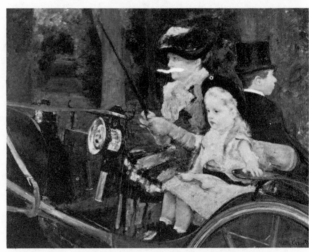

Woman and Child Driving
by Mary Cassatt, 1881.
THE PHILADELPHIA MUSEUM
OF ART: PURCHASED: THE W. P.
WILSTACH COLLECTION.
The artist painted
her sister Lydia driving
Bichette, the mare that
the horse-loving Cassatts
kept in Paris. Seated beside
ydia is one of Degas' Fèvre nieces.

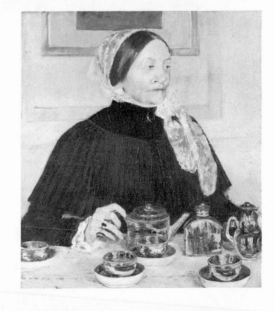

Lady at the Tea-Table
by Mary Cassatt, 1885.
THE METROPOLITAN MUSEUM OF ART,
GIFT OF THE ARTIST, 1923.
The portrait that was rejected—
e family considering that the artist had
painted the nose "too big, whereas
that organ had always been accounted
a great beauty."

Princesse du Pays de la Porcelaine by James McNeill Whistler.
COURTESY OF THE SMITHSONIAN INSTITUTION,
FREER GALLERY OF ART, WASHINGTON, D.C.
Whistler called it *Rose and Silver; Princesse du Pays de la Porcelaine*,
and painted it in 1864 to hang in the famous Peacock Room designed
for F. R. Leyland, who rejected it. The room is now restored—with
the exception of the porcelains—at the Freer Gallery.

Sargent said to Mother . . . it is a good thing to have a Whistler in the family."

Getting the Whistler in that family turned into a typical Whistler story. By 1884 it was still not delivered, Robert Cassatt laments in a letter to Aleck of June 8. "As to Whistler," he storms, "he is behaving in what in anyone else than an artist would be considered a very dishonorable way. Last week young Durand-Ruel, being about to visit London, was requested by Mame to call in her name on Whistler and enquire . . . Whistler of course promised that it should be finished forthwith and forwarded to you. That will probably be the last of it. Mame's advice to you is . . . wait, say a couple of months, and if within that time you do not receive the portrait . . . have some London businessman call and demand the picture *finished,* or the return of the money, peremptorily . . . if I were in your place I would no longer use delicacy toward him— He does not deserve it after the altogether gentlemanly manner in which you treated him . . . they may make what excuse they please for artists —but the man who takes your money under pretence of giving you a certain thing in return for it and does not do so or offer excuses for his neglect, is little short of a swindler."

At the end of 1884 Aleck came to Paris accompanied only by young Robbie and a manservant. Writing home to Lois he said, "We have word that Whistler is actually working on your portrait. Of course I shall go to see him as soon as I get to London." From England his letter begins, "I first went to Pool's where I ordered a lot of clothes. After lunch I went to see Whistler. When the old janitor . . . announced me, I heard Whistler gasp out in a frightened whisper, 'Mr. Cassatt,' but after a few seconds he came into the dining-room where I was, as self-possessed as ever. He took me into the studio, got the picture down, sponged it all over so as to bring it out, and promised most faithfully to have it finished by my return here in two or three weeks."

Mary got in another last word: "I hope Aleck will get Whistler to give up your portrait," she wrote to Lois. "He is now working on it I hear . . . I am sorry you don't like it. You remember I recommended Renoir but neither you nor Aleck liked what you saw of his. I think Whistler's picture is very fine." March 17, 1885, she writes Aleck, "I met Bridgeman at Durand's this week and told him the way Whistler was behaving about Lois' portrait. He said if he were in your place he would give someone an order to forcibly bring it away from the studio. I am in great hopes of [Whistler] hearing of it through Bridgeman, who was very indignant." Juxtaposition of the two letters gives another opportunity to marvel at a sensibility that could perceive the quality in Renoir,

invisible to the rest of her family, and at the same time speak seriously of pillaging another artist's studio.

By September, Mary was writing Aleck, "I had a letter from Scott, a dreadfully cheeky young English painter who was in Paris last spring. He had been to see Whistler and saw Lois' portrait, which he said was very fine but not done yet, that Whistler was dreadfully distressed but could not find a model to finish the dress with." This last was another reminder of how valuable, in the end, had proved those many and longer sittings Mary exacted for Aleck's portrait. April 14, 1886, Mr. Cassatt wrote Aleck, "I feel curious to know how you will finish with Whistler. I do not believe you will get your picture until he is made to understand that he no longer has any quarter to expect."

In the end Whistler finished the portrait (more than he sometimes did). As *Arrangement in Black, No. 8*, Mrs. Alexander J. Cassatt's portrait was hung in the latter half of the 1885–86 exhibition of the Society of British Artists in London's Suffolk Street. When he finally shipped it off to the Cassatts, he enclosed a letter of apology and included, as compensation for waiting, *A Chelsea Girl*. The portrait today belongs to Mrs. John B. Thayer; the *Chelsea Girl*, to a cousin.

The story does illustrate Whistler's unreliable side, for every reproach Mr. Cassatt leveled at him was justified; and yet . . . It is equally true, what René Gimpel reported that the painter Leon Dabo, who had worked in Whistler's studio, told him: "When an artist in the United States has talent, he can go hang—like Whistler. That's all his own country cared about him," Dabo asserted, adding, "America let him be turned out, three times, by the British bailiffs . . . Whistler knew that the portrait of his mother was his best canvas. He sent it to the Metropolitan, then [under the direction of] a Greek American. 'He isn't a painter,' this man replied, 'Pack that up fast and off it goes back to Paris.' . . . [Whistler's] jokes, his bon mots, and his sarcasm all hid the furious worker. If he had said [at the time] 'I'm working,' he would have been laughed at: 'Ah! Ah! He's working ! . . . ' Whistler was as pure-minded as a young girl, and if you could have known his sense of elevation when he worked! As great as Fra Angelico's, who would pray before painting." The explanation for the one side is embedded in the other.

Children ever came first in the list of Cassatt concerns. Robert had described the fascinations of a toy he got for the children's Christmas, in a letter to Aleck on December 13, 1878, sounding quite as fascinated as the children would be: ". . . a *baigneuse*, it is a mechanical doll dressed in bathing clothes, wound up with a key, is then placed in a tub of water and swims about as naturally as life, and to the delight of all beholding, young and old. It is the invention of a gentleman for the amusement of

his own children, but in being exhibited created such a *furor* that a manufactory was immediately established and they have been selling hundreds of thousands of them. A shallow tub of 2 feet diameter will be about the thing to put it in . . . you may have it in your parlor if you please." Although Robert certainly did not bequeath Mary any artistic talent, he had at least the child-mind required for it.

With children, merged money, in Robert's May 26, 1879, letter to Aleck. "I am glad that your financial success has been so good, the thing now is to keep it from wasting. Most anyone they say can make money, only the wise know how to keep it.

"You ask me to say what I think of the conditions of the Trust, as far as the children are concerned,

"1st. I would put the age at which principal is to be paid over at 24 instead of 21 as you have it.

"2nd. With regard to the girls I would not pay over the Capital but continue it in trust—during life—for their *sole and separate use and benefit exclusive of any husband*, at death capital to go to the children if any—if not [already] legal heirs.

"3rd. You reserve right to yourself, if alive, and children of age, to direct how capital shall be reinvested—why not in case of your death also provide by will for this?"

In the summer of 1879, Aleck's children had visited their grandparents at Marly-le-Roi. About then Aleck commissioned a group portrait of his family, from a not-very-good French painter, Charles Detaille (brother of Édouard, who painted his military pictures as if they were of tin soldiers) on account of his accuracy in painting horseflesh. This commission was Aleck's maiden plunge into picture-buying. On July 21, horses thus blend with children, in a letter to him from Robert Cassatt: "Last evening the children received their Mother's letter of 19th, we were glad to know that she was well again—The enclosed letter for her arrived by last night's mail, the letter from Detaille Eddie opened supposing it, or rather his Grandmother supposing it, was for him, and as soon as the signature was recognized, closed it without reading." The proud grandfather was a disgruntled one next day, when "Eddie wrote you yesterday what he said was a secret letter, carried it to the Post Office himself, I suppose he told you we were getting on as well as possible . . ." Then Robert, pulling himself together, goes on, "This morning we go to the 'Jardin d'Acclimation' where I expect to be very much amused with their amusement; Elsie's eyes opened wide when she heard that she would ride in a carriage drawn by a bird—whilst Katherine's [Sister's] ambition is to have a ride 'on top of the Elephant.'"

The similarity of Robert's mind to the children's reappears in a

letter of October 8, probably 1879, to Aleck, written from Marly: "You may tell the boys that yesterday their Grandmother and their Aunts on a special invitation from Colonel Lippman went down to see them throw pontoons across the Seine. The boys were to have been taken to see their manoeuvres when here, but the early hour at which they took place in the summer, prevented this—Colonel L. was polite enough to say that if he had known . . . he would have sent his orderly to conduct them . . ." April 18, 1881: "I dare say it will both puzzle and amuse Robbie to be told that, here in Paris, his pencil had to be put into the hands of an *ingénieur* to be repaired, and that the *ingénieur* promises to have it finished in two or three days—which in France means an indefinite time. *Ingénieur* in France means inventor as well as engineer, and the inventor of these pencils has a secret with regard to their construction which he has not revealed to the trade. —And so dear little Robbie remembered the fine view from the balcony of our town house? He certainly has a great deal of observation, with a good memory, two things very necessary in the making of what we call a 'Smart Man.' "

Of the subject, children, the subject of education soon became part. "I am not sorry to see that you are thinking seriously of Eddie's education," Mr. Cassatt wrote Aleck, August 1, 1881, from Louveciennes where they occupied Mary's favorite among their summer rentals, Villa Coeur Volant. "You can hardly give the matter too much thought and care. As for keeping him at home and being taught by private tutors until he is ready for college, I do not think you could take a worse plan. Unless he has previously had some experience of the world before entering college, he will certainly find himself imposed upon and besides . . . suffer from . . . many mystifications which a little precious experience and roughing it would save him from, or at least teach him how to meet in a proper spirit, or . . . bear like a man.

"I think, my dear son, if I were in your place I would search out some boarding school at a distance, kept by able and conscientious people, where no favors (undeserved) are shown . . . and there let him remain . . . until he is entirely fitted for college—and in doing this I would let Eddie understand that such is your irrevocable determination. You haven't the time to attend to him, and he ought now to have a man's care [Eddie was twelve]. There are many excellent private institutions . . . in different parts of our country, especially in New England . . . Look one up. I suppose you would not send him over here?"

Aleck would, though; and did. On the 1882–83 trip, Eddie was started in the Monge school in Paris, with his younger brother going too —although Robbie was to go home again when his parents did. Aleck's "irrevocable determination" began to be needed; in Lois' diary she notes

for November 29, 1882, with impotent maternal distress, that Robbie "and Eddie were in a sort of way examined, and then they were ushered into the class. Poor little boys! They knew no one, and there are scarcely any English boys to speak to. They suffered a great deal." November 30: "Mary and I . . . [ordered] for the boys the uniform of the École Monge. Plain dark blue clothes. Rob is in perfect delight at the suspenders." December 1: "Rob got up complaining of headache and sickness—kept him from school . . . While sitting in our parlor at 6, Ed walked in and closing the door behind him said he would never get on in that horrid old school and burst out crying. He is much perplexed by the method and confused by their French, and after dinner I went to work with him. We worked away until 9.30 and then I sent him to bed. He will not listen to any comfort. He is homesick and disgusted. The boys tease him about his clothes, as he has no uniform yet and he sees nothing ahead but misery. Poor little soul." Next day: "Ed went off to school in the most dreadful frame of mind, having wept freely all the time while he was dressing . . . Rob likes the school."

The little girls attended classes held at 54, Faubourg St. Honoré, and while Sister had been "confused and frightened" being examined for entrance, "both little girls like the idea of the Cours." They also took music lessons from a Madame de Loche. When the Aleck Cassatts returned to Paris from their London excursion, Lois' diary notes, January 26, 1883, "Ed is fretting himself about the chance of staying after we go," and, January 29, "He is in very bad spirits about staying here. If we tell him positively, he will be better contented."

Old Robert's advice was fully justified. At the École Monge, Eddie Cassatt soon after excelled, rising to be third in his class. Like the other Cassatts he rode; his Aunt Mary insisted on further riding lessons to perfect his equitation. June 22, 1883, she writes Aleck, "Eddie's riding lessons [have] improved [him] very much, can put his horse through the 'Haute École' very well; I am going to make him keep it up for another month, when the ticket will be used up and the holidays begin . . . he does not seem in the least dull [by which Victorians meant bored]; in excellent spirits; Mrs. Ellis told Mother they were struck with the change in him *à son avantage* as the French say. The school has done him good, he has been obliged to put up with an immense amount of hazing and nagging from the boys, it was very hard at first he says, but he don't mind it now, and answers them back. I cannot understand you and his Mother putting him to Haverford [his previous school] amongst those Quakers, their grammar alone is enough . . ."

After what is described as a slight illness that summer, Eddie went, with his Aunt Mary, to Fontainebleau, and in a letter to Lois of July 11,

told about the trip, occasionally taking a tone Lois' children did take
when speaking of Mary to their mother: "Aunt Mary and I went over to
the doctor's and he said we had better come out here.

"They have very good dinners here but I cannot eat them.

"It is good fun doing nothing as I am not sick and I don't go to
school, I just walk around and do what I like. There were no bugs in my
bed last night, but they might come any time. I saw a deceased cat this
morning. We did not bring Batty [Mary's dog] along, thank fortune, as
I would have had to carry him and the valise and the shawl strap and
two umbrellas . . . get the tickets, and find a compartment which would
hold all these things . . . I am to go back to school on Monday, maybe
today I hope.

"Aunt Mary is going to paint a water color picture of me about a
foot square. My head is to be about an inch and a half in diameter so
you can imagine how small it is to be . . . We saw the palace but there
was not much to see except the throne of Napoleon the First. This will
interest Sister: it was an arm chair sitting on three steps and about it
were curtains covered with gold Bed Bugs, at least that is what they
looked like . . . I am having a snap time. With much love to all I am
your affectionate son—"

That July the honeymooning Gardner Cassatts came over, and the
augmented family went to see Eddie graduate from the École Monge,
with honors and many prizes. August 3, Robert Cassatt put his grandson
on the S.S. *Pennland* homeward bound; then Mary and her mother de-
parted for the trip to Cowes—where Jennie and Gardner, having "done"
part of the Continent, soon joined them. The Isle of Wight was festive—
"filled with Lords and Ladies and the gayest place imaginable," Jennie
wrote a receptive Lois on August 17; unlike Lois she had adjusted to her
in-laws with Virginia ease: "The family have been delightfully kind, and
never have I received more kindness and delicious eating, and I feel
perfectly at home. Tell Sister that the mashed potatoes were all she said
they would be."

Back in Paris a disgruntled Robert was writing Aleck one of those
really misogynistic letters of his. August 21: "I am here all alone . . . Your
mother wrote [from Cowes] not to send any more letters there . . .
until further directions—as I have had nothing since and there are several
letters for Gard and his wife waiting . . . I begin to suspect that your
Mother has forgotten all about what she wrote me and they may be . . .
wondering why there are no letters. Mame was very sick in crossing—
had to be carried off the boat . . . never was such madness as for her to
undertake a journey of pleasure in which crossing sea water was in-
cluded. She is dreadfully headstrong in some things, and experience is

lost upon her," he observes; she may only have been trying, blindly, to conquer her weakness.

For the Cassatt men, concern for health was the principal vehicle for conveying their love for Cassatt women. For the women—although they too worried about their health—it served as an unassailable excuse for evading masculine domination. Before Lydia died, Mary and Mrs. Cassatt had taken her to Pau on doctor's orders, and—left at home—Mr. Cassatt wrote Aleck, "We expected to have some trouble in keeping your Mother from backing out, but strange to say, she seems this time to be rather pleased with the idea of leaving home, a new trait in her." He was thinking of all the many times his wife had, vainly, tried to get out of breaking up yet another home to go off somewhere else with the then-peripatetic Robert.

Lydia, of course, had been their real, their perpetual sufferer (to the Victorians "a great sufferer" was a term of high praise). As with those geniuses who went to bed, it was her only way of saying No, to family togetherness. Lydia was not a genius, however; instead of achieving something, she simply contracted Bright's disease. When she felt up to it, her family helplessly moved her about: from Paris to Pau, to Louveciennes —where she grew much worse—back to Paris again, where at length she died. Her niece, Ellen Mary, the late Mrs. Horace Binney Hare, described her: "Lydia was very charming, very gentle and kind . . . From her photograph she was quite handsome and attractive. Aunt Mary *adored* her."

Lydia gone, all Robert Cassatt's exacerbated apprehensions fastened on his wife and Mary. Mrs. Cassatt in the end outlived her husband by a good four years; Robert, if he had been capable of commenting, would have retorted that it was only his incessant anxiety that kept her alive so long. (Perhaps it was, in view of the state of contemporary medicine.) His attitude toward his own health he expressed to Aleck in an April 18, 1881, letter, after an attack of "dyspepsia and vertigo"; "I did not think I wrote you in low spirits, I did not feel so, only sober in view of what might happen any moment—I do not fear death for that is inevitable—and have for several years past thought of it a good deal and endeavored to prepare myself to meet it calmly, putting my trust in a merciful and just God and submitting myself to his will." Women's health was something else. Its seemingly extreme fragility, to men like Robert was another evidence of weaker makeup.

May 25, 1883, Robert writes Aleck, "We have all been pretty well. I would say very well if your Mother would let me—but she won't! She had a letter from Gard today in which he happened to say that he was happy to learn from my last letter . . . that she was much better

. . . whereupon she rated me roundly for writing so falsely of her health —declared she was not a bit better, that I never observed anything, and a deal more in the same strain. The fact is that she is pretty well with the exception of a slight rheumatism, and the Doctor expresses himself astonished at her improved health and the disappearance of the dangerous symptoms of a year ago. Whilst the Doctor found her ill she believed him; now that he finds her well or nearly so she calls him an ignoramus. —Now not a hint of this from either you or Lois if you do not wish to have me *catch it*." The light fell differently, seen from the woman's point of view.

August 3, 1883, Mary wrote Aleck, "Gard chose a horse for Mother, and sold Bichette and the cart [the one that Mary had painted Lydia driving, beside a little girl, a boy groom up behind]. The new arrival is a gray colt we call Joseph, after Gard. I hope he will be useful, he has no style, in fact is common looking." Horses, health, and money thus come together over Gardner. October 14, Mary is writing Aleck, "We are rather anxious about Gard. In fact I am very anxious; he did not seem well when he was over here and he worries himself ill. I am afraid about his business. Jennie writes me that he was threatened with typhoid fever. He might well bring on a fever with that horrid Denver [a railroad stock] which I see is going down down down. I too hope he will get out of it soon, without a great loss." April 27, 1884, she bursts out to Aleck, her only confidant in such matters, "from the tone of Jennie's letter of the 13th . . . Father may have to come to Gard's aid [he later did, and his own income was reduced]. I am very sorry for him, and unfortunately we see Denver down to 14 since that letter was written. Do you think there is any danger of his breaking? Jennie is fearfully despondent and I suppose she gets it from him." Since Lydia's death Mary felt even closer to her brothers. Their masculinity buoyed her up, yet—flesh of her flesh—they expected of her only to be their sister.

At the close of 1883 Mary had taken Mrs. Cassatt to Spain. It was hoped that Alicante's mild climate would be beneficial to both rheumatism and heart trouble. January 5, 1884, Mary gave Aleck a glimpse of how health matters looked to *them*: "I feel very badly about leaving Father in Paris, more especially as he evidently considered the whole [trip] perfect nonsense, he really cannot be made to understand Mother is a sick woman and that if we want to keep her with us, she *must* be taken care of . . . The fact is, that apartment [the one in the Avenue Trudaine] is too much for her, those five flights of stairs; Father does not feel them, and thinks nobody else ought to. When you write him, you might say you are glad to hear he intends to move, that you are sure it is too much for Mother, and that you hope he is going into

a house with a lift. Now *please* don't forget this . . . I dare not open my mouth, he won't listen to a word I say. He thinks I want to move for my own pleasure, whereas I like our apartment very much, and would never dream of moving were it not for Mother."

Away from Mr. Cassatt Mrs. Cassatt's health did improve, so much so that when they moved on to Madrid in early February she insisted on "doing" the Prado, and had a relapse. After resting a week, they went on to Biarritz, but not until the middle of May did Mrs. Cassatt —so great was either her improvement or her reluctance to go home— return to Paris. Mary spent the spring shuttling between Biarritz and Paris, searching for a new flat; she wrote Aleck, "I am glad you wrote Father about the apartment. He . . . is now willing to change; before that he kept saying he would, but whenever it came to the point he backed down. I don't think Father gave in on account of money [Aleck sent $1,000 to help with moving, which Mr. Cassatt returned] because we don't really need it at all. Mother had money enough saved for her journey this winter, and . . . we only paid 27 francs a day [at Alicante] for all three of us [Mathilde was in attendance] including everything . . . I am in hopes we can get the fifth floor above the Dreyfus for 4000 francs (with a lift) and with one room more than we have, which will enable me to take a room for a studio. We can perfectly afford [it]. This winter if it had been necessary to practice strict economy we could have dismissed Martin [the coachman] and sent Joseph [the horse] out to . . . the Vet's . . . whereas Father has had the carriage ever since we left. When we were [in Cowes in 1883] Mother paid the expenses . . . out of what was saved out of the housekeeping allowance, so you see Father has been at no extra expense . . . Our apartment we could have rented easily, and no doubt will find a tenant again; but Father, the moment we left for Spain, told the concierge not to allow it to be visited by any one . . . he is all wrong, about money matters."

Mary found what they were looking for at 14, rue Pierre Charron (in a section of it since renamed rue de Servie), which they could afford, was fashionably located near shops, and which Mr. Cassatt pronounced "very elegant"—but at what cost is illuminated in letters Mary wrote Aleck April 17: "The apartment in Paris is very nice and even Father seems satisfied . . . but I sometimes despair of being able to take Mother back here. Father went on like a crazy man the first three weeks and nearly killed me, but latterly he seems reconciled and . . . no doubt will much prefer this apartment to the other. He was so unreasonable about allowing me to rent the other, that we lost about 100 francs by his obstinacy. He begins to realize, I think, that he is no longer able to manage matters for himself." Later, April 27, she goes on, "the house is very

handsome, and the rooms nicely furnished . . . Considering the difference
in the . . . quarter, the rent is not any higher . . . Father told me before
we went to Spain that he would pay 4000 francs, and this is 50 francs
under that [in modern terms, about $65 a month]. I have not touched
a brush since we left home, have not been out of Mother's room except
for a walk when I have been [at Biarritz]. It will do me good to get
to work again. I am going to take the salon for a studio and Father has
a small salon arranged for him." Even so, Mary completed seven pictures
in 1884.

She was the more willing to forego painting and take on self-im-
molation all that time, because of the affair of Mrs. Riddle's portrait,
undertaken in November 1883. Mrs. Riddle's daughter, Mrs. Scott—mar-
ried to Thomas Alexander Scott who had been president of the Pennsyl-
vania Railroad in the '70s—could well have commissioned a portrait of
her mother, but, of these cousins and the picture, Mrs. Cassatt explained
to Aleck, November 30, that "when they came here, Mary asked Mrs.
Riddle to sit for her portrait thinking it was the only way she could re-
turn their kindness [they had put the Cassatts up at a hotel in London].
She consented at once, and Annie [Mrs. Scott] seemed very much
pleased. The picture is nearly done but Mary is waiting for a very
handsome Louis Seize [frame] to be cut down in size before showing it
to them. As they are not very artistic in their likes and dislikes of pictures,
and as a likeness is a hard thing to make to please the nearest friends,
I don't know what the results will be. Annie ought to like it in one
respect, for both Degas and Raffaëlli said it was 'La distinction même';
and Annie goes in for that kind of thing."

When Mrs. Scott saw the portrait, however, she was deeply dis-
pleased. She considered it made her mother's nose too big, whereas that
feature had always been accounted a great beauty. The two ladies re-
jected the portrait. Rejection never sits easy on a painter, but this one
hit Mary so hard she thrust the picture out of sight in a storeroom where
it remained until 1914. It was discovered by Mrs. Havemeyer; Durand-
Ruel exhibited it to universal acclaim. Mary Cassatt gave it to the Met-
ropolitan Museum, where, as *Lady at the Tea-Table*, it may be inspected.

—And where it may be seen that there is, in fact, something very
much the matter with the nose. It is entirely understandable that other
devoted daughter would not enjoy having her mother endowed with a
pig's snout—which snout, incidentally, reappears in others of Mary's paint-
ings like *Children Playing with a Cat* and *Woman in Black at the Opera*.
Lady at the Tea-Table looks just the way formidable old ladies would
look to a little recalcitrant girl; it is a child's-eye view of the disagreeable
side of claw-fingered old ladies. It is beautifully painted. From an artist's

point of view the tea-set in it—Japanese china in the Canton style—is quite as important in it, if not more so, than the sitter. The untutored, "not very artistic," eye of the sitter's daughter, however, spotted a basic, human animosity that was indeed there. The painting constitutes one of the turning-points in Mary's career, for in its unintended ruthlessness it begins a gradual cropping-out of old, long-plugged resentment. From Mary's shock at the picture's rejection, from the way it made her oddly uneasy, she simply escaped to Spain, and for months did not hold a brush or cease from filial devotion.

The rue Pierre Charron apartment did well enough for a time, but on December 10, 1886, Mrs. Cassatt is writing to Aleck that "We have not yet selected an apartment but Mary is busy looking around here— there are plenty of them but I seldom see one without thinking of the saying Degas once repeated to me, namely, 'Bête comme un Architecte' —and that apropos of his own brother-in-law. Why, I actually saw an apartment on the 5th story where the kitchen was so small that there wasn't room for a box large enough to hold a day's supply of wood and coal—and there was no pantry . . . I don't know what we would do without Mary to look for us. She has a knack of finding out what is for rent, and don't mind scaling the stairs when the lift is not yet in working order." In March 1887 the Cassatts moved into the 10, rue de Marignan apartment, from which they were never again to transfer.

No scene in Mary's life is more charmingly visualizable than that of her pausing, mounted (side-saddle of course; no woman rode astride) on her way from riding in the Bois, at the house of her artist friend Berthe Morisot, to speak to little Julie Manet, Berthe's only, adored, much-painted daughter. Julie's son, the present-day art critic Denis Rouart, says his mother never forgot how the American lady used to lean from her tall horse to talk. "Miss Cassatt must have been on her way home to the rue de Marignan for the Manets lived at No. 3, rue Paul Valéry," explained M. Rouart, who stayed on at the old address until Julie's death in 1967.

"Berthe Morisot was a friend, yes, of Miss Cassatt's," he went on. "They used to show their pictures together, but she was not a great friend, you understand. My grandmother's letters to Mary Cassatt begin, 'Chère Madame'—*not* an intimate form—while Mary Cassatt's to my grandmother begin, 'Chère Berthe.'" He paused, as if struck by various implications of this statement.

To the inevitable question, about whether Mary Cassatt and Degas had an affair, Rouart replied that his mother, Julie Manet Rouart, had never known. "My mother was very virtuous," he observed; and added, "*No one* knows!" His feeling was that Mary Cassatt shared with Degas

what he called "a certain lack of joie de vivre" that would have prevented any affair. "The other Impressionists, the *plein-airistes*, were filled with joie de vivre. But not they! They were not *plein-airistes*, they were not really Impressionists"; they were more what Cabanne calls moralists.

Even Mary's family, who loved her, were not really interested in her art, only in Mary, who happened, as they saw it, to paint pictures. The Cassatts' idea of an interesting picture was one with horses in it, with the conformation accurate. Like many other lovers of horse-flesh, the Cassatts' could have their whole pleasure in a painting ruined by one misplaced hock. To them, the Detaille picture of the Aleck Cassatt family was the way a picture ought to look. For sympathy, for understanding, for comprehension, with Mary it had to be Degas or nobody.

Hardly a Cassatt letter fails to mention horses, frequently in combination with money. The horse Mary bought in 1882 while at Louveciennes when Lydia was nearing death is described in loving detail by her father in a letter to Aleck of July 3: "A thoroughbred 12 years old, which the vet found for her at 800 francs. He is an old *trooper* belonging to an officer, who will not part with him until after the military manoeuvres are over . . . I was quite surprised to see so fine a looking animal offered for so small a price." August 2 he is writing, "When it came to the point about the price they screwed her out of 50 francs more than the sum first indicated, and besides the vet's commission is yet to be paid . . . I suppose if she gets off on 900 francs she will be doing very well—she has a good saddle and bridle which cost her 70 francs . . . So that the turnout will not exceed 1000 francs—the horse is a good size for Mame, carries well in showing, even, and has unmistakeable signs of blood—with double the money she might have gone farther and fared worse. Need I say she is very proud of him? I ride him a good deal as Mame in her rides does not give him enough of exercise."

The next year the horse, named Deauville, was operated on at a veterinary school at Alfort for lameness—"the nerves cut just above the hoof," Mary writes Lois on June 15, 1883. "A horse dealer yesterday told us to sell him immediately. '*On fiche quelqu'un dedans*,' he said with a laugh; and when the lameness returns, as it surely will, then the purchaser would hunt up the place where the nerve has been cut and he will understand that it is all up with that horse!" No doubt this horse-dealer's trick was practiced originally on Mary, that Deauville cost "so small a price." This time, however, on June 15, Mr. Cassatt could write Aleck, "I believe I wrote you of Deauville's great promotion? . . . His case is considered very remarkable, only three like it known in the history of the establishment. Head Prof. performed operation himself in presence of

200 *élèves*, lectured, and then consigned the interesting patient to the special care of his *plus fort* pupil. Fancy Mame's pride in being the owner of a horse like this. A historical horse, treated at the expense of the Government . . . I doubt if any sum of money would induce her to part with him *willingly* after all this." It was perhaps the only time a Cassatt ever joked about a horse; and very likely it covered the mortification of having got took.

Mary, deep in horse mystique herself, on September 2, 1886, wrote Aleck: "Father and I went to the first day's racing here [between Arques-le-Bataille and Dieppe] the ground is lovely, beautiful green meadows with hills on either side; there were not a great many people there the first day, but it was a beautiful sight. I must say Degas has done some very fine pictures of races, it is a pity he has given it up. —We have Isabella [horse] lame, and I have been treating her with success; that is, when I don't ride her far or fast, she keeps well, but if I trot too much then she limps a little the next day. It comes from a windgall on her right foreleg, and the end of it will be that we will put her in the carriage and sell old Joe. She is younger and far better than he is, he is getting cranky." That same summer, on June 30, she had written Lois something that, while not a joke, approached one, but again not *at* horses: "We would like to be informed about the racing [that Aleck's horses took part in]. Mother don't approve but still wishes to know all about it. The other day I had a good laugh at her. Gard sent me two New York papers with an account of the exhibition [the Durand-Ruel show] after reading about that Mother searched a good while and finally exclaimed with disappointment, when she found we only had half the paper; she was hunting for the racing news! A still better story yesterday—Father had a long letter from Mrs. Alden who sent him an extract from one of the Chicago papers about Aleck, she said Cousin Belle had sent it to her and that last winter Cousin B. had sent her an account of [Aleck's] horses from one of the papers! He's corrupting all the old ladies in the family."

Like so many painters, Mary Cassatt functioned above all through physical senses, especially, of course, sight; that was part of why riding came so naturally. Only in the feminine and the maternity paintings did feeling get past the powerful, bluff, active personality she was developing. Feeling—muffled at first by shyness and then by the conquest of shyness —had been steered on Degas' advice into a channel through which for years it could successfully if symbolically flow. Mary's maternity paintings are so full of feeling that it is easy to forget that that feeling's source was her remembered, not her active, experience. She felt the scenes because she had been in them. She knew how it felt to sprawl; she

remembered exactly the maternal caress. In the brilliance of these tours de force it is easy, too, to forget what Mary never could express with any feeling at all: men and horses.

In the 1879 painting of Lydia driving Bichette in the dogcart with little Odile Févre (niece of Degas and sister of the infatuated Jeanne) sitting beside her, the boy groom, facing the other way, is wooden, perhaps on purpose. The hindquarters of the horse—all that shows—is wooden too. For all she loved horses; for all, as Lois put it, "She thinks only of her father" she never painted either men or horses with freedom. The various portraits of her brother Aleck all show the same constraint. That he was rather a wooden man only contributed to the effect. She knew it herself; the portrait she painted of Degas she very likely destroyed.

Only in painting women, painting delicious children, was she free, as with Lydia. Lydia . . . finest of Mary's many representations is perhaps *Lydia Crocheting in the Garden at Marly*, where her sister wears a wonderfully translucent lace hat. A dress of strong blue, a garden of green, purplish foliage, a sandy path leading up to the villa—even the pale and sickly face of the sitter gives the sense of summer's peace; of all gardens everywhere.

For young males, for the little boys who like to ride horses and to run away, she had feeling based on memory's truthfulness, as may be seen in the various pictures of Robbie, Aleck's younger son. Mary was especially interested in Robbie since he showed artistic talent. Painted the year the boys began at the École Monge, *Head of Robert No. 1* is marvelously boylike, full of recalcitrance and rebellion, far more so than the more formal *Master Robert Kelso Cassatt*, which no doubt better pleased his parents, showing a tamed Robbie, neatly dressed, leaning decorously on a sofa arm.

One of Mary's greatest portraits was of her mother and called *Reading Le Figaro*. Painted in 1883, it is all feeling—no hint of snoutlike nose in this serene face. The old lady, hair still dark, glasses perched on nose, reads bathed in wonderful, translucent, Impressionist light. *Young Woman in Black*, painted the same year, sitter unknown, demonstrates another side of woman's quality Mary understood: chic. More style was never painted with more verve than here. Mary's grasp of chic was in fact what made her able to render Lois the only service that lady ever appreciated from her, beyond the hiring of servants to send her in Philadelphia: ordering dresses for Lois from the haute couture houses Mary herself patronized—Redfern, Doucet, and La Ferrière.

While on the trip to Paris alone with Robbie and a servant in 1884, Aleck wrote Lois, "Mary has commenced a portrait of Robbie and me together . . . I hope it will be a success this time," for the family was

aware that something in those masculine portraits was not quite up to Mary's standard. The portrait did turn out to be rather more of a success. The seated man is still wooden, the little boy is still tense, perching on the arm of his chair; but the juxtaposition of the two heads, the relation of one to the other, suggests something that is lacking in Mary's other portraits of men.

It is lacking, for example, in the pastel of 1885, *Mr. Robert S. Cassatt on Horseback*, although, at the time, she wrote Aleck, September 21, that she had "done a large pastel of Father on Isabella with which he is much delighted but he says you will never believe that she is as handsome as I have made her." The animal looks, even to a sympathetic eye, like one of those jointed wooden models artists used to have to get horse anatomy right. Mr. Cassatt, back to, looks hardly more lifelike. The elderly slump to the back does render the old man almost human, but not quite. Mary may have thought only of him; she may have in fancy "been" him; but she did not know how it really felt to be him. In imagining him, she did not get it right.

On the other hand *Mathilde and Robert*, painted out-of-doors the same year, is all life; all humanity. Robbie, conspicuously trying to get away from the *gouvernante*, is held on to with an equally conspicuous firm grip. Mrs. Cassatt wrote "Sister" Cassatt about the painting, "I tell [Robbie] that when he begins to paint from life himself he will have great remorse when he remembers how he teased his poor Aunt, wriggling about like a flea." Although Robbie plagued her to distraction, Mary knew how his frantic efforts to free himself felt. She remembered them.

Paintings of children, ever more children, marked the years 1885 and 1886 for Mary; above all, the *Little Girl in a Big Straw Hat and Pinafore*, painted the latter year. From that disconsolate little girl's face gazes, with the same abstracted gaze as in Mary's 1878 self-portrait, everything Mary felt about being a little girl: the helplessness, the dismay, the longing for somebody to come and give the command "Live!" In Mary's own life, even before art came, horses had been the carrier to take her away, up, out, from frustrations and disappointments and the encircling web of womanhood. Her dream of horses was a good dream, but a horse does not really carry its rider out of one world into another; only almost. Riding is, however, an excellent physical release and Mary, troubled in a thousand ways by the ocean, had always found that in riding.

Early in the summer of 1888, out riding with her father, she had a disastrous accident—the first of a number of others which followed in rapid succession. This first accident alone made it impossible for her ever to ride again.

PART III
The Fall

NINE

DEGAS DESCRIBED HOW the accident happened in a letter to his old friend Henri Rouart, that summer of 1888:

". . . Tillet [Armand Tillet, editor of the weekly *Chronique Artistique*] must have written you that poor Miss Cassatt had a fall from her horse, broke the tibia of her right leg and dislocated her left shoulder. I met him two days later and told him the story; he was to have written you the same evening. She is going on well, and here she is for a long time to come, first of all immobilized for many long summer weeks and then deprived of her active life and perhaps also of her horsewoman's passion.

"The horse must have put his foot in a hole made by the rain in soft earth. HE [capitalized, in the Marguerite Kay translation] hides his daughter's amour propre and above all his own."

It was not the only time Degas spoke, in letters to friends, of Mary's "horsewoman's passion." That passion, with its danger, speed, taking of chances, was worlds away from his own views on horses. To the painter and sculptor Paul-Albert Bartholomé, with whom, shortly after, he enjoyed a very different type of equine experience, he wrote, earlier in 1888:

". . . In reply to a letter of mine Miss Cassatt told me among other things that while out riding in the forest her mare shied. She thought she saw some wild creatures moving in the grass, and when she reached home she saw that the horse's leg was swollen. It had been stung by a viper. It seems that viper-sting is less harmful to animals than to human beings, and doesn't kill them."

If ever an event was laden like a ship to the gunwales with mystery and suggestion, it was Mary's fall. It was not an isolated accident, either. She wrote a friend, George A. Lucas of Baltimore, an art collector and friend of Whistler's, with whom she felt particularly close because he shared her horror of the sea, about another of them. Lucas, coming over to Europe on the Grand Tour, had been so disastrously seasick he swore never to go aboard a ship again, and never did—to go home or anywhere else. This sharing of the experience of Nature—instinct—as menace, made Lucas a good confidant to tell of this accident involving horses:

September [c. 1890]

Dear Mr. Lucas,

You would have heard from me before now . . . if I had not had another accident. I was thrown from my carriage on the stones at the corner of the Rue Pierre Charron and the Place d'Iéna and as I lighted on my forehead, I have had the blackest eye I suppose anyone was ever disfigured with. The carriage was kicked to pieces, the coachman pitched out, and even the dogs wounded, and all because a man driving a van thought he would amuse himself cracking his whip at my cob's head, finding it frightened her. He leaned out of his wagon and continued his amusement until he drove her nearly mad with fright, and drove off smiling.

Fortunately none of our wounds were very serious. I am well again but still with patches of red and blue on my forehead and around the eyes. As soon as the doctor would allow me we came here where I am beginning to work . . .

"Here" was the Château de Septeuil, in that north-of-Paris region to which they had returned after the summers near Dieppe. Though Mary's letter is dated September it may refer to the same one of her rash of accidents that Robert Cassatt mentioned on June 21, 1890, in a letter from there to Aleck:

"I suppose some of them [Aleck's children] told you of Mame's second accident? She had a very narrow escape, but is now as well as ever with the exception of one of the blackest eyes I ever saw. Mame is hard at work getting up a new series of dry points. She has had her press brought out here and proposes doing a lot of work. I only hope she may be as successful as she was last year." During the year of her fall Mary only painted two pictures, but in 1889 she completed twelve paintings, some among her very finest, including the great *Emmy and Her Child*.

Mary was a restless patient. Mrs. Havemeyer recalled one recuperation, after Mary's horse fell in the Champs Élysées, when she was "full of a new hobby"—a doctor named Raspail, and his camphor treatment for her broken leg:

" 'You must get his book, my dear,' she said to me. 'Camphor! Nothing but Camphor! Compresses of Camphor! Spirits of Camphor! Pomade of Camphor! It is wonderful!' "

Degas was most sympathetic in 1888, when Mary was recuperating from her worst fall. With a considerateness unusual in him, he even brought her flowers, because he knew she loved them, while he himself hated flowers—cut flowers, that is. He once picked up the centerpiece at a

friend's table and threw it out of the window. He wanted flowers to be growing in the garden. If flowers were sent to him he passed them on to some woman friend because, he told Jeanne Fèvre, he could not bear to see them "die in his house." The notes he wrote to Mary as she lay recovering did not survive the holocaust to which she submitted all his letters before her death. Around this time he also wrote for and surely about her his curious sonnet.

Degas' young friend Halévy gives the genesis of the painter's turning to poetry at this period which, for Degas also, Halévy asserts, was "a sterile time . . . The difficulties that Degas was now encountering in his painting would year by year become impossibilities. Otherwise he would never have found the freshness of inspiration that charmed us in his sonnets." He related that "to me, to our little group of friends, Degas' first sonnet came as a surprise . . . It came out of the blue and was recited with the great care that every poet attaches to his own work . . ."

When Nepveu-Degas later published a selection of the poems under the title *Huit Sonnets,* he observed in a foreword that Degas wanted to prove to himself, through them, that in originating any work of art will is paramount; that to be a poet, it is enough to want to. For his writing of the poems the great Mallarmé bestowed on Degas the best advice a poet can give. "Degas," he said, "one does not write sonnets with ideas, but with words." To Berthe Morisot, Mallarmé wrote in 1889: "Degas lets himself be distracted by his own poetry. He is on his fourth sonnet. He is obsessed with this new art, which he picks up, *ma foi,* very prettily." Berthe Morisot is turn observed wryly, "Are they poetry? or a variation on the tub . . ." In fact the poems do recapitulate, in a new medium, the themes preoccupying Degas at the time: horses, dancers, women in the bath.

"The sonnet usually called the second," wrote Halévy, was "dedicated to Miss Cassatt . . . We assumed that they were close friends, but never did I hear the sonnet dedicated to her read aloud to an amused audience. Never did I hear Miss Cassatt's name on Degas' lips." Jeanne Fèvre—going on in her infatuated way about "These aerial poems, winged, living, which today seem to us to have been written with great ease and under the intoxication and joy of the imagination"—reveals that Degas kept a poetry notebook, which has been lost, that was like "a tragic confession of the suffering the poet knew before achieving [them] . . . To make two lines rhyme, Degas had to search, grope, take"—marvels Jeanne—"trouble. He makes one think of the rough mariner, with great difficulty making headway against a storm. But there is also evidence of the ringing proof that the Muse, touched by his ardor, turned to him and gave him her kiss." The sonnet to Mary's parrot, it seems, took a long time, and gave Degas particular trouble—indicating that, if he was writing the fourth

sonnet in 1889, the second may well have been begun after Mary's fall. Starting by amusing him, it became increasingly worrisome.

"He read it over and over," Jeanne relates. "The rhyme rebelled. At last it was finished. Was the author satisfied? It is difficult to say . . . But it is so beautiful! He is there, rendered human, this animal with its prodigiously-colored plumage. One hears it call its mistress and the voice is human, truly." Another not wholly human being—with that voice which the English writer Vernon Lee described as "loud and harsh," in her prodigious plumage from Redfern and La Ferrière—resting on some chaise-longue for sequestration while her bones knit, must have wondered just what Degas meant. No parrot had such thoughts, such sentiments. The sonnet compares Coco to the parrot of Robinson Crusoe on his solitary island; but what parrot? what castaway? what island did Degas mean?

PERROQUET

À Miss Cassatt à propos de son Coco chéri

Quand cette voix criait, presque humaine, là-bas,
Au long commencement d'une même journée,
Ou durant qu'il lisait sur sa Bible fanée
Que devait ressentir ce Robinson si las?
Cette voix de la bête, à lui accoutumée,
Le faisait-elle rire? Au moins, il ne dit pas
S'il en pleurait, le pauvre. A cris perçants et gras
Elle allait le nommant dans son île fermée.

C'est vous qui le plaignez, non pas lui qui vous plaint;
Le vôtre . . . Mais sachez, comme un tout petit saint,
Qu'un Coco se recueille et débite en sa fuite
Ce qu'a dit votre coeur, au confident ouvert,
Avec le bout d'aile, enlevez-lui de suite
Un bout de langue, alors, il est muet . . . et vert.

The American poet, John Frederick Nims, translating Degas' sonnet especially for this book, makes this of it:

When that voice, nearly human, rasped the air
At the slow start of each day like the rest
Or while he read, worn Bible to his chest,
How would he feel, poor sagging Crusoe there?
That creature's cry, familiar—would he dare
Laugh at it, though? He never once confessed

He wept as it cried his name—lush, overstressed—
Abroad on his private island, everywhere.

As for your own . . . You pity; but it? No.
She's really a plaster saint, is Polly, though,
At recollection—of secrets won from you.
She flounces off to gossip, all prate-and-preen.
Clip off her wing-tip. Clip her tongue-tip, too.
What's Polly then? She's wordless . . . and very green.

It is hard to believe that what Degas felt about not only art, but what he could not say outright, his hurt, was entirely concealed from Mary in these words. Lesser things had made her angry.

The will-to-art on which Degas staked so much was in complete contrast, though, to the instinctive act of falling off a horse. Degas' letter to Rouart conveyed that Mary fell with her horse, not off it which, to an equestrienne of any amour propre at all, would be the unforgivable sin. It is thus all the more mysterious that Mr. Cassatt is described in Degas' letter as "concealing his daughter's amour propre and above all his own"; amour propre about riding, that is, since it is in the same paragraph as the description of the fall, and Degas, unlike Mary, stuck to the subject in his paragraphs. If the fall was unexceptionable, caused by the horse putting its foot in a hole and not by poor horsemanship, what was there to hide? It seems unlikely that old Cassatt's intuition would have been up to connecting horses and sex, even horses and instinct. What Degas' letter actually said, however, was that the horse "must have" put its foot in a hole. Room is left for the possibility that Mary fell off, and that this fact was being concealed at all cost by her father, for his own self-respect and hers.

Her accidents were, of course, just that: accidental. Yet it does not take very much imagination to hear a voice speaking in them that was not her everyday one. When she fell, out with her father in 1888, it was as if instinct, the same instinct that once made her long to ride out into life, now said, "Father, I'm riding with you no more. I'm leaving you. You belong to my childhood, to the past," and as if it were crying, to herself on her high horse of convention, "Oh, come off it!" It was as if instinct were announcing, "I cannot go on like this. I have done this way all I'm going to. I am smashing everything to pieces." To none of this, of course, would, could, the woman actually smashed up, listen.

It is not necessary, even, to be so fanciful. The fall did break Mary's lifelong bond, of riding with her father. It did end her principal form of physical release. It did introduce suffering into her present. After her fall it did become necessary to find something new, if there was to be

any outlet for the same energy. The only mystery about it was what form the outlet would take—if there was any.

There are ways and ways, of course, of looking at horses. During 1890 Degas exhibited quite another attitude to horses and all they stand for in the course of a long, meandering, food and wine tour he took with his painter-sculptor friend Bartholomé, whose wife's death had awakened Degas' always tender sympathy. He had given Bartholomé the pastel *Miss Cassatt at the Louvre*. They drove in an English cart called a tilbury, behind a white horse that was the antithesis of any horse in the Cassatts' lives. The trip was paradisaical. Degas' letters back to the Halévys and others, giving his views on sex, women, and pleasure, for sheer sparkle and exuberance could be set to the Strauss waltz "Artist's Life"; they show what life with Degas was like. The gaiety seems moreover, as in the waltz, to be suppressing despair; something had happened, not only to Mary but to Degas.

The collection of Degas' letters in the Bibliothèque Nationale de France has attached a note in Ludovic Halévy's hand: "Tuesday morning the 30th September, Degas and Bartholomé arrive at Montgeron [where the Halévys had a country house] in the tilbury harnessed with the white horse. They lunch at Montgeron and leave at two o'clock. We accompany them on the Melun road as far as the Pyramide." The letters that follow begin previous to September 30.

Sunday morning, 1890

The time is approaching: a white horse is crossing the forest of Senart, and behind him two old men [Degas was fifty-six] are being drawn, one of whom, still a little younger [Bartholomé, who drove], is holding a whip, sitting a little higher. He, it appears, knows just where he is going. He does not believe the peasants, who never tell the truth about the way. He says that he who knows how to read a map should travel with his eyes closed. For a whole week maps had been stuck on the walls of the damp place [Bartholomé's Paris studio] and he studied them with a little rolling instrument in a dial, which was to prepare the varied route. He who has drawn a straight line and who wishes to follow it will not drink, say the scriptures.

We shall leave about midday. The white horse is intact, so is the tilbury, so are the two men, but less so, thank heavens! . . .

At bottom we have no other wish than to see again the enchanted palace where the gold ring was almost lost which the little princess Henriette [Mme. Georges Jeanniot, wife of the painter, for whose château they were bound], the most beautiful republican princess

in existence, dropped carelessly, advised as she was by the genie disguised as a Scotch terrier, who had persuaded her that in this way she would break the spell and be able to refurnish the castle all in one morning.

He who scorches the roads with a white horse at the rate of ten leagues an hour, say the scriptures [a league: about three statute miles.], is certain to arrive in a short week at the place unknown to the horse and familiar to the two old men . . . Notice sent out en route will enable you to follow us on the map and to see us approaching perfectly happy.

Tuesday evening, 30 September '90

Evidently animals think and speak, particularly among themselves. Bartholomé noticed that our white assumed in the stable an air of vigorous roguishness toward your noble servant.

At the end he took on, behind the other [Bartholomé] a vexed and impetuous air—after the obelisk, the isolation and the sight of an enormous straight line [the road] calmed him. He slowed down to a walk too often. He acted exhausted in a town he did not wish to leave again. He has just devoured.

Another note on September 30 says:

He is tired, we think only of him. Oats are everything, say the scriptures, they are better than a good word.

The following day Degas wrote:

Everything goes like clockwork. He appeared in the morning without animation at half past six. He left feebly. There was nothing wrong with him. He had slept too much . . . Everywhere praise of the horse, particularly in the stables. "You have had him a long time," said the stable boy to Bartholomé. "He was born at my place," he replied. Alas! it is only two days that we have him! What would we not have done already if we had had him in our days of maturity!

2 October '90
Sens. Thursday
About 1.30

Montereau, Hôtel du Grand Monarque
(the real one)

LUNCH
Sheeps' foot
Fried Gudgeon

Sausage and mash (admirable)
Beefsteaks with cress
Cheese, fruit, biscuits (admirable)

The horse made a fine descent on Montereau.
Left at 3 for Villeneuve-la-Guyard.
There, continue to descend to the Hôtel de la Poste.

DINNER
Panada with milk
Brains, melted butter
Jugged hare
Leg of mutton, mixed beans (famous)
Salad
Mixed dessert
Light red wine

Left this morning at 7 o'clock.
No more thoughts, one eats too much. Each meal 3 francs.

Writing from Flogny on October 3, Degas observes, "One needs to have been sad and serious for a long time to enjoy oneself so much." At once he adds, "It is useless to be horrified at having such emotions. Our coachman is carrying the horse in his arms . . ." Robert Cassatt would not have been amused.

They reached the village of Diénay, close to the Jeanniot château, on the seventh of October. No Renoir picnic was ever more lighthearted than this reception:

"Arrived here at 4.30, a quarter of an hour too early for the manifestation. At the insistence of a person sent to meet us, we waited for the three strokes. Then a real policeman on horseback came and demanded our papers. A sub-prefect in uniform advanced with a dish and two keys and a speech, that the ladies interrupted by lancing [at us] as from a cannon, the flowers of honor. General ecstasy, joy everywhere, a joy of excellent hearts . . ."

The "real policeman," Georges Jeanniot himself, further retouches the scene in his *Souvenirs de Degas*: "We were warned of the exact time at which the white horse was to appear on the road. All our friends were there, the young girls with their baskets of flowers, Edmond Couturier, as an inspector, carrying the keys of the village on a silver dish. When the moment came the young girls advanced with their flowers, with which they covered the horse and the travelers. The keys were offered to Degas who was very touched by it. Our little band, escorting the carriage, entered the village slowly, with all the dignity worthy of the occasion."

The travelers stayed on at the château until October 12, Degas dropping a note from there to Durand-Ruel, dated October 10, instructing him to give Zoë, his maid, 200 francs "for which I shall bring you a repayment in objects done by my hand."

Later in the journey, which described a wide circle, Degas wrote: "The horse has never been fed like this: instead of weakening it is putting on weight. Moreover, I defy anyone to deny it, he knows that he is regaining Paris, he knows that direction without a map."

At twelve o'clock Wednesday, October 15, he wrote to Ludovic Halévy: "You will reproach me with not having invited you to lunch at the Lion d'Or? One does not eat like that, once one is a member of the Academy, you will tell me. With one hand, the right one, I am writing to you, with the other I am eating a dish in which things are happening that chicken and veal can produce only here. —Bartholomé's right hand is eating grapes. We are living. Here is the cheese, it is as it should be.

"The effect on the horse is much more precise. It is a timepiece. From the terrace of the tilbury one sees under his tail, and according to the color and quantity of what comes, we know what we have to know. —How does he know geography? He knows it."

"Poor Miss Cassatt" liked good food too, as her mother mentioned in a letter to Aleck on January 23, 1891, after the Cassatts had received some American delicacies from him and Lois: "I think you would have laughed had you seen your Father and Mary lunching on the oysters which were excellent—they ate so many that they had to wait between the plateful and I had to explain to your Father that the oven only held a certain quantity . . ." The jokes about horses, however, to say nothing of horses' rear ends, would not have gone down with Mary any more than with Robert.

From St. Florentin, October 16, midday, Degas wrote, "Rain all night, but we were in bed. This morning the wind rises, chases away the clouds and drives us here in dryness. People clean their windows a lot in the provinces and they see nothing through these windows."

The travelers now headed for the Melun house of a friend, Pietro Manzi, an engraver, who knew all the Impressionist group. At Sens once more, Degas wrote, October 17, "Telegram from Manzi: 'Shall be on road Melun to Montereau Saturday Affectionately.' Go on, do something," Degas adjures Halévy. "Be less Montgeron, more Senart. Be at Melun, be at the Grand Monarque, with a raincoat . . .

"Do you want a fact? Here it is: A thing, that costs more than women, is property.

"Almost continuously walking pace."

They reached Melun the eighteenth of October; Degas wrote at seven-thirty that evening, "No Forain, but Manzi. At 10 kilometres from Melun a coupé advanced upon us. I had my revolver in my hand; it was Manzi. I did not fire. I must tell you that I am on the watch and am always eager for danger."

The trip could have worked wonders for Mary, after her accidents, if she could have taken it, in any sense at all; if only to listen to Degas' nonsense about horses, money, and health—so different from the way Cassatts talked. The lack of joie de vivre Berthe Morisot's grandson perceived in Mary contrasts with the way of life of her fellow painter and, up to a point, friend, Berthe ("Chère Madame . . ."). John Canaday catches Berthe's likeness at one stroke, when he says that although she died fairly young, in 1895, "People are still falling in love with her." She too was conventional, but she substituted other kinds of seriousness for lack of humor. Joie de vivre would have come easier, to a descendant, as Berthe Morisot was, of Fragonard, the exquisite eighteenth-century painter.

Berthe had been deeply in love with Édouard Manet, who early in her career became guide and mentor to her in the same sense Degas was to Mary. However, although Manet indulged himself with fair freedom in casual affairs, he was, also like Degas, too sensible, too honnête homme, to involve himself in the seduction of a girl of good family, even though that family had artistic tradition, lacking in the Cassatts. Berthe and her sisters were brought up studying art, in Berthe's case equipped with a talent capable of real flowering. Her painting did not have Mary Cassatt's force, as Gauguin pointed out. It was more delicate; the draftsmanship not so formidable. It was more feminine, and so was she.

For Berthe Morisot, as for Mary Cassatt, there could be no question of a liaison with no matter how delightful, mysteriously dear, wise, and familiar an older man. Berthe, in addition to finding relief from frustration in her work, did the sensible, French thing: after her father's death she married. She married Manet's brother Eugène. There was a certain irony, a certain chagrin in the match, but she could write her brother Tiburce shortly after the marriage in 1874: "I have found an honest and excellent man, who I think loves me sincerely. I am facing the realities of life after living for quite a long time in chimeras that did not give me much happiness." Her decision provided her with her greatest joy—a daughter, Julie, who from infancy up posed for her mother's pictures. It is poignant that, in the end, Berthe was buried in the same tomb with her great love, Édouard Manet, who had died in 1883.

Not only did the childhoods of Mary and Berthe make a difference; their nationalities made a difference. Berthe, by placing herself in the

position of a married woman in good Paris society, was following the advice of Henry James's poor regretful Strether, in *The Ambassadors*—"Live!" The Eugène Manets went about as a couple, dined out, invited people back. It was a life that did not interfere with, that augmented, Berthe's work; it is even possible it prevented her art from becoming fixated on any one theme. Her faults as a painter were more in the intellectual discipline of draftsmanship than any emotional weakness in color. She knew friends, frustration, sex, the painful joy and joyful pains of childbirth.

Until her fall, in the world of Mary's Infant Jesuses with their English nannies, all was calm, all was bright. The cross of suffering had not raised its bleak and lonely head except for the sorrow in the faces of forlorn little girls, pent-up little boys. Berthe Morisot's work does not so much depict suffering as take it for granted; the faces of her women, her own face as Manet painted it, are faces familiar with pain. Those earlier paintings Mary did of Lydia suggest, rather, sickness. The wavering green reflections under the lace hat in *Lydia Crocheting in the Garden at Marly* make it appear almost seasickness. The third angle to maternity is left out; but almost at once after 1888, her pictures hint at it—in the 1889 *Emmy and Her Child* with Emmy's look of stoic fortitude, and *Mrs. Robert S. Cassatt*, of a lifetime spent enduring. Mary's fall had come as a sort of Nemesis: she had been riding for a fall because she was, not exactly feminine—passionate.

No more passionate woman ever drew breath. It speaks from every letter. She lost her temper continually, at Degas but also at most people. She adored her family. She was violently loyal to the Impressionists. Within her divided life she did nothing by halves. For such a temperament (a very American one) the price of denying instinct comes high. Mary denied it partly because being "only a woman" filled her with childhood's horror; partly out of conventionality; partly out of devotion to increasingly dependent parents; mostly because of her faith in art as a vessel for the transformation of instinct. In art she had created a shrine for a youthful life she had denied. Now she was in her late forties.

The advantages she was sacrificing cannot be scamped. Degas had often enough confessed to his desire for a wife, "even children"; but if Mary expected him to sweep her off her feet she could have waited to eternity. Forcefulness was in her nature, not his. Forcefulness might even have succeeded with Degas, too, witness his later docility at the hands of the Terrible Maria. If, too, Mary had really been a Philadelphian, she might have had the effrontery to make a dead set for him, but it would not have occurred to her; the iron of Pittsburgh was in her soul. Like generations of women for centuries, she had no notion of her own power,

or that Degas' attempts to quell her were just that: efforts to subdue a formidable force, not a puny one. Power does nobody any good if it is unaware; what Mary was aware of was Degas' wicked tongue, his ability, far from welcome, to "dissolve your will-power"; ample reasons for not wanting to share his life.

Over the years she had not so much desired Degas as desired his powers. It might be said she parroted him. Because of her way of learning through "being," instead of seeing him plain, she was able to believe him strong, misogynistic, and dangerous. At Pissarro's funeral she would say to Degas, "You're nasty to your brother, you're beastly to your sister; you're bad, you're bad." At which, Gimpel reports, Degas, "uttered a raucous snarl, the snarl of his life." That was fifteen years later; the century had turned. Back in 1888 there were still possibilities.

Together she and Degas could have painted in fruitful if tempestuous proximity. They might still have had real children, union of Degas' intellect and Mary's gusto, brought up in an atmosphere of art and Paris. Life with her might have modified his involuntary hurlings of epithet; made him see before it was too late that he really hurt people. Life with him might have modified her misanthropy, to say nothing of her French. They would have made one of the most remarkable couples in the history of art. Paradoxically, she was, however, too much him, to love him. When he was harsh, she assumed it was from the same hostilities she felt when she was harsh. It seems not to have occurred to her that, in him, harshness had other sources. Actually Degas was oceans away from being like Mary; for one thing, he was male. Mary's childhood experience of maleness had been too painful to make possible the remembering that is the basis for the kind of imagining necessary to understand someone very different.

When as an old woman she was asked by the publisher and writer on collecting, A. F. Jaccaci, "If you could start your life again, would you marry?" she admitted, "There's only one thing in life for a woman; it's to be a mother." When Jaccaci, who had known her for years, gave his opinion to René Gimpel that, "She's become a viper," he added, "She was always very sharp-tongued. What she needed was a husband, or a lover." To this masculine assumption he added more: "She sacrificed her chance of having children, sacrificed it to her art. When she was young and showed her adorable paintings of motherhood, no compliment irritated her more than, 'One can feel you're a woman!' She wished to be an artist exclusively." Forbes Watson, who understood her better than anybody, revealed that in old age she told him, "A woman artist must be . . . capable of making the primary sacrifices." Mary's sacrifice is only sad be-

cause her pictures suggest how deep her feeling was for the sea-lanes of life and the rides of love.

Destiny, however—hers and Degas'—had other plans. Both these artists clung to art, Degas because of being "so badly made, so badly equipped, so weak" when his "calculations were so right," Mary because her work rendered her "independent. It made him furious that he could not find a chink in my armor." Back in those days, the days of the fall from her horse, Mary made the primary sacrifices, and it worked.

What happened is heralded in a Degas letter of late April 1890 to Bartholomé. "Dinner at the Fleurys Saturday with Mlle. Cassatt. Japanese exhibition at the Beaux-Arts," Madame Fleury being Bartholomé's sister-in-law, whose décolletage Degas had stared at; Mary that year painted her portrait. Degas added, "Alas! Alas! Taste everywhere." At about the same time Berthe Morisot wrote Mallarmé, "I go on Wednesday to Miss Cassatt's to see with her those marvelous Japanese prints at the Beaux-Arts."

The exhibition of Japanese art which ran from April 25 to May 22 included, among its other marvels, 725 prints and 362 books—all items lent by French collectors. Impressionists like Degas and Mary had for years been "Japonesque," but this show was the apex of the influence, and the beginning of its appeal to the general public. Mary invested in figure prints from the show by Kiyonaga, Shunjo, Harunobu, Utamaro, and Yeishi, as well as in landscapes by Hokusai and Hiroshige; in later years they filled a gallery of her château de Beaufresne. Simultaneously, suddenly, there appeared in Mary's work a new thing, characterized by intellectual rigor together with a devotion no mother could have exceeded toward a real child: the medium of color-printing which she made uniquely her own.

She had learned work habits in the hard school of Degas, and already, as Adelyn Breeskin points out, they were "mercilessly hard. She was in her studio by eight o'clock every morning and usually did not leave it until daylight failed. All day she painted or worked in pastel. Then, when any other person would certainly have called a halt and relaxed, she spent her evenings concentrating on her graphic techniques. [Prints don't need daylight.] She used to remark, 'There are two ways for a painter, the broad and easy one or the narrow and hard one' "—a good definition of sacrifice; a short trip to Venice had been her only vacation, apart from family life, in twenty-three years. Aquatint was more of a discipline than anything she had yet undertaken.

Even artists, if they have no experience of it, can dismiss aquatint as just another form of print-making; but anyone who has so much as witnessed the process, with its infinite detail, long hours, unremitting concentration on effect, will appreciate its rigors. Aquatints of Mary's like *The Letter* and *Afternoon Tea* seem almost to be by a Japanese, of Jap-

anese models; but this is illusory. It is the way this American woman united East and West that is remarkable. Her print-making, which had begun in a tentative way in 1879, reached its peak in 1891 with ten superb, now famous, aquatints. The element of suffering that had merely touched some of her paintings entered the mainstream of her work through this subtly Oriental door. Prints on the maternity theme, like *The Bath* and *Maternal Caress*, bear the unmistakable look of human endurance—partly because, to Western eyes, the Japanese face is a tragic mask. Others —*The Parrot*, which portrays Mathilde holding Coco, *Quietude*, and *The Caress*—also assimilate the third angle to life and love; it is part of their greatness.

"Since she never worked in woodcut, which was the method used by the Japanese," Mrs. Breeskin explains, "she naturally had to translate their technique into one in which she was proficient, using metal plates instead of wood blocks, with dry point line over soft-ground line . . . her idea may have been to broaden the line without making it too sharp . . . By this means she came closer to the character of the woodcut line. [A] print went into at least thirteen states before she completed it . . ." and each state had to be recorded minutely. Later, after the first years of inspiration had passed, Mary was to write, on January 9, 1903, to Samuel P. Avery, president of the trustees of the Metropolitan Museum, giving details of her method:

"I have sent with the set of colored etchings all the 'states' I had. I wish I could have had more but I had to hurry on and be ready for my printer when I could get him. The printing is a great work; sometimes we worked all day (eight hours) both as hard as we could work, and only printed eight or ten proofs in the day. My method is very simple. I drew an outline in dry point and transferred it to two other plates, making in all three plates, never more, for each proof. Then I put an aquatint [resined the surface] wherever the color was to be printed; the color was painted on the plate as it was to appear in the proof. I tell you this because Mr. [seasick George A.] Lucas thought it might interest you, and if any of the etchers in New York care to try the method, you can tell them how it is done. I am very anxious to know what you think of these new etchings. It amused me very much to do them although it was hard work.

"Mr. Durand-Ruel is going to have an exhibition of my work, pictures, pastels and etchings in the fall in New York. Will you be so kind as to lend him some of my early etchings? You are the only person who has everything I have done in that line.

"I received the Annual Report of the Metropolitan Museum you were so kind as to send me. I should like very much to give something to the Museum, but I don't feel as if I were well enough known yet at home

to make it worthwhile. After my exhibition, if I have any success with the artists and amateurs I will certainly present something to the Museum if you think they would care to have it."

Pissarro throws more light on the brilliance and difficulty of Mary's new achievement in a letter to his son:

Paris, April 5, 1891

My dear Lucien,

It is absolutely necessary, while what I saw yesterday at Miss Cassatt's is still fresh in mind, to tell you about the colored engravings she is to show at Durand-Ruel's at the same time as I. We open Saturday, the same day as the patriots [a gibe, as will be seen] who, between the two of us, are going to be furious when they discover right next to their exhibition a show of rare and exquisite works.

You remember the effects you strove for at Eragny? Well, Miss Cassatt has realized just such effects, and admirably: the tone even, subtle, delicate, without stains on seams [in the printing], adorable blues, fresh rose, etc. Then what must we have to succeed? . . . Money, yes, just a little money. We had to have copper-plates, a *boîte à grain* [box of resin with a bellows to blow it evenly over the plate], this was a bit of a nuisance but it is absolutely necessary to have uniform and imperceptible grains and a good printer. But the result is admirable, as beautiful as Japanese work, and it's done with printer's ink [instead of water-based rice paste]! When I get some prints I will send you some . . .

I have seen attempts at color engraving which will appear in the exhibition of the patriots, but the work is ugly, heavy, lusterless and commercial. I am certain that Miss Cassatt's effort will be taken up by all the tricksters who will make empty and pretty things. We have to act before the idea is seized by people without aesthetic principle.

Pissarro's gibe about the patriots referred to a new organization, which included most of the artists who had shown with the Impressionists, calling itself the Société des Peintres-Graveurs Français. It was holding its first show at the Durand-Ruel galleries. The new group's ruling was that only native French could be members, which ruled out Mary, and Pissarro, who was born in the West Indies. Foreign-born artists could be invited to show with the group, but that was not good enough for the two thus cold-shouldered, by the same group, in essence, as they had for so long given fealty to. They retaliated by holding exhibitions of their own, also at Durand-Ruel's, simultaneously with the big one. Mary's was her first one-man show, and included twelve prints and five paintings.

The day before the opening the members of the Peintres-Graveurs held a dinner party at the house of Degas' friend Bartholomé. Mary was invited and, this time, made a mistake, in accepting. Her biographer, Segard, tells how even when she was an old lady she felt the sting in the memory of how the other artists teased her for her effrontery in holding a show next to theirs. Their barbs were so cruel, she said, that she left the room all upset, almost in tears.

Mary's show did not meet with any great success. Pissarro wrote again to his son: "What has befallen Miss Cassatt is just what I predicted: great indifference on the part of visitors and even much opposition. Zando-meneghi was severe, Degas, on the other hand, was flattering; he was charmed by the noble element in her work, although he made minor qualifications which did not touch their substance. As to the practical results which Miss Cassatt anticipated, we must not count on them unduly. The general response is mostly hostile! They do not love what is simple, sincere, or if indeed they notice something which has such a quality, it is only when its simplicity is the result of cunning." Edmond de Goncourt remarked of Mary's etchings that the praise of them in the papers was enough to make him die laughing: "Truly this is an epoch of the failures [in art], of which Degas is the high priest and Miss Cassatt his choir-boy." In spite of the lack of tangible and spoken appreciation, Mary continued to make aquatints in her new way, with all their terrific labor; she produced seven more.

Degas' praise meant much to her, but as usual carried the kind of barb that made her, like a horse, throw up her head and bolt. In admiring the new prints he said, of *Woman Bathing*, "I will not admit that a woman can draw that well." It almost spoiled the compliment for her; although, from where he stood, it meant all the more for being wrenched from the stranglehold of prejudice. Indeed, the drawing of the back in that famous aquatint is a miracle; a single line conveys complete modeling without the back having been modeled. The combination of these experiences, however—her exclusion by those to whom she had been loyal, their heartless teasing, the—to her—faint praise—came together to convince Mary that, as a woman who was an artist, she stood alone. It set her on the path of feminism.

Hitherto Mary's work was the issue of her refusal to face suffering: an escape from childhood, an escape from Philadelphia, an escape from domestication. Since her fall her work had to and did deal with present suffering. Although she had not pitied Degas, any more than herself, in what he gave to and endured from art ("You pity it, it does not pity you . . .") she had, all the while, been taking in his technique for dealing with suffering—that technique which again and again, as with *La Famille*

Belleli and *The Cotton Brokers*, brought from real longing and despair, great paintings. With the reappearance of pain in her life she was now intellectually equipped to deal, and through this technique, to find a new artistic synthesis. The chief authority on her aquatints, Adelyn Breeskin, writes, "These prints were her next great triumph and one which would give her fame if they were her sole accomplishment. They are indeed her most original contribution, adding a new chapter to the history of the graphic arts and, as color prints, have never since been surpassed." At last, Mary had attained her artistic majority. Even her greatest admirers agree that she had been more or less derivative; now, as in the line of that back, she, like Degas, had moved from being a worshiper of Nature to mastering her.

Mary's New York showing of the prints later that year, together with paintings and pastels, turned out no more successful than the Paris show, as far as immediate results went. Nothing sold. In a February 1892 letter to Durand-Ruel she wrote, "I am still very much disappointed that my compatriots have so little liking for any of my work"—although the statement, like so many of her remarks about America, was hyperbolic. Degas could have warned her of the slavery implicit in art's freedom; did warn her, in that sonnet, how it can create an existence at once self-centered and deserted by self. His own "poor life," as he called it, had moved worlds away from Mary's. The not-very-good artist Suzanne Valadon, for instance, who had been only ten years old when Degas first met Mary Cassatt, was assuming for him an increasing importance. Like other girls whose cheekiness gave him pleasure, he called her "terrible." Mlle. Louise Braquaval was always "the terrible Lou-lou"; in a letter to Eugène Manet, Degas called Berthe Morisot, "Your terrible wife." In the case of Suzanne Valadon, it was "the Terrible Maria" that he called her, in his many letters pleading with her to come and see him and show her drawings ("I shall soon be old . . .").

Years ago the critic Robert Rey pointed out an analogy between Degas' Spartan girls and the gamines Valadon loved to draw standing free and naked in the air. Suzanne Valadon herself was not only cheeky, she was tough and free. She would take nothing off Degas, not even his criticism, which might have benefited her; and she was never one to boggle at equality in the pleasures of sex. At one time a circus performer, along the way she had an illegitimate son, who grew up to be the painter Maurice Utrillo. Even today her work, for all its dated look, is outstandingly sensual. It does seem a mystery, however, why Degas should have called her by the name of another woman: the Terrible *Maria*.

After naturalistic writers like the Goncourts had introduced prostitution into literature, Degas began going into the houses and making "lith-

ographs so brutal that they are still locked up in various portfolios,"
Halévy reveals in the foreword to his memoirs (continually revised, their
editor Mina Curtiss tells us, until his death in 1962; however, in 1918, the
year after Degas' death, René Gimpel assured Mary Cassatt that "the fam-
ily destroyed the erotic works for fear of seeing a *Degas Erotica* published
some day"). After 1890, shut in his island of a studio, living solely for and
by his work, Degas saw almost nobody except that handful of intimates
who could respect his privacy. Mary continued to see him, but it was dif-
ferent now.

The Cassatts spent the summer of 1891 at the Château de Bachi-
villiers. From there, in a July 23 letter, Mrs. Cassatt reported to Aleck on
Mary's state of mind previous to the New York show:

"Mary is at work again, intent on fame and money she says, and
counts on her fellow-countrymen, now that she has made a reputation
here. I hope that she will be more lucky than she is in horseflesh. Her new
horse has been down, this time when driving him. We thought he was
perfectly sure-footed but he has a thin skin and the flies set him crazy, so
that in knocking his head about, and tossing about to bite them, he came
down . . . Mary firmly believes she has bad luck, and it looks like it. Hap-
pily for her she is immensely interested in her painting and bent on doing
something on a large canvas as good as her pictures last summer which
were considered very fine by critics and amateurs . . . After all," Mrs.
Cassatt concluded with Victorian resignation, "a woman who is not mar-
ried is lucky if she has a decided love for work of any kind, and the more
absorbing it is the better."

The rash of Mary's accidents had, however, run its course. In Decem-
ber, completing the break commenced in 1888, Robert Cassatt—whose
legs, heart, lungs, and stomach had all been giving out—died in Paris. In
the end he left Mary, not she him. When Berthe Morisot's Victorian father
died, she married. When Mary's died, she returned from the grave to live
alone with her mother and, in many ways, start life all over again. From
Degas she had all she wanted so far: the picture of love.

The Women and the Spirits

TEN

In 1894 MARY CASSATT was still only fifty. She had over and over asserted and demonstrated that a woman's life could be lived in more ways than as wife and mother. Now she had the second half of her life for living it independently, and in fortunate circumstances. As she moved into a new role, head of her tiny household, an opportunity came as though in corroboration of the rightness of the direction she had taken: a commission from the World's Columbian Exposition in Chicago, better known as the Chicago World's Fair, that would open in 1893. She was asked to paint murals for the south tympanum (semicircular space within an arch) of the Woman's Building. Only women were being commissioned. It thus represented striking, at one time, a blow for art, for women, and for her own judgment.

The source of the commission was Mrs. Potter Palmer, chairman of the Board of Lady Managers in whose hands the Woman's Building was, and one of the real powers behind the whole Fair. Beautiful Mrs. Palmer's personality, as projected by Anders Zorn in a full-length portrait, resembles a four-masted ship under full sail: formidable yet wholly a she. Whistler described Rome as "a bit of an old ruin" when alongside a railway station that contained Mrs. Potter Palmer. She had dealt out Mary's commission during the summer of 1891, while making a triumphal progress across Europe, entertaining diplomats, peeresses, and high government officials in a successful effort to get them to take the forthcoming Fair more seriously than they had intended. She and Mary Cassatt always had hit it off. As far back as 1889 it was Mary who sent Mrs. Palmer to Durand-Ruel's, thus doing them both a good turn. The Renoirs Mrs. Palmer bought there in 1892 alone cost $5,000, and even back in 1922 were valued at $87,000. To-day they would be priceless.

Mrs. Palmer returned the good turn by way of the commission, which Mary was more gratified to get than she would have admitted in view of her painterly aversion to commissions: because of her ambiguous relations vis-à-vis America. She bitterly resented not being better recognized in America at the same time that she often rejected its overtures. Mrs. Palmer's commission furnished an opportunity to have her work viewed in America by large numbers of people, under impressive auspices, without having to back down on her principles. In taking it, she was moreover striking out on her own, independent of Degas.

.

She was not aware of the wiles that the diplomatic Mrs. Palmer found necessary in October 1892 to justify the selection of Mary as a contributing artist, at a meeting of those redoubtable Lady Managers; particularly to those from the West. Mentioning the "exhaustive research" she had gone to before settling on Mary and Mrs. McMonnies (another female contributor, who was more tractable than Mary and had an in already, since her husband, Frederick McMonnies, was one of the sculptors for the Exposition) Mrs. Palmer deplored that, solely because of Miss Cassatt's prejudice against jury-selected exhibitions, she had remained unknown in America though so very well known abroad. She made much of the fact that Degas was Mary Cassatt's mentor. Craftily she drew the attention of the large, well-groomed ladies to the expense Miss Cassatt had gone to in painting the murals—causing to be constructed "an immense glass-roofed building at her summer home [at Bachivilliers] where, rather than work on a ladder, she arranged to have the canvas lowered into an excavation in the ground when she wished to work on the upper part of its surface." Muffled chatter surely broke out at this, for she touched on the ladies' dearest values: practicality, ingenuity, to say nothing of money.

In the impression they made, Mrs. Palmer and Mary were something alike; but the confidence and power conveyed by it rose freely in Mrs. Palmer; it had been sidetracked in Mary. After the Exposition was over Mrs. Palmer would be off and away to conquer new worlds in the shape of Newport, a bastion no Middle-Westerner had hitherto broached. For Mary, the result of her venture into murals proved something of a blow. Among other women artists commissioned were Rosina Emmet Sherwood and Lydia Field Emmet, both with connections in Philadelphia; but Mary made friends only with Mrs. McMonnies, who also worked in France, and had studied with the mural decorator Puvis de Chavannes, and with a Bostonian, Sara Hallowell, Secretary to the Director of Fine Arts for the Fair. The director, Frank Millet, a not-insensitive painter, certainly was not sensitive to women; Miss Hallowell was badly needed, and not only for her expertise as Paris agent for many American museums.

Miss Hallowell was to be one of the few who wrote glowingly of Mary's murals; from the very start she showed her faith in them when she assured Mrs. Palmer "it is all right for her to leave her work to my approval," while of Mrs. McMonnies a preliminary sketch was required, "since she makes no objection." Mrs. Palmer set on Mary's plans the seal of her own approval when—advising the tractable Mrs. McMonnies that the figures in her preliminary sketch had better be draped than nude, since "West of the Mississippi river . . . even semi-nudity attracts more comment than it would in . . . Paris!"—she recommended that she emulate Miss Cassatt's figures which "I was pleased to find . . . were entirely clothed,

there not being even a décolleté gown assigned to her modern woman."
After the Fair was over Miss Hallowell was invited to visit Miss Cassatt at
Antibes. She was one of the many new women friends who were entering
Mary's life, for all that Mary always made no bones of the fact that she
did not really like women.

Mary remained prickly throughout the execution of the murals; there
was much to be prickly about. At one point she even resigned; the con-
ditions of the contract Mr. Millet had sent her were, she said, impossible.
They were indeed, stipulating as they did that Miss Cassatt and Mrs.
McMonnies, unlike the men artists for the Fair, were not to be paid until
their work was completed, and were to install their murals at their own
expense. Resigning was Mary's way of expressing her indignation at this
denial of their equality as painters and women. Mrs. Palmer came to the
rescue; rather than will-to-power, she had power itself. By September 10,
Mary was writing to her, "Thanks to your good offices, all my difficulties
. . . seem to be arranged, and my [new] contract is here." Mrs. McMon-
nies had felt mollified way back in August.

Exactly what Mrs. Palmer said to Mr. Millet is unknown except for a
memorandum: "With reference to the McMonnies-Cassatt contracts, they
feel that I am their medium of communication with you, and perhaps I
have not given you all the letters I have received from them and Miss Hal-
lowell. Pray pardon my oversights . . . Will you not have the contracts
made out with such modifications as we discussed, extending the time of
delivery until February fifteenth [Millet had asked for October] and ap-
pointing Miss Hallowell to accept the sketches etc. [Millet had demanded
sketches from both artists.] Please be as liberal about terms of payment
as you find it consistent to be . . ." It is a remarkable document. Where
the embattled artists thought in terms of equality, shrewd Mrs. Palmer
could slip on the velvet glove and call it consistency.

Mary still had complaints, of course, or she would not have been
Mary. Her note thanking Mrs. Palmer goes on, "my contract is here al-
though not yet in my hands as it was sent by mistake to Mrs. McMonnies
and hers to me . . . Between you and me I hardly think women could be
more unbusiness-like than some of the men are. Here is Mr. Millet sending
me 'the exact size of those tympana' at this hour of the day. It will entail
on me a good deal of extra work which he might just as well have spared
me by sending the exact size at first." It must indeed have been madden-
ing; but Mary seems to have heard some echo of her own railing tone,
for—having grumbled—"It would be ungracious of me to grumble," she
tells gracious Mrs. Palmer, "for really I have enjoyed these new experiences
in art immensely, and am infinitely obliged to you for the opportunity."

Another legitimate grievance, Mary brought up with Mrs. Palmer in a

letter of October 11: "One of the New York papers . . . referring to the
order given me, said my subject was to be 'The Modern Woman as glorified
by Worth' . . . That would hardly express my idea of course. I have tried to
express the modern woman in the fashions of our day, and have tried to
represent those fashions as accurately and in as much detail as possible. I
took for the subject of the center and largest composition [of three panels]
Young women Plucking the Fruits of Knowledge and Science. That enabled
me to place my figures out of doors and allowed of brilliancy of color. I
have tried to make the general effect as bright, as gay, as amusing as possi-
ble. The occasion is one of rejoicing, a great national fête [the term con-
sorts oddly with Chicago]. I reserved all the seriousness for the execution,
for the drawing and painting. My ideal would have been one of those old
tapestries, brilliant yet soft. My figures are rather under life size, although
they seem as large as life. I could not manage women in modern dress
eight or nine feet high.

"An American friend asked me in rather a huffy tone the other day,
'Then this is woman apart from her relations to man?' I told him it was.
Men I have no doubt are painted in all their vigor on the walls of the other
buildings; to us the sweetness of childhood, the charm of womanhood, if
I have not conveyed some sense of that charm, in one word if I have not
been absolutely feminine, then I have failed. My central canvas I hope to
finish in a few days. I shall have some photographs taken and sent to you.
I will still have place on the side panels for two compositions, one which
I shall begin immediately is Young Girls Pursuing Fame. This seems to me
very modern and besides will give me an opportunity for some figures in
clinging draperies. The other panel will represent the Arts, Music (noth-
ing of St. Cecilia) [nineteenth-century pictures with a musical theme
always worked St. Cecilia in], Dancing, and all treated in the most modern
way. The whole is surrounded by a border, wide below, narrow above, bands
of color, the lower cut with circles containing naked babies tossing fruit,
etc. I think my dear Mrs. Palmer that if you were here and I could take you
out to my studio and show you what I have done that you would be
pleased. Indeed without too much vanity I may say I am almost sure you
would.

"When the work reaches Chicago, when it is dragged up 48 feet and
you will have to stretch your neck to get sight of it at all, whether you
will like it then, is another question . . . A recent article . . . declares that
in the evolution of the race painting is no longer needed, the architects
evidently are of that opinion. Painting was never intended to be put out of
sight. This idea however has not troubled me too much, for I have passed
a most enjoyable summer of hard work." The idea *did* trouble her, for in
the next sentence she returns to it: "If painting is no longer needed, it

seems a pity that some of us were born into the world with such a passion for line and color. Better painters than I am have been put out of sight. [Paul] Baudry spent years on *his* decorations. The only time we saw them was when they were exhibited in the Beaux-Arts, then they were buried in the ceiling of the Grand Opera. After this grumbling I must get back to my work . . ."

The flies of doubt in the ointment of the commission had been there all along, implicit in the venture's very independence. A letter from Mary to Mrs. Palmer dated December 1, 1892, while still at Bachivilliers, explains the nature of her doubts:

"The fact is I am beginning to feel the strain a little, and am apt to get a little blue and despondent. Your cable [of encouragement] came just at the right moment to act as a stimulant. I have been shut up here so long now with one idea, that I am no longer capable of judging what I have done. I have been half a dozen times on the point of asking Degas to come and see my work, but if he happens to be in the mood he would demolish me so completely that I could never pick myself up in time to finish for the exposition. Still he is the only man I know whose judgment would be a help to me. M. Durand-Ruel . . . was here with his daughter a week ago, it was most kind of him to come . . . [he was] very kind and encouraging, said he would buy it if it were for sale, and of course from his point of view that was very complimentary, but it was not what I wanted. He seemed to be amazed at my thinking it necessary to strike for a high degree of finish . . ."

From out this letter of an outstandingly self-reliant woman, independently successful as were few other women of her time, speaks the voice of the disconsolate little girl in the 1886 painting. The letter ends by expressing sympathy for Mrs. Palmer who "must be feeling the strain too" and hopes for her the "strength and health to bear you through." Mary need not have spared a moment's anxiety for Mrs. Palmer, but as far as Degas was concerned, her fears were not unfounded.

Pissarro, in another of his letters to his son, says, "Speaking of Miss Cassatt's decoration, I wish you could have heard the conversation I had with Degas on what is known as 'decoration.' I am wholly of his opinion: for him [a mural] is an ornament that should be made with a view to its place in the ensemble, it requires the collaboration of architect and painter. The decorative painter is an absurdity; a picture complete in itself is not a decoration. It seems that even Puvis de Chavanne doesn't go well in Lyon . . ." and Mary was well aware of Degas' sentiments.

She had confided earlier to Mrs. Havemeyer, "When the Committee first offered [the decoration] to me to do, at first I was horrified, but gradually I began to think it would be great fun to do something I had never

done before. The bare idea of such a thing put Degas in a rage, and he did not spare any criticism he could think of. I got my spirit up and said I would not give up the idea for anything. Now, one has only to mention Chicago to set him off. Bartholomy [sic], his best friend, is on the jury for sculpture and took the nomination just to tease him."

However much Degas' strictures may have been pique at the defection of his protégée, with the wisdom of hindsight it is clear that it might have been wiser for Mary Cassatt to take counsel with her caution. The world would not have lost much if the murals had never been undertaken, or never finished; and the world has lost them anyway. After the Exposition was over, they disappeared; it is still a mystery what became of them. Even while they were in place at the World's Fair they were not a success.

In the official publication of the Exposition, their reception is summed up: "Miss Cassatt's large painting for the decoration of the south tympanum of the Woman's Building, two years ago, will be remembered by many visitors notwithstanding the very inconvenient height at which it was placed . . . It may also be remembered that some of the Western 'Lady Managers' thought this conception of 'Modern Woman' . . . somewhat inaccurate."

Even an admirer, Ernest Knauff, director of the Chautauqua Society of Fine Arts and art critic for the *Review of Reviews*, deplored the work as mural-painting, saying, "Miss Cassatt . . . apparently defied the laws of decoration" in having her figures, at such a height, on so small a scale. The anonymous critic for *Art Amateur* felt the use of dark greens and blues "makes her painting unduly conspicuous which is the more to be regretted as it is more pictorial than decorative in feeling," and stated flatly that the two end panels were "more or less ridiculous." "Opposing this erratic production by a woman of unquestionable talent," he proceeded, "is a much more decorative painting by Mrs. Frederick McMonnies." It is easy to imagine how Mary took being called erratic and ridiculous; Degas' criticism could in the end not have been more unpleasant, and from him it would at least have had painterly authority.

What the mystery murals sound like from today's perspective, is a celebration of woman rampant. Women running, women reaching, women browsing, women working, even a woman flying; there was no end to the women, with nothing for contrast except those babies, some of them conceivably male, babies immaculately conceived, with particularly disinfected nannies. The murals did indeed depict woman apart from her relations with man, and as such, apart from conflict—a step backward from the virtuoso achievement of Mary's aquatints, produced under the critical eye that this time she avoided.

Even Frederick A. Sweet, a thoroughgoing Cassatt admirer, grants the

work had "none of the flair of Degas or even of her Impressionist con-
temporaries. It was at best . . . fairly fresh, decorative . . . As a muralist
she produced one of her least notable efforts. She had worked hard . . . in
a sphere in which she had neither experience nor . . . interest"; neverthe-
less he points out, "as a woman and something of a feminist, she was
proud to have been asked." Some of Mary's reluctance to call in the astrin-
gent aid of the man who had for so long directed her creativity, may have
been instinct for what he would have made of that, as a motive for paint-
ing.

A letter Miss Hallowell wrote to Mrs. Palmer in February 1894, after
the Fair had closed, suggests how Mary reacted to the reactions to her work.
Miss Cassatt had invited Miss Hallowell to visit her "at her mother's villa
at Antibes," and in her "delightfully urgent letter," said that the Luxem-
bourg Museum was "in treaty for one of her pictures." Mary had exploded
in her letter, "After all, give me France. Women do not have to fight for
recognition here if they do serious work. I suppose it is Mrs. Palmer's
French blood that gives her the . . . determination that women should be
someone and not *something.*" Miss Hallowell was not unaware that Miss
Cassatt could be just as critical of France: back in 1893, in a publication
called *Art and Handicraft in the Women's Building,* endeavoring to tout
Mary's work—"probably better known to those intimately connected with
art than to the general public"—she had told how "the French government
invited [Miss Cassatt] to present it with a picture, an honor which falls to
few, and which it is characteristic of Miss Cassatt to decline."

Miss Hallowell accepted Mrs. and Miss Cassatt's kind invitation. In a
letter she wrote Mrs. Palmer just before sailing from Hoboken, she let
drop a final note on what became of the murals: "Miss Cassatt's is safely
packed in one of my boxes. I have written a letter to Mr. [Ernest] Fenol-
losa and sent it to the Boston Museum of Fine Arts." Some commentators
have thought this meant Miss Hallowell sent some part of the Cassatt
murals to Boston; but since the Boston Museum has never owned any part
of them, the use of "box" by one as cosmopolitan as she makes it more
probable that, whatever "it" was, "it" had been packed in Miss Hallowell's
luggage for France.

The murals disappeared except for one preliminary sketch, which this
may have been. It is not at all impossible that the artist's fine Italian hand
was involved in the disappearance. It was she, after all, who later disposed
of the portrait Degas had painted and presented to her, knowing full well
how he felt about having his presents given away—simply because by that
time it was not the way she wanted to be remembered as looking. Already,
in an access of wounded feelings, she had hidden—was still hiding—her
portrait of Mrs. Riddle: the one with the tea-set and the nose. Like most

painters she was quite capable of destroying her own work. She may have hidden, destroyed, or even sold the murals. If those seem brutal acts, it is instructive to note how one of Mary's new women friends, Theodate Pope, said to have been America's first woman architect, would, when working up on a ladder on one of her buildings, break with a hammer as much as she put up, entirely unaware of her alternations of creative and destructive moods.

Mary's creativity had its own uses for destruction. During Miss Hallowell's visit to the villa at Antibes, which she called "the loveliest spot on the Riviera," the ladies were joined by the Gardner Cassatts; a portrait Mary painted of little Gardner, Sweet attributes to 1894. In the course of the sittings Gardner got bored with posing, one day, and relieved his feelings by spitting in his aunt's face. His mother was mortified, as they say in Virginia, and dealt out the classic Victorian punishment—locking him in a closet. It was not the gentle Jenny, however, but the spat-at Mary—always tenderhearted toward young males asserting themselves—who drove into Antibes, bought a box of the best chocolates, and, returning home with this gift for Gardner, let him out of the closet. Eighteen ninety-four was definitely the year, and Antibes the place, where Mary undertook a new painting, *The Boating Party*, that was a triumph of all she was and wanted to be.

In autumn 1893 Durand-Ruel had held a large one-man show of her work in its Paris gallery, followed in 1895 by another in New York. The Paris exhibition included seventeen paintings, fourteen pastels, and sixty-odd prints of all kinds. The catalogue for the show carried a foreword by the critic André Mellario, which stated flat out that Miss Cassatt was, with Whistler, the only artist America possessed with a talent "so elevated, personal and distinguished." French critical praise was uniformly high: "No painter has seen with so much feeling nor has anyone, with such convincing art, translated into canvas the poem of the family." "Extraordinary design and exquisite taste . . . deserve long study." "Exquisite gifts of color and design, that rare gift of some artists of genuine individuality . . . a woman who, according to the apt expression of La Bruyère, 'has all the qualities of an honest man.'" "Superb exposition . . . sound workmanship . . . supple and virile design, the masculine palette. She treats the eternal subject—maternity—with the most subtle talent . . . a masterly skill that reminds us of Manet, Renoir, and . . . Degas."

For all the notions about masculine palettes, *that* was more the way to talk! Which pictures were hung is recorded in Durand-Ruel's files, so it is possible to walk around the gallery in fancy, viewing the pictures in that profound hush characteristic of art galleries, while outside, unheard, the Parisian afternoon rumbles its length away into the dusk. There hangs *The Cup of Tea*, pale Lydia gazing reflectively at her guest; *At the Opera*,

with all the reserve and chic of its black-robed lady; *La Loge*—red-haired Lydia leaning forward with her now-vanished eagerness, on the velvet rail; *The Bath*, into whose composition Japan entered and was made one; *Emmy and Her Child* with its mother's immortal severity, its child's trusting slump —the very antithesis of sentimentality. The pictures made a history of Mary's development up to the minute and not a picture among them was greater than, or in achievement as great as, *The Boating Party*.

It, however, was not in that show although it made part of the show Durand-Ruel took to New York; in 1893 Mary was still working to make it the technical tour de force it is. A Mediterranean boatman's back fills the right foreground of the composition—dark, muscular like a Tintoretto back—and beyond, encapsulated in light against a background of water, a woman and child are framed between the white of the sail and the dark of the man. Composition, design, texture, light: not one element is missing out of the Cassatt powerhouse.

Much more is remarkable in it than technical virtuosity. As a created thing it expresses its creator, and in it the dark form, back to, that rows the boat they are all in, is brought into absolute harmony with the brilliantly lit mother and child and the quiet water, for a satisfying whole. Few of her contemporaries did not comment on Mary Cassatt's strength of mind, critical to the point of harshness; but this had never been how she felt herself to be. Her feelings, like the mother and child in the stern of the boat, were merely blocked by that dark back conducting them on their voyage. Now the boatman's face could just be glimpsed, and it was a reflective one.

In those days a mind like Mary's was called a "man's mind," and it is true that of all her pictures this one might most possibly have been painted by a man—might, in fact, have been painted by Manet. If a forger had produced it, critics would exclaim over his mastery of Manet's style. One modern art critic suggests that *The Boating Party* took its "idea" from Manet's *In the Boat*, painted four years before his death in 1883—"even though the composition is different." Actually it is handling, not idea, feeling, not composition, that gives the picture, eerily, the Manet touch. *The Boating Party* was influenced by an affinity with Manet, and in the result Mary proved once again that she "had not been born alone"; this time, in proving it, she took a leap toward liberation from Degas.

She herself sensed the importance of the picture to her life. "About the painting, *La Barque*," she wrote to Durand-Ruel as late as 1914, "I do not want to sell it: I have already promised it to my family. It was done at Antibes 20 years ago—the year when my niece came into the world." "My niece" always meant one particular niece, Ellen Mary, Gardner's child, born in 1893, even though Mary had others. It sounds as though she sensed also a connection of Ellen Mary with the picture through the birth

date. Ellen Mary, as it turned out, was to carry forward Mary's artistic and psychic victory.

The Boating Party proved other things than the freedom of affinities. It proved what Mary had wanted to prove in those murals—that she had chosen the right direction in striking out for herself, alone. It proved the world of art *is* a real dimension, in which do operate such imponderables as immaculate conception, death-in-life, and rebirth; for Manet was the fertilizing agent in this painting if there ever was one; and Manet had been dead ten years. Out of the humiliating failure of the murals had risen a phoenix of technical power and artistic insight—insight which further proved that she was capable of going on with a critical component of her own and not depending on Degas for judgment. It proved that Mary was capable of looking at the other side, in the mirror of her art, like a female Perseus holding up that shield, to gaze upon a male Medusa. It proved the objectivity implicit within the highly subjective process of "being" another person; with the inconstancy of the artist nature, Mary left Degas, "became" Manet, and painted her most objectively rendered male.

It was no figure of speech when Flaubert said, "I am Emma Bovary." Degas—accused by Victorian contemporaries of viewing his washwoman and half-starved little ballerinas without pity—was capable of taking the leap and becoming those working women; he *was* the exhausted dancing-girls. He could transpose the sexes like a key in music, his technique being distilled into a mere medium of conversion. Hitherto Mary's best pictures reflected things she remembered, knew by heart, about women, about children. She had only rarely been able to remember men, only little boys; she would have if she could have, but the memory was too painful. Now art—transcending her fall, her father's death, her false start on the murals—released memory. Mary, too, as artist had made the leap across the sexes. If she never literally had been a man, neither had she ever been a mother. In the aquatints, she made use of the element of darkness through what the Japanese call notan, the discriminating contrast between light and dark, intensity and delicacy, as with that single line of a woman's back in *Woman Bathing*. In *The Boating Party*, darkness is a part, and so is maleness in the dark torso and deeply reflective *profile perdu*.

Critics sometimes link *The Boating Party* with a picture of Mary's painted at about the same period, *Summertime*. "Another delightful work," one calls it, "depicting a boating party filled with sunshine, with bright accents of ducks in the water . . ." The two pictures are actually poles apart. *Summertime* is all too full of delightful sunny bright ducks; has a loosening of fiber and sleaziness of execution, as well as the lessening of vitality on which art historians comment in her later work. "The sense of tender rapport," writes one, "becomes dominant over the pictorial concept . . ."

which is a polite way of saying, became sentimental: the other side of Mary's new situation.

For in real life the dark side, men, continued very much a thorn in her side. Victorian ladies (Mary was very much a Victorian lady)—were not supposed to have in them anything hard, tough, cold; as for deep introspection like Degas', everyone was against it, even the Impressionist painters, none more than Mary. A Victorian lady-artist's "gift" was thought to be made of pure gold, something lovely to possess. If Mary after years of labor knew better than that, she also knew that in becoming a professional artist, she had reached the frontiers of permissible freedom. She wanted more than that. It was the world she wanted, and no longer from horseback.

Resentments, grievances, anger, she sought to rise above by loving and giving out to her friends, her family, woman's cause, even more than she had already. She sought to pass around the dark figure filling the foreground in her picture, as though to the other side of the moon, to see it full face. Having all her life rejected home as woman's only place, Mary's inner revolution began rejecting work as woman's only salvation. Her triumphant *Boating Party* had given her independence of Degas, through the artistic fertilization which owns no fidelity. It was not enough. In life as in work she wanted to free herself of any influence.

If we glance at the circular model of the whole person in Chapter Five, Mary may be seen moving from lower, parent-dominated quadrants into the upper realms of maturity. From now on, the world began to be uppermost; art behind, below, within. In her work she tended to hew to what had already worked for her: women, children, mothers, and babies. Looking back at the circularity from the dispassion of outside, the new challenge would seem to be bringing the child that doeth the works, into harmony with the new woman.

Within its limits, some of Mary's best work was produced during the '90s, not only in printing but in pastel, for which she shared the enthusiasm of Degas, whom she did not cease to see. They especially admired the work of Quentin de la Tour, eighteenth-century pastelist: Mary used to advise the young artists who were beginning to consult her to study de la Tour closely. Her pastel technique followed that of Degas: the pastel was applied very thickly, with parts of it steamed to make it penetrate further into the paper. Degas worked the moistened part with the tip of a brush to model the forms; he also used even to grind up pastel into an impasto which he would apply to the paper with a brush.

Mary achieved a number of dazzling pastels, notably the portrait of *Madame Aude and Her Daughters* in 1899, for which she was commissioned by the brothers of Madame Aude—her old friends the Durand-Ruels,

Joseph, Charles, and Georges. *Madame Aude* has all the neat, succinct chic of Paris. A similar chic marked *Madame and Her Maid* in 1894, in which the profile of a lady, epitome of sophistication and high style, is silhouetted against the ingenuous fat face of her servant. For the most part and when not pressed into extra effort by a commission, the best of her pastels were of what was nearest and dearest to Mary Cassatt: Mrs. Havemeyer and—because of Mrs. Havemeyer—her daughter Adeline; and Ellen Mary Cassatt, the niece that Mary loved so long and so dearly, and who loved her even longer in return.

Yet another imponderable to be weighed in assessing the degree of Mary's freedom was the Château de Beaufresne, which Mary had bought soon after her father's death. Five miles down the road from the Château Bachivilliers, at Mesnil-Théribus, so much repair work had been required on it that 1893 arrived before she and her mother could move in. The house was there, however, a concrete fact; and nothing affects someone's feelings more than the fact of a house. Although Mary's murals were painted at Bachivilliers, and *The Boating Party* at Antibes, their conception, their execution, was in closest connection with this feeling of, for the first time, owning her own house: one bought and paid for from her own earnings from her own work.

ELEVEN

THE APPROACH TO the Château de Beaufresne is down a gradual hill from Le Mesnil-Théribus, through "not at all beautiful country—" in the words of one of Mary Cassatt's early visitors there. Vernon Lee, born Violet Paget, was a certain type of English woman of letters. Iris Origo recalls her, "hair cropped tight above an uncompromising man's collar and tie," as fond of "exchanging philosophic shouts on the nature of the Beautiful and the Good." Vernon Lee's description of Oise, contained in a July 28, 1895, letter to her friend Kit Anstruther-Thomson, continues:

"—crude or dingy in color, composed of blunt lines, without romance or suavity of village or old house, moreover apparently depopulate, has yet a charm of breadth, of belonging to an endless continent—no semi-island like England or Italy—there being *enough land,* and enough sky especially, leagues of cloud and air; a certain charm to me, of unusualness, of a back of beyond, due to its lines *leading nowhere* (do you know what I mean?). The complete scheme of the eternal story told by mountains and rivers, the story of watersheds and sea, of perpetually becoming and going." Curiously enough, the picture the English writer evokes could be of America.

"I liked the Louis XVI Château and the sort of white bareness of the rooms. Poor old Mrs. Cassatt is, I fear, slowly dying . . . Miss Cassatt is very nice, simple, an odd mixture of a self-recognizing artist, with passionate appreciation in literature, and the almost childish, garrulous American provincial. She wants to make art cheap, to bring it within reach of the comparatively poor, and projects a series of colored etchings, for which she wants me to write a little preface. She wants other artists to do something similar, suggested Sargent—do you think he would? She has most generously given me one of her new and most beautiful etchings, a mother and baby, green on green, quite lovely." Mary, of whom Théodore Duret wrote, "One day at the Louvre in front of the Burial at Ornans [by Courbet], she shouted out all of a sudden while showing the picture to a group of women, 'C'est grec!'" was a Main Line shouter. The visit from the English shouter must have been highly audible. The attitude Mary took to another outlet of this guest—more specifically epicene than most of her new friends—is suggested in a 1906 letter to Mrs. Havemeyer: "She once stayed with me. She never will again."

Many other types of guests came down to the château for a day or a

stay. The château—a word misleading to Americans romantically fired by visions of moats and crenellations—was no more than a good-sized country house. Its name means beautiful ash tree, and in Mary's day any number of ash trees shaded the grounds. M. Henri Riché, a well-educated native of Le Mesnil, recalled in 1946 how life at the château looked from the village:

"Mary Cassatt, who had kept her apartment in Paris, lived mostly at the château," he wrote, "where she found the perfect background both for her work and her amusement. Inside the château were hung nearly all the Japanese prints of her collection. At the end of the ground floor, where two windows gave on to the lawn [the north side], was what she called her *salle de peinture* [studio]. Wearing a white crepe de chine smock, she used to work there for hours on end, as demanding of herself as she was of her models . . .

"Without taking the temperature into account, she took a two-hour *promenade* [he could mean either walk or drive] every day, keeping an eye out for models in the neighboring villages. She was always accompanied by her housekeeper [Mathilde]. Miss Cassatt never felt the cold.

"She was very wilful, austere, with a loud, harsh, but nevertheless attractive voice and her manners were elegant and distinguished. She dressed in a classical style, and liked large, elaborate hats."

The wife of M. Riché, who had taught the village school and was still living in 1971, recalled in a letter to the author that "Miss Cassatt did not associate with anybody in Le Mesnil-Théribus, and entertained only artists like herself. She used to drive around the countryside in a horse-drawn carriage . . . when she met a girl who could serve as a model, she took her to the château to work.

"I don't believe she was very wealthy, but that didn't matter in France where life was cheap at that time. Whenever she had work done at the château she would argue price with the contractor or workman. Once, she wanted to have a fountain built in her garden which was to be fed by a small river. The fountain was built and everything was fine until one day there was no water in the fountain. She decided that the work had been badly done and took legal action against the mason (he was my husband's uncle). Luckily the river began to flow again and to feed the fountain. Small rivers sometimes have such whims!" is Mme. Riché's Gallic conclusion.

The artists that she was positive were Mary's only guests included Berthe Morisot and Jacques-Émile Blanche, also the likes of George Moore, Mallarmé, and Ambroise Vollard the art dealer. In fact, however, many others came, Mary's old friend Clemenceau among them, and the politician Marcel Cachin, whose radical views reveal how liberal Mary's

were. Alert to politics in general, she was specially alert to local politics, and early on commenced holding sessions at Beaufresne whenever a local election was coming up. Nathaniel Choate, who knew her in her old age, recalled that by that time she was so respected by local politicos that they used to call at the château to ask her advice when making political plans.

She, like all France, was swept by the tidal wave of the Dreyfus affair; its political and racial backwash reached the whole world. In 1894, Alfred Dreyfus, a Jewish army officer, was appointed to serve in the Ministry of War. Shortly afterward he was arrested on charges of revealing military secrets; tried for treason, he was sentenced for life to the infamous swamps of Devil's Island. A letter supposedly written by him, upon which the conviction was based, was later discovered to have been written by a Major Esterhazy; Esterhazy was tried but acquitted, in 1897, to conceal the staggering error that had been made. It was then that Émile Zola wrote to the President of the French Republic his *J'Accuse*—an open letter denouncing the cover-up, and demanding the release of Dreyfus. There were three thousand signers, mostly intellectuals, of a petition protesting the Army's violation of procedure in the trial; the signers included the Halévys, Anatole France, Monet, and Marcel Proust.

There never was a more emotion-packed case. It divided old friends, even families. Mary Cassatt was passionately pro-Dreyfus. Mrs. Havemeyer wrote: "Dreyfus did not have a more ardent or more able defender than Mary Cassatt . . . She fearlessly expressed her firm conviction of his innocence . . . She felt, as she expressed it, France's honor was at stake . . . It is no wonder she quarreled with Degas over the Dreyfus affair although on other [contemporaneous] occasions she would defend his works." Like many Frenchmen of the old school who had aristocratic and military connections, Degas was anti-Dreyfus. Nothing more served to widen the breach between him and Mary, or to distinguish their emotional differences—she, all feeling for freedom and fair play, with a passionate indignation for the underdog; he essentially related to the past, with a kind of caste loyalty surpassing even his devotion to his friends.

Daniel Halévy, part Jewish, related how with the Affaire Dreyfus his family's friendship with Degas "was to end suddenly and in silence." With great forbearance he recalled that at their last meeting, when no other subject was discussed in a pro-Dreyfus gathering, Degas' "lips were closed . . . as though cutting himself off from the company that surrounded him. Had he spoken it would no doubt have been defense of the army, the army whose traditions and virtues he held so high, and which were now being insulted by our intellectual theorizing . . . From then on the respect I retained for Degas was often tested . . . A hue and cry was raised against me and I was so young that I would have found it difficult to face if I had

not been backed by Renan's [the historian's] son, Ary . . . 'I have seen Degas' life for over twenty years,' he said, 'and I have never known him to be at fault.'"

That was late in 1897. In March 1898, hearing that Degas was ill, Halévy went to see him. "'Oh, it's you?' he said, . . . greeted me with exquisite cordiality. Only his fine canine head emerged from under the sheets. I . . . told him my news [Halévy married, in November 1898], knowing that for several months he . . . no longer railed against marriage. 'You understand now, don't you, that people do marry?' 'Oh, yes. I am alone . . . It's a good thing to marry. —Ah, *la solitude—*'"

Mary Cassatt's own re-encounter with Degas after the Dreyfus affair was of a very different order. "I have been amused," Mrs. Havemeyer wrote, "during the long years I have known [Mary and Degas] at the little luncheons or dinners that have been planned by friends to effect a reconciliation. I recall Miss Cassatt was perplexed whether or not to accept.

"'By all means, accept,' said I.

"'But this Dreyfus affair!' she objected. 'I know he will anger me.'

"'Don't hesitate,' I answered. 'Go and silence him for once and for all time.'

"'But Louie dear,' she said pathetically, 'You don't know what a dreadful man he is, he can say anything.'

"'So can you,' I answered, and she reluctantly decided to go. Just at that moment Mathilde, her good maid, entered with a beautiful new gown over her arm.

"'Wear that new gown,' I suggested, 'and enjoy the repose and assurance the conscious elegance gives you.'

"Needless to say Miss Cassatt attended the luncheon, while I impatiently awaited her return to learn what had happened.

"'Mercy, Louie,' she exclaimed as soon as she saw me. 'Who do you think sat next to me at table?'

"'Degas?' I queried, knowing from her tone I was wrong.

"'No! Worse!' she answered. 'General Mercier! . . . I wanted to run away!'

"'I hope you did nothing of the sort!' I said.

"'Oh, no, I couldn't, on account of Degas! He has aged, dear, aged so very much, it made me sad, but I was glad to see him and he was very nice and did not say a disagreeable word.'"

If this conversation sounds excessively genteel, it may be partly because, two years after Mary and her mother moved into the Château de Beaufresne, the old lady died, freeing Mary and at the same time further trapping her. "In her last illness," wrote Mrs. Havemeyer, "I recall sitting beside her holding her thin hand in mine, filled with pity for the poor

sufferer, and regret that the world must lose such a remarkable woman. To poor Miss Cassatt the loss was irreparable. She struggled bravely . . . like many another . . . she sought to see through the mysterious veil that hides our dear ones and . . . was deeply interested in . . . psychic phenomena. She must have found some hidden strength; for . . . I could never see that Mary Cassatt grew old. Even in looks she changed but little." The extent of Mary's devotion to her mother's memory may be gauged by the course her maternity pictures took, since it was that relationship which had first given them their deep feeling.

"Anyone who had the privilege of knowing Mary Cassatt's mother," Mrs. Havemeyer went on, "would know at once that it was from her and from her alone that [Mary] inherited her ability. In my day she was no longer young, [but] she was still powerfully intelligent, executive, and masterful, and yet with that sense of duty and tender sympathy she had transmitted to her daughter [who, when her parents arrived to live with her for good, made her life] ever after . . . an example of devotion to duty. She held duty high before her as a pilgrim would his cross. No sacrifice was too great for her to make for her family . . . For years she put ambition aside, to devote herself to her invalided family, and only when she had laid them to rest in the quiet tomb at Mesnil, did she again return to work and seek consolation in her art." Yet in cold fact it was then her work began to go off.

Soon after the "executive and masterful" presence was removed, Mary set sail on a Mediterranean cruise with her brother Gardner and his family —just such a sea voyage for pleasure as Robert Cassatt had termed madness for Mary ever to so much as contemplate. These Cassatts, with young Gardner and Ellen Mary, still a baby, had come, after the old lady died, to be with Mary; they remained in Europe for two years, spending part of the 1895-96 winter with Mary in the rue de Marignan, where she painted the first of her many pictures of "my niece"—the irresistible *Ellen Mary Cassatt in a White Coat* for which the baby girl sat, good as gold, in a yellow chair, wearing a white bonnet edged with the same brown fur as trims the cape to the coat. For this portrait Mary made a pastel study—same pose, same clothes—but with a faintly apprehensive shadow crossing the little girl's face. Other pictures outstanding among those done after Mrs. Cassatt's death, were the fine pastel of Mrs. Havemeyer in a white evening dress, her grave countenance displaying the deep reflectiveness of the dark boatman's; as well as the pastel of Mrs. Havemeyer stolidly holding a stolid daughter Electra in her lap; the pastel *Two Sisters*, and the magnificent maternal painting *Breakfast in Bed*, with its sensuous rendering of human warmth. There were also a num-

ber of less successful pastels and paintings, in which the "tender rapport"
all too fully "dominated the pictorial concept."

Aleck Cassatt, too, came over with his family the year of Mrs. Cas-
satt's death, and chartered a yacht for a North Cape cruise. In January
1896 he engaged a private dahabeah to convey him and his family up the
Nile. On neither of these voyages did Mary venture, but confidence and
thwarted wish mounted in her to the point that, in the winter of 1897–
98, she accepted Gardner's invitation to come along on the Mediterranean
cruise. Now that she was head woman in the Cassatt tribe, strength might
possibly be sent for her to conquer the ghost of an old adversary.

Gardner had taken a private yacht, *Eugenia*, for the jaunt; it speaks
volumes for Mary's hopes that she came aboard accompanied by luggage
containing a whole wardrobe of clothes for yachting purchased for the oc-
casion, as well as by Mathilde to look after them. They had only sailed a
few miles out to sea, however, before Mary became so violently seasick
they had to put in at Toulon to let her off. (She missed thereby a sight
she would have enjoyed: in Marseille harbor, *Eugenia* was anchored along-
side the Prince of Wales's yacht when the Queen arrived in pursuit of the
peccant Bertie.)

By winter of 1898–99, Mary had the accumulated visits from her
brothers to return, as well as the newly intolerable defeat by her natural
foe, when she made a decision to visit America. She had not been home
since the Franco-Prussian War, and had given no sign while her parents
were alive of ever wanting to go. Now she did. It was a token of her new
position in life.

Meanwhile back in Philadelphia, Aleck Cassatt—who for years had
been part of fashionably equine Main Line Society just as Lois had long be-
fore become a patroness of the Assembly—was about to "stroll into" the
presidency of the Railroad. The sons and daughters of both Mary's
brothers, "my niece" among them, were growing up happy, natural-born,
Philadelphia children, not one of them with the need to be rescued by
talent or by anything else. There was everything to reassure the voyager
of her reception—her reputation as a painter was securely established in
knowledgeable art circles; she had in fact received invitations to exhibit
not merely in America but from Philadelphia itself. It was always possible
Philadelphia had changed. At all events the "social" origins of the
antagonism were lost in the mists of her memory.

Any dreams Mary had of a new kind of encounter that would redeem
the past, however, were dashed. Philadelphia remained stubbornly the
same. A paragraph from the Philadelphia *Ledger* spells out exactly how
much Mary's arrival meant there:

Mary Cassatt, sister of Mr. Cassatt, President of the Philadelphia Railroad, returned from Europe yesterday. She has been studying painting in France and owns the smallest Pekingese dog in the world.

It is not surprising that Mary stayed rather a short time in Philadelphia. She stayed, not at Cheswold where Lois was mistress, but with the Gardner Cassatts in their town house. It was long enough for her to do two more pastels of Ellen Mary, one a study for the other, and, as before, reflecting quite different nuances of baby expression and mood. She also painted a portrait of a flat-headed young woman with a prim mouth—a cousin, daughter of the formidable Annie Scott, she of the body-blow dealt over the portrait of her own mother, Mrs. Riddle, the lady with the nose. Mrs. Scott had in the meantime dealt Mary just such another blow. In 1895 Mary painted this daughter, Mary Dickinson Scott, and that portrait too had been rejected by the great rejector. In 1898, after young Mary married, Mary Cassatt painted this *Portrait of Mrs. Clement B. Newbold,* and it was accepted. Impossible to conjecture, whether by that time acceptance inspired more relief or bitterness in Mary Cassatt.

Her reaction to Philadelphia was to embark on a course much against her usual habits: she accepted a commission to paint the children of Mrs. Gardiner Greene Hammond of Boston, and made off for that city without more ado. (Her aversion to taking commissions, shared by many artists, was based on the implicit yielding of a certain amount of control into the hands of those doing the commissioning; the artist's conception, in a commissioned work, could not be wholly her own.)

After Philadelphia, Boston was more like it. Mary made independent headquarters at the very French Hotel Vendôme on Commonwealth Avenue, but the Hammonds gave a series of dinner parties for her at their house on Clarendon Street. At the dinners, and everywhere else, she spread the good word about the Impressionists ("Our little band of Independents," she calls them, which sounds more like Mrs. Havemeyer), taking every opportunity to exhort the Bostonians—characteristically concealing their wealth behind painfully unassuming exteriors—to buy French art. Boston provoked a couple of sharp remarks from Mary, as well. Just before her arrival Sargent, himself a Bostonian, was there, was, in fact, the one to recommend Mary to the Hammonds. When asked her opinion of him, Mary replied, even though all Boston was at his feet, "What Sargent wants is fame and great reputation." Degas might have made the crack, if more wittily.

Of the hub of the universe itself, Mary later wrote to a new young friend she made on this trip, Theodate Pope: "I assure you when I was

in Boston and they took me to the library and pointed with pride to all the young ones devouring books . . . I thought how much more stimulating a fine museum would be . . . Never did I meet anyone in the Boston Museum, where the state the pictures are in is a disgrace to the Directors."

Every morning she walked with her dog from the Vendôme to Clarendon Street, where for her use a parlor had been converted into a studio from which the parent Hammonds—for fear of "helpful" suggestions—were excluded. The first commission to be executed, in pastel, was the portrait known as *Frances L. Hammond as a Child*—a plumpish little girl sitting conventionally and a bit glumly in a chair. Frances' brothers Gardiner and George were next posed, together, and also rendered in pastel—another conventional portrait that does not get off the ground. All Mary's strictures against taking commissions seemed confirmed; then one day she happened to see little Gardiner coming down the stairs of the Clarendon Street house on the way to the Public Gardens with his nurse. He had on a green caped coat and a tricorn. Enchanted, Mary had him pose for her thus, and afterward presented this far livelier pastel of a little boy transfixed forever in George Washington's hat to his parents.

Back in 1892, in Paris, Mary made a friend of John Howard Whittemore of Connecticut, through his cousin, Clinton Peters, an artist who had come abroad to study with Gérôme and Lefebvre—names illustrious in salon art. After Mary finished her Boston commission, she proceeded to Naugatuck, Connecticut, where Whittemore had his place, again to execute commissioned portraits. This time what served as an excuse for staying away from Philadelphia was her friendship with John Howard.

Of the four pastels she did, *Portrait of a Grand Lady*—Mrs. John Howard Whittemore—is usually considered outstanding. The deeply reflective eyes gaze sidewise out of the picture; the "grand" of the title is an agreeable irony, since all that is grand about this simply-dressed lady is innate. An elderly woman was also rendered in a far grander dress, with a young grandson leaning his chin over the back of her chair; this time the boy is the one gazing reflectively into the side distance. Harris Whittemore, Jr., a different grandson whose hair had not yet attained the dignity of the other's crop, was posed alone in what in those days passed as a sailor suit, for a pastel entitled *Boy with Golden Curls*. His mother posed with her youngest child for *Mrs. Harris Whittemore and Baby Helen*, a pastel where the baby has charm, the mother little.

Naugatuck was where Mary first met the Pope family, whose daughter Theodate became her close friend; she wrote to Mrs. Pope, too, about gardening, off and on for years. During her Connecticut visit the Whittemores

took her to see an old brick factory at nearby Beacon Falls, shut down on account of a current depression. Mary was much taken with its beautiful country setting and urged the Whittemores to buy it and contrive a sort of country-house folly of it. (With all her political awareness, it is interesting that the economic and social disaster implied by its standing empty left her unmoved.) When she had finished the commissions, and paid a visit to the Havemeyers in New York, she at last returned to Philadelphia, sufficiently buoyed up by the expedition that she made several more enchanting pastels of Ellen Mary, one (wearing bows in her hair as in most of the others) sitting on her big brother Gardner's knee.

Once again she was staying with the Gardner Cassatts and not with Aleck. Although she and Aleck never ceased to be close, her relationship with Aleck's wife was as thorny as ever. One reason why "my niece" Ellen Mary played the important part she did for the rest of Mary's life, was that nothing barred Mary from this child and her sister Eugenia. Aleck's children, for whom Mary and her parents had done so much—Eddie and Sister and Robbie and Elsie—became, not hostile to, but influenced against their aunt through the untender mercies of old Lois. Lois' animosity continued operating into the next generation, as in the case of a ruby and diamond ring Mary bought for Eddie's only child, Lois, when she was sixteen, which the old Lois would not allow her granddaughter, whom she largely brought up, to keep. By then the antagonism had grown even stronger, as antagonisms do; it served even further to poison the atmosphere of Philadelphia for Mary, making it seem even more her enemy.

From Mary's point of view neither Philadelphia, the indifference Philadelphia showed her, nor her rebellion against it had altered one particle. Sidney Fisher had, of course, died, in 1871; and with him much of Sidney Fisher's Philadelphia. Yet art, which for Mary displaced the importance social ranking once represented to a little girl, was still no pearl of great price in Philadelphia currency, and did not become so until years later. In 1924 R. Sturgis Ingersoll, on a trip to Europe with his young family, spent a total of $700 on contemporary paintings—Modigliani, Joan Miró, and such; on his return to Philadelphia he was made to feel that he was considered unsound as a lawyer, for owning such pictures and hanging them in his office.

Homecoming to Beaufresne was almost as pure a relief and enchantment for Mary as the flight to Paris had been half a century before. Everything she loved, and the memory of everything she ever had loved, were here in this receptacle of her life. Between what her father left her (many American families of the nineteenth century made a point of leaving any money to the daughters; it was felt sons should be able to look after them-

selves, as indeed Aleck and Gardner did) and her not inconsiderable earnings from painting, eked out by the contributions she always indignantly denied getting from Aleck, Mary could live at Beaufresne, if not in state, in style.

The red brick château, with a mansard roof, and hexagonal towers surmounted with belfries at either end, had been begun in 1783 and completed in 1817, though claims were made for its being older. Many of the peasants of the region still remember, or imagine they remember, the lady they call "l'Impératrice." "All of us children knew her," says an old charcoal-burner; and the sister of a onetime servant at Beaufresne recalls, "She was very just, but an authoritarian, and had a bad temper." Her household was made up of the faithful Mathilde—lady's-maid and *gouvernante*—a cook, a housemaid, three gardeners, and a coachman named Pierre, for "in France life was cheap at the time." Though her fall had put an end to Mary's riding, she retained her interest in keeping good horses and her love of animals had extended to dog-fancying; what she fancied was Belgian griffons. Her first, a purportedly pure-bred puppy, as it grew changed as if by black magic into a King Charles spaniel; it must have been quite a day in the household when it dawned upon the redoubtable Miss Cassatt that she had been had.

The reparation offered by the offending kennels was peculiarly French: it consisted of a *real* griffon prize puppy, with its own trousseau of brush and comb, raincoat, overcoat, and pocket handkerchief. This animal turning out all that had been claimed for him, Mary went on to become something of an authority on the breed, as well as providing an object of terror to children who posed for her, in the shape of her swarm of nipping griffons. The original, pocket-handkerchief-equipped griffon, when it came to dog's estate, was presented to Ellen Mary—one of the many presents Mary Cassatt made her.

As late as 1900 Mary was writing to her new friend Mrs. Pope how excited she not only had been, to move into the château, but still was. She had done nothing ever since, she said, but get settled. She had only just added more plumbing, and changed the room arrangements around until "I am nearly up to the American standard. I need not say that I am so far beyond my French neighbors that they think I am demented . . . Now that my lawns have all been properly turned over and levelled, and walks designed and made, I have gone into roses. I have over a thousand planted."

There was a special affinity between Mary Cassatt and roses. From that time forward she spent hours over hers. One of the most lasting pictures the village of Le Mesnil has of "l'Impératrice" (they called her that among themselves; Mary Cassatt and her relatives were under the im-

pression they called her "Notre Mademoiselle") out in front of Beaufresne, in the vast rose plantations, bending over her flowers even after she could no longer see them. They will tell you Miss Cassatt could tell each separate kind apart by scent alone; no one else, they say, has ever been able to grow roses in the soil of Beaufresne since.

A stream—Mme. Riché's "small river"—runs through the grounds, and in Mary's time fed a pond, stocked with fish, where the present-day M. Charles Durand-Ruel as a little boy used to angle, while his father the art dealer, and his mother, were calling on Miss Cassatt. Little Jean de Sailly and his sisters, too, children of the owner of the neighboring Château de Pouilly, came to fish. As the afternoons passed, the sun would sink slowly down the west, the pheasants speak up. The mourning dove moaned in the great ash trees, and from the village up the hill sounded, at intervals, the sweet, cracked note of the church bell. Beaufresne was in process of becoming a place of peace and beauty. A clue to Mary's approach to it is found in the same letter she wrote in 1900 to Mrs. Pope about the joys of getting settled at Beaufresne. "There is nothing," she said, "like making pictures with real things." That instinct for selection and arrangement which is the artist's equipment, seemed to operate just as well managing a household, or gardening among the roses.

She was making real pictures, and not only with things. The picture she herself made, that neighbors in the country remember, was of a lady dressed beautifully and expensively in clothes from Doucet, Redfern, La Ferrière, topped with hats by Reboux trimmed with spiky aigrettes (nowadays interdicted). Mary considered French shoes too frivolous to be worn; like any Philadelphia or Boston grande dame she ordered hers from London. She, like other such ladies, especially maiden ladies, wore long chains, some set with amethysts, looped around her neck, with a lorgnette and watch attached, and tucked into her skirt band. The impression two of the little boys fishing in the Beaufresne pond got of this figure is particularly instructive.

"Typically American," declares M. de Sailly, from behind an imposing desk at the Banque de l'Indo-Chine in Paris. "Strong, tall. She smiled often, revealing the vertical lines in her face. A real American lady. Once when I was a very little boy I had lunch with her; the American financier, Jay Gould, was also there. It was an unusual privilege, you understand, for me, a child, to be at the luncheon table—I had, after all, been fishing. With worms. Afterwards when I was alone with Miss Cassatt, she said to me, 'M. Gould is not an American gentleman.' I tell you this as an example of Miss Cassatt's wit." M. paused, possibly wondering what he meant. "As to how she looked," he resumed, shrugging it off, "her appearance was, as say, typically American. Typically Red Indian. High

cheekbones and reddish skin. Like a typical American." This curious no-
tion may be explained by the influence on little French boys, growing up
at the beginning of this century, of Buffalo Bill and his troupe, which
made France Indian-conscious.

"Degas?" M. de Sailly continued, "did I see Degas there? No, never.
But I must tell you this: Mademoiselle Cassatt could not possibly have had
an affair with Degas." M. de Sailly paused and reflected. "Or with any-
body else," he added. From the fish-pond, the little boys did view other
illustrious guests, drinking their coffee after lunch on the long, wide gal-
lery that ran along the façade of the château, and discussing art and
politics with their "almost garrulous" hostess. The view back to the pond
from the gallery was over wide lawns. The land rose on either side, form-
ing a shallow bowl; many English country houses have a similar setting. To
the eyes of the other little boy fishing, Charles Durand-Ruel, become senior
member of the firm, "Miss Cassatt looked, not commanding, or arrogant,
as some say; just *old*. Of course, actually, she was not so very old; but to us
children—!" He let his eyes roll back. "What *is* all this talk of her being
arrogant? I believe she was very warm and sweet," insisted the member of
a business Mary did so much for financially, in its gamble on the Impres-
sionists.

"*Monet* was the one who was arrogant," he went on. "All the other
Impressionists were nice except Monet, who became more arrogant as he
became more successful. Later on, for example, in the World War, every-
one's car was taken away. Requisitioned, you understand, by the Army.
Monet, alone among the painters, kept his, because he had influence,
was a friend of Clemenceau's. When the Durand-Ruels would go to
Giverny, Monet sent his car to Vernon to pick us up at the train. It
rankled, I can tell you!" Actually in 1915 Mary—also a friend of Clemen-
ceau's—was also still being motored to Grasse, where she rented a villa,
in the Renault landaulet Mrs. Havemeyer gave her in 1906; it is only
one more example of how Mary was not thought of as being the same as
"all the other Impressionists." "Miss Cassatt was a true aristocrat," M.
Durand-Ruel went on, "but far from autocratic. My recollection of her is
that she was *sweet*. Look at her sweetness to the Havemeyers!

"Did her helping the Havemeyers with their collection hurt her work?
Oh, it did not take very much of her time, advising," he tossed off lightly.
"As far as society went, she associated a great deal with neighboring châ-
teaux. That was what I was enabled to observe as a child of six or seven.
—She *must* have associated more with people in the country than with
society in Paris!" he said feverishly. "In Paris she was so *very* quiet . . .
Somehow the Opera pictures did get painted, however," he mused, per-
plexed. "In Paris, she has always been appreciated as a great painter," he

resumed, brushing the riddle aside. "A painter of fine, Impressionist pictures. It was her *own* country that failed to value her." He crossed his office to consult a file case. "Thirty thousand dollars in American money," he reported of a 1971 sale in Paris. "That is about typical for today." As the old gentleman was speaking, a Mary Cassatt, *Summertime*, offered in the Huntington Hartford auction in New York, was bringing $150,000. Returning to his desk M. Durand-Ruel also returned to Beaufresne. "At Miss Cassatt's one had a good lunch," he said, "carefully served. Aristocratic, certainly." His eyes grew dreamy as he slipped off into legend. "She was the daughter of the President of a great American railroad," he began . . .

Among châteaux in the country with which Mary associated was the Château de Pouilly, owned by M. Octave de Sailly—a good friend, her lawyer, and father of Jean the fisherman. In 1909 Mary made, in pastel, one of her most successful male portraits of him. The Saillys, mère and père, used to dine at Beaufresne, and their son recalls Mary did a good deal of calling about the countryside, "dressed elegantly, from Redfern. She did not come in. People came out to her car. Her French? It was— queer but okay. Her intelligence?" The elderly gentleman placed the tips of his fingers together. "It was irrational. Emotional. I should say that Miss Cassatt's political judgments were always emotional. Yes. She bobbed about in her judgments, politically. Emotionally she was what we French call da-da—bobbing about. Her food was, however, very good.

"I do not know who her friends were in winter. The country, you understand, was a separate life. My parents did not see Miss Cassatt in Paris. Her political judgments: I should call them Communist— socialist, actually. She was great friends with the Communists, as well as with Clemenceau. In the country, there was a rich American friend of hers, a Mrs. Mellon . . ." M. de Sailly began, like M. Durand-Ruel, to remember memories inherited from his parents. The house where the rich Mrs. Mellon lived was Villotran, an eighteenth-century château in a beautiful park, owned by a family of French Mellons. Mary was often asked in summer to bring her nieces there; tea would be brought, to an eighteenth-century *temple d'amour*, in a cart drawn by a donkey through the vast gardens. There was also the Château de Mesnil; but in view of what happened about the village school, it seems probable Mary would have been on less cordial terms. M. de Sailly's face brightened as he returned to the subject of food.

"Her teas were excellent," he reported with satisfaction. "I remember them well, as it was for tea that I was generally invited—being, you understand, a child at the time. We would have tea on the beautiful glassed-in gallery, where she always sat, and where were many—a great

many—Japanese objects. When my sister was married, later, Miss Cassatt presented her with a great Japanese vase.

"It was with children that Miss Cassatt excelled. My sister and I used to pose for her, and we definitely considered the experience agreeable, since we were well supplied with books and toys. We were, however, driven to distraction by those little *roquets* of griffons, nipping at our heels . . . Miss Cassatt often had us to tea—she was very good with children. She took excellent *care* of children. For example, her models among the village children had to be disinfected—their hair deloused— before she would permit them to have tea with her nieces or ourselves."

Another reason Mary Cassatt is well if mythically remembered in that part of the country is for the material aid she gave to Le Mesnil. Not all her charities are charitably remembered. "She paid to get rid of the nuns in the school only because she was a Protestant," says an old woman who "cooked for another château," referring to the village school which was on Château de Mesnil property. Another old woman, however, thought the gesture "openhandedness to all," especially paying the salary of a teacher when the Commune refused to. Mme. Riché, who was the third teacher after the departure of the nuns, recalls that this salary was "paid by Miss Cassatt, but through the Ministry of Education, so that I had no direct dealings with her," though she used to see her often at the Poste. Mary also bought the furniture for the school, even though it was the Château de Mesnil's affair. Her opinion of a proprietor who refused to pay for the furnishings is not likely to have been high, nor kept to herself. "It was very American of l'Impératrice to have *wanted* to," insisted Mme. Riché, standing on the sidewalk of her nearby brick village (all the villages in that part of Oise are brick, many of them bomb-damaged), with a black shawl like a concierge's shawl held tightly around her bosom. Mary Cassatt did in fact feel strongly about getting schools, among other things, out of the control of the Roman Catholic Church. She wrote to Mrs. Havemeyer during a 1906 political crisis, "The only thing that can save [France] is a protestant campaign."

The social villain of Le Mesnil was the button factory, which paid women a bleakly meager wage. Over the years and up to her death Mary, in her efforts to make a better life for women, rescued many young girls from the button factory, either employing them at the château, sending them to jobs with friends in Paris, or both. Reine Lefebvre, most characteristic of all Mary's local subjects, whom she painted again and again with babies and without them, was one. Assistant cook at Beaufresne at seventeen, she received her wages for cooking, not posing. Mary later sent her to the Cordon Bleu in Paris, whence she went as cook to one of the baronial Rothschilds, says Reine's granddaughter, wife of the Mayor of Le Mesnil. —To someone

quite different, insists another villager who recalled, too, that Mary sent Reine to England—to study English, she says; to study cooking, says another with considerably less probability. Mary was kind to all children, say many of the villagers; severe with those who posed for her, say others. It was, however, Mary Cassatt's standing up for the rights of Le Mesnil's women (the first time it had ever been done in all those centuries) that made of her a legend, a folk tradition: *The American lady artist, always out in front tending her roses, who rescued our village girls from the button factory.*

Legend surrounded Mary from the beginning, perhaps because of the extent of her own independence. An old harness-maker, standing deep in the mud of his barnyard in "bleu de travaille" and sabots, insisted he had known Mary Cassatt well. She did a lot for the village, he said; pressed, he did not know quite what. Nevertheless, he asserted stoutly, "When one said the name Miss Cassatt, everyone knew who *that* was!" It turned out he glimpsed her when, once a year, he used to go to Beaufresne to repair harness, especially for the pony-cart used by the little nieces. Some of the familiarity claimed by the country people turns out to be based on inherited memories: one peasant who said he had known "l'Impératrice Mary Cassatt" well, in fact never saw her at all. It was his grandfather who had known her—ah, but so *well!* Very, very well indeed . . . It is the same quality of myth as tinges the recollections of M. Durand-Ruel, discoursing on how Mary Cassatt's father was President of a great American railroad . . .

Mary was mistress not only of a château but of a whole demesne. It was the first time she had ever enjoyed the pleasures of being a woman alone: no obligations to parents, no nagging urge to join another's life. She was good at being a woman, as good as or better than the ordinary wife. Recipes for some of the dishes from that excellent cuisine Mary supervised—like *Caramels au chocolat* and *Truffets au chocolat*—were recorded by the daughter of a new friend Mary made presently—Mrs. Montgomery Sears of Boston—another large, formidable lady, one with an interest in spiritualism.

The daughter, Mrs. Bradley, commented on the recipes, "You can see how fussy [Mary] was by the language; and the eggs and butter *had* to come from Mesnil-Beaufresne." Lest anyone imagine, moreover, that it was easy work managing a household where there were servants, any businessman will testify that to delegate work successfully is always more difficult than to do it oneself. With the realms traditionally assigned to women—kitchen, children, even church—Mary was dealing outstandingly, using the same powers she had developed in pursuit of her art; there was "nothing like making pictures with real things." It seemed, in fact, as if

there were nothing personal, any longer, to rebel against: only the continued challenge of women's cause.

Within the picture Mary was making of her life at Beaufresne, were, however, recognizable not only Mary's mother, "executive and masterful," and her father, with his old, saving instinct for clearing out and going somewhere pleasanter, that had made her escape the art world; but still another, as though ghostly, presence, even though as yet Mary's interests had not turned to "see through the mysterious veil." Something she had been fighting and escaping all her life was on the scene, too, and in the same quarter as the images of her dead parents, for whom, she told Miss Pope, she had wept long: in herself. For George Biddle—a new and much younger friend Mary made, not only a sharp-eyed painter but an echt if dissident Philadelphian—to identify the picture he was encountering by the time he met Mary in 1911, as "a typical, slight, tall, dynamic old Philadelphia lady, capable of saying anything to anybody. She would bang her fist on the table if she disagreed with you. I met that type of Philadelphia woman often. Socially and emotionally she remained the prim Philadelphia spinster of her generation" is not only eerie, but realistic. For of course by any tenet except snobbish ones, Mary Cassatt *was* a Philadelphian, having been brought up there. To Philadelphia, however, and even more to herself, she had never seemed so. (The only slip in George Biddle's accuracy was to say she had "remained" what she appeared, for she had not always looked so.) That which once judged her father, who himself had judged her mother, that which she took for a mortal enemy, was also part of the Beaufresne picture.

TWELVE

THE PHILADELPHIA IN Mary only came out after she was faced with a life that gave her more time than when she was daughter of the house—although she devoted much of it to such family as she had left. In the summer of 1900 the whole Gardner Cassatt family came and stayed with her at Beaufresne (the first thing Ellen Mary, aged seven, did on arrival was fall into the pond). The others, the Cheswold Cassatts, also came abroad that year, staying at Bad Homburg for Aleck's health. In September their son Eddie's daughter—he had married Emily Phillips in 1893, and was made military attaché to the London Embassy the same summer—six-year-old Lois, paid her first visit to Beaufresne. This granddaughter of old Lois' recalls feeling then that Mary cared more for Ellen Mary and Eugenia than for "us others"; and thereafter noticed that she was always invited to the château at different times than her cousins, whom in fact she never knew till she came out in Philadelphia the same year as Ellen Mary.

Any energy Mary had left over from her parents and her work had always been given to the advising on collecting she began with Louisine Elder and Aleck. It made a liaison between her two worlds. Naturally enough, after the death of both parents she turned to it, but there is more than that to what was a major shift in her direction, of which Adelyn Breeskin writes:

"She returned [from the American trip] with a new idea dominating her keen mind . . . While in America she sensed the great need for great art works to strengthen our civilization . . . The incentive was then born within her to persuade . . . wealthy friends to buy art works which would in the long run benefit the entire American public. This then became her great ambition. It diverted her from furthering her own art, but how can we judge if the sacrifice was not worth the great end in view? She thus became a worker in a cause and in consequence her own work suffered, for art is selfish. It demands complete concentration on itself. After giving her full time and her all-inclusive strength and labor to it for thirty-one years, she now wavered. She still worked hard and actually produced more work than ever before for the next ten years but her attention was definitely divided."

The art historian's view is the common one, which assumes in the artist a personality apart from, and that does not depend on, painting to maintain its identity. Mary Cassatt's did. Everything she ever had won for herself had been via her talent, and this accounts in part for her willingness

now to turn it toward other ends; for artistically she was in a rut. In furthering the collections of others to benefit America, however, Mary was turning to something analogous to applied science as above the pure thing. Degas would have derided the notion that an adviser on art does more for the world than an artist, since the latter's contribution is unique, while any non-artist, given the expertise, can advise. Conversely, work with others for a cause can be quite as concentrated on its own goal—and that goal merely human, not perfection. Mary Cassatt's art spoke, still speaks, to the world as clearly as the pictures in the Havemeyer collection do, and moreover in her own voice. Art remained Mary's vocation, but it was not quite what it was to Degas—thought, feeling, life—to which, far from being self-serving, he was the willing slave.

In a letter to the author, Denis Rouart describes the dangers of such immolation as Degas': "The artist, creating in solitude without contact with people capable of loving and understanding, runs the risk of falling into doubt and discouragement, or narcissism. But exchanging ideas and views with the amateur can perhaps provide excitement and dynamic enrichment. The only danger would be for the artist to deny his own personality." This is a critic's view; Degas himself wrote: "If the artist wishes to be serious . . . preserve his own innocence of personality—he must . . . sink himself in solitude. There is too much talk and gossip; pictures are apparently made, like stockmarket prices, by the association of people eager for profit . . . All this traffic sharpens our intelligence and falsifies our judgment." In one of the curious crossings of sexual lines between him and Mary (another is the elegance in his work, the increasing sturdiness of hers) Degas' immolation to artistic creation resembles a woman's sacrifice, in giving birth to children, of her personal desires, even of her safety, for the sake of the race. Mary's "working for a cause" with the Havemeyers resembles a man's impulse to force his way upon the real world.

Did she paint less well because of the energy she lavished on advising? Or did she advise because, in her new liberty, she did not need painting as much—after all, in the days when she first dreamed of riding unstoppably out into the world, she had never heard of art. Men who were young and art-mad at this period remember what happened to her work. One, an English connoisseur, says he simply thought of Mary Cassatt as a painter of sentimental mothers and children. An American painter, starting out in Paris about then, adds, "There is nothing gooey about mother-love, but mother-love played a big part in gooeyness." All those pretty babies, held by cheerful, humdrum, "Dutchy" mothers, that Mary; "producing more work than ever," was now painting, lack what gave *The Boating Party*, and the aquatints, their nervous subtlety, their touch of greatness. The fact is, mother and child was for her a worn-out motif. Two portraits of men—

M. Octave de Sailly in 1909 and Charles D. Kelekian (son of a dealer friend)—come closer to the new thing her art was looking for.

To use the critics' word, the "period" Mary was in (in emotional terms, the period in her life she was reflecting) *was* cheerful and humdrum. Philadelphia had conquered mother and father, Mary had safely escaped to France, all was again calm and bright. Since the kind of person she was struggling to be never before existed in the world's history except in myths of the Amazons, it is not surprising that even Mary Cassatt could not paint a more satisfying image of one. What *is* reflected in her is as woman-centered as the Chicago murals.

Taking on the Havemeyers involved the expense of vast energies: traveling with them, viewing works of art from their point of view, of investment; to say nothing of hours and hours spent writing letters to Mrs. Havemeyer—about every three days during these years. It was an approach to art fundamentally different from, if not opposed to, painting pictures. A letter of Mary's dated August 9, 1901, after they all had gone on a long buying trip together, sets the tone of the correspondence, which dealt not only with art but with crafts.

Mr. Havemeyer was great on crafts. Without Louisine, he would very likely not be known today as a collector of fine art. He could be happy for hours simply fondling the various Greek vases, Chinese bronze jars, Japanese lacquer boxes, brocades, carved ivory inros (intricate boxes) and other objects of great price, that he purchased, moreover, in wholesale lots. He bought, for example, 475 Japanese tea jars. Mary's letter began with a reference to the crafts side of her services:

"I also wanted to ask Mrs. P. [probably Mrs. Pope] to take your Lalique comb to you. When I went to Lalique I found he had not even begun it. I thought him rather common and full of airs, however he said he remembered you very well and no doubt would get *just* what would suit you, and he *might* have formed his idea before the P's leave. Now as to Harmisch [the scout they employed in Italy] it would be a pity to miss the Holbein portraits at 16,000 lira, which the dealer means to resell at 18,000. I intended going down to Florence later, I could not go now. I don't see why Harmisch cannot get at least some sort of a photograph, but he says it is difficult, there is no reason though that he should not send a photograph of the Andre[a] del Sarto. He seems to think I would buy a picture for Mr. Havemeyer on my own judgment without consulting Mr. Havemeyer. I have explained often enough. Well, Mr. Havemeyer must decide as to whether he will risk it . . .

"Pottier [another agent] I also saw in Paris, he has an insurance of 50,000 fr. and nothing in his rooms at present so the Goya will be safe there until inspected, repacked, and I can go in for consular certificates. Pottier

told me he got the better of the Custom House on the subject of a bas relief price 50,000 which they wanted to tax at 50 percent. He said they must tax it as marble pure and simple or else as a work of art, cables went flying to and fro, but he won. Pottier is agent for Pierpont Morgan and always has a credit of a million francs!! [sic] he seems thoroughly honest and reliable."

It is not the letter of an artist. It is the letter of one who knows that buying pictures takes money. It reveals how different the advising Mary was from the one who speaks to the generations through her pictures. It is the Mary Cassatt of George Biddle's recollections—confident of stealing a march on the customs, admirable at overawing picture-dealers. There is nothing whatever the matter with being a grande dame, of course— those Philadelphia women George Biddle had in mind dealt masterfully with their world. Mary Cassatt is the one who held the low opinion of Philadelphia grandeur; who had not been able to help ridiculing Mrs. Riddle, with her crooked finger holding the teacup. In letters to Mrs. Have- meyer, Mary, in her concern with finances, frequently takes the opposite side from the artist involved in the sale. She almost always protested Monet's prices—admittedly high—although the Havemeyers could well afford to pay them. It is of course only friendly to try to save one's friends' money; the only question is, which are one's friends?

"It is true," said Mme. Adhémar, directrice of the Orangerie, "Mary Cassatt sounded a trifle arrogant, as the artists never did, in bullying dealers for the benefit of the Havemeyers. Also, one may add, in taking advantage of the artists for the Havemeyers' sake. —Of course, advising on art to the extent Miss Cassatt did," she added, "would take away *any* artist's ability to concentrate on work."

Of all the women friends whose company Mary Cassatt sought, after the death of her mother, Louisine Havemeyer was most intimate. Intimate women friends in the Victorian era could and did express themselves in their letters, in unself-consciously emotional terms, meanwhile preserving the purest and most conventional relations. The kind of affection and demonstrativeness of Mary's letters to Louisine, and in Louisine's memoirs of Mary, expresses, almost, the feelings of two girls, the younger with a crush on the older.

Louisine Havemeyer was that Victorian ideal, a sweet, wholesome woman, as Mary's portraits reveal; and she was genuinely kind and warm. In some ways, though the younger, she filled the place left by Mary's mother. She was too earnest and conscientious to let the culture-vulture in her stop at that; she really worked at mastering the epochs in art, the different techniques, the outstanding figures, the representativeness within their epoch of pictures. She knew a great deal about art. It was not her

fault, it was her nature, that she did not know art as an artist does. Her sentimentality (a trait thought highly suitable to a lady) about art may even have been soothing to Mary after all Degas' vitriol.

In *Sixteen to Sixty*, certain phrases do dismay the reader, as when she remarks, of a visit from an actor, that it "lingered like a cameo" in her memory. Mrs. Havemeyer's way of expressing humility was: "How little we in the foothills know of . . . those who traced the narrow path that leads . . . to the high realms of great art!" Often she attempts flights of her own, as in a not-uninformed conversation she invented between Manet and the Venetian painter Veronese, on the subject of Manet's *Blue Venice*, which the Havemeyers bought from Durand-Ruel.

" 'Do those posts look thus to you, Father Paul?' queries the modern.

" 'Aye, my son,' answers the great Venetian, 'paint them as you see them and others will learn through your eyes. I had trouble enough in my day and criticism too, mind you . . .'

" 'Critics! Father Paul, did you have critics? and in Venice long ago? Did they sit in cafés and cast jests at you as you passed by?'

" 'Fie, my son,' answers the shade reproachfully, 'you a painter!—and mind critics! Go your way and think naught of them . . .' "

After considerably more of this, " 'Oh surely, Father Paul,' rejoins Manet . . . 'they call you the father of the modern school.' "

Even the most charitable comparison of the conversation of the Havemeyers with Degas' sparkling talk reveals what Mary Cassatt took on, along with advising them. Her own conversation was quick and—though it does not survive as witty—sharp. She always enjoyed Degas' repartee when she was not being wounded by it. Degas, however, did not really give a hoot for society, or Society either, in endeavoring to follow what seemed to him the good, the true, and the beautiful; Toulouse-Lautrec, after a gay night out in Paris, once led a group at dawn to the house of Mlle. Dehau, an art enthusiast. Pushing his companions in front of one of Degas' paintings, Lautrec commanded them to kneel in homage to the great and aging master, as one who had overcome the world.

Mary Cassatt had done well, for a woman of her century, to be an artist at all. If she did not follow the steep path Degas took, Degas was a tortured soul, with a Catholic tradition, who was not astonished by the fact of suffering. Mary could endure, but not accept, much suffering—like all but the immolated she sought relief; and relief was what Mrs. Havemeyer gave. Louisine was relaxed and easy-going. Her observations about people were often, moreover, discerning, as when she had the wit to notice how, in Degas' bad times, he would say he had "perdu le chemin"; it makes up for much she did not notice about his pictures. Of peasants that the Havemeyers and Mary saw in the course of their travels she noted they were

"good-natured and kind, and their chatter . . . not disagreeable." Any arrogance in the observation is offset by the curious fact that it applies so precisely to Mrs. Havemeyer herself.

Although in matters of finance Mr. Havemeyer's talents were of course spectacular, in genuine humanity and artistic taste he was his wife's inferior. A pale, moon-faced man with steel-blue eyes, he had a passion for bidding prices up. He genuinely enjoyed many of his pictures, yet he was one of those collectors who will admit their passion is a by-blow of the competitive instinct; that they get their main pleasure in art out of vying with each other for top examples, and from filling out their hoardings to make a collection all of, or else the best of, its kind.

Mrs. Havemeyer was the noncompetitive one, sometimes to the point of unwise thrift; yet hers was the real spirit behind the Havemeyer collection. Without her exceptional taste it might have turned out to consist of brocades and vases. To accomplish what she did required, out of the Victorian woman's arsenal of available weapons, all sorts of wiles to overcome Mr. Havemeyer's resistances. He was forever putting his foot down about some picture, she forever getting him to take it up again. In her efforts she was sustained by Mary Cassatt's skilled counsel and, not quite to the end, her friendship.

After 1890, when the Havemeyers built their mansion at 1 East 66 Street, New York, to be a setting for their pictures, the priceless and unpriced advice Mary gave them was given unlimited scope. If Mary's brother Aleck had taken advantage of the same free advice, he might today be remembered the way Andrew Mellon is, but he didn't and he isn't. Their great house, the architect of which was Charles Haight, later originator of what is known as Yale Gothic, was decorated by the Tiffany Studios, founded by Louis Comfort Tiffany, scion of the jewelers, he who alone and unaided thought up Tiffany glass. In her diverting book about collectors, *The Proud Possessors*, Aline Saarinen describes Tiffany as "enamored of every rich decorative style he encountered: the Moorish style, Japanese art and artifacts, and above all the sinuous, flowing forms of . . . art nouveau . . . His own rich confections mixed together strange and exotic elements from Near and Far East . . . The Tiffany Studios, true to the tenets of William Morris . . . could take care of its clients' needs lock, stock and barrel—but never have lock, stock and barrel been so exotically and sumptuously made. Aside from [Tiffany glass] the firm also built furniture, made special lighting fixtures, cast ornamental bronze, hammered wrought iron, handblocked wall-papers, and wove or dyed rugs and textiles to order . . .

"The Havemeyers got the full tutti-frutti . . . Mrs. Havemeyer was thrilled that the Byzantine chapel of Ravenna inspired 'our white mosaic

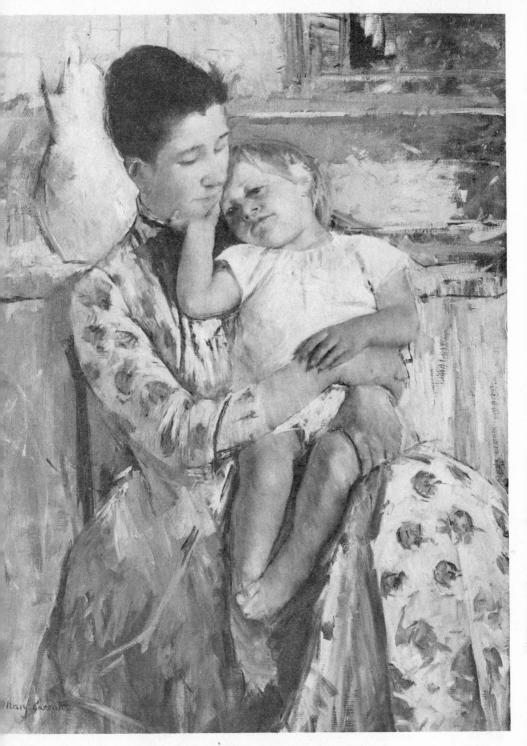

Mother and Child by Mary Cassatt, c. 1890.
THE ROLAND P. MURDOCK COLLECTION, WICHITA ART MUSEUM.
Also called *Emmy and Her Child,* this, perhaps greatest of Mary Cassatt's maternity
paintings seems "the very antithesis of sentimentality."

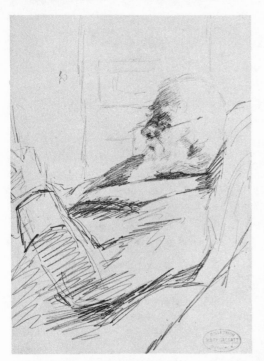

Portrait of Her Father by Mary Cassatt, 1881.
COURTESY OF THE ART INSTITUTE OF CHICAGO.
This is the pencil drawing that compares
interestingly with Baumgaertner's
engraving of the family, which appears
earlier in this volume, as corroborating
Cassatt's drawing of the head.

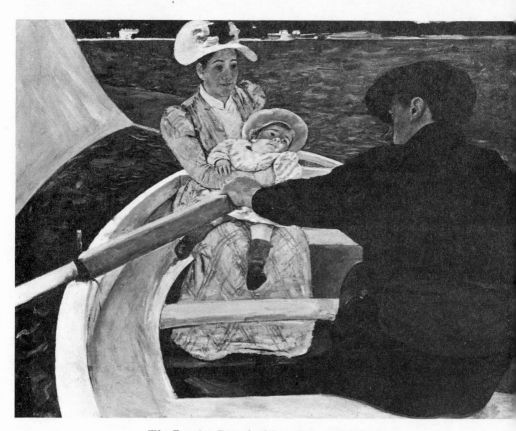

The Boating Party by Mary Cassatt, 1893–94.
THE NATIONAL GALLERY OF ART, CHESTER DALE COLLECTION.
"Of all her pictures this might most possibly have been painted by a man—in fact, been
painted by Manet."

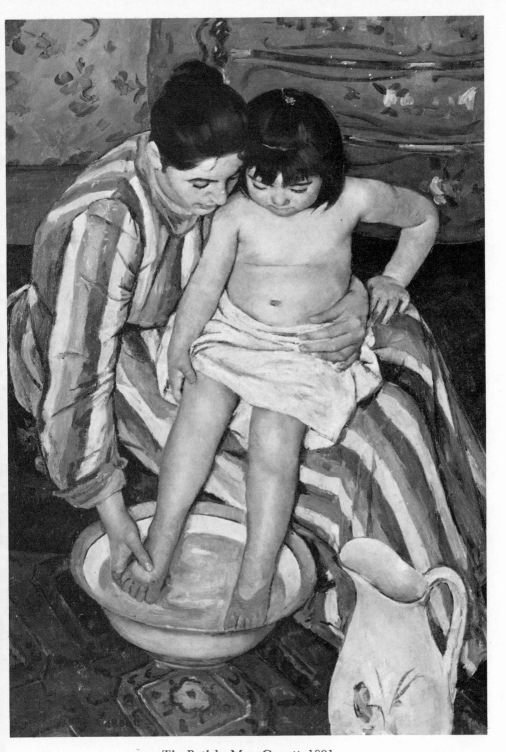

The Bath by Mary Cassatt, 1891.

COURTESY OF THE ART INSTITUTE OF CHICAGO.

The vast influence Japanese composition and approach had on the Impressionists is reflected in every aspect of this painting.

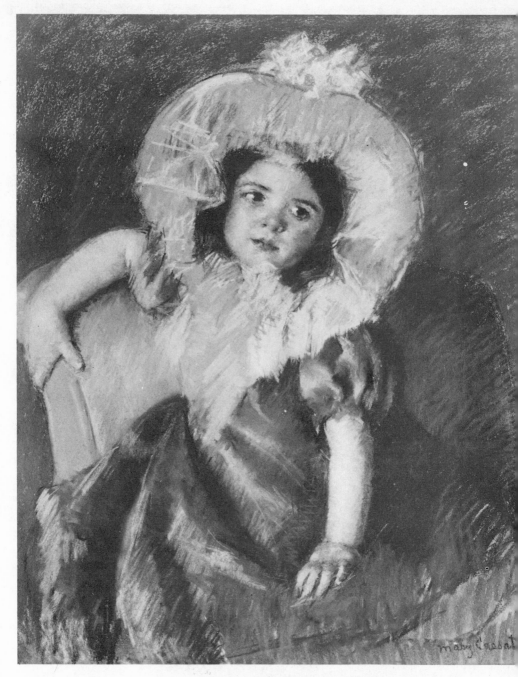

Child in Orange Dress by Mary Cassatt, 1902.
THE METROPOLITAN MUSEUM OF ART, ANONYMOUS GIFT, 1922.
Also called *Margot in an Orange Dress*, this pastel is one of the long series of "pretty little girls with pretty names" Mary Cassatt turned out at this period.

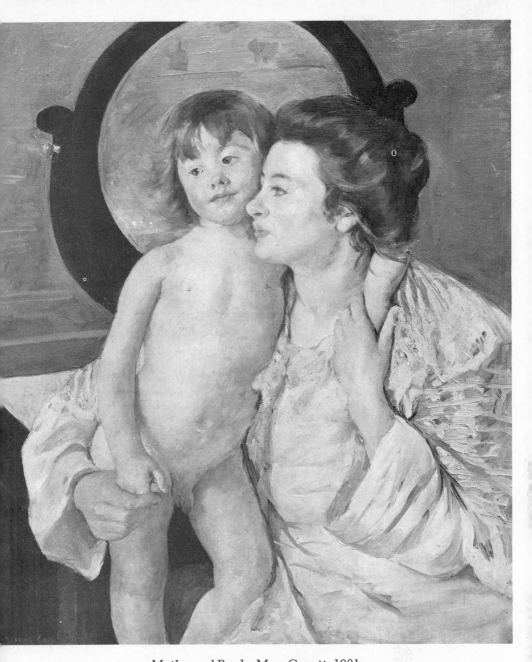

Mother and Boy by Mary Cassatt, 1901.
THE METROPOLITAN MUSEUM OF ART, BEQUEST OF MRS. H. O. HAVEMEYER, 1929,
THE H. O. HAVEMEYER COLLECTION.
Also called *The Oval Mirror*, this is the painting Degas described as looking like the infant
Jesus with his English nanny.

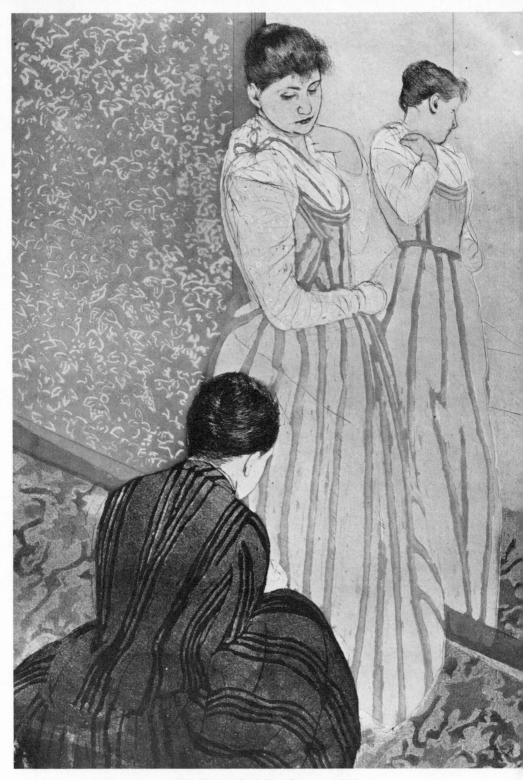

The Fitting by Mary Cassatt, 1891.
THE METROPOLITAN MUSEUM OF ART, GIFT OF PAUL J. SACHS, 1916.
"Aquatints of Mary Cassatt"—the culmination of her art—"seem almost to be by a
Japanese, of Japanese models"—but with a difference.

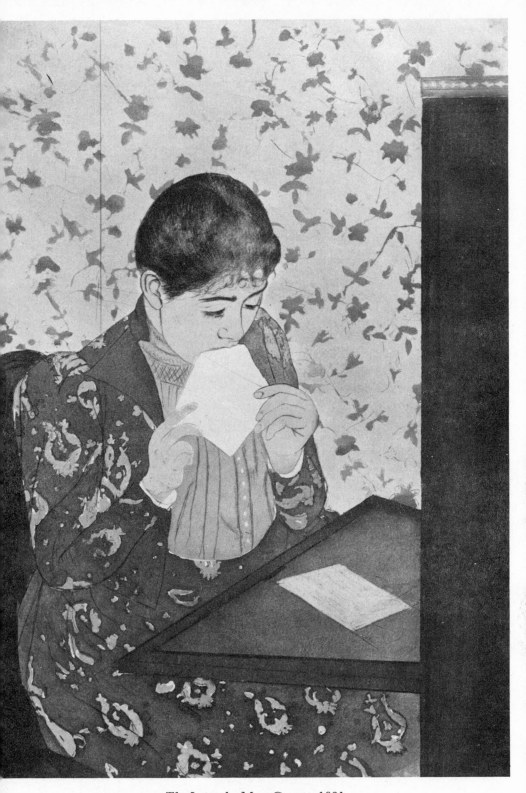

The Letter by Mary Cassatt, 1891.
THE METROPOLITAN MUSEUM OF ART, GIFT OF PAUL J. SACHS, 1916.
"The element of suffering . . . here entered the mainstream of her work through this subtly Oriental door."

The Parrot by Mary Cassatt, 1891.
THE METROPOLITAN MUSEUM OF ART,
GIFT OF ARTHUR SACHS, 1916.
One of the great
aquatint series that shows the artist's
faithful Mathilde with what may have
been Coco—the parrot that Degas'
curious sonnet purportedly concerned

La Toilette by Mary Cassatt, 1891.
THE METROPOLITAN MUSEUM OF ART
GIFT OF PAUL J. SACHS, 1916.
Of this aquatint Degas
remarked, "I will not admit that
a woman can draw that well."

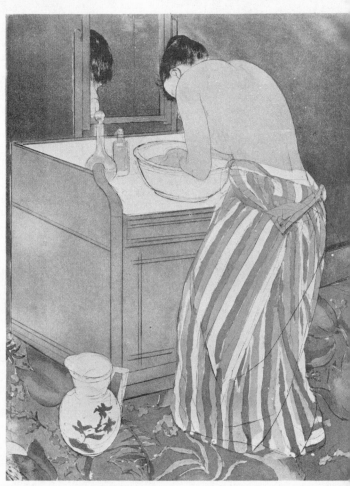

hall and ten pillars at the entrance of our gallery' and that the staircase
derived from one in the Doges' Palace . . . The walls of their music room
were covered with Chinese embroideries. On the blue and gold Chinese
rugs stood special, richly-carved furniture rubbed with gold leaf . . . The
furniture and woodwork in the library were based on Viking designs and
Celtic motifs . . . The library ceiling was a sensation. [Mrs. Havemeyer]
found the whole rich mélange 'modestly submissive' to the eight Rem-
brandts . . . that graced the library walls."

Against this background Mary Cassatt's views stand out in relief.
"Much as I admire Tiffany glass," she remarked in a letter to Louisine of
March 12, 1913, "I confess I don't love his furniture. If I were Electra [a
Havemeyer daughter, then to be married] I would not have him make
me any. All the new designs in furniture were the outcome of very talented
cabinetmakers, Reisner, Jacob [French designers of Louis XVI and Em-
pire], Chippendale, etc. Bing [an American along Louis Comfort Tiffany
lines] thought he could get artists (painters) to design furniture but it
was a complete failure."

The strenuously simple life Louisine nonetheless favored (her sister
Mrs. Samuel T. Peters once complained she had hopped the streetcar to
go to an auction to save ordering her carriage), took on in her sumptuous
nest a kind of reverse grandeur. After the Sunday afternoon concerts that
came to be a specialty at 1 East 66, the Havemeyer children spread pâté
on biscuits for the assembled multitude, because the maids had alternate
Sundays off. In similar contrast, against those walls of more-than-Oriental
splendor hung the Impressionists' celebrations of a simple life.

During Mary Cassatt's 1898–99 visit to America, while staying with
the Havemeyers she and Louisine evolved a technique for guiding Mr.
Havemeyer through what Mary described as "the ordeal of deciding on a
large Manet." The two ladies simply caused to be sent home not merely
The Alabama (an enormous marine) but the even bigger *Bull Fighter*,
which even Louisine thought too big. The artist in Mary asserted itself
when she replied that it was the size Manet wanted it to be, and that
ought to be good enough for Mr. Havemeyer. In the end Mr. Havemeyer
did buy it—bought them both—like a lamb. True to his bent he went on to
buy a case lot of Manets, including *Mlle. V in the Costume of a Toreador*
(and Mr. Havemeyer didn't even approve of bull-fighting), the portrait of
George Moore, and the controversial *Bal de l'Opéra*. As Mary said, "he
learned by leaps and bounds . . . more quickly" than any other collector
she knew. Similarly, once "educated up" by the ladies to Courbet, nothing
would do but that he buy thirty-five paintings by him. And Mary Cassatt's
advice was by no means limited to the nineteenth century.

They had traveled together before, in search of old masters. Mary

was always at their ear, either in person or via letter and cable, to steer them toward paintings that would serve as links between the art of the past and the modern. In February 1901 they all started from Genoa on a major hegira, accompanied by Mrs. Peters. It was freezing cold, in that beautiful land whose natives imagine it to be always warm, when the little party made their first stop to inspect the Black Rameses at Turin, which Mr. Havemeyer was mysteriously determined to see. A black diorite statue holding a gold scepter, it dates from 1400 B.C.; one male art historian describes it as epicene; guides generally refer to its enigmatic smile. Mary Cassatt's indifference, hitherto, to Egyptian art (followed by her later, drastic response) to say nothing of what Mr. Havemeyer's reason was for seeing it, make Louisine's account of the morning fascinating.

"There he sat," she wrote in her memoirs, "superbly grand, with an immense crown, and with but little raiment—just as he had sat centuries and centuries before upon the warm sands of Egypt . . . 'Isn't it lifelife?' said Miss Cassatt softly [we may be sure that softly was not how she said it]. 'You feel as if you touched it, it must be soft like flesh.'

" 'It was worth coming to see,' said Mr. Havemeyer emphatically.

" 'What made you want to come and see this?' asked Miss Cassatt.

"He answered, 'For many years I have wanted to see Egyptian art, and it occurred to me this would be the easiest way to see some fine examples.' Then turning to my sister he added, 'You are frozen, aren't you, and would like to go . . .'"

On the net result of the Italian trip Mrs. Saarinen comments: "The Havemeyers could hardly have done worse. They fell into the hands of an impoverished German [Harmisch] whom Miss Cassatt had known years before in Italy when he was [a sculptor]. With rare poor judgment Mr. Havemeyer and Miss Cassatt rose to his bait [an Italian wife claiming to be on good terms with Italian nobility]. He provided them with adventures whose cloak and dagger aspects appealed to Mrs. Havemeyer . . . secret visits to the darkened, shabby palazzi of the poverty-stricken Italians . . . sneaked into a chapel that contained a painting attributed . . . to Filippo Lippi. He . . . provided them with more than two dozen works of art bearing such celebrated names as Raphael, Andrea del Sarto, Titian, Veronese, Donatello . . . Only two survived the test of time." (Mr. Havemeyer, to do him justice, had humility as well as confidence. Once when he was showing Anders Zorn around 1 East 66, the painter stopped in front of a fine Dutch picture and said, "Do you call that a Rembrandt?" Mr. Havemeyer replied quietly, "No, I did not call it a Rembrandt, do you?")

Things turned out more rewardingly after they continued their trip— first leaving Mrs. Peters in Paris—in Spain. As a result of encounters with assorted grandees, real ones—among others the godson of an Infanta of

Spain—they were able to track down fine Goyas and outstanding Grecos; Greco was then a taste in mint condition. The fundamentally modest Louisine wrote of her realizing, as they were being shown around his pictures by the young Duke of Alba, that to be a collector of portraits is not at all the same thing as being their inheritor.

One Greco the Havemeyers in the end bought, and it took them four years to come up to the fence, was the portrait of *The Grand Inquisitor*— Cardinal don Fernando Niño de Guevara. Laymen view portraits in quite a different light from that in which an artist, any artist, does. Otherwise cultivated people, for instance, are reluctant to hang a portrait of themselves at home; it seems to be for them a symbol of overweening pride, even though framed photographs of the owners may mar every exposed surface in the house. They are just as leery of buying portraits of people not in their families, the matter of the portrait as picture being entirely overlooked. Mr. Havemeyer felt that a portrait of someone not in his own family should at least be of someone comely. The Cardinal was far from comely; also Greco had painted him with his glasses on. It took Louisine's feminine wiles and Mary Cassatt's so-called masculine mind to guide the poor man into making a good investment. In the end he did, and at the same time "opened the market for Grecos and Goyas in the United States," as Mrs. Saarinen says; moreover, she adds, "The Havemeyers' Spanish paintings remain unsurpassed."

An incident of the 1901 journey that is described with girlish admiration by Louisine, appears in her account of her friendship with Mary Cassatt: "When we left Madrid Mr. Havemeyer, like any another tourist, in the rush of the Easter Fête had omitted to have his tickets stamped, in fact he knew nothing about the necessity of stamping them. When we arrived at the frontier, the guards attempted to collect another fare. It was an old trick, and they had several other victims among the waiting crowd upon the platform . . . Miss Cassatt at once demanded the Chef de Gare, who reluctantly appeared. Miss Cassatt said to him:

" 'Monsieur, will you kindly stamp these tickets?'

"I am sorry to say his sullen rejoinder made us suspect . . . collusion between the Chef and the guards. He said to Miss Cassatt, 'Madame, I cannot do it. Those tickets were not stamped in Madrid and it is distinctly printed on them that they should be . . .'

" 'Yes!' quickly replied Miss Cassatt, 'printed only in Spanish and French. This gentleman speaks neither language. In order to be legal for him, it should have been printed in English. Monsieur will kindly stamp them?'

"He did so, and . . . those of the other tourists, to the discomfiture of the guards and the delight of the travelers, who gave Miss Cassatt a

hearty round of applause as she walked down the platform and entered the 'train de luxe.'"

In the meantime the journey had taken months and months of what would once have been painting time for Mary, and brings inescapably to mind those other months and months she spent away from work with her ailing mother, also in Spain. Was it for this that she had remained maiden —to advise on pictures, to sit listening to Louisine talk? "Mr. Havemeyer usually sat in stony silence," Mrs. Saarinen relates, "in the carriage, while the jabbering [the word Mrs. Saarinen uses] of the ladies eddied around him." It was in all ways a different kind of trip—a different kind of change from work—from that trip behind that white horse in that tilbury. Yet Mary's advising-on-collecting side had by no means taken over, as is evident from the bread-and-butter letter she wrote Mrs. Havemeyer that tells how stimulated to paint she was by the trip. However, when the Havemeyers invited Mary to go picture-buying with them in the spring of 1903, she declined.

To Theodate Pope she wrote, from Paris, how it would be impossible for her to go to northern Italy because there was to be an exhibition opening April 2 at the Bernheim Gallery, of all "our set" including Manet, Degas, Monet, Sisley, Berthe Morisot, and herself. She believed there would be "some interest excited, it is so long since anything of the kind has been done." The excitement she had described to Louisine in her thank-you letter was of the same kind: "All day I work! I am wild to do something decent after all the fine things we have seen! Oh! If only I could! Goya's unhesitating firmness upsets me."

Alas, when painters talk about how they are dying to work well, it is too often because they can't. As usual, Mary Cassatt's work expressed her situation, in a medium she turned to just then, and also expressed that situation's ambiguity. Perhaps it was Mr. Havemeyer's influence that put china-painting into her head; in those days, there was no more touchy subject among artists. To most, china-painting was a craft, and crafts were looked down on (though even Degas himself experimented with painting fans). Of all crafts, china-painting seemed most the epitome of lady-painterism. Mary's work with it, while it reveals her search for something new, also suggests a new equation in her—as being less an artist who happened to be a lady, than a lady who happened to paint. She painted on vases (Mr. Havemeyer's special enthusiasm) but wrote of her dissatisfaction with the results, with customary vehemence, to the dealer Ambroise Vollard, a special friend. (Dealers, serving artists, seemed to Mary in precisely the proper relation.)

"I am almost tempted to efface the one that was fired," she said, "as I am sure this would give me nothing" and then admits ruefully, "One

must serve an apprenticeship for this as for anything else." Did she think it would be easy? Nothing made well is easy. She could not repeat old triumphs; she must either move on—like Degas, after he was blind, making superb wax figurines by touch—or quit; Degas somehow knew, if he could not make one thing, how to make another. That the artist in Mary Cassatt's equation was still restless and searching, is evident in the remainder of her Vollard letter: "To return to the vases, I can make them even in Paris, but on the other hand I have models of flowers here [at Beaufresne] in abundance; when it rains I can't work outside." It was still inconceivable that she not work.

Vollard—a dark young man brought up on an island in the Indian Ocean, who opened his Paris shop in 1894—bought a lot of Mary's work in 1906. Around the same time occurred the curious and revealing matter of the counterproofs, the tracing of which has been one of Adelyn Breeskin's many contributions to knowledge of the artist. Vollard offered to buy a number of the pastels Mary was making, of all those conventionally pretty little girls named Simone, Sara, and so on, if she would allow him to have counterproofs made which she would retouch, like etching a plate with only one print. Mary agreed to this proposal, and the work went forward, the lithographer-printer Clot running the pastels through his press with another sheet of paper slightly dampened so that some of the pastel came off on it. Mary would then work on both the original from which the pastel was removed, and on its mirror image. It is easy to distinguish between the two since Mary was a right-handed artist, and not only does the shading in the counterproofs slant in the left-handed direction, but the signatures appear on the opposite side from the originals. It constitutes one interesting feature in the total Cassatt output, but of special interest is what agreeing to the counterproofs suggests, in the way of a slackened impulse to originate.

Vollard, well known for bringing Cézanne—neglected sport of Impressionism—to public notice, was a grateful admirer of Mary's. He had more than her pictures to be grateful for. She turned the Havemeyers over to him, and Vollard was well aware that Mr. Havemeyer was Sugar King of the United States, even though the first time the millionaire came to his shop he took the plainly dressed man to be some minor haggler over prices (whereas Mr. Havemeyer was, in fact, a major haggler over prices). Mr. Havemeyer ended up buying his usual case lots—of Cézannes—from Vollard.

Vollard rewarded Mary with devotion. "How often did she get me providentially out of a difficulty . . ." he wrote in his memoirs. "It was with a sort of frenzy"—Vollard's word—"that generous Mary Cassatt labored for the success of her comrades, Monet, Pissarro, Sisley, and the

rest." He was fond of recalling a scene he was once privy to, at an Impressionist exhibition when someone, standing talking about painters with Mary Cassatt without recognizing her, exclaimed, "You are forgetting a foreign painter whom Degas rates very high!"

" 'Who is that?' she asked in astonishment," or so the Vollard story continues.

" 'Mary Cassatt.'

"Without false modesty, quite naturally, she exclaimed, 'Oh, nonsense!'

" 'She is jealous,' murmured the other, turning away."

One honor Mary Cassatt did not refuse, and, in accepting, gave more than she got, was the honorary presidency of the Paris Art League, in connection with a hostel it ran for American girl students. She used to go to talk to the girls on "Art for Art's Sake"—a notion still in pristine condition —and offered scholarships to the two most deserving students. These carried a proviso, however: the students must spend a year in Saint Quentin studying the work of the great French pastelists of the seventeenth and eighteenth centuries that had meant so much to Degas and to her. Her work, like his, sprang from experience; but the proviso in the scholarships marks a growing tendency in her, not so much to use her experience, as to judge in terms of it. She never really admired any art after Cézanne; he signified her sole break with pure Impressionism as the final word in art.

Back in 1894 she had written to Mrs. Stillman about Cézanne: "When I first saw him I thought he looked like a cut-throat, with large red eyeballs standing out from his head in a most ferocious manner, a rather fierce-looking beard, quite gray, and an excited way of talking that positively made the dishes rattle. I found later that . . . far from being fierce or a cut-throat, he has the gentlest nature possible, *comme un enfant*, as he would say . . . His manners at first rather startled me—he scrapes his soup plate, then lifts it and pours the remaining drops in his spoon; he even takes his chop in his fingers and pulls the meat from the bone. He eats with his knife and accompanies every gesture . . . with that implement, which he grasps firmly . . . and never puts down until he leaves the table. Yet in spite of the total disregard of the dictionary of manners, he shows a politeness toward us which no other man here would have shown. He will not allow Louise to serve him before us . . . he is even deferential to that stupid maid . . . I am gradually learning that appearances are not to be relied upon over here. Cézanne is one of the most liberal artists I have ever seen. He prefaces every remark with *Pour moi* it is so and so, but he grants that everyone may be as honest and as true to nature from their convictions; he doesn't believe that everyone should see alike."

To another friend Mary wrote: "Some years ago [a certain collector]

saw one of Cézanne's still-life pictures in [Mary's] dining-room and could see nothing in it. Now he sees nothing but Cézanne and, with the rest of the crowd, put him far too high, selling his Degas to buy Cézannes . . . I sold my Cézanne for which I paid 100 francs twenty-five years ago—I was one of the first to see merit in his pictures—for 8000 francs! And immediately added something to it and bought a Courbet." Mary was unable to extend this liberal attitude one step further, to Matisse. Even to speak of him brought out the Philadelphia in her—demonstrating how much it was for her a kind of defense, a thorny refuge from what seemed to threaten.

The difference between Matisse and the Impressionists, she declared, was that the latter had the admiration of other artists in their time, whereas Matisse "did not exist for the serious artists today." The fact was, he did not exist for her. On February 22, 1910, she wrote Louisine, "There is one exhibition of Matisse at Bernheim's, I assure you it looks as if the pictures were painted by negroes from the Congo. They, poor souls, are at least naive and sincere, but Matisse is neither, and there is a public ready to swallow everything." Of the years following, George Biddle asserted, "Miss Cassatt was almost unaware of anything that happened in the world of art after 1910."

In 1908, for instance, Mary's new, spiritualistic friend Mrs. Montgomery Sears took her to an "evening" at the home of Gertrude Stein who, being also from Allegheny City, wanted to know Mary. However, after Mary met a number of Miss Stein's and Leo's friends and looked at their array of early Picassos and Matisses, she went back to Mrs. Sears expressing total rejection of her host and hostess. "I have never in my life seen so many dreadful paintings in one place," she said. "I have never seen so many dreadful people gathered together, and I want to be taken home."

One writer on art, Camille Mauclair, defined what had happened when he said Mary Cassatt had "an accurate sense of her exact destination and of the natural limits of her temperament and of her art." The destination of modern painters was not the outward scene. Mauclair's definition amounts to saying that Mary Cassatt could not, like them, look in. She had nothing against looking in. To Theodate Pope she wrote November 30, 1903, after her friend had lost her fiancé, John Hillard, "I long for one thing for you, regular employment; you do look in, and that seems to me a good thing, but only with regular work." However work and looking in never met in Mary. The destination her nature sought all her life was outer.

Degas could not look in either. To the end of his life he, however, never ceased paying close attention to the younger painters, no matter how much they upset him—and they did. Van Gogh, for instance, was opposed to everything Degas believed in, in art, yet with his still-meager

funds Degas bought fruit and flower pictures of Van Gogh's. The moderns appreciated his open mind. Van Gogh wrote, "A Greek statue, a Millet landscape, a Dutch landscape, a nude woman of Courbet or Degas—these calm, modeled perfections." Degas was far from indifferent, he was profoundly sensitive, to such homage. He liked the young men the way an old dog likes puppies, a trifle leery of them.

Mary Cassatt was more divided toward the young. She could be acid when it was a woman, like the journalist, a Miss Gassette, of whom she wrote in a letter to Louisine, with thanks for granting permission to her to see the Havemeyer pictures. She continues: ". . . as she means to talk about them [in print] she ought to have the chance of saying the right thing. She is a girl (not young—34) of many qualities, but I do not think Art is one of her gifts. I strongly advise matrimony, especially as there is someone, if after three years the feeling remains the same. I must tell you that she grates on the nerves of some of my friends on account of her way of echoing all I say as original. And I am sometimes surprised myself at having my words of wisdom returned to me from her mouth. Then she has courage, she called on Degas! He received her very politely, but she told him she was going to write about me. She said nothing about her intentions about him."

When it was a man, she was kinder. One young painter, Carroll Tyson, became a good friend, asked down to Beaufresne—partly because Philadelphia was their mutual bugaboo. She could unburden herself: "I have been thinking of you . . . and your efforts, your future efforts to obtain recognition," she wrote him from the country on July 11, 1904. "Where the real trouble lies I think is in not having a good intelligent dealer in Philadelphia. If there is such a man, he must be a recent acquisition. In these days of commercial supremacy artists need a 'middle man,' one who can explain the merits of a picture or etching, 'work of art' in fact, to a possible buyer. If an intelligent young man with some knowledge, some enthusiasm, and a good deal of tact, would arrive in Philadelphia he would do much to create a race of buyers. If I had the doing of it my shop would be near the commercial element, and I would turn my back on the society side, for in that set pictures are bought mostly from motives of vanity. Once a cousin (N.Y.) said to a member of my family that she much regretted not being rich enough to buy pictures— she had $70,000. a year! Let the dealer take for motto Degas' answer to Vibert [a society painter] anent pictures being articles of luxury. 'Yours may be, *ours* are of first necessity.' You will think me absurd, perhaps, but the question interests me above others, and I half wish myself young again to take part in the battle. If a man like Vollard for instance was in Philadelphia, your friend . . . would have sold pictures ere this."

To this same young man she expressed her deep feeling for the person on whom she had poured collecting advice. "I have already announced your visit to my friend Mrs. Havemeyer," she wrote Tyson on January 23, 1905. "Do go and see this collection, take a friend with you, an artist. If she is there herself I think you will doubly enjoy your visit and you will find one woman in America who loves art and knows what it means in a nation's life . . . I wish I could hear that you had a young and active dealer in Philadelphia," Mary fumes, "it might wake them up."

Her temper, always quick, was getting quicker. In spring of 1904 *Caress*—one of her better paintings of Reine, with two baby children— was awarded the Lippincott Prize of $300, at the Pennsylvania Academy's Seventy-Third Annual Exhibition, for the best figure painting in the show. The letter from the Managing Director, Harrison S. Morris, announcing the award and explaining that the Messrs. Durand-Ruel had already been notified, went on "we are most happy that it should have received this award, as denoting the honor paid to a distinguished artist who is also our fellow-townswoman."

His notifying Durand-Ruel first was one big mistake; another was the release of the news to the press before Mary had accepted the award. The Philadelphia *Inquirer*, among other papers, had already carried the story, beginning "Miss Mary Cassatt's picture 'Caress' has carried off the Walter Lippincott prize . . ." In the letter Mary wrote March 2 declining the award, in which she said it was "gratifying" to know her picture had been chosen, her temper nonetheless boiled up as it did every time Philadelphia was in question. "I was not aware Messrs. Durand-Ruel had sent a picture of mine," she snapped. She laid her refusal to her regular grounds; juries and awards went against Impressionist principles. "Liberty is the first good in this world and to escape the tyranny of a jury is worth fighting for," she informed Mr. Morris, adding, "I have no hopes of converting anyone. I even failed at getting the women students here to try the effect of freedom for one year," deploring America's "slavishly copying all the evils of the French system," and recommending that if awards must be given, they go to young and struggling artists.

Mr. Morris, replying on March 15, was more polite than ever: though "Our Board of Directors . . . sincerely regret that your well-established principles will not allow you to accept an honor which we desired to confer upon you in sincere admiration for your work, we nonetheless understand . . . We trust that you will always want to exhibit your interesting and distinguished work in the Annual Exhibitions of this Academy . . ." In his letter of the same day to Durand-Ruel he mentioned transferring *Caress* to the Washington Society of Artists at Durand-Ruel's request; "That the picture was appreciated here and therefore your generous

courtesy," poor Mr. Morris concludes, "is made evident by the honor with which its painter was crowned." Angels could do no more.

The Philadelphia Academy, nothing daunted, invited her to serve the following summer on the jury for its Hundredth Anniversary Exhibition—it was as if they had failed to read her letter. This time Mary was even more curt: "That is entirely against my principles. I would never be able to forgive myself if through my means any pictures were refused . . . I know too well what that means to a young painter and then why should my judgment be taken? Or anyone else's for that matter in the hasty way in which pictures are judged . . . I abominate the system and think entire liberty the only way." In candor she adds, "I did allow my name to be used on the jury of the Carnegie Institute but it was only because Whistler suggested it and it was well understood I was never to serve, and I hoped I might be useful in urging the Institute to buy some really fine old Masters to create a standard. In this hope," she adds tartly, "I was naturally disappointed."

It is worth observing how the Philadelphia Academy took it. Mr. Morris's letter in return—quite conceding the validity of Mary's strictures, though "in civic government there seems to be no substitute for the Jury and I suppose while human nature remains as it is we must submit"— goes on to urge her to send anything she might "consider the most important picture of [her] career" to its Centennial; even though the Academy could of course "secure an adequate example from Messrs. Durand-Ruel as we have done year by year . . . it would be an intense satisfaction if you would point out what you most desire us to have." "I trust you will feel like being with us in this signal event in our history," the letter concludes, "which to you as a Philadelphian bears peculiarly fit relation . . ."

Mary's vehement negatives were ever on matters of principle; when it was a question of personal generosity, she almost always agreed. It was almost as if she had no ego—but she did; for who was it that cared so about success? Who feared the ocean? In spite of that dread, she actually considered going to America for the opening of the Seventeenth Annual Exhibition of the Art Institute of Chicago, in which she would be represented by a group of studies of children. Why she didn't go, is made clear in a November 11, 1904, letter to her niece Minnie, Robbie Cassatt's wife, whom Mary wrote to congratulate on the birth of a new Alexander Johnston Cassatt on November 5: "I had half a mind to go over this autumn for a month, but the journey frightened me and I hope you will bring the baby over here before long. If you don't, I shall have to risk it and go over."

Her pictures were highly praised in the Chicago press. "Really ex-

traordinary," said the *Tribune*, "tenderly considered . . ." The Chicago *Inter-Ocean* observed that Mary Cassatt had been "styled 'the painter of the modern Madonna.'" In late November, Mary learned *Caress* had again been singled out, to win the Norman Wait Harris prize of $500. The letter announcing it came from William M. French, brother of the sculptor, Daniel Chester French, and the Art Institute's director. Replying on December 6, Mary again hewed to the main line: "The pictures belong to Messrs. Durand-Ruel, and were loaned by them under the proviso that they were not to be in competition for any awards. I was one of the original 'Independents' who founded a society where there was to be no jury, no medals, no awards. This was in protest against the government salon, and amongst the artists were Monet, Degas, Pissarro, Mme. Morisot, Sisley, and I. This was in 1879, and since then we none of us have sent to any official exhibition and have stuck to the original tenets. You see therefore that it is impossible for me to accept what has been so flatteringly offered to me. In Philadelphia last year," she cannot resist adding, "the same honor was offered me, but that also was on account of an error of the Durand-Ruels'. Of course unless you had lived in Paris and seen the ill effects of official exhibitions," she allows, "you can hardly understand how strongly we felt . . . I think money prizes so much more sensible than medals, but not in case of painters practising their profession with a fair measure of success for long years. I think such prizes should be awarded to young artists or students." It was the closest she ever came to questioning her principles. Certainly when she was first called to the Impressionist colors, she too had been classifiable as a young artist; moreover in Chicago there was no such thing as a government salon. With far more warmth than she had showed Philadelphia she ended her letter, "I wish we could talk it over together. I feel sure we would agree . . . Do believe though that I feel very highly honored."

Did she realize what a formidable figure she presented? Mr. French took her at her word, and did award the prize to a young artist: Alan Philbrick, a cum laude graduate of the Art Institute's school, who had taught there after graduation and was at the moment in France on a traveling scholarship. The five hundred dollars meant that the young man would be able to stay in Paris a whole year more. He made his manners, calling on his benefactor in the rue de Marignan, where she found him to have, so she wrote Mr. French, "the makings of an artist in him." Philbrick's impression of the apartment was different from the Victorian one of most other guests. "Not formal but colorful," he told F. A. Sweet, "full of glitter with lots of Japanese things."

As for his hostess, "I was scared to death of her . . . A fiery and peppery lady, a very vivid, determined personality, positive in her opin-

ions." Philbrick had the feeling that they lived in two different worlds—she so entrenched, he and his fellow students living so differently, so freely. He saw, in short, her formidable side; a mixture of Philadelphianism and the irascible artistic personality she had acquired from "being" Degas all those years. It was a pity. The personality that scared him to death had been contrived, over the years, to meet old, vanished situations; people he knew nothing of. If Mary, aware "what it means to a young painter," to receive encouragement, had herself met when young with a comparable pepperiness, she would undoubtedly have been wounded, though with fertile results.

Now that she had Beaufresne, only in principles was she principally an artist. In them, she was more artist than the Impressionists, who, for all she boasted of their solidarity, often lacked her scruples about sticking "to the original tenets." Her integrity, stronger even than her longing for recognition, was never displayed more characteristically than in the matter of the Harrisburg murals. Mary had entered an American competition to decorate the new Pennsylvania state capitol building, completed in 1905. Large sums of money were being spent to make it the finest public building of its kind not only in architecture but art and decoration. Mary had already executed two tondo compositions of mothers and children before she got wind of the political graft rife throughout the whole project. Shady gentlemen with conflicts of interests were involved in its every aspect. Without a moment's hesitation (no art for art's sake here) Mary withdrew from the competition, breaking off all communications. These murals, unlike the Chicago ones, survive in private collections.

She cared deeply about surviving, too; yet in a February letter of what was probably 1910, she told Mrs. Havemeyer about an offer that offical art experts had made to a dealer, for a picture of hers "for the Luxembourg, at a very low price, and promising it a prominent place, & the Louvre after my death! How do they know? Do they think all the pictures in the Luxembourg will go to the Louvre, everyone now promises me [Mary rushes on in her usual unpunctuated way] that I will survive. I'd as leave survive in your gallery, *there* I would be surrounded with pictures that are sure to survive."

Toward the end of 1904 she had received an official accolade, from a source at whose hands she could accept it, when she was made a Chevalier of the Légion d'Honneur. It meant more to her than she cared to show. In the same letter to Carroll Tyson that recommended him to Mrs. Havemeyer, she once more talks high-mindedly. Thanking him for writing about the award, she adds, "It was very gratifying to get the ribbon, for there had been difficulties and my friends had some trouble; especially is it hard to get the honor awarded to a woman. Perhaps it will

help me to a little influence with Museum Directors at home, to get them to acquire genuine old masters, and *educational* ones."

She was right; the award meant much more in America than France. Monet actually refused the ribbon, Renoir accepted it only with misgivings. Degas considered it should be reserved for soldiers, as Napoleon I intended. Even Clemenceau—two years later Premier of France—remarked to Mary he didn't need to see the ribbon to know she was a great painter. The *American Art News*, on the other hand, was impressed, citing the French Minister of Fine Arts, and the Director of Fine Arts, M. Marcel, as having been "enthusiastic admirers" in Mary's cause. The ribbon, moreover, was what made the Paris Art League, closely related to the American colony, appoint her its honorary vice-president.

In Mrs. Havemeyer's account she describes how "when the red ribbon was conferred upon her, she wore it for a year, after that I did not see it for a long time and I asked her the reason.

" 'Oh,' she said, 'it is etiquette to wear it for a year.' "

That natural pride in it did exist, is revealed when Mrs. Havemeyer relates how Mary told her later, " 'M.M. asked me to paint a picture for the Petit Palais, saying the Government would surely give me the red ribbon if I did, did you ever hear of such a thing, my dear?'

" 'What did you answer?' I asked.

" 'Why, I told him I had had the red ribbon for several years and he appeared much embarrassed.' "

Ironically enough, in the archives of the Légion d'Honneur in Paris, all trace has been lost of what the citation for the award said about the woman it honored. It is a sad little commentary on official recognitions that, with all the honors Mary Cassatt proudly rejected, this praise she did accept is irrecoverable.

THIRTEEN

THE 1903 LETTER to Theodate Pope that mentioned "looking in" was on the subject of bereavement and how to endure it. Since her fall, Mary had learned much about pain. Of Mary Hillard—sister of the dead John and headmistress of the Westover School that Theodate founded—Mary said: "What a comfort you have in being able to speak of your loss together you perhaps don't realize. Oh! if you could only know what it is like to be quite alone in one's sorrow, it would lighten yours to think that, at least, is spared to you . . . I do wish I could . . . cry with you too, I used to think I could never weep again, but I do when I see others suffer as I did . . . Poor Pissarro has just fallen victim to a mistaken diagnosis of his disease, and I feel sad over his loss, I had known him for so many years, and at one time we saw so much of each other . . ."

On December 4, 1907, Henry Havemeyer died. Mrs. Havemeyer's account of Mary Cassatt recalls, "In my hour of grief a cable was handed to me from [Mary] and I read the touching message, 'I too mourn a friend.'" The conventional phraseology cannot conceal the real suffering felt, the real sympathy given. Mary had been bereft the autumn before, too, of her brother Aleck, who died of an adult's virulent case of whooping cough, supposed today by Gardner's children to have been their unhappy gift to him; by his granddaughters Lois and Cissy, to be theirs. Mourning Aleck did nothing to heal the breach between Mary Cassatt and Aleck's widow, but it and the other deaths still on the way brought Mary and Louisine ever closer. Letters flew back and forth sometimes daily, dealing not only with grief, but with art-collecting, and with woman's suffrage in which, her husband once dead, Louisine became deeply involved.

One of Louisine's flights of description, in the account of Mary, shows the artist in Paris in these years:

> Although Miss Cassatt's taste was for a quiet life, she often entertained in her apartment . . . Her evenings "at home" were attended by . . . diplomats, painters, critics, and writers. Her brilliant mind was like a crystal with many facets. She [would discuss] the Boer War with her friend the special envoy; the destiny of museums . . . with the Directors and leading critics of the day; or realism in literature with some young god of Parnassus. Her luncheons were delightful. I remember one where church and state met at the time of the

"separation" [between 1903 and 1905, when the religious congrega-
tions were expelled] and it took a Clemenceau to calm the resulting
agitation.

After one of her dinners, you would find her spell-binding an ad-
miring group of guests, herself a striking personality, beautifully
gowned (usually in gray, always high at the neck) her hair parted
and waved on either side of a broad forehead, and large eyes whose
glance came frankly to meet yours, a wonderfully flexible mouth and
a nose like Garrick's, remarkable in its modelling and with those
sensitive flaring nostrils which I always said made her an artist in spite
of herself. Miss Cassatt's tall figure, which she inherited from her
father, had distinction and elegance and there was no trace of artistic
negligence or carelessness which some painters affect. Once having
seen her, you could never forget her, from her remarkably small foot to
the plumed hat with its inevitable tip, upon her head, and the Brus-
sels lace veil without which she was never seen. She spoke with energy
and you would as soon forget her remarks . . . as to forget the motion
of her hands. Not even to a Spaniard need she yield anything in the
matter of gesture or expressiveness.

"I give myself out too much," she said to me one evening as we
drove home from a dinner and she became conscious of her fatigue;
yet her endurance was marvellous. I have seen her entertain a large
house party until two in the morning, and be ready for another busy
day after only a few hours' rest.

With windows both on the rue Marignan and on rue François
Premier . . . all cheerful and light and . . . an excellent exposure for
painting, how well I recall that little room she used as a studio! It was
not half as large as the studio at Beaufresne, and tiny in comparison
to the glass gallery where she worked in Grasse [where in 1907 Mary
began to go for the winter, renting Villa Angeletto from the Harjes
family of banking fame; showing that, after Aleck's death, she did be-
come more than comfortably off] but many and many a pastel was
done there and [the closet] was full of canvasses of pictures that were
never finished, portraits she kept for herself, sketches for composi-
tions, or studies for children. It was a simple room and without any
"artistique" effects. She selected it because it had a good light and it
contained little furniture but her easels and a few fine Empire and
Louis XVI chairs . . . familiar to anyone who knows her work . . .

I recall her drawing room and the tender green of the soft silk cur-
tains, the rich brocades she had collected when in Italy or Spain.
Several Degas, and a still life of Cézanne, were upon the walls and a
gesso of Donatello was on an easel in the corner.

How many pictures of [the Havemeyer collection] at one time or another were placed in the salon or hall, waiting to be sent to America, or to be seen and passed upon by friends and critics! Goyas and Grecos, Courbets and Degas, Ingres and Chardin, all went to the rue Marignan, where Miss Cassatt could see and pass judgment on them. In the dining-room was a little cabinet of exquisite silver, and a fine Courbet on the wall. Wonderful times we had in that dining-room, true symposiums of intellectual refinement . . . free from any taint of bohemianism.

It was in the rue Marignan that Miss Cassatt developed her remarkable capacity for work. She inherited her energy from her mother, but its application to her work was all her own. I remember she said to me one day, "Why do these young girls come to me for advice? They have not the slightest notion of giving to art the devotion it requires. I say to them, 'Do you ever go to the Louvre and copy some of the great masters?' and they invariably answer, 'Oh, no, we can't, we are working in a studio, we have no time.'

" 'But Degas does,' I answer . . . What good does it do to talk to them? They will never arrive. Madame Morisot was right when she said that a young student should go to some provincial town, where there are a few good pictures, and avoid the distractions and the snares of the studios of Paris." Miss Cassatt was silent a moment and then continued, "I went to Seville when I was a young girl. It was horrid! and I was alone but I braved it out for a year. Then I felt I needed Correggio and I went to Parma . . . I stayed there for two years, lonely as it was. I had my work and the few friends I made. I was so tired when my day was done that I had little desire for pleasure. Even now I work eight hours a day and afterward take my walk with Mathilde, and in the evenings after reading a little, I am quite ready to go to bed . . .

"I doubt if you know the effort it is to paint! the concentration it requires to compose your pictures, the difficulty of posing the models, of choosing the color scheme, of expressing the sentiment and telling your story [or so Louisine recalled Mary's putting it]! The trying and trying again and again and oh, the failures, when you have to begin all over again! The long months spent in effort upon effort, making sketch after sketch. Oh, my dear! None but those who have painted a picture know what it costs in time and strength.

"After a time you get keyed up and it 'goes,' you paint quickly and do more in a few weeks than in the preceding weary months. When I am *en train* nothing can stop me and it seems easy to paint, but I know very well it is the result of my previous efforts . . ."

Miss Cassatt always deplored the invasion of the French studios by Americans, who were lured to Paris . . . thinking that a disposition for art means a talent for art, and who were sure to fail after years of useless labor, or be lost in the contamination of the Latin Quarter. "How much better for them to find something to do at home," she would say . . . "I have worked for forty years and I feel I need forty more—few have the courage to stand the strain."

Even allowing for Louisine's crush on Mary, she gives a picture of a woman secure and confident in her achievement. What unsettled the magnificent whole, lay in the nature of the achievement: art, that came to Mary so long ago as a solution to insoluble problems. In her new, independent life—for all her hard work, and no matter what Degas said about will—she found talent not subject to her will. With all her prestige, all her affluence, that she was looking for something more is suggested by her intense interest in spiritualism after the deaths of people she had loved and was, unaware, dependent upon. Her conviction grew that they were still somewhere, to be reached if only one found the right medium of communication. This concern of Mary's and others for the occult runs parallel to the impulse that sent the first of Freud's patients to him, looking in a different direction for a relationship with the forces that govern the universe and finding it in an equally mysterious realm, the unconscious. Not only imaginative women were interested in spiritualism, but adventurous men, including William James. It did not appear to them fanciful; it appeared as a possible proof of their strongest convictions.

Mary's interest in spiritualism is expressed as early as April 21, 1903, in a letter to Theodate Pope, who was traveling in Europe with Miss Hillard, giving the address of a Paris medium, a Mme. Ley Fontvielle, 26 avenue d'Eylau. "If you think it would help . . . to have me with you, I will go with pleasure," she wrote. "We owe it to the [Society for Psychical Research]. I long to know what your experience will be." It was probably not this medium Mary had referred to in a May 19 letter: "Do let me know that . . . you are enjoying the medium. [My] experience was curious, in as much as it consisted of prophecies, but the oddest part was, that no sooner did she go off than she remembered all about the last seance, then months ago, and which she certainly in the natural course of things would not have recalled . . . This accords with the theory of the perfect memory of the 'subliminal self.' I told her you had had a complete failure, and she said different things, but . . . she said that she was perfectly willing to have me interpret for Miss Hillard."

Before Theodate sailed for home she sent Mary F. W. H. Myers' *Human Personality and Its Survival of Bodily Death.* "What a book!"

Mary wrote in October. "I simply am overcome . . ." In her November letter, after John Hillard's death ("Your bereavement is a great shock") Mary tells Theodate that when in the evening, at Beaufresne, she sits "all alone, I read Myers' book. The more I read the more I admire, and the more I hope. I wonder if you have seen Hodgson and Mrs. Piper [American mediums]. I think I would if I were you. Myers would approve of that for you." Theodate did follow her advice, for in a later letter Mary wonders how the séance with Mrs. Piper has gone. In the letter about John Hillard's death she had cried, "Oh! We must not lose faith, the faith that life is going on though we cannot see it, you may some time have a convincing proof, just because he has gone before, I mean this for us both. I do so hope you may . . . What a consolation for those who have had it."

Another woman friend, Mrs. Montgomery Sears, was with her daughter Helen in Paris in 1906 and 1907, where she lived at 1, Place d'Alma, in comparable dignity if lesser area than in her Boston mansion opposite the Public Gardens. Every other Thursday evening Mrs. Sears held a séance, directed by a highly thought-of medium, Mme. de Thèbes (whether she borrowed her name from ancient Egypt, with its spirits of the departed, is not known) who wore flowing robes and a black veil over her head. Participants might include several of the cream of the spiritual cream: Sir Oliver Lodge, the American Poultney Bigelow, Ernest Schelling and his wife Lucy Draper, or William James himself.

Some of the participants also held séances in their lesser dwellings, to one of which Mary refers in a letter of May 27, 1909, to Electra Havemeyer—Louisine's daughter who had recently married J. Watson Webb. The excerpt that is quoted is part of a single paragraph in which Mary also discusses picture dealers and a pamphlet on vivisection, all in one breath.

"I will read [the pamphlet] but all the same I am for psychics," she declared. "I dined with Mrs. Schelling Friday evening and did not get away before twelve o'clock . . . because of our weird experiences. The family who are experimenting were there and we sat around a table which rose four feet off the floor *twice*. Do you remember Mr. Stillman asking if there was a woman in Europe who could make that table rise off the ground? Well, it rose. They, the group, say that was nothing. They had seen a table more than once rise above their heads and hang suspended for *more than a minute in the air*. It was intensely interesting to hear of their experience. They are relatives of . . . Mrs. Mellon, my friend and country neighbor, and the things the mother told me were thrilling. They think the religion of the Egyptians and Greeks was founded on certain things of this kind and now we are rediscovering them through a scientific road. Oh! You young ones may see things we have never dreamed of. I know you have a steady brain and . . . understand that we are on this

planet to learn. I think it very stimulating to believe that here is only one step in our progress."

What she looked for in the beyond, is reflected in Mary's continued urge to conquer her worst enemy, the sea. Letters to Theodate reveal her, feeling her way: "I wonder if I shall be able to screw my courage up to cross this month and see your place? How did you all bear the journey [to Europe, from which Theodate with her mother and Miss Hillard had just returned] did the ship behave as well as it did coming out, and was Mrs. Pope as good a sailor? All these questions are in view of my trying it." In 1904 when Mary was contemplating the Chicago show, she wrote, "Mrs. Pope's account of the *Cymric* was so encouraging I can almost make up my mind to cross that awful Ocean to see my friends this winter, just for the two or three weeks when work is done here, on the *Cymric*." In the fall of 1908, she finally took the plunge and crossed, in order to spend Christmas with her brother Gardner and his family, now that Aleck was two years gone.

Gardner was the last living representative not merely of Mary's family, but of the brothers who had done so much, in her childhood, to set that pattern of courage which she had taken on—the personification of her masculine side. If Gardner was not as close to her as Aleck, he was more like her when it came to horses—the family preoccupation down to the present day. As Mrs. Thayer says, "Cassatts loved horses in every way— romantically, ideally, practically." Aleck had assumed the approved horse- man's view of horses, as dumb brutes; Mary and Gardner were more the sugar-feeding type. Once after Mary sent one of her horses to be de- stroyed for some incurable ill, she and Gardner, walking along a street in Paris, saw the same horse drawing a cab; Mary's groom had sold it to the cabbie instead of taking it to the knacker. Their horror was shared; after- ward Mary fired the groom. In going to America in 1908, Mary also had it at heart to visit Louisine, to support her on the anniversary of Henry Have- meyer's death; and she hoped to go on with friendships made in Paris with such artistic personalities as Philadelphia afforded, like Carroll Tyson and the painter Adolphe Borie, who had spent 1907 abroad.

In the battle with the ocean, Mary lost again. She had to be carried off the ship when it reached New York, and spent weeks in bed at Mrs. Havemeyer's, recuperating; her object in being there, however, attained when the sad date of December 4 came around. By the eighteenth of December she was at Gardner's house on Philadelphia's Spruce Street. From that address she wrote Tyson, who had asked her to visit his studio while in Philadelphia, to explain why she failed to keep an earlier engage- ment to meet him at Mrs. Havemeyer's: because of a horse accident once again after all these years, like a harbinger of impending disaster. The

horses drawing the carriage she was in had fallen, "and were with diffi-
culty gotten on their feet again, then we walked to a place some distance,
and sent for an auto-taxi, which broke down several times and had to be
abandoned, and we walked home; but you had left by that time. I fear the
present storm, which I would welcome were it in France, will make the
streets rather difficult," she continued, for the first time sounding elderly;
she was in fact sixty-four. "You may be sure however that I will do my
best to get to your studio."

While Mary was at Gardner's, friends from her youth came to call on
account of old friendship—quite oblivious of her achievement, her fame.
A surviving member of the household at Spruce Street, Mrs. Percy
Madeira, retains the impression that not only Philadelphia failed to appre-
ciate Mary, but America; and that she was much better appreciated in
England. (However, in 1971 the Tate Gallery knew Mary Cassatt only by
reputation, the Corthauld Gallery, specializing in Impressionism, had not
a single example of her work, any more than did the National Gallery. To
find a Cassatt in the British Isles required a trip to Glasgow and Manches-
ter. For Britain, an old pun about Mary rings true: "Qu'est-ce que c'est
que ça?")

Gardner Cassatt gave at least one whole-hog Philadelphia dinner
party for Mary while she was there, complete with "turning the table"—
the hostess switching the conversation from side to side with the regularity
of a chronometer. In order that Mary might gratify a lifelong wish to meet
an African big-game hunter, one night Percy Madeira, father of Eugenia's
future husband, was the lion. Mary loved it. She sat spellbound by his
stories, and it was like her to decline to leave the table when the ladies
withdrew, in order to go on listening. As ever she dilated, she glowed,
imagining the risks and triumphs of a dangerous life.

Part of Mary's visit was spent at the fifty-three-room house that
Gardner had, the previous year, decreed at Daylesford, near Berwyn. It was
named Kelso, after Old Kelso—one of the country houses Mary remem-
bered from her childhood, when Robert Cassatt was moving the family
about from house to house. While there, the imposing Miss Cassatt was
chided by the farmer's wife for daring to come into the spring house with
her shoes on; such unawed directness was exactly what Mary relished,
when it did not threaten her. Her stay in the Pennsylvania country was a
great success; it brought back her childhood in its happy aspects. She did
not, however, enjoy it so much as not to make a firm vow, which she kept,
never to cross the Atlantic again.

Back in France, she still retained one American impression in No-
vember a year later when she wrote to Carroll Tyson: "I am very glad to
know that you have been working this summer and am interested in your

work. It must be the best time at home to work. I confess I was so disap-
pointed at the light in winter when I was there. The houses too are so
dark, it affected my spirits. I was so glad to get back to my *cinquième*
[fifth floor] where I have the sky to look at. I don't think we [Americans]
have made the best use of our material and if I were obliged to live in
America I would always live in the country. Fine pictures are going over
[to America] fast, and soon there will be little left in private collections
on this side. I wish more of the pictures were for the public, but that is the
people's fault. They ought to insist on the galleries buying good things."
Museums, too, ought to acquire only major pictures, she often asserted;
not forever play it safe. While staying with Louisine in New York she had
gone so far, in her antipathy to museum ways, as to advise the Havemeyer
family against giving their collection to the Metropolitan. Its standards of
taste, she said, were too low.

The same contempt for the official made her earlier that year decline
to accept election as an associate member of the National Academy of
Design, the ranking American artistic body. She explained once more that
her principles would not permit affiliation with an organization which
made awards to specific pictures or whose exhibitions were juried. Not un-
til 1914, when the Pennsylvania Academy—to whom she had just given
two first-rate Courbets—presented her with their Gold Medal of Honor, did
she say Yes to such an honor, and by that time she was blind; besides, she
said in her letter, there was no money attached to the medal, and it was
not for a specific painting.

Her spiritualistic friend Mrs. Sears, who was an amateur painter, was
also a collector of art. She had not only bought several Cassatts but called
on the artist for her invaluable advice on collecting. To that kind of in-
vitation Mary never said No. In return, Mary accepted advice on the spirits
and faith-healing, which she passed on to the bereaved Louisine; on Jan-
uary 14, 1909, after reaching home from America, she wrote her: "Here
I am once more after, as I learned from [the papers] a very stormy passage.
I don't agree, we had one storm, and a ground swell on approaching
Plymouth, and the *America* is a roller, seizes, it seems to me, every op-
portunity to roll . . . I wish you were here, the change might help you. I
have seen Mrs. Sears, she thinks it likely you have had no relief from Mrs.
Cross [a Cambridge, Mass., healer] as yet, it does not relieve at once, often
the reverse. What she thinks you ought to do is to go to Cambridge, take
your maid with you and go alone with her, and give Mrs. Cross a chance
for a week—if this [letter] finds you no better. Even if it does, do try
it, it is worth trying. Mrs. Sears looks as if she had been through a dark
valley [after the recent death of her husband] but it has left a beautiful
expression on her face, she says she often has despairing moments even

days yet, but she feels she is being helped. I could not bear to think of your sad face as we said goodbye and would give much to know you were cheerful once more . . ."

Another new friend who sought Mary's million-dollar advice on art was James Stillman the banker, who collected on a grander scale than Mrs. Sears, and whose mansion on the Parc Monceau outdid even the Commonwealth Avenue house. A different man from Degas can scarcely be imagined, yet Stillman was the only other man whose name was ever coupled with Mary Cassatt's. Surely it is a rare woman artist who receives, as gifts, and from Tiffany's, a jeweled collar and feeding bowls for her little dog! Mary was, if not Stillman's constant, then his frequent, companion; present-day Cassatts believe Stillman wanted to marry their maiden aunt. Nonsense, say present-day Stillmans. Whatever the truth, Mary was much attached to him, although it was quite in character that throughout their long friendship her attachment was expressed with as much irritation as affection. That dog collar had been, for instance, a frankly placatory gift.

Stillman knew all about anger. He himself had terrified many. A friend, who was sitting in Stillman's office when some errant underling was brought in, remembered Stillman "wearing his immovable expression and tapping [a pencil on his desk]. Without moving or raising his quiet voice . . . he berated the offender in terms so harsh, with an irony so . . . insulting, and concluded with such . . . savage intensity . . . that the unfortunate man trembled and the sweat stood out on his forehead."

Appalled, the friend took it upon himself to say, "A man has no right to treat another so, or to let himself go like that." The banker made no reply, his face was "a mask of rage." The friend, assuming their friendship was at an end, later wrote him a note saying though he knew it was none of his business, to his mind Stillman's tirade showed "dangerous nerve-strain and lack of rest."

He got no answer. Months passed. All at once he and his wife received an invitation to a reception at the Stillmans'. Though suspecting it had been sent through an error, they went, and were greeted cordially by Stillman, who said to the wife, "Tell your husband . . . that owing to something he said . . . I am . . . back from the best holiday I ever had." The friend concluded, "There were two James Stillmans. I knew them both." Between them, the two James Stillmans possessed qualities which—by the year 1909, when Stillman moved to Paris—sufficed the formidable personality who once had been an eager young woman leaning forward from Degas' portrait.

The wife of Stillman's son Ernest went so far as to compare him with an emperor. "I never knew the greatness of Napoleon until I saw his

tomb," she wrote in a memoir. "Nor did I realize the greatness of my father-in-law until . . . I entered the columned portal of the National City Bank . . . Standing in that mighty shrine . . . the cathedral hush, a pigmy under its vast ceiling, I wondered why I had never felt awe in his presence . . . He was such a little man. I had hardly to reach, to kiss his cheek." The road to that "shrine" led from countrified New England, whence Stillman's swashbuckling father had gone to Texas (people used to paste "G.T.T." on their New England doors when they went West) where, known as Don Carlos, he became very rich. Impending Civil War made the already dangerous life on the Rio Grande out of the question, once Don Carlos had two babies by his New England wife; he followed his nose for money to New York, shortly before war's outbreak. His son James, born back in 1850, left school at the age of sixteen, went into a business firm, and so eventually into the Presidency of the National City Bank of New York.

"It is interesting to recall that period, when a man's business was an article of religion, when his office was a church," writes the Stillman biographer, Anna Robeson Burr. Stillman—with J. P. Morgan, Moses Taylor, Edward H. Harriman, and Jacob Schiff—represented the more humane of the financial brains in a world that also contained Jay Gould and Jim Fiske. Stillman was richer than the dreams of avarice. By 1907, big business was beginning to lose its sacredness; tycoons were turning to penitential benefactions, rounds of golf on their private courses, sybaritic cruises on their private yachts. Stillman was a cut above that. Like Henry Havemeyer he was aware of another world, and, seeking it, he went to Paris. There he set about developing a whole new side to himself; unlike most of his kind abroad, for instance, he learned French. A large chart of the irregular verbs was hung just above his bathtub. Everything in Paris stimulated him, and art was an integral part of Paris.

His house there is, today, a monument to his way of life. Enormous, as magnificent as a prince's, it occupies the whole corner of the rues Rembrandt and Murillo. From his rear windows Stillman could look over the exquisite Parc Monceau; Anna Burr relates how he enjoyed watching the boys and girls playing along its paths because he "loved little children." A grandson of Stillman's, recalling that "Stillman in his later years was so forbidding, so reserved and chilly, that his own children must have been in awe of him," adds, "Out of fairness I can say that he was jocular and relaxed with his grandchildren." He quotes his own father's saying, "Miss Cassatt was the only person who dared tease Father," and comments, "Both he and Miss Cassatt must have been complex characters."

They were the more complex on account of their celibate situation. James Stillman was, it is true, married; however his wife had managed his

establishments in New York and Cornwall up the Hudson in a manner so far from perfection, that he took the authority away from her and gave it to a housekeeper; understandably enough, Mrs. Stillman left. After 1894 she never saw him again, although the apartment she moved to was not far from the Parc Monceau. Her taste for Paris, in fact, suggests his wife may have had more influence on the direction Stillman's perfectionism took than he knew. Perfectionism was part of the bond between Stillman and Mary Cassatt.

The memoir by Mrs. Ernest Stillman, who with her husband visited her father-in-law in 1911 as a bride, recalls it. "The 'cream of the world' was caught in that perfect house at 19, rue Rembrandt," she wrote. "We might have been in a Normandy château, our sylvan isolation seemed so complete . . . We led a lazy life . . . Mr. Stillman had to work all morning over his cables and did not join us till lunchtime. There was a large mirror in the ceiling of my bedroom and as I lay in the wide directoire bed, I could look at the ceiling and watch the gardener walking in the park below . . . [After an afternoon of shopping and sightseeing], long after we had gone to bed, Mr. Stillman would work . . . for although he was supposed to be retired . . . he could never be out of communication with New York. The bank . . . was on his mind day and night . . . He did leave his mail and cables and take us out of Paris . . . to Beaufresne, the home of Mary Cassatt . . . Much of her best work was done at Beaufresne, where the models were . . . peasant women and their children. Critics have sometimes objected to the homely faces of her women. But as Miss Cassatt wrote to me later when I sent her a picture of my first baby, 'Most mothers with nurses do not know how to hold their children.' This great painter of maternity wanted the rhythm of the constantly curving arm—the constantly bending back. She found it in those French women of the soil . . .

"Miss Cassatt herself was tall and gaunt, dressed in a shirt waist and a black skirt. But her strong face and her rapid, intelligent conversation gave me little time to notice externals . . . Miss Cassatt wanted to paint Mr. Stillman's portrait and I wish that he had given her the opportunity . . . Miss Cassatt was heart and soul a modern"—or so the young woman was given to understand. "She prevented Mr. Stillman from buying two heads of Greuze, with their pastoral sweetness; and when I mentioned the beauty of Mme. Vigée le Brun, she dismissed her with this comment: 'She painted herself.' . . .

"Mr. Stillman's great recreation was touring . . . in the big Mercedes . . . [He] sat in front beside Gramont, the chauffeur, directing the course of the car as he used to direct the passage of [his yacht] in and out of Newport Harbor." Mary, though often driven to distraction by Still-

man's extremely inaccurate direction, had also become addicted to the motor-car after Louisine presented her, in 1906, with a Renault landaulet, which she used for the rest of her life. The chauffeur was her former coachman, Pierre Lefebre, of the same family as Constant, whom Mary had got his job as butler for the Gardner Cassatts. Together Mary and Stillman indulged their hobby—sign of advanced ideas in those days, as well as of wealth—on trips especially around the South of France, during which Mary was as communicative as Stillman (like Henry Havemeyer) was silent.

Even the impressionable Mrs. Ernest Stillman does not fall victim to the illusions Louisine entertained about Mary's massive intellect. "Loveable, whimsical," she calls her, "violent in likes and dislikes, vehement and crotchety, quick tempered and soon over it, she was full of all sorts of fiery causes and beliefs . . . She found James Stillman's tranquility and steadfastness decidedly soothing . . . Sometimes his quiet self-control would irritate her; she would lose patience and refuse to see him; he would have to keep that smiling philosophical tolerance, send her [those presents from Tiffany's] and soon she was all smiles again . . . She threw herself with great zeal into his collecting plans, and . . . pursued his artistic education in her own fiery way . . . We find her summoning him imperiously to see some picture she thought he ought to buy."

Mary's influence did not stop at checking Stillman from buying Greuze. By fortifying him with her judgment she helped him to get rid of the aesthetic timidity which causes collectors to make as many mistakes as over-confidence does. Stillman bought Gainsboroughs, Ingres, Murillos, Rembrandts, Titians—pictures of which his great fortune was worthy; many other millionaires settled not only for the sentimental, but for the merely antiquarian. It was impossible for Stillman, given his nature, to throw caution entirely out of the window. He used to hang a picture on approval from a dealer's on his walls for days or even weeks, and consult a dozen or more experts on it, before letting go with the cash. Young Mrs. Stillman wrote, too, "Sometimes, Mary Cassatt said, she longed to shake him, for [a habit he had] of breaking off . . . and never going on. He never stopped protesting he wasn't a real collector, he didn't wish to be, because one was apt to get into it too deep."

Another, more curious object of Stillman's collecting instinct was women's clothes, which he purchased in large quantities from the most expensive Paris houses. It was not just that he was unusually interested in women's dress, as reflected in letters to his old mother which put to shame the observant eye of a society reporter. When he was presented at the Court of St. James's, for instance, the costume his daughter Elsie wore to accompany him is dwelt on with more care than anything else in the

ceremony. "Her gown [had] a train nearly four yards long. It is very beautiful and becoming to her. Worth . . . never made anything like the train before. The gown is soft white satin with silver embroidery, the train is a sort of mosquito netting with whole brilliants sown about on it about an inch apart, laid on a rather stiff, dull silvery material lined with a soft white satin with a border of Russian sable all around it, which shows the lines, and serves as a frame setting it off beautifully. It's really very magnificent but youthful and appropriate . . ." His idiosyncrasy reveals the germ, not of the collector, but of the artist in him: another bond between him and Mary.

"Afternoons often found him," writes F. A. Sweet, "in a large chamber of his house which he had transformed into a private fashion salon. Here he would sit for hours, rapt in contemplation of the latest creations of noted Parisian maisons. Worth was a favorite. Here the famous couturier brought for his inspection hats, gowns, and lingerie by the gross. These were paraded before his eyes by beautiful mannequins. While Stillman's purchases were extensive, the couturiers admired, too, his subtle sense of color. He once sighed, dreamily, that he would have liked to be a fashion designer."

The curiously feminine hobby is not, really, surprising to find in such an "aloof . . . powerful . . . saturnine . . . cold man." Mary's grueling work-habits, of a kind traditionally associated with men, were, in that painter of the tenderest of subjects, a counterpart. In both, the impression they made on the world was compensated by an opposite, suggesting a sort of androgyny embracing the whole of Plato's image. It was one reason, too, why Mary Cassatt could have fun with James Stillman. He was not the threat to her that Degas had been. With him she felt on balance, an equal. As far as sexual attraction was concerned, they were like a pair of heavenly twins, neither one interested in what they would have called "things of that sort."

Myths attach to Stillman today the way they do to Mary Cassatt. Perhaps the most curious concerns his mansion on the Parc Monceau. The present owner, a M. Pierre Louis Dreyfus who has been called the Onassis of France, states firmly that Stillman never lived in it, merely built it; that it was then at once, in 1914, taken over by the French Army for use as a hospital, and so used until 1919, when Stillman decided not to live in it. (The facts are, Stillman bought 19, rue Rembrandt ready-built in 1911, having occupied it for several years before that, and that he died in New York on March 15, 1918.)

Those masculine work-habits of Mary's are vividly recalled by her surviving niece, Eugenia. At Beaufresne, although her aunt would come in

to lunch with the others, she always went back after coffee on the glassed-in gallery to work for the rest of the day. Late in the afternoon there were walks with the little girls; any posing Ellen Mary or Eugenia did would have been in the morning. Eugenia never cared to be painted —hated to pose as much as Ellen Mary lent herself to it. There may be a connection between this intransigence, less agreeable to Mary in little girls than in little boys, and something Eugenia overheard her aunt say that, in a twelve-year-old memory, rankled: "She is as tall as I am, but I suppose she'll look all right when she grows up."

Even Eugenia recognized, however, that Mary was good with children. She never talked down to them, never "talked baby talk." The alert little girl's impression was, however, that Mary Cassatt only painted mothers with children because Mr. Degas had advised her to, that up to that time the subject had not been treated except religiously, and that she needed, to counteract the onus of being a woman painter, a specialty. In a letter to Mrs. Havemeyer of March 8, 1909, Mary bears out this impression of her feelings about painting children, very different from what sentimental admirers imagine. "I had several portraits to do," she says, "but it is not worth while to waste one's time over little children under three who are spoiled and *absolutely refuse* to allow themselves to be amused, and are very cross like most spoiled children. It is not a good age, too young and too old, for babies held in the arms pose very well." It is a good example of how a painter of children need not entertain the emotions of motherhood; had better not. She is painting them, not mothering them. It was children under three, in fact, that Mary in real life preferred. When they got to an age to talk back, like Eugenia, she was disgusted.

Mary's hard work *was* masculine in her day, because a lady did not work such long hours unless, in "reduced circumstances," she had to. Both having to, and reduced circumstances, seemed things to be ashamed of. Not until after the First World War would holding a job begin to have cachet; thus in still another detail Mary was ahead of her time. To work, constituted her self-respect. It was the incorporeal horse that could carry her out—out of herself, out of whatever it was inside, behind, that did not bear contemplating. Even now, as she moved into her late sixties, she did not succumb to the indolence and pleasure-seeking that held most women of her upbringing in a bondage men had long ago struggled out of. A few men, like Stillman in his touching reveries over the haute couture, were potentially raising indolence to a new level.

The only trouble with her work, for Mary, lay in the nature of art's principal characteristic: making something. In Beaufresne, or in shaping great collections, Mary had demonstrated she could create other things

besides pictures. This did not mean for a minute that she was ready to sacrifice painting. The sharp criticism she deals out to Edith Wharton in a letter to Louisine of November 24, 1906, was two-edged. "I have been urged to try 'The House of Mirth' . . ." she had said, "literally I could not read it, such an imitation of [Paul] Bourget, a writer I cannot endure, by the way, so a copy [wouldn't be likely] to please me. Those people aren't Americans, the heroine is just such a one as Bourget makes or rather the situations are. She tries James, for the character . . . Dear, dear. No Art! At home or here either." She was reflecting her own situation. She needed a new form, having exhausted the old. Just so Degas, after he went blind, felt around and found sculpture. For him and for Mary, the new form was adumbrated, hovered ambiguously, just outside their ordinary vision until it was grasped. Mary was living in the faith that the new thing would come as it had before—from the unexpected. Meanwhile like some cloistered nun she continued practicing the chastity, poverty, and obedience of work, meanwhile keeping a weather eye open for a sail on the horizon.

It was with the vague memory of the long-ago voyage that *was* a complete shift of scene, that Mary Cassatt agreed, in the fall of 1910, to go on a trip to Egypt with her brother Gardner and his family. It went against certain of her grains, among them indifference to all the arts of Egypt except, lately, the occult; and dread of the water, and of boats of whatever size. She was in addition opposed to the kind of luxury in which the Gardner Cassatts liked to travel. Of the dahabeah she had engaged, at Gardner's request, to take them up the Nile, she wrote on November 13, disapprovingly, to Louisine that it had six rooms and nine beds, and added, "I hope my brother will be satisfied." On the whole, however, it was more with hope than fear that she faced a trip on which in any case she would see strange sights, with her family, and take on her old enemy the sea in minuscule doses.

The letter about the dahabeah does confess, "I am beginning to tremble." On December 5, after the Cassatts got to Paris, she wrote to Louisine that she had "little time since the family has been staying here. They leave on Thursday . . . I hope to follow on Saturday night and join them in Munich. We go by Constantinople, and find there is a very good line of Roumanian boats which go . . . to Alexandria . . . We have been constantly at the dressmakers and milliners and so on since they have arrived, and have now about collected all the necessary clothing for Egypt . . . I am afraid the journey will be fatiguing. But no doubt we will see fine things and afterwards digest them," she adds doubtfully.

It was not, however, like Mary to quail. In the same letter she gets back in her usual positive vein writing about being at "the legation where

I went for a passport [in those days required only by Egypt and Russia]. Louie, they actually administered the 'iron oath' to me before giving me a passport. What are the suffragettes about, to submit to that?" The 'iron bound oath' refers to the oath of allegiance to the United States required of passport applicants; a provision of the citizenship law that in those days put a woman's American citizenship in jeopardy if she should marry a foreigner abroad was the part of the oath that got Mary's back up.

Just before the party left for Munich, James Stillman took them all out to Versailles for the day, and photographed them standing by the Grand Trianon. When Stillman next saw Mary she would be a much altered person; yet from Constantinople she was writing Theodate buoyantly: "I am so glad we came . . . It seems so odd not to be working all day but seeing sights and enjoying the young minds of my nieces." The letter goes on: "I am glad you will be in New York, seeing Mrs. Havemeyer often, I hope. She has had hard times, just think how much better if women knew all about the men's work. What we ought to fight for is equality, it would lead to more happiness to both. Of course with that great big heart of yours, you lean toward socialism. Up to the present time it don't work, then too I believe if we are to be led to that promised land of more equal rights it will be by a silent leader. There has been far too much talking and Roosevelt has been the sinner. I am not hard, at least I hope I am not, but I am an individualist and I'm of Gissing's [a contemporary novelist's] opinion. He said when he saw certain individuals he wondered the world did not move faster, but when he saw the crowd he wondered it ever moved at all . . . I am quite sure Henry James is a fine man," she said, going on with an argument, "and he has improved since he first wrote, then he was inclined to be society, but superior people soon get over that." No matter what aristocratic myths the Paris art world might entertain of Mary, there was no question how she herself felt. She had never "been society."

One clue to her high spirits comes at the end of the same letter. "We were so interested to hear, in Sophia, of the great longevity. Our Doctor, called in for a sore finger, declared that individuals of ages varying from 140 to 150 were scattered over the country and he knew personally a man, Jew, still retaining all his faculties at 135 years. Of course most people would not care to go nearly as long as that, but it is interesting to know some cases."

It was more than interesting; it was heartening. The forceful Mary made the entire party drive miles back into the countryside to a certain village where a man of great age lived—only to find when they got there that the man of great age was away. Still, the possibility that life could go

on, with undiminished faculties, for years and years, was encouraging as it only can be to those who have begun to feel that if they had their lives to live over, they could do better. Moreover, after so many deaths in the family, after so much sorrow and suffering, the time did seem ripe for a little pleasure.

PART V

The Egyptian Blow

FOURTEEN

THE STORY OF what happened on the trip to Egypt is painful no matter how it is told. Mary Cassatt's voice—sharp, rapid, unself-pitying, at times strident—tells best of its gradual transition from pleasure to horror, in letters home.

"Dearest Louie," she wrote to Mrs. Havemeyer on January 4, from the dahabeah *Hope* in Cairo, "Your letter of the 18th I received this afternoon, I am so glad I heard from you before we go on the Nile . . . We got here from Constantinople [and] found the [dahabeah] illuminated in our honor! Two days quarantine in Piraeus, in sight of Athens and not able to land, and another in Alexandria . . . enabled us to get here at 9.30; the illumination was very Opera Bouffe.

"This morning a young Egyptian we [met] on the boat came in his motor and whirled us out to the Pyramids and then to see the tree the Virgin Mary rested under when she fled to Egypt! and we drank from the well she drank from! The young man is of Syrian descent and a Catholic, very rich. Of course travelling with young girls we make more acquaintances. We met a number of Americans . . . in Constantinople. A Psychic lot, very interesting.

"My impressions here are rather mixed, I think we will have had enough in two months, and we will return to Europe content. It is something to have seen; I am, we all are[,] so glad we came . . . but one must not exaggerate, and I confess the Byzantine [in Constantinople] did not carry me away in the least; how could it, fed as I am in the French Gothic? And the Greek, indeed in some respects equal to it, is the Gothic . . .

"I really must be back in the beginning of March," she continued briskly, never paragraphing, "we think of sailing on the boat we came on, March 1st for Piraeus, taking afterwards the boat to [she must mean from] Athens. It seems a pity to miss Greece; I don't think I will ever come again . . . I must tell you about our visit to the Harem, but I think I [must not?] write about that. We crossed with the head of the Bible Society in the East, really women have been slaves and perhaps still are, why don't we improve?" demanded Mary from the land associated in the Judeo-Christian mind with bondage.

As the dahabeah moved off, Mary wrote Minnie, her nephew Robbie's wife, "Here we are, going up the Nile in a most comfortable boat, and you,

I suppose, enjoying snowstorms in Philadelphia . . . We have just passed a camel pumping, or rather turning a crank, with palm trees for a background. Of course you know all this, but if ever Rob wants a thorough rest and change, bring him up the Nile. I cannot imagine anyone not benefiting from it, such air.

"Your Uncle Gard, poor man, has an attack of hives, and is unfortunately in bed, but we got a little Egyptian doctor on board yesterday who prescribed, and promises a cure for tomorrow. I hope he will soon be up here on deck, we are being towed to Luxor and Asswan. All the party are well, your Aunt Jennie looking so well, and Eugenia now reconciled to travels abroad, although looking forward to boarding-school next winter. This is a great change for me. I can hardly believe I am sitting on the deck of a dahabeah, writing to you . . . We had a good deal of suffering on our way from Constantinople but I was not as seasick as usual. If only, as Mathilde says, we could cross to America this way!"

Iris Origo in *Images and Shadows* recalls a contemporaneous trip of her childhood, and makes it come to life in words as visual-minded Mary could not:

"A sailing dahabeah knocks a steamer into a cocked hat. A tug is necessary, one only makes 2½ to 3½ miles *with* it, against this current, but the motion is delicious—you don't perceive that you are moving . . . The charm of the Nile is . . . great." Her parents' dahabeah passed, "along the shore . . . a band of some fifty yards of cultivated land of the emerald green of Egypt, and beyond was the desert—still, majestic, lonely . . . a landscape of tawny rocks and shimmering sand." Miss Origo recalls "the low monotonous chant of the Nubian ship boys, rowing out to us with the provisions and the mail. The boat would bump against the ship's side— a grinning white-turbanned figure would bring me a bunch of bananas— and then, as the midday breeze sprang up, the river would be studded with little white or orange sails. Close beside our ship a woman was bending down to fill her water-jar, and further off a group of fuzzy-headed Bishareen children were dancing like small black devils around a blind beggar."

At night "the sky changed to gold and green and . . . then a lean, dog-like shape was suddenly outlined against the sky, the first jackal's shrill yelp broke the stillness, and it was time to say good-night . . . I was carried below to fall asleep to the sound of . . . singing and of the Nile lapping against our keel." A friend of her father's, when he was dying there beside "the shining river, the palms and the desert, the sense of isolation which fell with the night, the calls of the jackals and wolves . . . [which] appealed to him . . . liked to feel the touch of adventure which . . . supports a true traveller."

Mary, who merely longed to be a true traveler, wrote Louisine on January 17 from the *Hope,* above Luxor, "It is a pleasure to be able to write you once more. Yours of the 28th we got today at Luxor. We have been detained by my brother's having a severe attack . . . which lasted three days and necessitated visits from two doctors, one a native, and one a young man from Vermont brought over by a rich Copt to attend to his employees on a great estate. We are distinctly disappointed in the climate, and to tell the truth, thus far in what we have seen. This morning the Temple of Luxor, fine of course; last night Karnak by moonlight. I was so provoked at seeing the ruins first by moonlight [there spoke the painter —after visual clarity, not misty sentiment] . . . We know Egyptian Art without coming here, and the Temples can teach us little more. The greatest, it seems, is beyond Asswan, between there and the second cataract, it is a rock temple. Mr. Th. Davis told us this this morning at an Antiquarium in Luxor, where we met a party of Americans . . . We are very comfortable and well in this boat, but my sister-in-law declared that were she forced to spend three months on the Nile she would grow melancholy. I feel well, but haven't grown fatter as I hoped, I am beginning to dry up, as the Empress [Eugénie] says she is, only she is 85 [Mary Cassatt was sixty-seven]. You say no word of any possible visit to Paris in the spring. I hope to be there again in March. It will seem good to get to work once more . . . Just at present I don't feel very enthusiastic over the ever-recurring Egyptian type. The reliefs we saw this morning are very fine, but I saw an Egyptian head at Rodin's [Paris studio], small and of much greater beauty.

"I think my nieces are enjoying this, the youngest [Eugenia] has so changed, grown fat and looks very well. She was far from strong when she came over."

Also at Luxor that winter was Miss Anna Ingersoll of Philadelphia, accompanied by other members of that Old Philadelphia family. Could they have been the "party of Americans" Mary met at the Antiquarium? It was just the way she would have dismissed them. Miss Ingersoll later described how, to her side, the Cassatt party appeared: "She was with her brother Gardner, his wife, and daughters. We were travelling in plebeian fashion with a [Thomas] Cook boat, and were so glad we had not taken a private dahabeah as they had, when we saw how everyone who had one got on each other's nerves, and was bored. Mr. Cassatt was [sick] which did not add to the cheer of the party . . . I remember our surprise that Miss Cassatt seemed quite uninterested in the scenery, temples, and 'art' that we loved so, and could only talk of the charming little boy who had driven her donkey." Actually, Mary no doubt saw, in her mind's eye, just how she would paint him. At this point Egyptian art left her unmoved.

"Dearest Louie," she wrote on January 20 from the *Hope* at Asswan,

"We arrived here this evening, and our first visit was to the P.O., and your letter of the 1st I have just read. Tomorrow I will send you a cable, what news! . . . [Mrs. Havemeyer's son Horace had just become engaged.] One so wants the young ones to be happy, and yet happiness is rare, isn't it? My nephew and his wife seem to be in every way suited to each other, the only cloud I can see is her health. She isn't strong. Ah! my dear, these dreams of others, uniting the young, are nonsense. I am sure Horace and Ellen Mary would not have pleased each other if they had met [an old hope the two friends had indulged in]. Ellen is charming, in my opinion, but not in the beauty class, more charm than line; and Horace likes the classic. She, Ellen, is brimming over with fun, and I doubt she will marry early," continued the adoring aunt, who had written earlier to Louisine that Ellen Mary was like Mary's own mother—conscientious, and not likely to care for what Mary called "general society." "She is enjoying the Nile, we are glad to be here, and hope now really to see something.

"Today was my first impression [of the Temple of Kom Ombo], it is very Greek but of course heavier, still it does not bowl you over like the Concordia. [Kom Ombo is a very rare type of temple, being dedicated to two gods, having two inner entrances, and two altars. As for "Concordia" —since the temple of Concord at Agrigenti has no parallel with the Egyptian, could Mary have referred to the Place de la Concorde with its two balancing buildings, the Crillon and the Naval Building?] Tomorrow the Tombs, and Philae on Sunday; we are hesitating about going above to see the rock Temple. We have so much to see we may give that up.

"Life on the boat is something like prison life," Mary confessed. "When we tie up we rush out for a walk, even when it is dark. Now we say goodbye to the tug, or if we don't it will be entirely under our orders, and we can stop when we please and where we please. All the dahabeahs are towed up here without stopping, as the tugs are dear, and then one sails down with the current.

"My brother isn't very well, only an awkward affliction, *hives*, but not pleasant. The weather is cold and gray, and very unusual on the Nile."

More than the weather had changed by the time Mary wrote Louisine from the *Hope*, above Assint, February 11: "No, my dear, we are not enjoying ourselves, my brother saw his *sixth* doctor today! An American from the mission here. He has Nile fever very slightly, but he is miserable and in bed most of the time.

"Such a day yesterday. We could not move, had to anchor; blowing the river into white caps, *cold!* oh, how cold, and gray with a white sun, and such a flying of sand, like a mist. The American doctor here said that it was the worst day he had ever seen; . . . Today it was blowing and cold, but we have a tug to take us down to Cairo and may go direct with-

out stopping at [Beni Hassah], and at [Sakkara], the latter we can do from Cairo.

"No, I am very thoroughly disappointed. The tombs don't seem so very interesting to me. I am looking for Art, not Archaeology. There is nothing of Temples and tombs later than the 18th dynasty, and the finest things were of the 1st Empire, and of these I think the best is in Europe, and perhaps in the Cairo Museum. I intend if possible to see them thoroughly.

"It is too bad that my brother for whose health we came," Mary went on—as usual, without paragraphing—"should have taken Nile fever, however his throat is well, but of course he feels very badly and cannot eat, and a dahabeah, no matter how comfortable for a dahabeah, isn't the place to be ill in. The Doctor of the mission here, or rather one of the three doctors, was here this afternoon and is to return tomorrow . . . and told us of an American, aged 76, in the Hospital here, fell in getting on a donkey and broke two ribs, is delirious, and will probably die! He was on one of Cook's boats, and the accident occurred near Cairo; they ought to have put him off, but brought him here. He has his wife and daughter with him, they were on their way around the world, for the second time! Fancy dying in this strange place," Mary muses uneasily. "Why do people so love to wander? I think the civilized parts of the World will suffice for me in the future.

"I am pining to get back to work. There are things I am dying to do, it will be so good to do them if I can. I haven't been able to do my Nubian [donkey-boy?] in water colors, the weather has been so windy and no awning possible as the winds are contrary . . .

"I am glad Miss Hillard will take Eugenia [at Westover], I wonder did Theodate get my letter. I wrote to her about it. I am sure Miss Hillard is the right person in the right place . . ."

Missing mail was waiting when they got back to Cairo. Safely ensconced in Shepheard's Hotel, Mary was at her most cocky in writing to Theodate Pope, February 19.

"Your letter reached me here and I return, duly signed and witnessed, the paper for Westover," the letter begins mildly enough. "I think there is no doubt that Eugenia will be ready as to studies. The only one who has really profited by the Nile trip is she. She has literally blossomed like a rose, she is intelligent and very active, and likes to work, is as tall as I am and has grown quite stout, from being a reed. [In 1911, "stout" was still a compliment.]

"We are much worried by the breakdown of my brother," she reveals. "The climate has not agreed well with him, he has fever, we hope only Nile fever, and is in bed now with a nurse, but things look brighter today, tomorrow we will hear the result of the blood test. I trust there is nothing

very serious and that he will be able to leave Egypt the first. The climate and even the country is a great disappointment, and apart from some of the Temples there is nothing to see. Temples and Tombs; still one learns.

"I am so glad you are enjoying your winter and are so pleasantly situated at the St. Regis, it isn't socialism," she points out dryly, "but that is far away in the dim future. So you think my models unworthy of their clothes?" she bursts out. "You find this type coarse I know, that is an American newspaper criticism; everyone has his criterion of beauty. I confess I love health and strength. What would you say to the Botticelli Madonna in the Louvre? The peasant girl and her child, clothed in beautiful shifts and wrapped in softest veils, yet as Degas pointed out to me, Botticelli stretched his love of both to the point of painting her hands with the fingernails worn down with field work.

"Come over and I will go to the Louvre with you and teach you to see the Old Masters' methods. You don't look enough at pictures. Paul Veronese had a jacket which he took about with him and constantly painted on all his models. I doubt if they were 'cultured'—how I hate the word—there are elemental things which no culture changes. Thus, who do you think make the fashions? The uncultured girls; and they are launched by the 'free lances,' also uncultured; but copied by the sheltered women. No, you must learn more before snubbing me. I certainly won't paint you a picture; try one of the refined American ones produced in New York, almost all my pictures with children have the mothers holding them; would you could hear them talk, their philosophy would astonish you. France has always been the home of Art and reason too . . ." Descending from her high horse she concludes, "When am I to see you to thrash this out together? It is always stimulating to talk things over with you . . ."

On March 8, still in Cairo, she explains to "Dearest Louie" that "I have not had the heart to write to you lately, but now I think, and the Doctor insists, that all will be well. My brother still has his feet up, but his temperature is about normal, it never was very high, and the other symptoms are such that he is to be dressed soon and sail for Marseille I trust, in a week; I hardly dare write it.

"I leave tomorrow for Naples and Paris direct. I stayed, though I am entirely useless, till I was sure he was convalescent. To me it has been a dreadful time. I haven't slept one night properly, and some nights have not closed my eyes. Just think, we saw seven Doctors along the Nile; not one had the sense to tell us to stop and go back to Cairo, though I begged my brother to, and follow a treatment!

"I have a great prejudice against English Doctors; and we have one, and an English nurse. She will accompany my brother to Paris and perhaps

America! To prepare his food. Poor Jennie, I do pity her, she is very devoted but believes in Doctors: I don't. I feel so utterly helpless, and I am . . . I feel so done for. This modern way of sending for a nurse to make a poultice humiliates me. Really, Louie, if I look at the women here, we do seem useless creatures."

Suddenly, fantastically, the letter reveals an utter *bouleversement.* "Then this country," it goes on without a break, "its Art, how overpowering; fancy going back to babies and women to paint. I am glad Mr. Stillman will pose for me, he wanted me to paint him last year, I did not feel equal to a man's portrait, but now I must, to work off if possible this overpowering impression. I am crushed by the strength of this Art. I wonder, though, if ever I can paint again."

On the seventeenth of March, back in Paris, alone, Mary exposed the surrender even more nakedly: "All that Egypt has left of me arrived this morning. What an experience, I fought against it but it conquered, it is surely, surely, the greatest Art the past has left us. All strength, no room in that first empire for grace, for charm, for children, none. Only intellect and strength. How are my feeble hands to ever paint the effect on me? I am so weak now I could not do anything. I am so glad I did not see Greece. I don't want to weaken the impression.

"We had the smoothest crossing to Naples, still I had to stay two days there to recuperate & I did go to the Museum. I wanted to see the Titian, but the sculptures, even the Greek, did not interest me, and as for the Romans, what pretentious poseurs! Going from Rome to Florence, I met Nicole in the restaurant of the train, he exclaimed at my appearance; I am sure I have lost twenty pounds. I will say, he understood at once, and said the impression had been too strong for me. The French do understand what art is. Trotti I saw next day, but he is only a dealer . . ."

What on earth was there about the Egyptian experience, apart from anxiety for Gardner, to precipitate such total *enantiodromia?* By a kind of affinity, through a voice that spoke to her across the millennia, Mary Cassatt had found her new thing, all right; but it was anything but a calm and peaceful advent.

A French historian who was also a doctor, Élie Faure, analyzed, in the course of his monumental *History of Art,* what the experience of Egypt represents in relation to Egyptian art. He sets the physical scene: the Nile, flowing between monotonously twin banks, without current, without tributary, without eddy, relentlessly, from the beginning of the world. A harsh blue sky blazing above it, with an intensity that makes it dark in daytime, is only lightened at night when an onrush of stars illumines it. Hot winds off the desert; starkly outlined shadows; colors baked to burning blues, reds, yellows—in the Egyptian dusk these turn as to molten metal. The

eye's only refuge is in the shifting greens and golds of those strips of fertile land that run on either side of the great river.

Against this setting ancient Egypt's innate, irresistible urge was to seek and give form to eternity. That urge was the more tyrannical because of the dryness of a land where death is arrested in every process of change; where the very corpses dry up without rotting. In the Nile's flooding, moreover, the country re-experiences each year an overwhelming resurrection—the river's rise and fall are sure as the god Osiris in his journey across the heavens, up from the sea at morning to be buried in the sands with night. The flooding of the Nile pours out, over Egypt, a fecund mud Faure calls the father of life.

The Egyptians never ceased regarding death. In their attempt to arrest the universal movements they set an example that has no precedent, no follower. The Egyptians believed that only organized forms die, in the midst of a wholly immutable nature. Their intuition of survival over death was committed, as in a vessel, to the human soul, which they endowed with undying life. Although Egyptian art deals with religion, and with burial, its preoccupation with death paradoxically reverses itself into a paean to life, achieving wisdom's pinnacle. This vitality was the Egyptian artist's rescue of the Egyptian philosopher, for the only Egypt that endures is the one that we see stamped indelibly on stone.

Faure, writing at a time when certain words could not be printed, expresses with French delicacy the nature of the fundamental dynamic in Egyptian art; yet even with decorative words he manages to evoke a sexual compulsion so tremendous, so shattering, as to reduce the word erotic to frivolity.

He sees the Egyptian temple as expressing symbolically what he calls the primitive syntheses, that is, the uniting of fundamental opposites through creation's basic experience. Thus in the temple the Egyptian worshiper saw the lesson of the oasis echoed, in the columns like stout, rough, thrusting trunks of palm trees, and in flooring that repeated the supine forms of lotus and water lily and all the lush flowering vegetation of this most fecund of rivers.

These symbols, of what underlies not only the act of creating but creation itself, together with the strong, burning colors in which they are conveyed, spoke, too, of Egypt's past—the terrible centuries of domination, toil, spawning, cruelty, suffering. Why, in his hell, did the Egyptian never settle for the dangers of an absolute spiritualism?, Faure demands; and answers that it is because desire is stronger than death. The Egyptian's polytheistic and naturalistic religion clung to its love of the form, basis of hope. The surroundings in which the Egyptian found himself, moreover, did not allow time or freedom for pure contemplation. He worshiped his

gods only in animal or human form, and it was only as the result of cease-less labor, and methods requiring unending attention to their daringly ingenious workings, that the Egyptian could so much as wrest a living, from the vast excesses of his river. As Faure notes, struggle is, at least, an education in positivism.

The artist, in Egypt, constituted just one more laborer, toiling like the others in age-old servitude. We know, from the tomb inscriptions, names of hundreds of kings, priests, warriors, administrators; we do not know the name of a single artist, even though it was the artist who passed on to us everything we know of Egypt and of Egypt's thought. His were unsigned statements. The priestly philosophers' great illuminations, the beauty with which they are expressed—these come, not from priest or philosopher, but from the artist, unequipped with intellect, equipped with instinct alone. The artist saw, while the priest only cerebrated.

Today we are able to detach their meanings from Egyptian works of art, just as we detach meanings from the modes of life those works illus-trate. We can see how the Egyptian artist followed conceptions that were dictated to him by the priest—like the animal with the human head, the human with an eagle's head. The inner meanings of such composite forms the priest kept to himself, as well as of the curious postures he decreed they were to take. What the artist made out of the decrees, achieves life solely as a result of his feeling for the medium, of the faith he had in the religion he gave form to. If what he made was beautiful, it was entirely because of the life in the artist. In what he created, the priestly wisdom mattered not at all. It was the simple artist who mattered.

On the naïve artist from Pittsburgh, in the year 1911, this relentless experience, these passionate symbols, struck home with the impact of the elemental. She was helpless—not so much against Egypt, as against her own instinctive recognition of it. Faure, asserting that knowledge of the truth is to be gained only by personal experience, adds that what he calls the highest generalizations start as the crudest, most undefined conceptions, and attain to highmindedness only as they rise to consciousness. The un-derlying generalizations are available to artists drawn to them, as Faure puts it, logically and fatally—like Mary. The ability to give life to the philosophical language which treats of these generalizations, however (the Frenchman adds wryly) is not logically and fatally given to the intellec-tual. If the artist had taken the occult as his point of departure, his creation would have been doomed to lifelessness. As it is, today, although posed by the priestly dictates in attitudes rigid as death, Egyptian statues yet live, because of the love that was in their sculptors.

Mary Cassatt, who had been seeking an answer to death in the occult and not finding it, logically and fatally found it in a form she could not

but recognize through her surest instinct: that had made her recognize Correggio, that made her recognize the Impressionists. In Egypt she had glimpsed a generalization, the abyss that underlies creation with its myriad spawning forms. Her artist's faculty, of giving life to generalizations (manifested in her celebrations of maternity, the basis of her work's perennial appeal) had taken its course toward the stout, rough trunks of the temple columns she saw, their thrust, and underneath them, the supine forms of lotus and water lily and all the lush flowering vegetation of this most fecund of rivers. Mary Cassatt was no intellectual. She did not disengage the meaning of what she saw. She merely knew it, if blindly.

Of course (as another, verbal type of artist, Thomas Mann, put it, decades later, after sex could be spelled out, in the mouth of Joseph, Potiphar's gardener in *Joseph and His Brothers*), "The universe is full of begetting and giving birth that is exalted high above sex . . . There are the trees . . . and their mystery, wherein creation plays her game with sex . . . according to her whim . . . so that no one knows the name or order of their sex or if it is actually one . . . Often it happens not at all through the sex that they propagate, but outside of it; not by pollination or conception but by shoots or runners or because they are planted; and the gardener sets out shoots but not kernels of the palm, that he may know whether he is growing a fruit-bearing or a barren one." Joseph was talking about the reality of virgin birth.

The other, more personal aspect of Mary's Egyptian ordeal was touched on in her March 17 letter to Louisine—the one about "all that Egypt has left of me." The letter goes on: "I have had a cable from Jennie, they sail [from Cairo] next Wednesday or Thursday, what an experience that has been I cannot write about; if only all turns out well in the end, but I am afraid my brother has long convalescence before him, and he may not be ever so well again, nor may I"—returning helplessly to her blow—"only if I can paint something of what I have learnt, but I doubt it . . .

"Egypt, which was so cruel to me, changed Eugenia and Ellen too, for the better. Jennie also stood it well, notwithstanding her anxiety."

In a letter she wrote Louisine on March 24, the old, tart Mary was so far re-established as, after a paragraph of exclamatory remarks about babies, weddings, and plans for the summer, to go on, "I am glad Miss Beaux [the Philadelphia painter, for whom Mary seldom had a good word] liked the Saint [one of the Havemeyer old masters] but how then can she continue to think so much of Sargent? For it seems she does . . .

"Of course I am anxious to know how my brother is bearing the voyage," she continues. "Dr. Osler [the renowned physician] is on board their

boat! I wish he was safely in America. I rather dread the four weeks [the Gardner Cassatts planned to spend] here at Crillon's."

The rise in Mary's spirits was short-lived. On March 31 she could "only scribble you a line. My brother arrived on Tuesday morning, desperately ill with *pleurisy* travelling in that state.

"I have had a most kind note from Dr. Osler, who was on the boat as far as Naples, telling me he was very ill (but Dr. O. did not know of pleurisy) and saying to get him home as soon as possible, and to consult Prof. Chauffard. I met them at the station with Dr. Whittman and an ambulance, he had two nurses travelling with him, and took him to the Crillon, where they had reserved rooms little thinking of his state. Chauffard was horrified at his travelling . . . and took charge, with Dr. W(hittman), yesterday he said he was 'un peu mieux.'

"All I can hope for is that there is a chance. Gardner [Joseph Gardner Cassatt, Jr., and his wife, Polly] are on the way over. The girls are with me, and everything he can take is made here [at rue de Marignan] and they are feeding him. They kept, or rather the English Doctor in Cairo kept him until he was in this state; my dear, they are murderers!

"Here I can do something, but I am dreadfully down."

On the fifth of April 1911, at the Hotel Crillon, Gardner Cassatt died.

At first Mary Cassatt held up well. Characteristically she flew into a rage because, at the English church where memorial services for Gardner were held, the clergyman offered prayers for the King instead of for the President of the United States. However, by April 12, to a cabled offer from Louisine to come over and be with her, she could only reply:

Doctor orders rest and to be alone So grateful dear Louie Come later when I am well Love

Mary.

To creative people, doctor's orders to rest and be alone need not come as all-bad news. Charles Darwin, Florence Nightingale, Elizabeth Barrett Browning were only three of the Victorian geniuses who turned illness to their own, and ultimately the world's, inestimable account. Art, in one of its aspects, *is* getting to oneself; even God, who created man in his image, did so alone. Degas, in many ways Mary's guide in life as in art, perceived when only twenty that "Today if one wishes to practice art seriously it is necessary to gather renewed strength in solitude." As for natural gregariousness and love of one's fellow man, these are sacrificed; "To produce good fruit," Degas wrote in later years, "one must line up on an espalier. One remains thus all one's life, arms extended, mouth open, so as to assimilate what is happening, what is around one and alive . . . Art does not expand; it repeats itself."

Given a Frenchman's acceptance of sex, a Catholic's of death, Degas early on arrived at his own "primitive syntheses," expressing the durable truth of "instinctive life in its irresistible affirmation," through forms he gave them which now have "the relative immortality which endures so long as those forms shall endure." Stretched on his espalier, he assimilated that answer to death made by the Egypt he never saw. Louisine Havemeyer in her *Sixteen to Sixty* says of his *Danseuse,* done in the eighties, to which he had given real hair and a real tulle skirt: "To some it was a revelation, to others an enigma. The graceful figure was as classical as an Egyptian statue and as modern as Degas . . . Here was a problem! All Paris said, 'Has the soul of some Egyptian come to our modern world? Who has achieved this wonderful creation? Whoever he is, he is modern to his fingertips and as ancient as the pyramids.' " Just so Renoir commented that Degas as sculptor "combined a certain joyousness and the rhythm of an Egyptian bas-relief."

For Degas, solitude was not only a requirement for creating something, it was a snoot cocked at destiny and even art. "If you are a bachelor," he said, "You have moments when you close up like a door, and not only against your friends. One annihilates oneself—killing oneself, in fact, with one's revulsion." The words strike a modern note that echoes through the present century, in suicidal acts like what is asserted to have been Mark Rothko's artistic purgation of the ego. "There is in the destiny of some men," Cabanne observes, "moments when destiny reverses itself; but destiny does not have death's face unless the man ignores love. Degas all his life ignored, or pretended to ignore, love. After any creative destiny, the work is written on the margin of mankind's heart—a heart exalted by Rubens, mystical with Greco, passionate with Delacroix, subdued by Degas. 'The artist's voice,' wrote Delacroix, 'draws its strength from that which is born of . . . a solitude called the universe, for him to impose on it a human heart.' "

One who had ignored, or tried to ignore, all love but family love, had already lived for sixty-seven long, positive, active years. In 1911, however, Mary Cassatt's destiny reversed itself. By April 28 she was writing Emily Cassatt (Eddie's divorced wife, to whom Mary was kinder than the other Cassatts were), "Now I am the only one left in my family! Who would have believed that both my brothers would go so near to each other . . . I must get strong again and get to work, it is the only thing." Remembering what her brothers' examples of achievement and fortitude meant in the formation of Mary's personality, it is not surprising that in the letters she continued to pour out to Louisine—so much younger and yet so much like a mother—she reveals a condition indeed isolated, but which the present day would not hesitate to term a depression. "Yes, Egypt has been

torture," she wrote James Stillman, declining an invitation to go driving, "but we learn even on the rack. I can congratulate you on doing good work . . . even if I never again can hope that for myself."

The dual blow, of Gardner's death and of Egyptian art, had in it the possibility of great things. The first flowering of her talent, like a rose-tree spilling up out of the fertile soil of childhood's blow, was finally exhausted. Now there was a fresh wound, requiring to be healed in fresh ways. If there is one circumstance, however, which more than another reveals Mary's intransigence, it is in how long that wound took to heal. She could not and did not stop being an artist, of course; that was what she was. Something was bound to come of the Egyptian blow, and something did.

Blindnesses

FIFTEEN

Mrs. Percy Madeira—once the young girl named Eugenia Cassatt who went along on the trip on the Nile—insisted in 1971 that what her Aunt Mary suffered afterward was "not really a breakdown, whatever that is." The handsome old lady on the chintz sofa shifted uneasily at the very word. Out of her blunt features Mary Cassatt's sharp ones seemed to peer, and her bluff speech to echo Mary's attitudes. Back in 1911, Aunt Mary had been no great favorite of Eugenia's; a young girl of spirit could hardly be expected to feel enthusiastic about a relative who so often expressed her preference for a sister. "She is like me," Mary Cassatt said of Eugenia. Perhaps they were too much alike to be drawn to each other.

In Mary's letters to Mrs. Havemeyer after 1911, she herself over and over used the word breakdown for what she was going through. She meant physical breakdown; for disorders do not get called mental until they can no longer be controlled mentally. Mary Cassatt was, her niece says, "just lonely" after her brother's death; her state for years afterward was, "only reaction." Loneliness, reaction; depression, breakdown; the elderly lady on the sofa revealed how much a Cassatt would prefer some of these words to others.

Mrs. Madeira's life expresses the horsy, social side of Mary Cassatt. Her large stone Pennsylvania farmhouse, with its stables, its great vase in the hall full of walking sticks and whips, its Irish terriers as impatient as their mistress for a walk, incarnates Cassatt interests. Physical luxury is scorned; on a cold January day Mrs. Madeira—white-haired, red-cheeked, hearty in well-tailored slacks—halts the houseman about to make a fire in the fireplace.

The house, three hundred years old, is filled with comfortable, sporting, controlled clutter; in such an atmosphere it is a shock when the eye suddenly falls on an exquisite Mary Cassatt pastel or painting. There are as well many fine Japanese prints from Mary's collection, and a dark little Courbet, a dark Picasso, and a possible Cézanne—not established, says Mrs. Madeira with a knowledgeable air. A Cassatt mother and child hangs in the dining-room; the stairwell and bedroom corridor are lined with Cassatt etchings and aquatints. In one of the bedrooms is the 1885 pastel portrait of Mary's father on a horse, back to; as wooden as in reproductions.

Degas came up in conversation as it does in any conversation about Mary Cassatt. Her niece asserted, in the positive, Cassatt way, that Mary

could not possibly have used "that word" (common) in speaking of Degas; but that she would have felt "any ordinary Frenchman was out of the question for her. She was accustomed to something else, having been used to upper-class Philadelphians." Degas, she added, may not have realized it was impossible for Mary Cassatt to consider him as a parti. As for an affair— "She could not *possibly* have had an affair!" exclaimed Mrs. Madeira. When Mary was young, after Robert Cassatt brought his family back from Europe, she "had no beaux whatever. She came back to Philadelphia too late for all that. Too late in her teens. She must have been eighteen by the time they got home." In point of fact, Mary was eleven.

The word Victorians used to use for the state Mary was in after the Egyptian trip was "prostrated." For the next two years, although she continued advising Mrs. Havemeyer on art, only two of her innumerable letters to her fail to describe symptoms. On December 14, 1911, for instance, she was writing: "I am at the doctor's, taking inhalations of radium. This is the eighth day, and I am suffering very much, which it seems would prove that it is doing me good, that it will be a success, provided I can stand it. We are a party—an old Englishwoman, Lady Pirbright, and a French comtesse, an Italian princess, and Miss Hallowell. I would find it easier were there fewer persons, and if we were not [afraid] to talk."

The treatments, given her for incipient diabetes, may have done much else to her. At that period radium was not understood as a method of therapy, to put it mildly; actually its dangers were not wholly grasped until the late 1940s. In 1911, radium treatment was a panacea. A paper in the July 1910 issue of the *Boston Medical and Surgical Journal* lists some of the "diseases amenable to radium therapy" as carcinoma, Leucoplakia, hypertrophied scars, angiomata, pigmentary naevi, hairy naevi, tuberculosis cutis, as well as "miscellaneous diseases" including psoriasis, angiokeratoma, linear ichthyosis, lichen planus, acne rosea, rhinophyma. It had an analgesic effect on many kinds of pain caused by neuralgia, herpes zoster, neuritis, gonorrhea, and rheumatic arthropathics and iritis, gastritis, tabes dorsalis, and sciatica; and gave "decided relief in pruritis ani, pruritis vulvae, neurodermatitis, lichenification and chronic eczema." The treatments were also intended to relieve Mary's pains in the legs, associated with diabetes, about which she constantly complained.

Radium, the new discovery, reflects off another facet of Mary's changing personality. In a December 1, 1911, letter she says, "I send you this account of the Curie business . . . We, Louie, are living in the morals of our forefathers, but people who hadn't any forefathers? . . . And after Mme. Curie, what can one count on?" In a December 29 letter, "Did you know that Columbia College has become a college for Jews? Mr. Stillman

tells me that Doctor [Nicholas Murray] Butler told him that these young Jews have absolutely *no* sense of right and wrong. Now, my dear, Mme. Curie is a Polish Jewess! So I have been assured, and it is only too evident that she has no sense of right and wrong. That comes of centuries of oppression. Prof. Langevin is a genius, it is said, and he helped Mme. Curie in her lectures; she isn't capable by herself of doing anything like that, but must always have someone to help her."

Paul Langevin, Professor of General and Experimental Physics at the Collège de France, was professionally associated with the widowed Mme. Curie. *Le Journal* of Paris broke the scandal linking him amorously with the winner—with the late Pierre Curie—of the Nobel Prize for their co-discovery of radium. In July 1911, Langevin's mother-in-law told a reporter Mme. Curie had "kidnapped" him, referring to a trip to England (on which, in fact, he was accompanied by two of his children, and not by Mme. Curie at all).

Langevin's wife, interviewed, said she regretted her mother's indiscretion but that for three years she had suspected an affair, and known of it for a year and a half. She had said nothing, she declared, on account of the children. At this point *Le Temps* sprang to Mme. Curie's defense, noting that the attack resembled earlier, successful attempts to block Mme. Curie's election at the January meeting of the French Academy. The paper declared a cabal existed for blocking Mme. Curie (who was due to receive the Nobel Prize a second time in December) adding that now she would never have a chance at election to the Academy. Mme Curie, interviewed, denied the entire story categorically and threatened to sue any newspaperman who impugned her, proceeds to go to charity.

Mme. Langevin then gave out that she was tired of being pictured as jealous without a cause and that she was suing for separation. "My husband and Mme. Curie present me as a madwoman who could not understand their relation was scientific," she told a reporter. "My husband did not run away with Mme. Curie, nor did he spend his vacations with her as has been said; but I have material proof of his infidelity."

The Curie affair took on prurient journalistic juiciness, and was compared to the Affaire Dreyfus. For several months representatives of government and of science kept rushing forward to attack or else to protect Mme. Curie. An inflammatory set of brochures, called *L'Oeuvre*, reproduced the list of complaints in Mme. Langevin's suit. The writ served on Langevin asserted he had had adulterous relations with Mme. Curie in conditions "constituting maintenance of a concubine in the conjugal domicile," gave the dates when he had rented the apartment used and purchased its furnishings "in particular a bed," and stated he went there several times a day with Mme. Curie and often ate meals there for which

she did the marketing. It published letters, claiming they had been written by Mme. Curie to Langevin, that urged him to leave his wife. One read, "When I know you are with her, my nights are agonizing. I can't sleep . . . Do what you can to put an end to this."

Years later Eve Curie in her biography of her mother summed up the moral impact of the scandal: "A scientist, devoted to her work, whose life was dignified, reserved and . . . pitiable, was accused of breaking up homes and of dishonoring the name she bore with too much brilliance . . . Let us leave in peace those journalists who [insulted a] woman pestered by anonymous letters . . . threatened with violence . . . her life itself in danger. Some among these men came to ask her pardon later on with . . . repentance and with tears, but the crime was committed. Marie had been led to the brink of suicide and of madness . . . Let us retain only the least murderous but the basest of these knife thrusts . . . her origins were brought up against her: called in turn a Russian, a German, a Jewess and a Pole, she was the 'foreign woman' who had come to Paris like a usurper to conquer a high position improperly."

The reason the scandal matters in a life of Mary Cassatt is because of the spectacle it affords of one—also a woman with a career, also a foreigner, one who had championed Dreyfus—scandalized by it. Ten years later Jaccaci was able to assert of Mary, apropos of her sharp tongue, "She's become a viper." In 1911 the viper was hatching in her own breast.

Another element in Mary's changed makeup is referred to for an instant in the December 1, 1911, letter: "Degas is almost out of his mind, for he has to move . . ." she reports, "and he hasn't even dusted his pictures for years. His temper is dreadfully upset." The deaths of Alexis and Henri Rouart precipitated Degas' move from the apartment on the Avenue Victor Masson which his old friends had owned, where he had lived for twenty years. Almost simultaneously his faithful and put-upon maid Zoë died. She whom he called the Terrible Maria—Suzanne Valadon, chivvying and bossing—found and helped him to get into a new place on the fifth floor of a building on Boulevard Clichy; but he could not endure it. It was the last straw.

Since 1885 imminent blindness had hung over Degas, ignored, defied. He never did give over his art. Even after he was really blind, he made enchanting wax figurines by touch, and it was after he was blind that he said, as with his fingertips he caressed the portrait of Mme. de Seronnes in a retrospective exhibition of Ingres, "Look how pretty the detail is!" In the years before the 1914 War, when Mary Cassatt was groping around for something to express her Egyptian experience, Degas was literally groping his way, hands out before him, to stand for hours in front of the structure going up on the site of his old studio. The artist in his shabby

hat and coat nevertheless held his head high, with "the air of an old Homer," Cabanne says, "Oedipus with a white beard," as he felt his way along streets familiar to him from a lifetime spent in the same quarter of Paris.

More than physical health was shattered in Mary Cassatt by the Egyptian blow. Late 1912 was when she gave those instructions to Durand-Ruel, not only to dispose of two Degas paintings she owned, but to sell the portrait of her Degas painted and gave her, the lively one holding the cards. From Grasse, where she was recuperating and motoring with James Stillman, she wrote the dealer, "It has qualities of art, but is so distressing and shows me as a person so repugnant that I would not want anyone to know I posed for it . . . I would like it to be sold to a stranger, and especially that my name should not be attached to it." With this act, not the act of an artist, she was in effect repudiating the past with Degas, for no one knew better than she the way Degas felt when his friends sold his pictures, especially his presentation pictures; he had broken with Manet and Renoir for it. In a later letter Mary told Durand-Ruel that she didn't care who bought the picture since the dealer had informed her he believed no one would ever recognize her from the Degas portrait; in 1910 she had indeed called it, to James Stillman, "Degas' painting from me. I cannot call it a portrait." More than her appearance had altered. It is inconceivable she could have sold the painting earlier.

Degas, for his part, said to Vollard around this time—and Vollard reports he said it often—"A man should marry. You don't know what the solitude of old age is like."

"But then why have you not married, M. Degas?" the dealer would ask.

"Oh, with me it's different," the old man used to reply. "I was too afraid of hearing my wife say, after I finished a picture, 'That's a pretty thing you've done there.'" The young woman who leaned forward in the 1885 portrait could never have said such a thing to Degas; who knows what the woman who sold it might not have said? More than anywhere else, in this act is revealed the Egyptian experience working like a poison, now that Mary was unable, herself, to use it.

Her earlier awe of Egypt, as before a tremendum, was poisoned too. "A lady here has been telling me," she wrote Louisine from Grasse, February 4, 1912, "of weird stories about the dreadful things that have happened to people owning Egyptian mummies; one, it seems, in the British Museum is never shown to anyone, such dreadful things happen. I have necklaces coming from the tombs, and so have you." October 17, that year: "No wonder you write that the idea of Annie's [Louisine's aging sister-in-law] going to Egypt fills you with horror. I don't think she

knows what it means; how is she to ride miles on donkeys and all the other fatigue? . . . Do persuade her not to try it." The darkness in the experience was overcoming the light that for a time exalted Mary's vision.

Indeed, during the years of stubborn, baffling illnesses, she reacted with her usual violence against any form of travel at all. "Please give my best wishes to Lulu Jackson," she wrote on December 18, "but my dear, how her mother must feel about her going off to Egypt. Why are we all so restless? As to Japan, Miss Cockcroft was ill *for years* after her visit there." In Mary's condition the cozy daily drives with James Stillman were infinitely more appealing. When she got home to Paris from her winter in the South she wrote Louisine, March 29, 1912, "My dear, I am such a living barometer; yesterday I went down to Beaufresne and there was wind and the weather changeable, and I came home so wretched I cried myself to sleep . . ." Her letters were still written on mourning paper, black-edged.

Mary had the bitter satisfaction of seeing in April 1912 all her darkest suspicions of the sea and of ships justified. From Paris, April 16: "What a disaster! I wrote by the lost *Titanic* to you and to Jennie, and now she is at the bottom of the sea! It was said she *could not* sink. We have been to the [steamship] office, but they have no further news than was given this morning in the *Herald* . . . [Some passengers] are saved, they hope more. The anguish of those who don't know if theirs are amongst the number . . ." Three days later, in another letter: "Oh! my dear, what horrors have we been feeding on . . . The French declare she was insufficiently armored, not nearly enough of plates for her size, many less than the smaller French ships, but the discipline was fine, and humanity comes out . . . This thing of luxury before safety is the trouble. My dear, if only you care to come [for a visit] I am free, will this dreadful business frighten you off?" Safety was becoming a major consideration for the once-dauntless Mary. What was once represented by seasickness was spreading, in her apprehensiveness, to forms of getting about only mildly daring.

Mary's letters to her friend told all about her elderly beau, her weight, her treatments, even her bowels—resting all her troubles on Louisine. "I never saw [Stillman] looking so well and so young. He was kindness itself, but I think he must be glad to be rid of this sick old woman," she wrote on March 12, 1912, after getting back from Grasse. "I think I would be, in his place . . . I . . . must get to bed with a hot water bag to stop the pains." August 1, from Beaufresne: "I meant to write, but then felt too miserable . . . The weather has been *so* atrocious for me, and no doubt for other people wracked with pain. We have had a five days storm, I *had* to take medicine to get some sleep . . . I am not to motor, except very gently. I am no use to anyone, Louie dear, and no one can be of any use

to me until, if ever, I am rid of these pains . . . All my doctors want me to work!" she suddenly breaks out. "How is it possible, they don't know what it is to paint, they say only *ten minutes* a day . . . Do write, your letters are one of my chief solaces."

October 2, from Beaufresne: "I got yours . . . after a very bad night, and needed something this morning to distract my thoughts . . . I was unnerved to find myself in such a nervous state, and I had to call Mathilde, and did not get to sleep until three o'clock, and I haven't disturbed Mathilde for weeks until last night. [The doctor] came to see me while I was eating my dinner, if you can call it a dinner, which consists of soup, tapioca which he at once forbade because tapioca is made of flour, and a roast potato and an artichoke. Now I ought to see *no one* after five, and, as much as possible, no one before; solitude is rest," she observes, "however late, I ought to be quiet, or no sleep." October 17, again after seeing the doctor: "I am getting on, but so slowly I found it hard to believe I am getting on. The diabetes, with my strict diet, has almost disappeared . . . Now, they say the pains come from diabetes; and I have none, or so little, and just as bad pains. I have taken aspirin three times this last 24 hours and still suffer much. I don't get my strength back at all. Though I walked half a mile without fatigue . . . only scribbling this tires me." On November 8, almost two years after the Egyptian blow fell, she writes Louisine from Paris: "I am scribbling this in bed, being decidedly worn out already with Paris. We got in on Tuesday, such a horrid day, and I am sure I must have caught cold, for I have had such pains since; then I have lost more than two pounds, how I don't know, for I eat always the same things. I long for the sun and the South. We will go by train as soon as we can."

She described her arrival with Mathilde, in a November 20 letter from a hotel in Grasse: "Two wretchedly shaken and sick women got out of the [train de] Luxe on Sunday at Cannes, and one, you can guess which, parted with her breakfast at the Cannes station, supported by a sympathetic porter." This letter encloses her new address: Villa Angeletto, Route Nice, Grasse, Alpes Maritimes. From there, in a letter written December 18, a Mary Cassatt spoiling for a scrap, as in old days, reappears momentarily: "I am sitting here at 8 in the morning waiting for the masons, architect, agent, and to see about drainage. We had a stirring day yesterday, and I am looking for a scene this morning, if they all come. What a set are the architects; absolutely *no conscience* and less sense. If only we escape. I wrote my proprietaire [landlord] in Paris yesterday and if things are not fixed, it is quite in the cards that I move out and ask for my rent back again." In the end Mary wintered at the Villa Angeletto quite happily for years, escaping to it when war forced her evacuating Beaufresne.

Another change working in Mary showed in her doubts and suspicions of relatives, now that all her own generation was gone. On April 19, 1912, from Paris: "I have been decidedly upset by a most unexpected letter from Jennie saying she and Ellen leave on the 25th for Genoa! They don't come to Paris on their way to Italy as they are afraid of the excitement for me. I was cut up at first, and cabled to say that I was better, there would be no excitement only great pleasure in seeing them; could they not change their plans? I got a cable last evening. Change impossible, Jennie says; she will see me for a week in July, in Paris. Of course I think it a little hard, for I have suffered so much this last year; I should think she might want to see how I am but this is the first time she could be rid of me when in Europe. She wrote to me, after I had written how ill I was in Cannes, offering to come over and take an apartment near me just to be near and nurse me. I answered her very affectionately, . . . thanking her, but saying it was not necessary—now she passes by me without seeing me!"

This tiny event built up into still further misunderstanding. On June 4 Mary, outraged now because Jennie wanted to come at once to Beaufresne, writes: "Why won't she understand my state, I need no immediate attention, and she goes on as if I did not want them; yet when I cabled for them to come, she refused . . ." June 7, she reports Jennie and Ellen Mary are coming: "I dread the visit a little, we won't be in accord, but she will see for herself what a state I am in, which she seems incapable of understanding. Oh! I want peace and quiet."

On October 2, 1912, Robert Cassatt, Jr.'s wife Minnie had been in Paris with her two boys, Alexander and Anthony. Mary wailed, in her letter of that day, "She offers to come out here [to Beaufresne] but I am afraid that would upset me more than my going to town." Mary's feeling for all the children remained intense; the way she imagined they felt about her was something else. March 12, 1913: "I am so glad of what you tell me of Eugenia [who had left Westover and returned to Philadelphia]. I think home influence ought to be the best, but it isn't always. Now that her father is gone, everything is changed, and her mother and I are poles asunder in our ideals of life. It has made oh! such a difference to me . . . I used to feel as if the children were half mine, but I have not the slightest influence now. If only I felt strong enough to work, then life would be filled with something. I don't feel anything like so much interest in Art. I only want to get to work, and [I] think of all I want to do and never will."

It was true. Mary did not take "anything like" the same interest in art now that art was something she could not practice. Her first, fine careless rapture—once it had given her what she wanted, independence—ap-

peared to be as done for as the drone by any queen bee. The Egyptian experience that followed had not yet found a form; it is interesting that in all these letters to Mrs. Havemeyer, constantly advising her on art and artists, Egyptian art is no longer mentioned.

About Post-Impressionist art she was increasingly vituperative. She even advised Mrs. Havemeyer to sell her Cézannes. A letter written on Easter Day, 1913, spells out her views on Matisse, whom Louisine had ventured to compare with Richard Strauss. "Matisse is a facteur [literally, a postman; in slang, "the bad news," as of a bill come due]. If you could see his early work! Such a commonplace vision, such weak execution; he was intelligent enough to see he could never achieve fame, so shut himself up for years and evolved this; and has achieved notoriety. My dear Louie, it is not alone in politics that anarchy reigns. It saddens me; it is in a certain measure our set [the Impressionists] which has made this possible. People have been persuaded that composition, pictures, were not necessary; that sketches, hints, were enough. Certain things should not have left the artist's studio nor his portfolios."

On the other hand Degas—whose raffiné mind remained ever open to the moderns—it was lately becoming the fashion to ignore. Cézanne said about him, "Degas is not enough of a painter, not enough! With a little temperament he would be very much of a painter. It is enough to have a sense of art, but that seems to be the horror of the bourgeoisie." Among the Fauves, only Raoul Dufy allowed himself to be influenced by the venerable master. Nevertheless Cabanne, in speculating on how Degas "with his insatiable curiosity" would unquestionably have had a taste for Cubism (one of his favorite aphorisms was Apollinaire's 'A picture is a drawn state of silence, and a motionless one') notes that Pablo Picasso seized on exactly the same things as Degas: in Ingres the secret of the relation of lines; in Japanese art its new and unusual perspectives. Even themes chosen by the two painters, so widely separated in the popular mind, were the same: theaters, brothels, race-tracks. There can be no question of who came first.

Mary Cassatt's disintegration—or reconstitution, it was too early to tell which—was not apparent to an outsider, even an observant one. On June 4, 1912, she had written Louisine from Beaufresne, "I must have Monsieur Segard on Thursday or tomorrow, who is writing a book on my art, for which he has an editor! [the French call a publisher an éditeur] and I cannot write a line nor think of work, so weak am I," and on June 7, reported, "Monsieur Segard . . . came out to luncheon and to see my etchings. After he left I was *exhausted*. I cannot talk or listen to much talk; silence and solitude are best for my state."

Achille Segard got no such impression. He began his book on her

work, *Un Peintre des Enfants et des Mères, Mary Cassatt,* published in Paris in 1913: "A tall and slender silhouette, very aristocratic, dressed in black, leaning on a cane and advancing cautiously on the sandy paths of her park with its magnificent trees: in such a way Miss Mary Cassatt appeared to me the day when I visited her for the first time at her beautiful hermitage of Mesnil-Théribus, in Oise.

"An extremely kind smile lighted up her grave face; and her blue-gray eyes, the color of still water, animated its strongly marked planes. She held out an energetic and fine hand—long, thin, hard-working, vital, vibrating with sensitivity. We talked. [Later], on the walls of her windowed gallery, Japanese prints created an atmosphere. Through a half-opened door could be seen the sketch for a portrait of a child in a spring hat, sitting by a young mother wearing a bodice of rose-red color, mixed with violet . . ."

Today dismissed as sentimental and old-fashioned, Segard nevertheless far outdistances his critics in ability to bring his subject to life. The opening of his often inaccurate biographical study could almost be the delicious beginning to a novel by Turgenev.

SIXTEEN

THE FIRST WORLD WAR came like a great ship to rescue Mary Cassatt, foundering in the waves of little illnesses. After August 1914, illness—with one major exception—is no longer the subject of her long and frequent letters to Mrs. Havemeyer. Just as aboard the rescuing ship when she was seven she was not sick, she was not sick now, either. She returned to her former concerns and preoccupations; she "went back" to being active. Yet, as the critic Clive Bell put it, later in the century, "Impressionist doctrine boils down to this: sensational truth is the only proper study of artists." Now that Impressionist doctrine was no longer in the air but in the past, and Mary took so little interest in the art doctrine of the future, her sensations continued to respond to everything that was in the air; only now the response was to take a most unpleasant form.

A letter from Beaufresne of July 16, 1913, sets the prewar scene. Beginning as usual with discussions of family: Mrs. Havemeyer had become a grandmother; Polly Cassatt, Gardner Jr.'s wife, "takes no care of herself"; it continues: "Altogether I am rather sad; it seems to me humanity moves in a very restrained circle; fancy the Chinese having known of aeroplanes! . . . One passed over our heads this evening as we were walking up the hill. —My dear Louie, what does Mary Hillard teach her girls? Here is Eugenia smoking (all Ellen's friends smoke) and their Mother has succeeded in making them promise not to smoke more than *three* times a day! and only at home. There is no harm in a woman's smoking if she is careful not to oversmoke, but a girl not yet sixteen! and Ellen only nineteen. I wrote to Jennie to say that it would be good for Eugenia to profit by this coming winter spent in Paris to study languages; she says I am an artist but she is just a 20th century girl. It never enters her head to ask or care what the others want, and she is better than most."

A letter from James Stillman to his sister Clara, from the Hotel Victoria, Grasse, gives an outside view: "I am telling Miss Cassatt never to offer another of her paintings for sale, that then they will begin running after her, and when they have, often enough, to consent to dispose of one for a hundred thousand francs. I have also made the prediction that Degas' [reputation] will decline and hers advance so much that in ten years her paintings will sell for as much as his, and I believe it. You should have heard her shrieks! She confided in me that she has gained 16 pounds [Mary, who the year before had been down to 86, still weighed less than

110] and, I think, is painting, but irregularly owing to the difficulty of getting models to go as far as her villa. She has taken it for two more years. She declares she is perfectly well and is anxious to get back to Paris. Then, if she plunges in her excitable way into her old life, I fear she will be made to realize that she has had a long illness and is not as young as she was—but no one, not even Mathilde, can stop her."

At last she could work. Mary wrote Louisine from Grasse on May 21, thanking her for a gift of nuts which she declared would put weight on her and promising to deliver a package of them to Renoir, who had left Grasse, in Paris; then she bursts out, "Perhaps, who knows? I may have still something to do in this world. I never thought I would have. I felt as if I were halfway over the border. I am so much better I think I may be still stronger, strong enough to paint once more. Perhaps I may astonish Segard yet, who rather finishes me, in his book on my Art . . ." As ever she rose to any baiting, of that work of hers she always capitalized: hiding the hurt and displaying the rancor. Courage was needed, indeed, now more than when she was young and alone in Parma; it was infuriating and daunting to find her hard-won knowledge relegated to the done-for.

On July 16, back at Beaufresne, she had been working that morning. "I was able to show Joseph [Durand-Ruel] a pastel nearly finished; he wanted it, but my great desire [is] to do something for Sir William Osler, in recognition of his kindness to Gard; I know he likes my work. Until I have done that, I don't want to give up a pastel." The Egyptian experience can be seen working in her; but its fruits bore little relation to the blinding flash that in 1911 struck across Mary's vision. Twenty-seven increasingly blurry, fumbling pastels, executed during 1913 and 1914, reveal only that the Impressionist light had failed, and the Egyptian flame never been kindled. It is doubtful that she even knew two pictures of hers had been entered in the 1913 Armory Show in New York.

Mary Cassatt, once the ambassador of maternity to the world, had now no country to interpret. She had of course other memories. If like Eakins she had been able to paint Philadelphia being Philadelphia, the barrens of celibacy, or even the death of the spirit that later occupied abstractionists . . . but she kept on painting mothers and children. Whatever image memory might have supplied to contain and express Egypt had not surfaced, yet, although Egypt was still working in her.

"I know the nudes of Degas in the Hyasaki collection," the letter continues, "I had the catalogue. What astonishes me is that the general public wants them; these fragments aren't pictures. The taste of the public has been perverted by Gauguin and even Cézanne. If only you were here that we might talk! I am sure Mr. Freer [the collector] enjoyed his stay with you; he is doing a fine thing and I have no doubt if we are to have

original Art it will be greatly influenced by Chinese, [but] why does he care for such poor modern paintings? I wish I could look forward to motoring," she goes on without the slightest break, "but I must not; my eyes have greatly changed, my sight disturbed by incessant motoring in the South. I am no better [from this] for I have had to go twice to Paris and that has interfered with my rest . . . Here I am feeling so much more as I used to feel, sleeping from eight or nine until seven, when I had so many many months of sleeplessness; often . . . I never slept at all; and now that that is over, my eyes, which have always been my strong point, are troubling me. If only I was sure of a good oculist . . . I must just wait and see if I don't improve: I seemed to, and now not." A postscript adds, "You haven't received any acknowledgement of the nuts from Renoir, neither have I. He cannot write, and she [Mme. Renoir] hardly knows how. It is a curious household; fortunately for him there is a former model, now nurse, whose devotion is beautiful."

Mary Cassatt's letters after 1911 became infinitely more interesting when they concern other people's affairs than when they are about herself or "Art." Exactly the opposite had been true formerly. "I am expecting a visit from a niece of Degas'," she writes, for example, from Beaufresne, September 11. "She is to come out for the day. I urged her to come to Paris to see for herself and for her sister and brothers, her uncle's state. She is staying with him, and writes that he is just as I said, immensely changed mentally but in excellent physical health. Of course he may live for years yet. He is seventy-nine, but his family will have to take care of him later." Then she goes on, "I am thinking of going to Italy, to Parma, the last of October, to hunt up Parmigianino, from whom Greco got so much. I hope I may be strong enough to go, if I am don't you want to come over and go with me? . . . Do come if I am strong enough, if not I will put it off to spring. I need to see something." A merely nostalgic note is struck. (She never did go.) Yet when the letter continues, "I think Ed and his [new] wife would be better received in Newport than in Philadelphia" (referring to the bad odor in which divorced people were held) immediately things look up.

On September 18, "My eyes worry me . . ." and, November 4, from Paris, "Here I am for a very little while, my only wish is to get away again. It is dark and rainy, my oculist has turned out terribly. I have conjunctivitis, an inflammation of the eyelids, he said it was nothing, that I had very good sight, one eye very good the other not so good, but not very bad. Then when I saw him again, change of front: wants to keep me here two months and try experiments on the poorer eye, trained nurse to assist at the operations twice a week! Dr. Whitman was horrified, he told me plainly it was to make money. My dear, it is so hard that one goes for

a little simple advice and to be tested for glasses, and they (he is like the most) see a chance of making money and [do] not hesitate to risk making you blind! My theory is they get so hardened with vivisection that human suffering is nothing to them. You may be sure that Dr. Whitman would not dare to tell him that I was his patient and he would not allow it; that would not be professional etiquette." The word operation, used for the eye treatments, may account for a myth in circulation that by 1913 Mary Cassatt already had cataracts. She did not in fact even remain in Paris for the two months of operations.

When on December 4 she wrote Louisine from Grasse, starved vanity had overwhelmed generous impulse: "You ask about sending Dr. Osler a pastel, no, not yet. I brought seven pastels to town, four were large, a nude boy and his mother. They were in many respects the best I have done, more freely handled and more brilliant in color. I kept one only. It is one of my best and very important, I felt I ought to keep something of mine for my family. I kept a lot around, which I [had] intended for Harrisburg. The Durand-Ruels were most anxious to buy, and other dealers too, these two represent a good sum. My things sell for very good prices at the Paris sales. The other three pastels were more studies, and would not have pleased Dr. Osler. I hope that here I may do something suitable. I am working, but not yet two séances a day. I am taking a breathing spell, and getting models together . . . I can bear a good deal of fatigue; of course very few women work, I mean at a profession, so they don't know that fatigue; if I were not doing this I could do as well as any I know . . . I have been like you, I have overlooked my bodily welfare, but I have worked so hard besides, and nothing takes it out of one like painting. I have only to look around me to see that, to see Degas a mere wreck, and Renoir and Monet too." In view of the clumsy handling, the garish color, of the actual pastels, her boastfulness about them is heartbreaking. She never did give the pastel to Sir William Osler.

A short letter from Paris, May 30, 1914, concerning an old preoccupation, stated that any exhibition of her work in New York must be for the cause of women's suffrage; but by the time her next letter was written on August 13 from Beaufresne, where her nieces and their mother Jennie Cassatt were visiting her, war had come.

"Here the days pass with leaden feet," she declared, adding, "the great drama bores the young ones, especially Ellen who naturally longs to be at home and amongst her friends and riding. The great drama going on so near us does not interest these young Americans. You may imagine how differently I feel. This morning one of the heads of the American Express Company came with a cable . . . wanting news of Jennie, he . . . gave us news, very precious news of the revolutionary state of Germany. I feel sure

of that; and that the German armies do not wish to fight. The battle in Belgium will be fought out long before you get this. May it be a crushing defeat for Germany . . . Oh, Louie dear, women must be up and doing, let them league themselves to put down the war. I ventured on this remark yesterday but was badly received. Women, my dear, it seems won't have the time to vote! I shall never mention the subject again."

The way one of those "young ones"—Mrs. Madeira, at her stone farm-house outside Philadelphia—remembers it, they were caught quite un-aware by the advent of war; her Aunt Mary, "not social at all," had no idea how bad the situation had become until a cable arrived from the family in Philadelphia saying, "Come home." They started out to Brussels on a trip to buy wine but at the station were met by the wine-merchant who said, "Get right back on that train and go home." From Beaufresne, the Gardner Cassatt family escaped to Saint-Malo in Brittany and from there to England. Mrs. Madeira asserts that it was 1920 before Mary Cassatt could return to Beaufresne (actually, letters of hers are headed Beaufresne in 1915).

The letters show that by November 8, 1914, at 10, rue de Marignan, Mary was, "with Hilda my Swiss chambermaid, the only tenant of this house." Mathilde was interned at Rennes, waiting for a train to take the internees out of France. "When I paid my bill at La Ferrière" Mary goes on, "they thanked me for my 'joli geste'; no one, or at least but few, are paying their bills. I begin to wish I were in America, but then I would have got there half dead, so Switzerland or Italy must do for me," she then supposes. "After the war no Germans will be allowed in France. What about [servants for] me, then?"

November 11: "Half of the Brussels Museum has been sent to Germany, they have stolen everything at Lille, at Arras, and they fear at St. Quentin! . . . The Rubens' at Malines are burnt! It is too too sickening. Oh! to see that wretched William [Hohenzollern] make away with . . . all his hoard!" November 15: "The D[urand]-R[uel]s are sending all my later pictures over [to America]. I don't see why I should keep my pictures for my family after I am gone"—so she had come to feel, since summer. "I have your letter written after you got my cable. Thanks so much, dear Louie, you were kind to write to Jennie, but they too got a cable telling of [my] change of address, but I have nothing from them. They have their lives to live, and you must remember we haven't a thing in common."

By November 24 Mary had reached the Villa Angeletto. "Mathilde and Julie are in San Remo [Italy]. I could have Mathilde if she would con-sent to Julie's going to her friends in Ulm [Germany] . . . For the mo-ment I have Hilda and a very poor cook, but I can get along. The sun is

what I need . . . If only we have bright sunny weather I will soon pick up
. . . As to the portrait (Mrs. R[iddle]'s), Duret [famous French critic] wants
me to give it to the Petit Palais. Bessie Fisher sent me through Jennie
such very disagreeable messages about it that I have no desire that the
family possess it. Then I sent some water color sketches [to America with
Durand-Ruel]. I called Brown [nickname for Ellen Mary] to see them one
day at Beaufresne. She hardly deigned to look at them; I meant to give
her some for her room, but after that I thought I would find more ap-
preciative people. I painted a picture at Antibes the year she was born
[*The Boating Party*] and wrote I would give it to her; she forgot to thank
me or acknowledge it, so I told Joseph [Durand-Ruel] he might sell it to a
museum [the Chester Dale Collection; at the National Gallery in Washing-
ton]. I don't understand them; after all they know my things have a
value. To tell the real truth, both the girls are Carters, especially Ellen, and
Eugenia is like [a special dislike of Mary's] who is their ideal. To come
back to the water colors, one or two could go to the Exhibition [in New
York for the benefit of women's suffrage] . . . Jennie assured me the ex-
hibition would not be graced by her presence! Think of her assuming to
direct my opinions! . . . As for Mr. S[tillman], he wrote from New York
that he had changed his opinions and that 1915 would see the woman's
suffrage in New York . . ."

Unkindness from her ewe lamb, Ellen Mary, was the last straw: now
that Mary Cassatt could no longer understand youth, she turned against it.
Unfortunately her rancor and self-pity suggest no one so much as old Lois
Cassatt and the way Mary herself might have been, given the same forma-
tive influences, if talent had not come to rescue and heal her.

Early in 1913 she had informed Louisine she didn't feel nearly as ex-
cited about politics as she used to; nevertheless the November 24, 1914, let-
ter cries, "Oh, for the Russians in Berlin!" though the next, December 3,
laments, "The great Russian victory I had so counted on is not to be . . .
The war will be prolonged." She almost reveled in signs of deterioration in
the work of other artists. January 11, 1915, from Grasse, Renoir "suffers at
times greatly, senile gangrene in the foot. His wife I dislike, and now that
she has got rid of his nurse and model, she is always there. He is doing
the most awful pictures, or rather studies, of enormously fat, *red* women
with very small heads. Vollard persuades himself that they are fine. J.
Durand-Ruel knows better." On February 4 Mary returns in a letter to her
obsession with the Riddle portrait: "On no account shall Bessie Fisher ever
own it. She sent me the most decided messages regretting that there was so
little likeness to her mother! . . . Even the worm will turn, and I see no
excuse for her too-evident desire to snub me . . . Edgar Scott [son of
Annie] was crazy to get the picture . . . I wonder if anyone will care for it

at the [New York] exhibition. I doubt it, its home ought to be in Paris where I painted it." Like the brain of the man in Daudet's *Cervelle d'Or*, now that Mary's golden work was done the sore behind it rendered nothing but blood and corruption.

The exhibition held for the benefit of women's suffrage, and composed of pictures by Mary and Degas, opened in New York the spring of 1915. "I am surprised at the coolness I show in thinking of exhibiting with Degas alone," Mary wrote, March 12, "but one thing, Louie, I can show: that I don't copy him in this age of copying; I cannot open a catalogue without seeing stealings from me . . ." However, she adds, "I am not working." April 14: "This will reach you when the exposition is over. I would be less than human if I did not take an interest in it . . . I do most ardently hope it may be a success, not on account of myself, you know that," she insists, as a male artist, even in 1915, would not have felt it necessary to, "but for the cause of suffrage . . . Degas . . . is just the same, walking about Paris all day long."

By July 5, eyewitness accounts of the show have caught up with Mary in Paris. "Joseph [Durand-Ruel] was here, and as to the exhibition, he said it was the cause which kept people away. 'Society,' it seems, is so against suffrage. Many regretted to him that they missed seeing a fine exhibition, but their principles forbade their going . . . [because] if women voted it would be for peace at any price . . . In fact [Durand-Ruel is] a goose—not too great, though, to take advantage of Degas still . . . I am so glad you spoke to all those people [in the speech Louisine gave opening the show] surely it will do good. Do you think if I have to stop work on account of my eyes I could use my last years as a propagandist? It won't be necessary if the war goes on, as it must. Women are now doing most of the work. I never felt so isolated in my life as I do now. Your letters are the only things that make me feel not altogether abandoned."

On June 19 [1915?] in a letter about "Psychics" and reporting that the heart trouble James Stillman was stricken with remained the same, Mary had first mentioned an eye condition more serious than conjunctivitis. "As to my eyes, Dr. B[orsch] says the cells are very young yet . . . therefore I must have patience and above all try and keep well." She had in fact begun developing the cataracts for which she was operated on several times in ensuing years, seldom with any success.

A present-day Roentgenologist asserts that exposure to radium can definitely cause cataracts. Those inhalations Mary took in 1911 were reason enough. Not all who received radium treatments, however, subsequently went blind, and the incidence of blindness among Impressionists, as has been noted, went far beyond the level of coincidence. It is legitimate to venture the not-very-daring flight of speculation that Impressionism's radi-

ant light in some way struck those painters—like the truth, Oedipus—blind. They were the last painters, moreover, to look out directly at the light.

The Post-Impressionists—even Cézanne, that proto-Post-Impressionist —were pioneers in a trek to the interior which has slogged on even to this day; for many painters, the sun might as well never have shone. Subjectivity becomes objectivity when a real curtain is drawn across the chasm between one real mountain and another; and the conceptual painter does not even need that much communication of the truth of his insights. Of course an artist does not exactly choose what he is going to see, or how he sees it. His vision is given him; all alone he sees what the world sees, only before the world does. Mary Cassatt, dead set against modern art, nevertheless responded, beyond her control, to trends. Instead of Matisse's way of seeing, or Picasso's private universe, what she was given was darkness. If she had been able to paint that, it would be immeasurably interesting to know how it looked.

Her eyes deteriorated rapidly. In a letter to Louisine on July 13, from Beaufresne: "My sight is so enfeebled I cannot read even large print." August 21, cable to Mrs. Havemeyer from Paris: "Am here care of oculist must not read or write." By September 8, another cable describes her condition as iritis (inflammation of the iris of the eye) with adhesions, being treated by a celebrated oculist who was succeeding in avoiding an operation. Then, on October 15, a letter to Mrs. Havemeyer from Dikran Kelekian, a highly knowledgeable picture agent the ladies patronized, announces: "You no doubt know that [Miss Cassatt] has been suffering from her eyes, and last Sunday [October 10] she underwent an operation. I am glad to be able to tell you that she is getting on very well, yesterday she got up on the sofa for half an hour. I have not seen her yet, but the nurse said she was very brave. In fifteen days they will operate on the other eye, when I hope she will be altogether cured." It was well into 1916 before Mary could resume her side of the correspondence with her friend.

When Mary Cassatt's letters recommence, there had been a great change in her handwriting. It is not merely that the letters were crudely formed. The writing had become sharp, angular, the vertical lines heavily accented. The crudeness increased, though characteristically Mary insisted on writing her letters until long after she could see to write them. Everything else sharp and angular about her increased too. In June 1916—the first letter after her operation—she denounced Pierre Lefèbre, for the coachman-chauffeur "whom I thought the most faithful and devoted servant, has been deceiving me terribly," and by July 7 he has become "the most deceitful and falsest creature you can imagine . . . Money is his God." Sharpness shows up in another grievance dwelt on: "George Biddle told

Ellen she ought to be ashamed of herself never to have gone to the exhibition last year [in New York]. She blushed, but what do you think of Jennie not sending the girls? I must sell all my things, I mean all I own, so that they will not undersell them."

Biddle, whom Mary first met in 1911 and who was at one time in love with Ellen Mary, had, with Abram Poole, another young painter, just spent a day at Beaufresne, having bicycled over from Giverny for lunch; they were on leave from the French Army. Shortly before his death in 1973 Biddle recalled, "She gave us White Mountain cake. Wasn't that wonderful of her? To have White Mountain cake for two young Americans? Such a typically Philadelphia thing to have for dessert." The cake seemed to Biddle to represent the warm side of Mary's relations with Philadelphia. The other side was exemplified in her furious antagonism to Cecilia Beaux— the Philadelphia painter who, in her development, followed the road not traveled by Mary Cassatt. Biddle reported that on one of Mary's trips to America, meeting Miss Beaux on the steps of the Philadelphia Museum, she cut her dead. To him Mary always referred to her as "that woman."

Mary was still fuming over how no one from Philadelphia had come over to see the show of her and Degas' work, not even her own family. It was then Biddle told her of Ellen Mary's blush. In 1973 he recalled that, when he would sit out with Ellen, and with other girls, at the debutante parties in Philadelphia, they always tried to pump him on whether Mary Cassatt had had an affair with Degas. Even this fellow rebel of Mary's against Philadelphia, even this fellow artist was convinced that she could not possibly have done so. She adhered, he said, to the double standard: men had affairs and went to brothels, but it would never have occurred to her to have an affair: she was a lady.

Ever since some occasion when Degas, in dealings over a picture with Mrs. Havemeyer, had not been entirely aboveboard, Mary spoke of him, Biddle said, as though he were her chauffeur-coachman. At the same time "artistically, she worshiped Degas," and pointed out details in his paintings with a kind of ecstasy. "Look at that landscape—the background!" she would cry. "Just like a Vermeer. Vermeer was no better!" Such divided vision was, Biddle felt, characteristic of her; Mary Cassatt could be simultaneously "intellectual, and irrational in argument." Her strong forte, he said, was instinct. Instinct had led her to the noblest in art, to Correggio in Parma, for example, instead of to the École des Beaux Arts.

All Mary had to say about the young men's pilgrimage was—in a letter to Louisine, dated July 31—"George Biddle and a friend came to luncheon a week ago, both painting at Giverny. They are too old to become great painters," though Louisine might have been interested that Poole brought Mary the news women's suffrage was on the platform of both political

parties in America. Domestic inconveniences loomed far larger for Mary than the young men. August 3: "It is hard for a suffragette like me to have two of the most incapable and lazy women in France here. I kept them on account of the husband [of one] and as the wife could not stay alone, her mother, a perfect terror, is with her. They have the impertinence to want my chauffeur who is here as man-servant to take them to Paris and put them on the train there for their homes!"

"When it is a question of being impertinent they can use their tongues. I [always] thought that my duty was to attend to my servants first, but I was wrong. Pierre is a proof, his smiling hypocrisy is the limit. Our weather is still very warm, the cannon not so loud." The letters are still crammed with advice on art and the buying of art. On August 30, for example, her missive concerns possible purchase prices of a number of pictures, including a Courbet. After business is attended to, and reports on her family, and on James Stillman, at a hotel—"weakened physically and mentally"—she exclaims, "Is this wholesale slaughter of men necessary to make women wish an equality such as they never before had? Strange how some women object to a change, and to women taking active part in governing the world, with such an object lesson as this war is of the government of men alone. Theodate said to me the first thing, when I saw her in Paris, 'All this is the fault of the Prussian women who have not known how to bring up their sons.'" Theodate had recently been married to a Mr. Riddle, and Mary disapproved: "Her health alone ought to have prevented the marriage." Besides theorizing, Mary gave bountifully to war causes; helped blind soldiers, entertained officers at Beaufresne; she sounded most herself, now, when she was outside herself. Mrs. Havemeyer's labors for the National Woman's Party were certainly encouraged, even sparked, by Mary's enthusiasm. Mrs. Saarinen's book on collectors tells how "the wealthy, respectable, elderly woman [Louisine was sixty-four when the War ended] her white hair still worn in a dignified pompadour" was a great asset to American feminism; and how, "touring New York State in a little landaulet . . . she called her 'Jewel Box,' balancing a big, fancy hat on her head, she held aloft the 'Torch of Liberty,' and delivered dozens of speeches. She devised a little model of the *Mayflower* which she called the 'Ship of State' ('Women were good ballast on the *Mayflower*, why not on the Ship of State?'). She was especially proud of her dramatic finale. As she said, 'When you give us freedom, my Ship will look like this,' she pushed the button so that thirty-three tiny lights," representing the States, outlined it.

Most of all, Mary's letters dwelt on the condition of her sight. July 12, 1917, from Paris, she related that she was to have had the operation on the right eye that day, but the cataract was not yet ripe, so it was put off.

That operation, as well as the operation due for the left eye, continued to be put off until after Mary had written a letter, dated Paris, October 2, 1917, which begins:

"Of course you have seen that Degas is no more."

The letter is matter-of-fact. There is much more in it about Mary herself and the aid she had rendered his declining years, than there is about Degas. "We buried him on Saturday, a beautiful sunshine, a little crowd of friends and admirers, all very quiet and peaceful in the midst of this dreadful upheaval of which he was barely conscious. You can well understand what a satisfaction it was to me to know that he had been well cared for and even tenderly nursed by his niece in his last days. When five years ago I went to see them in the South, and told them what the situation was, his unmarried niece [Jeanne Fèvre] hesitated about going to see him, afraid he might not like her to come, but I told her she would not be there a week before he would not be willing to part with her; of course she found this true, and now for two years and a half she has never left him. She was at a hospital . . . at Nice and had trained enough to know just how to nurse her uncle. I put her in the hands of . . . one of the well-known Paris notaries, and thanks to his advice everything is as it should be, for Degas' brother had meant to have everything and rob his sister's children of their share. One sometimes can help a little in this world, not often. There [will] of course be a sale. The statue of the 'danseuse' if in a good state you ought to have. Renoir spoke of it enthusiastically to me. It is a very fine and original work. Of course M. Duret has written to you about the Veronese," she continues, out into the wild blue financial empyrean, "It is not the old masters which are selling dear but the moderns. I have just had a Courbet brought to me to look at, a very fine nude, price 125,000 francs . . ."

Sentiment, on the other hand, pervades Daniel Halévy's account of Degas' death. Helévy had never—not even during the Dreyfus affair when the painter cut himself off from the Halévys—let anything stand in the way of his love for Degas. "The very night before my [army] orders came, Degas died," his memoir reads. "In the evening I went to his apartment. I looked at him for a long time and remembered far back. Oh, the kindness of this mask, idealized by old age, emaciated by illness, calmed by death. The long hair, the long beard—a Christ, throughout my childhood . . ." Halévy was able to obtain a delay in reporting to the Saxe barracks, in order to attend the funeral.

"Few people in the church, but why should there be more? The Rouarts, Mademoiselle Cassatt (I believe [Degas' friends were not sure of Mary by sight]) a hundred people at most [including Monet, Jean Bérard, Jean-Louis Forain, José Maria Sert, Raffaëlli, and two Durand-

Ruels]. The music beautiful, moving, but the real emotion lies in death itself. The ritual music . . . dilutes the true, the shocking significance of death. When the clergy withdraws, when the organ is silent, and the body in the coffin remains alone, surrounded by friends, then nothing is left but death, the snatching away, the destruction, the end . . . Poor Degas, so much loved, here all alone. A corpse, poor flesh that quivers in the coffin when the pallbearers carry it away! We surround him, we follow him, we put him in the ground.—

"That stone lies heavily on my past."

Behind the ferocious barricades Degas put up in his lifetime, behind his art's "primitive syntheses" of sex and fear, the heart that had stopped beating knew love. He loved to quote the arch-artist Da Vinci's saying, "The very appearance of beings is intended to lift others up to love." In the end Mary Cassatt, behind her own prickly barriers, knew it too: shortly after the funeral George Biddle got a letter from her that called Degas, "My best, my only friend."

Degas' barricades, his syntheses, his love even, meant less to him, however, than an entity so minute its existence was doubted even in his day. Yet upon the driftings of this entity, like a cloud, like a feather, he, like any other committed artist, was entirely dependent for his life work; the difference was, he knew it. Jeanne Fèvre phrases it, in her memoir, that *mon oncle* knew too well the spirit is what inspires, not to believe in God. She describes Degas as deeply religious, and claims he often remarked, "It is necessary to die in religion." If he did, he, not formally devout, was expressing his sense that, even beyond the life in art, a destination beckons to the soul.

SEVENTEEN

F OR A WHILE after Degas' death, everything went along the same. The voluminous correspondence with Louisine, into which Mary poured out her views on art and women's rights, served as outlet now that she could no longer see to paint. The friendship was almost everything to her now, and Louisine and Louisine's family so close to her heart that around 1920, for instance, she gave a large number of her pastels to little Electra Webb, Electra Havemeyer's daughter, Louisine's grandchild. Today this Electra, now Mrs. Dunbar Bostwick, recalls of the Mary Cassatt who gave them to her that she was "terribly frail and old, old . . . Not realizing the value of those pastels I wasted lots of them on playing, and swapping them with my friends." Paris was full of other friends of Mary's who were, for one thing, more intellectual than Louisine; but they did not mean to her what Louisine did; and to Mary Cassatt, outside of art, meaning was everything. It seemed as if Louisine was her life's friend.

She was not one to cry over spilt milk. If she couldn't paint she would busy herself with whatever was left. Her letters did not exactly mourn Degas' death, but they were full of the sales which followed it. On May 9, writing from Grasse as the authorities would not permit her to return, as she usually had, by this time, to Beaufresne, now near the war-zone, "I send you . . . this . . . account of the first day's sale of Degas' atelier. The prices are high, for there was nothing of his best. When one thinks of how nobody would buy, when you first began! But that is the way with everything." From that the letter moves directly into women's suffrage. June 25, still at the Villa Angeletto: "I am writing this while I am waiting for Jeanne Fèvre who is coming to stay with me for a day, it is the first time I have seen her since the sale, she will tell me about the wax statues. She is so grateful to me for what I was able to do, but I am equally so to her for the care of her uncle . . ." Same letter, next day: "I saw Jeanne Fèvre . . . yesterday . . . As to the Degas sale, it was perfectly genuine and not one single touch has been added to the pictures or pastels. Even pictures with half the painting scratched out sold for high prices! The explanation is, in part speculation by dealers—some neutrals, some French—and also amateurs, and the revelation of Degas as an artist of not only great talent but great variety.

"Now as to the statue [La Danseuse, the piece Louisine so much admired, and wanted if it were intact] George D.-R. took it on himself

to write me that the heirs would not sell, but it is not the case; they are perfectly willing to sell it to you as a *unique* piece [the suggestion had been made it be cast, so that France might retain a copy if it were sold outside] but the beauty of the statue would lose much if put into bronze as the dress could not be reproduced; the statues are in a place of safety and will not be cast until after the war. The founder [casting foundry] advised Mlle. Fèvre to accept an offer of 100,000 francs, I think 80,000 might be accepted," Mary added, loyal as ever to Louisine's financial advantage. "You will have then to think it over, I only wish I could see it again and especially that you could. The sculpture has made a great sensation. It is more," Mary concluded, just as Louisine said all Paris had, "like Egyptian sculpture."

The course of dickering for the statue ran anything but smooth. September 22, 1918, from Grasse, where Mary had remained all summer: "Mlle. Fèvre was here on Thursday. She told me many interesting things about the sales already made, and those to come. There are to be four sales, beginning in November: one, of the things Degas left of other painters without great interest, and which will be sold at the Hotel Drouot. [Of the sale of the important painters, Mary was to write on May 19, 1919, "I am glad that in the collection . . . I will figure honorably, in fact they thought that two, a painting and a pastel, were his at first."] One of the etchings; she says there are many of these. You have two . . . of course you will want others so I write in time. There are many fine monotypes and drawings touched with pastel, but you have many of these. Joseph [Durand-Ruel] bought for 9000 francs the splendid picture of the steeple-chase. Degas, as you know, wanted to retouch it, and drew black lines over the horses' heads, and wanted to change the movement. I thought these could be effaced but it was not possible. Well, now Joseph has had the lines filled in, no doubt he will sell it for $40,000 or more. I wanted the picture for my brother Aleck and Degas declared it was my fault that he spoiled it! I begged him so to give it [for sale] as it was, it was very finished; but he was determined to change it."

December 8, 1919: "As to the Degas 'Danseuse,' Hebrard, who is to cast it, says it is in perfect condition and only needs cleaning and a new skirt. As to the price, it has not yet been fixed, but every time the sale is mentioned it gets dearer. I think casting may be difficult because the [fabric of the] bodice is glued to the statue." Same letter, two days later, Mary goes on: "Degas' niece was here yesterday evening, they have finally decided on the price for the danseuse, 500,000 francs! When I expressed surprise, she told me that that was only $50,000 and that her uncle's works were rising in price every day. Now, they give you a month to get an answer to me, and then if you do not accept, the statue will be cast, not in

bronze but in something as much like the original wax as possible. As a unique thing, and in the original, it is most interesting; but 25 copies . . . takes away the artistic value in my opinion; they don't think of that. What would Degas have thought . . . ?"

On January 16, 1920, Mary writes indignantly: "As to the statue we feel exactly alike. I would not want one of those 25 chromos. I have written to Mlle. Fèvre to beg her to put off casting the danseuse. I have told her that her uncle is known only to a *very* few people as a sculptor. Let the other statues be cast. There are 60 in all, but Joseph D.-R. says 30 only are complete; then, when Degas' reputation as a sculptor is established, they can sell the danseuse as a unique piece (provided it is in a good state, which Joseph says it is not. They would not allow Kelekian to see it). I shall also write to Joseph to speak to the brother [of Degas], who is beyond anything. The Fèvres, niece and nephews, consider that they owe me a great deal; what I say may have an effect." February 7, Grasse: "Mlle. Fèvre . . . came to see me at last and reiterated that all was right with the statue, and you had only to make 'an offre ferme' without seeing it! As for the brother, who knows all I have done for them, he hasn't found time to come and see me though living only 12 miles off!"

Then, on April 18, 1920, from the villa, Mary explodes: "Jeanne [Fèvre] has just been here. Degas' brother refuses to sell the statue for less than one million francs, they have had an offer of 700,000. You will know what to do. When I think that for years you were the only buyer! Well, the world is a fine place, just think what [Degas'] life was. The brother's illegitimate children will get all, the others nothing. The brother is what he ought to be for this fraud . . . I hope when the world is governed by women it will be better." (The dancer statue did end up in Mrs. Havemeyer's possession, and is now in the Metropolitan Museum.)

Mary's concern with collecting was run a close second by one which, willy-nilly, is that of all the old: the deaths of friends. James Stillman died in March 1918, and on August 22—that was the summer spent in Grasse— Mary is writing that Georges Durand-Ruel told her he had "information" that Stillman's collection would be sold. "Amongst the moderns is that fine little nude of Courbet's which you want. As for mine, there will be many, 24, which when sold at auction may not bring much. My day is over for caring"—or so she imagined. "Are his daughters so in need of money as to sell all the things their Father owned? I know he advised them to give the Titian to Trotti to sell, Nicole told me so. Nothing for the Metropolitan! The Titian and the two Manets will bring twice the amount he paid for them. I wonder if the Mother can return to New York now. I don't think she could before. Her allowance was $15,000 a year," Mary goes gossiping on, "What curious lives people live, lives that as Browning

says 'hang patchy and scrappy' . . ." (In the end, his children have given much of James Stillman's collection, including several Cassatts, to the Metropolitan Museum.)

In December 1919 Renoir died. On the fourteenth Mary wrote Louisine from Paris, "His vitality was certainly extraordinary, and his pictures, bad and good, will sell very high; you know what the last were; the early ones will remain . . ." February 7, 1920, picking up the theme, she observes: "Manet's pictures are not going up much, and of course the later Renoir will and must go down; for the last 20 years he has done nothing worth having. Age tells, especially when there is no drawing." The unsoundness of this prophecy is only exceeded in Mary's September 8, 1918, letter in which she said: "René [Gimpel] went to see Monet and found him at work on large panels of water lilies. One would have to build a room especially for them, I suppose. I must say his [*Les Nymphéas*] pictures look to me like glorified wall-paper . . . I won't go so far as D who thinks he has done nothing worth doing for 20 years; but it is certain that these decorations without composition are not to my taste. Impossible to hang these with other pictures; alone, they tire one."

Not only friends died but, in 1920, an old enemy. From Grasse, January 16, Mary wrote Louisine that Lois Cassatt's death was "not unexpected, though she fought to the last. At one time she could not move head or foot; one of her doctors told my nurse in Paris in September . . . far rather death than her state. She was an unhappy woman, and made those around her unhappy. We have strange destinies, and we don't choose our own ways, 'there is a power which shapes our ends might live them as one will,'" misquoted Mary with characteristic abandon. "Poets have instincts certainly. I have been intensely interested in Tolstoi's novel *War and Peace*; the rereading of it after this war makes one think. My belief is that Russia will give us fine things yet. It is not possible that a nation producing such writers as Tolstoi has not a great destiny, the efforts to put Christianity in action is fine; then we don't know what is going on there . . . The extraordinary thing is the horror of the French at this Russian Revolution, and their protests that the French Revolution was mild! With all the Terror, and the guillotine working in every town . . . it seems that it was only sugar and water! . . . At home everyone is dancing and amusing themselves and the young men bring their whisky flasks in their pockets!"

March 22, Grasse: "Jaccais [doubtless Mary's misspelling for one of the brothers Jacquet, well-known engravers and etchers, who exhibited faithfully at the Salon] is here . . . What a man! One thing he avoids above all . . . responsibilities; he wants to talk, to amuse himself . . . I lent him books, you should have heard [him] talk of Tolstoi, he appreci-

ates him as a great artist and says Russian literature is the only one based on a moral sense. But where is the morality in [his] case? I wonder if he calls us Louie and Mary behind our backs. Everyone else is called by their Christian names." It is this letter in which Mary gave her cry of the heart, "I have not done what I wanted to, but I have tried to make a good fight of it." April 10: "I am plunged in Tolstoi's literature and life. He is an artist like Courbet. Such power and such realism. Read the book of his son on the life they [led], and it was [in] his own family and his surroundings that he found his models." April 18, "Jaccais can discuss Tolstoi . . . I am going to make him observe that in Russian literature women are quite on an equal footing as men, never a sneer because they are women; that is the reverse of Jaccais, which I shall also [take] pains to observe . . . He is always praising the conduct of men who are good husbands and fathers!"

Mary's dreams of a Russian Utopia reappear in a September 8 letter from Beaufresne: "As for Art nowadays who but the few care? I had a visit from one of the chief actors and his wife the other day, apropos of a dog they have, a Spitz bitch, and I have a dog, so they came here to make a match . . . they had been 8 years in Russia. They told me the actors of the [Comédie] Française could not live on what they earn (500 francs a month) that the Casino was the only thing that paid [here], not of course as in the U.S., that the plays that were written now had [no] artistic merit, so you see Art is down in all branches. These people were enthusiastic about Russia and believe in the future of the country and the race, as I do."

Her bitterness toward the French extended to Durand-Ruel. In the March 22 letter, "I sold to the D.-R.'s all I had left of my dry points and a lot of pastel drawings, and amongst them one unique etching of Degas', un essai wet grain, which Braque had got him to buy . . . in all there were 95 or 100 things. I asked them 10,000 francs for the lot, that was in the spring . . . They refused in the most decided manner, alleging that there was no sale for my dry points and etchings at any good price, the most they could get was $4 or $5. Before coming here [to Grasse] as I wanted a reserve with them, I let them have the lot for 5000 francs; just after that was concluded, I had a letter from a Club asking if for $100 I would let them have something, 'a pencil sketch.' Then came the picture of the man in the boat which I offered to give to Brown [Ellen Mary], she forgot to even thank me; seeing she did not care I sold it for the *very* moderate price of 10,000 francs. Now the D.-R.'s will find a purchaser. I disposed of my sketches because I knew that at least they would be preserved. Now I have another picture in their hands, probably you know it, the woman in shadows holding a child in her arms; if I sell it . . . I want

dollars . . . It seems to me I ought to have $3000. They never got over my selling that round picture to Harris Whittemore for $5000. [because an artist is supposed to make all sales through his dealer] and oh! how they behaved about the pastel you bought. When I told that to Renoir he said they were like that. At that time I was so angry I wanted never to have anything to do with them again. I have done so much for them. Renoir says I saved the house, of course Mr. Havemeyer and you did, but there were many others I sent them . . ."

She was bitter about Philadelphia. George Biddle recalled how she would rail at the city they had both fled. "Miss Cassatt still wanted more than anything else recognition from Philadelphia and her family," he told one biographer. "She was given neither. At one time she had wanted to present to the Pennsylvania Academy of the Fine Arts two portraits by Courbet. [She did present them, in 1914; and was shortly afterward awarded their Gold Medal of Honor.] She felt it would mean so much to the students . . . 'And do you know what the Academy had the audacity to write me?' she shouted. 'They thanked me and added that, by the way, they noticed that the Academy had no examples of my own work, and would I send them something, hi! hi! hi! I told them I had been exhibiting for years at the Academy and they had never asked my prices, although they had funds for buying contemporary American art.'" The outburst itself was pure Philadelphia; with cries of "hi! hi! hi!" would the great ladies of Radnor and Rittenhouse Square express their amazed disapprobation.

Biddle's view is supported by R. Sturgis Ingersoll—Old Philadelphia lawyer and brother of the rebuffed Anna—for many years President of the Philadelphia Museum, whose house and garden are crowded with outstanding avant-garde art. In 1971 Ingersoll observed, "Philadelphians are not really interested in art. The Philadelphia Museum doesn't get much financial support from Philadelphia people." Recalling that Mary Cassatt did not "dawn on" even him until 1923, when he went to an exhibition of the Impressionists at the Louvre, he added that not until 1926— the year Mary Cassatt died—did she "dawn on me as a great painter. I tried to get Robert Cassatt to buy that painting of hers, the one with two ladies seated in an open box at the Opera. Cassatt wouldn't, of course. It's now in the Chester Dale Collection at the National Gallery in Washington.

"About 1950 I suggested to young Alexander Cassatt that he give the Mary Cassatt portrait of old Aleck and his son to the Museum; but Aleck wanted $45,000 for it. Then, one time I wrote to everybody in the Cassatt family asking for contributions toward a fund to buy a set of Mary Cassatt aquatints for the Museum. All the fund *aimed* for, was $2,000. But

the largest Cassatt contribution was twenty-five dollars." Ingersoll's mind returning, perhaps, to an earlier discussion of the possibility of Mary Cassatt's ever having an affair, he added that the Cassatts were all close. "All the Cassatt ladies were particularly chaste ladies," he said.

Cassatts made Mary even bitterer than their city did. When she discovered it was "Elsie" (Aleck Cassatt's daughter, who married W. Plunket Stewart, the horseman) who would, after Lois' death, inherit a Degas Aleck had bought through Mary's advice, her indignation knew no bounds. For Elsie had "told my Mother when she was a girl what she thought of the pictures I had bought for her father, 'Grandmother, we have to look at them.'" she wrote Louisine, who wanted the Degas, from Grasse on April 9, 1920. "Everything was said [by old Lois] to make the children show contempt for my judgment . . . Do you wonder that I feel a certain bitterness, people think I was a pensioner on my brother's bounty; but for the Degas and . . . three Monets he paid 8,125 francs! and I don't think he paid on an average 1,000 francs apiece for the 12 or 14 Monets he owned. I wrote to Rob about the Degas, which is one of Degas' finest, and told him the price I had paid for all the pictures, and that I thought considering what I had done they might give you a preference. Elsie is impossible, there is nothing to be done with her. There are two figures by Monet, the head with the white veil and an Italian woman with her arms crossed; and a *very* fine Manet, Dutch fishing boats. I hope Rob won't sell his too, it is too bad if he does. I gave two pastel portraits of Elsie for which I have no thanks; perhaps she will sell them if she knew they were of any money value."

In Grasse, April 13, Mary felt depressed by the prospect of seeing Jennie and the two girls for the first time since they fled Beaufresne in 1914. "I confess I dread the visit, they never seem to understand that it may be a strain . . . We have so little in common. Brown has shown such influence, and Eugenia doesn't like me, well, I shall serve as something, they can get their clothes and gloves!" April 28, from Paris: "I am waiting for Jennie, I may say to you and you alone that it is weighing on me. They will be no help . . . Old people need calm, and the whole house will be upset, [when instead] I could give them baths here for [Gard's sake] and food! . . . I had a nephew of Jennie's here this time last year who came for all his meals for six weeks"—the same six weeks, in fact, that Mary was undergoing and recovering from an eye operation. May 18, she writes her visitors "will be here in two weeks. Oh, how I dread it . . . Jennie was just back from Washington when you were in Philadelphia, no doubt to do her best as head of the anti-suffragettes to prevent suffrage! . . . Sat [nickname for young Gardner] is the only one who is affectionate to me, but he has the memory of his father to attach him to the family. Eugenia

does not like me, and what is most distinct in her is a determination to be free—balls and hunting and flirting and hospitals. Well, it is this genera-tion and, alas, the want of traditions . . . if only I could talk to them of their Grandmother, but that I am not allowed to do . . . My dear Louie, no one who is coming here wishes me to be known, they secretly resent my reputation, for which I care so little . . . Pity me, dear, and don't worry about me I shall pull through no doubt, and if I collapse after they go, why, I shall at least be alone."

The visit was not, after all, so bad, and the following autumn another family visitation turned out a brilliant success. Robbie—Aleck's son—with his wife, who had been Minnie Drexel Fell (her middle name a synonym for Philadelphia) "are to sail on Saturday by the *Aquitania*," Mary wrote Louisine November 9, just before they left her. "It has been a pleasure to see them, and to my surprise I found that they were very much in-terested in the pictures they inherited, especially mine; and were so glad that I had given them all the drawings of the family which served me for my aquatints. Then, too, I found a portrait of my brother I had cast aside so many years ago, and which I now see was a good portrait, much bet-ter than anyone else had painted of him. Unfortunately it is somewhat in-jured but not in the essentials, but must be relined, and treated in the coat. I was the more glad to be able to give them this, as Rob got the round Manet which his mother had cleaned; and, of course, Rob and Min-nie would far rather have the portrait, one for each of the boys"—young Alexander and Anthony, their sons.

On November 18, hardly more than a week later, Mary is impelled, in her day's letter to Louisine, to tell the whole story of finding the portrait of Aleck—all over again, in full, with the same relief and joy. It is, she says, "the best that has been done of him" and repeats that it needs restoring, but that "Albert André has promised to fill in a few cracks, and then I send it to Rob; he and Minnie are delighted . . . I have been very foolish in despising my work too much," she carols, "but all artists are like that. It has seemed like old times, to be busy over pictures!"

Even Louisine could not appreciate how desperately Mary did need to be busy over pictures. Despair was more familiar to her today than joy. The previous March 28 she had written her friend from Grasse, "I see less with the eye that was operated on in October than I did with the other with a secondary cataract on it! [Dr.] Borsch knew that it would be so, and spoke of a film that sometimes formed after an operation for cataract even when the operation was ripe, and that it was nothing to make a slit, and then one saw! Which means of course another operation, which equally of course I must submit to; I think the state of my eyes will, I hope, shorten my life. Why must we live when one can so easily go? The

Japanese have no superstition about suicide. I wish I could have Mathilde
with me at the end, but this business in Germany forbids any hope of
getting her here." In her very next letter, March 31, she had cried, "Oh
Louie dear, my eye has another cataract growing, after all his assurances!
Oh dear, do wish for my end; I am so tired." Throughout the years with-
out Mathilde Mary had had to depend on a chambermaid, Hilda, just to
read her letters to her, "without understanding a word." When Hilda went
on vacation, an English nursery maid came in to read.

Now, apparently replying to a letter in which Louisine tried to rally
her spirits, Mary wrote on November 29, "What an irony life is! I ex-
pect to get off tomorrow [for Grasse] with my eyes in no better state. I
am taking piqures given by the doctor, he gives me one tomorrow morning
before starting, to reduce the arterial pressure, which is not high, only too
high for my sight. We die by inches. Yes, my dear, I know that I have
nothing to complain of; do you remember Mrs. Browning's poem—'The
Lost Bower'? You quote Browning, here is his wife.

> "I have lost Oh! many a pleasure,
> Many a hope and many a power
> Studious health and merry leisure
> The first dew on the first flower
> But the first of all my losses was the losing of the bower.
>
> I have lost the dream of Doing
> And the other dream of Done.

"Well, my dear, the dream of done came back again when I redis-
covered my brother Aleck's portrait. It goes to New York in a few days. I
do hope you will see it and let me know if I am mistaken in thinking it
one of my best things."

The poems of Mrs. Browning are today almost unread; this one
deserves reading if only to understand why it meant so much to Mary.
"The Lost Bower" tells—in innumerable stanzas—of a day in the poet's
childhood when she has been struggling, as often before, through brambles
and thickets in an almost impenetrable wood. Already the child knows in
what company she belongs: "The poets wander, said I/ Over places all as
rude," and invokes Chaucer. All at once, in a place where grows a linden
tree, a hawthorne, and ivy, she finds she is in "a bower for garden fitter . . .
A lady might have come there . . . The bower appeared a marvel/With
such seeming art and travail/Finely fixed and fitted was," with "a red rose
and a white rose/leaning, nodding at the wall . . . All the floor was paved
with glory," it seemed, and that the secret of the bower was "a sense of
music/Which was rather felt than heard."

From this state of grace the poet returns to the outside world, "Laughing/I have found a bower today!" and promising herself to return to it regularly; but next day, when she tries to find it, the bower has vanished and was never to be found again. Dealing with an experience familiar to artists, the poem struck a chord heartbreaking to Mary Cassatt.

Whether Louisine agreed with Mary about the old portrait of Aleck, is not on record. In 1921, after one of her cataract operations, Mary had a brief flurry of hope that she was going to see well enough to work, but the hope was soon dashed. Her discovery of old work she was sure was good was followed, however, in a couple of years, by what was at first another joyful surprise.

On the afternoon of October 31, 1923, Mary was lying down resting in her Paris apartment, when Mathilde, who had at last returned, brought in some dry-point plates she had found in the back of a closet she was cleaning out, in what Mary always called her "painting room." The plates, Mathilde assured her mistress, had not been printed, "the majority having work on them"—so Mary later told her side of the story to the curator of prints at the New York Public Library. "I was not able to distinguish the work on account of the reflection on the copper," was how she referred to her blindness, in this letter to Mr. Frank Weitenkampf. "That evening Mr. George Biddle came to see me and I showed him the plates. He told me there was a great deal, and advised me to have them printed, for they had never been printed.

"I took them to Delâtre, whose father printed all you have of my aquatints, soft ground etchings, and some dry points. [Delâtre père had, also, been among the very first to come on that volume of Hokusai prints, used for packing material, that started the rage for Japonism.] Delâtre, who knows my work well, was delighted with the work, especially with the lightness and the sketchy quality of the work. We found that there were 25 plates, in the number an aquatint of my mother of which a few proofs [had] been printed. I then sent two sets to New York and asked a friend to show them to Mr. Ivins"—the curator of prints at the Metropolitan Museum. The friend was Mrs. Havemeyer; and what Mary had written her was that she wanted Ivins to be the first to see the prints, to exhibit one of the sets, and that if the Museum wanted to purchase a set, the price would be $3,000.

When Louisine's reply came it was to say that Mr. Ivins informed her the proofs had been made from old, worn-out plates, and that better prints of the same plates were already in the Metropolitan's print collection. Either Mathilde or Delâtre, Louisine suggested, must have misled Mary as to the condition of the plates—from ignorance or from stupidity, Louisine suggested to soften the hard fact that Mary herself was in no

condition to make any assessment whatever. George Biddle was not brought up.

It was too hard, too bitter, too humiliating. As might have been predicted, Mary flew into a towering rage. She fired off bombshell letters, bristling with exclamations—"I have no respect for the opinions of Mr. Ivins," and "My surprise and anger were great when I was confronted with an accusation of fraud!" As Mary saw it, Louisine had taken sides with Mr. Ivins in order to put the blame for the "fraud" on Mathilde. To all this Mrs. Havemeyer had replied (Mary, still blind with fury, on May 24, 1924, told her old friend Harris Whittemore) "that 'they'—Ivins, herself and a collector who boasts of having all my etchings—were so jealous of my reputation they were going to save me. I answered that I could take care of my reputation and she of hers. I at once cabled to send the etchings to Georges Durand-Ruel. She cabled that [they were already in his hands] but they were not, only one set had been sent, as Joseph D.-R. wrote to me. She had kept the other to show to you and others."

Louisine, indeed, and with the best intentions, had offered the prints for sale. "As to the price Ivins most impertinently fixed," the letter to Harris Whittemore goes storming on, "I was to sign every proof the date of 1923 [as] a series of plates already printed. They have sent me photos of my dry points to prove this. I took them to [Delâtre] and he said what does this prove? I know there may be one or even two proofs of them," she admits, "but I defy them to show me a series." Pride, last stand of the failing artist, was proof against all evidence.

The letter to Whittemore has a postscript as passionate as it was tragic. "In case you should hear I am a mad suffragette," Mary wrote, "please don't believe it. I have allowed Mrs. Havemeyer to use my name far too freely, but as soon as I knew what her party was about, I withdrew my name."

Whittemore replied cautiously, saying that, if he understood Mary correctly, that she was to sign the rediscovered prints with the date 1923, "with the understanding that trial proofs, . . . may have been previously printed," he would "esteem it a great favor" if she would allow him to buy a set, price to be fixed by herself.

In June, Mary answered she was gratified Whittemore wanted to own the new prints, but that she now had absolute proof of the "falseness of the accusation. When the two portfolios were returned to me, I had to have an estimation made [for French customs] . . . Lair-Dubreuil [auctioneer at the Hôtel Drouot auction-house; in France, auctioneer is a position of prestige that carries the title Maître] had to examine them, and of course he made an estimate as low as possible. He then told Joseph D.-R. that he had never seen these etchings, [only] the aquatint

of my mother, but . . . I knew that one had been seen." She declined to sell Whittemore prints signed 1923, "because that would mean acknowledging Ivins is right, which of course I never would. When I have made Ivins acknowledge his error, it will be time enough to think of that." In still another of these letters that repeat the whole long, sorry story, Mary asserted she could produce still another bit of proof: when the art expert Lois Pettanel was shown the prints, he said he had never seen them before.

It was the last wound. She never did admit that she could be mistaken, and she cut Louisine Havemeyer—intimate friend, cherishing confidante—out of her life entirely. It was as if having long ago split off from Degas, whose tutelage seemed such a threat, she now followed a blind instinct to cut free of Louisine. Pride of work was the knife. With it, she could make the breach without one moment's hesitation. She gave up her friend, she gave up all her friend had brought with her—the advising on art, the interest in women's suffrage. In September 1924 she gave up the villa at Grasse. For she was at heart an artist: one to whom art and the making of works of art is the only thing that really matters, and comes first. Even so had Degas felt that, in comparison, pursuits like art expert, collector, worker in good causes, were faintly ridiculous.

At the end of her life Mary Cassatt was left standing alone. However, in the spring Ellen Mary did come to stay with Mary in the rue de Marignan, bringing her new husband, Horace Hare. During the visit Horace was rushed to the American Hospital for a mastoid operation. He made a good recovery, and the emergency only made the family group more united. Among others Mary invited to meet the Hares while they were with her was Adolphe Borie, one of the young Philadelphia painters with whom she felt such a special bond; as the end of her life approached, moreover, she more and more enjoyed the company of young men. It was either on this occasion or one close to it in time that Mary said to Borie, "My mistake was in devoting myself to art, instead of having children."

"I have not done what I wanted to," she had mourned, five years earlier, to Louisine. She was speaking then of art; the conviction permeated her now that she had failed in living. Quite aside from the failure to have children of her own, the devotion she had poured out on her nieces and nephews appeared to have been largely wasted. She believed they cared little, not merely for her pictures but for her. Obviously her love for them, like that for Beaufresne and the roses of Beaufresne, would come to an end the day she died.

EIGHTEEN

IT HAS BEEN often enough noted how old people become like children, how in their end is their beginning. When the *kinds* of children they revert to is also noted, an interesting light can be thrown on sides they never showed in living. When she was old, Mary Cassatt was still burningly rebellious, as positive as ever she was right about everything. Yet another side not evident earlier also showed up. In cutting herself off from Louisine Havemeyer she asserted her old passion for independence; but in turning more and more to the society of young men it was as if she were incorporating the young girl with beaux she had never been, had only painted. Men's company always was what she preferred, underneath the feminism which came into her life when Louisine did, and made a part of separating from Degas. It was as if in feminism she expressed her feeling for Louisine.

In her last years, Mary's feelings toward America softened too. She continued to detest Philadelphia, but now she who had once taken America for howling artistic wilderness was advising young painters not to do as she did, but do as she said; and what she said was, Don't come to Paris. If the advice were given to someone other than a Philadelphian like poor Anna Ingersoll—treated so ungraciously when she called on Mary for advice in 1920—it could be warm and friendly. In a letter to a young Utica, New York, art student, Helen Walcott, of April 12, 1921, Mary wrote from Grasse: "I think the essential thing is to give oneself as good an artistic education as one can. I avoided the students' quarter and saw many museums in Holland and in Antwerp and of course in Italy, in the smaller towns, always working and trying to find my way . . . My advice to you is not to stay in a place so far from art as you are . . . Live where you can see pictures . . . I think any provincial museum where there are half a dozen good Old Masters is a better place to study than Paris." She besought George Biddle and Forbes Watson—another of her young men—to 'shout from the housetops' to American art students, "Stay home!"

Watson, art expert and editor of the influential American *Art News*, of all her young men saw her most discerningly and with most love. He saw her first at Beaufresne, where he was asked down for the day. At that time, 1913, she was still physically active, and Degas was still in the world. As soon as Watson got there his hostess started talking a blue streak, he related in a memoir. She talked about her great contemporaries

in art—with sadness, of Degas' growing addiction to following funerals through the streets of Paris. (Watson, in conversation years later, said he and George Biddle had both always been dying to know whether Mary had had an affair with Degas, but never dared to ask.) She spoke of Monet's lack of mentality, of Renoir's "being like an animal," not in reference to personal morals but meaning that his feeling for art was entirely sensual. What struck Watson most of all that day was the breadth of her interests. "Instead of trotting out her own pictures" to show him— influential art editor though he was—Watson recalled that she drove him over in the afternoon to nearby Beauvais to see the stained glass.

One impression Watson got coincides with Biddle's: that she looked "not at all like a 'lady artist' but like a dynamic grande dame, voice raised often in anger." When the conversation turned to politics, as it often did, she would bang her fist on the table. As they tooled along in the Renault behind Pierre, Mary reminisced about the days when she lived alone in Parma to study Correggio. Gradually it was borne in upon the art expert that this old woman had worked out her own artistic problems for herself in the galleries of Europe instead of in Paris ateliers. It was further borne in on him that she had been almost the only American art student in Paris not to be overawed by the Salon system, and the only one who had embraced Impressionism from the start. It seemed to him, Watson recalled, that she had never allowed the world of Society to distract her from the very hardest tasks of the very greatest artists.

That day made him Mary's devoted admirer. One thing he was to love about her was that, though she received many artists at Beaufresne, she made no effort to conceal her contempt for artistic triflers and loafers. Her love of art was ferocious, uncompromising. It was during this period that Mary told Watson the only way a woman artist could accomplish anything was by a devotion to art capable of making "the primary sacrifices." When Watson went away after his first visit he—not for the last time—felt his own conviction of the importance of art strengthened. He had been made to share the old painter's hatred of what she called artistic lying and compromise. He got the feeling then, and he never lost it, that being in her company intensified his own thirst for more and ever more knowledge of art.

Another younger man to become an admirer was the sculptor Augustus Saint-Gaudens. In his *An American Artist and His Times*, Saint-Gaudens constructs a rather special portrait of Mary Cassatt around 1920: "Almost blind as she was toward the end, she never seemed to realize how dark was her . . . apartment . . . Here at these luncheons . . . was a kindly, forceful hostess, a woman fond of youth but secure in the authority of age, and charitable as to the local French pictorial eccentricities

that American stock-brokers and their wives were buying, at a fantastic price per square yard, and hiding under beds and bath tubs. Miss Cassatt neither exploded with joy nor grew bitter in criticism. Brilliance in art, she was sure, came about as often today as yesterday. She knew that she would recognize it when she met it. She wanted what she wanted when she wanted it, and what is more, succeeded in getting it." Mary charitable? Neither exploding nor bitter? Philosophical about the moderns? *Mary?* One conclusion to draw, is that Saint-Gaudens was suffering from the kind of rose-glazed blindness lovers do. Also old ladies tend to put their best foot forward when a young man appears, which would account as well for serving the White Mountain cake to George Biddle and Abram Poole, and for Biddle's insistence that Mary Cassatt was all in favor of modern art, when everyone else, and Mary's own letters to Louisine, report just the opposite.

As far as the American collectors who hid their Paris acquisitions "under beds and bathtubs" go, an amusing sidelight on the history of the famous Havemeyer collection is that Forbes Watson, at the end of his own life, recalled that, when he went, sent by Mary Cassatt, to look at the Havemeyers' *View of Toledo* by El Greco, Mrs. Havemeyer, after receiving him with graciousness, had "her man" take them up to the attic, where the Greco was stowed behind a trunk. The Cézannes, too, were in bedrooms, hidden behind the headboards of beds; "her man" pulled out the beds so they could have a better look. "My friends don't like these," Mrs. Havemeyer explained as she led him down to the proper galleries.

As Mary's practice of art became a thing of the past, places where she lived took on an ever more vital importance to her: home, after all, could always be created. The rue de Marignan apartment, first taken in 1887 on account of the elevator for Mrs. Cassatt's weak heart, had carried in that first lease signed by Robert S. Cassatt a rent of 5,700 francs. Between 1895 and 1910 the rent was reduced to 4,500 francs, but it rose gradually until in 1922 it reached 9,500 francs, rent in each case to include water and fuel. The lease describes the apartment's facilities: one salle de bain (for five bedrooms), one cabinet de toilette (not the same as the former, which was literally a room with a bath) and a water closet (likewise meaning what it said; the cabinet de toilette held merely a washbasin). Besides two, later three, additional bedrooms for servants, two cellars were included. Rents were to be paid in four installments throughout the year. Lessee, described as "bourgeoise," was not to keep dogs, cats, or birds, though in fact Mary Cassatt always kept dogs.

It is hard to believe advantage would be taken of the blindness of such a longtime tenant, but that is suggested, by a jump in rent, in 1925, to 13,500 francs; quite a jump, since no new amenities had been added.

In the last few leases, signed with a very shaky "Mary S. Cassatt," a section entitled *Conventions Particulières* makes a special stipulation for concluding the lease "en cas de décès de Mademoiselle Cassatt." This, along with other special stipulations in the lease, was initialed with that pitiful "M.S.C."

There was nothing pitiful, however, about Mary Cassatt herself. Besides the sadder changes wrought by age, a wonderful change was also visible, to a discerning observer. Forbes Watson's last meeting with Mary took place in Paris, in late 1920. At that time Mathilde had not returned from the years of internment as a German national in Switzerland and Italy. The young man arrived at the rue de Marignan at eleven in the morning. His hostess informed him she had given up having lunch; after they had talked for a couple of hours, "Run out and get something to eat," she told him.

At five o'clock they had tea, a proper tea served at the dining-room table. While they sat sipping their tea and eating, the old lady urged Watson to help himself to jam—"If there is any jam on this table." There was. There was a pot of strawberry jam, but not until that moment in the course of their long day together had Watson taken it in that Mary Cassatt was quite blind.

She was still talking a blue streak. Although from the moment Watson got there she had been firing questions at him about the state of art in America, politics kept breaking into her train of thought, and therefore into the conversation. The war was over, but Mary was violent about war's aftermath; she was not against the Germans so much as against Clemenceau—her erstwhile friend—and Wilson. Forbes Watson told a friend that Mary called Wilson "a syphilitic son-of-a-bitch," and then put her hand to her mouth and said, "I suppose if I were a lady I wouldn't have said that." She was against all politics except Socialist politics. Sitting in that apartment she could no longer see, yet more than ever needed and depended on, she suddenly remarked with force, "If I were not so old and weak I would throw all this away and live without luxury."

Her new side Watson expressed by saying she had taken on a different air: not the air of a society woman at all, but, except for what he called her intelligent hands, that of a skinny, bent, overworked old Puritan. "She looked like an old wife gone blind after years of incessant domestic drudgery." And so she was. "The act of creation calls for supreme energy, will, and sustained effort . . . for a lifetime," wrote William Rothenstein. Mary Cassatt was worn out by unremitting labor— on a domestic scene—for almost fifty years. The scene had never appeared in her work until she met Degas, and it is eerie, too, to reflect that Degas again and again painted women worn out with "incessant

domestic drudgery," as if he were painting the portrait of the Mary Cassatt he loved. This side of her was what survived; this was what, behind the mask of imperious Philadelphia grande dameism, that cheeky, durable little girl had become. Now it opened out into the light of Watson's affection like the roses at Beaufresne of which Armand Delaporte wrote, after Mary's death, "No one but Mademoiselle Cassatt ever had a right to cut a rose. She always did this herself, when she wanted to make a gift."

From Beaufresne, late in 1925, Mary wrote two letters that reflect as in a pool how her nature was nevertheless divided. Both were to a cousin, a Miss Mary Gardner Smith, who wrote to ask if she might call, not expecting to have her head bitten off. The letter she got back (she had to write again even to get that) snapped:

My dear Mary,
Of course I had your letter, but I never thought of answering it. If you knew what my life was, you would not expect it, ever. Ever since my mother's death thirty years ago I have been alone, carrying on this place and working here at my art.

Of course I have been better known as an artist in France than in the U.S.

If you would like to write anything that you think I would [be interested in] I shall be glad to know it, but I am a very busy woman. Most of my correspondence is done in French through my maid who is French, she has been with us 43 years therefore is a member of the family.

In the meantime I send you my kind regards and hope that next spring if I am well enough you will come out and see me. I had my three nephews and one niece here this last summer. Ellen Mary has a daughter born Sept. 9th. Eugenia also is very happy, married to Charles Davis.

Affectionately yours,
Mary Cassatt

Shortly after receiving this, Miss Smith got a second letter, which, coming from Mary, amounted to an apology:

My dear Mary,
I sent you a few lines which ended very abruptly. I had a sudden stoppage of circulation and could go no further. I am better now and send forth my excuses.

Affectionate cousin,
Mary Cassatt.

Enclosed some violets from Beaufresne.

One of the last people to see Mary Cassatt was George Biddle. He came down to Beaufresne one bitterly cold, rainy, January day and all but failed to see her at all. That morning Mathilde had sent a telegram, countermanding the invitation from Mary written in her now violently shaky, irregular hand; but the telegram did not reach Paris until after he took the train. From a note Mathilde had slipped into the invitation, Biddle was already warned that his elderly friend, greatly failed, could, for example, no longer walk unsupported.

Even in those last days, however, nobody could have called Mary a tremulous old lady. Armand Delaporte told years afterward how, walk alone or not, she in any event expected her daily drive in the landaulet. She "severely reproached" him if he ventured to take some other route from that she preferred, and they drove regardless of weather. Mademoiselle was never cold. Mademoiselle insisted the Renault be kept in perfect running order. As Armand put it, "Mademoiselle did not permit a breakdown."

That January day, Mathilde met Biddle at the château gates, after he walked down the hill from Mesnil-Théribus in the rain, bringing him the news that her mistress had been sick all night. For twenty-four hours she had been unable to take food. However, since Monsieur was already here . . . Perhaps Mademoiselle would see him later . . .

Biddle had lunch downstairs. Afterward he was shown up to Mary's room—the middle one in the string of bedrooms opening off a long corridor that runs the length of the château. In his autobiography, *An American Artist's Story*, he described the meeting: "She lay, quite blind, on the green bed I knew so well from the painting in the Metropolitan Museum and from other paintings . . . She was terribly emaciated. Her thin gray hair straggled from under the lace cap, over the blue veins of her high white forehead. Her hands, once such big, knuckled, capable artist's hands, were shrunken and folded on the quilt. When she began to talk they waved and flickered about her head, and the room became charged with the electric vitality of the old lady.

"'Well, [she shouted] Have you ever seen such weather? My doctor says that in forty years there has not been such a storm.'

"She was terribly put out that the weather prevented her coming down to lunch," Biddle recalled. "She would have ordered chicken, but really hadn't expected me at the last moment . . . She hoped the Château Margo [Biddle's spelling] was really good . . . It was the last bottle in a case . . . presented to her by her brother just before his death some fifteen years back." That would have been Gardner, whose death she never got over.

"Miss Cassatt as usual did all the talking. Her mind galloped along, shaking the frail human body lying propped up, thin and impotent. Every few minutes her memory would fail her, and her face became tortured in the effort to recall or concentrate on a word. She writhed about, frantically snapping her fingers. The faithful Mathilde leaned over the bedhead, painfully intent on interpolating the missing links of the conversation. She could almost read her mistress's mind, and would make hurried suggestions to the snapping fingers. Miss Cassatt would pounce upon the right one and gallop along in her talk."

This recollection was published in 1939. In 1971 Biddle, himself an old man, added that when he saw Mary Cassatt he thought she must have a high fever. She kept raving about those dry-point plates—how everybody had made a terrible mistake over them. They were, too, unprinted! No matter what anybody said! The opposite had been put about by a cabal, a conspiracy against her, she insisted to the man who came to see her the evening of the day Mathilde found the plates and encouraged her to believe in their originality. She kept saying over and over, furiously, "I'll show those people . . ." The words could have been the motto of her life. Biddle said he had the feeling that Mary was dying.

It was because of the rejection (as Mary saw it) of the dry-point plates that Louisine Havemeyer was not at the bedside when Mary Cassatt died. Mary never forgave Louisine, for all it had been Louisine who rescued the portrait of Mrs. Riddle—that other rejection—when it had for years lain stuck off in a storeroom; who had brought it back into the world of art. That rejection, too, rose to haunt Mary Cassatt at the end.

Shortly before she died her mind began wandering. A young cousin, Anna Newbold, daughter of the Mrs. Newbold whose portrait Mary painted in America in 1898, who had never met the painter but was the only relative of the dying old lady's anywhere near, came down from Paris to see her. To Anna's great confusion, Mary took her for her Grandmother Scott, the Annie Scott who had been so nasty about the portrait with the nose, all those years ago. That wound had become part of the original wound, dealt to a little girl, that started her off on an artist's career in the first place; the same wound reopened by Egypt and Gardner's death; the wound that never quite healed.

The manner of Mary's dying was described, in 1952, by Armand Delaporte. "Four people were close to Miss Cassatt the day of her death, June 14, 1926," he wrote, listing himself, chauffeur to Mademoiselle since 1922; Mathilde Vallet, forty years in service to Mademoiselle, as housekeeper and lady's maid; Hilda Surbeck, cook, for fifteen years, and Marthe Brune, chambermaid, of a mere few years' service. "The servants both in-

door and outdoor were happy with her, and all loved her." At "eight o'clock in the evening, her last breath was drawn in Armand Delaporte's arms, in the presence of Marthe Brune." Eight o'clock of a June evening: Beaufresne would have been bathed in evening light, its birds flying low in brooding scallops, its insects tuning a summer threnody.

"For a long time Miss Cassatt had diabetes," Armand continued, "which imposed on her a most severe regimen which she rigorously observed. She had a great desire to get well and to live. [She] had given orders in case of her death to open a vein. This was done by Dr. Gillet [of] Auneuil, Oise.

"Miss Cassatt is buried in Mesnil-Théribus in the family vault, the care of which I have taken upon myself out of gratitude during the time I continue to live. In this tomb are placed her father, mother, brothers, sister . . .

"Miss Cassatt had a most imposing ceremony (of the protestant religion) with military honors in view of her Légion d'Honneur, accompanied by the Mesnil-Théribus band." In their uniforms, the band led the procession, of elegantly dressed neighbors from nearby châteaux, village worthies in their best, mourning servants, as it wended its way as is the custom in France, up the hill from Beaufresne and along the road through Mesnil-Théribus to the cemetery. "She had a splendid turn-out," Armand wrote, "and quantities of lovely roses. The day of her burial was sullen, gray and raining, but during the funeral procession" as it neared the old graveyard "there was a clearing."

To this description Armand appended names and dates as they appeared on the tomb:

<div align="center">

SÉPULCRE DE LA FAMILLE CASSATT
Native de Pennsylvanie
États-Unis d'Amérique
Cimetière St. Louis

</div>

Robert Kelso Cassatt	Lydia Simpson Cassatt
June 5, 1842	July 23, 1837
May 25, 1855	November 7, 1882
Mary Stevenson Cassatt	Robert Simpson Cassatt
May 22, 1843	July 24, 1806
June 14, 1926	December 9, 1891
	Katharine Kelso Cassatt
	October 8, 1816
	October 21, 1895

The date on the stone for Mary's birth remained incorrect until 1952, when Armand wrote his account at the request of Frederick A. Sweet. Sweet pointed out the mistake to him, and Armand replied, in a letter, "You are quite right. I saw at the town hall the date 1845. There is an error in the inscription on the tomb, which I shall have corrected." He did follow the town hall date: and so, just for the record, the date on the tomb is still incorrect.

So ended the life of Mary Cassatt insofar as a good artist's life can be said to end. Early in 1927 Mathilde (devoted to her mistress, all right, but not without an eye to the main chance) held a sale at the Hôtel Drouot auction-house of pastels, oil sketches, and prints Mary had given her over the years, saying, "Here, Taudy, you can have this. It's no good." It was perhaps devotion that prompted Mathilde to hold the sale under the name of "Mademoiselle X"; perhaps some meaner prompting. She retained so many pictures that there was a second sale, probably in 1939; there was no catalogue, so the details are unknown, except that each item offered was stamped "Collection/Mary Cassatt/Mathilde X." Mathilde may be said to have begun the now-flourishing trade in Mary Cassatts, as representative of Impressionism, as investments, sometimes even as pictures.

Since Mary's death, by an ironic working of destiny, America has increasingly poured out the recognition she always felt it withheld from her. Not only do her pictures hold a central position in the Impressionist sections of American galleries, the Philadelphia Museum today boasts of its exceptionally large holdings, steadily augmented by bequests from proud Cassatts. The irony is that American recognition has come in such large measure that it exceeds her current reputation in France, where she was so confident it would endure. Serious French critics tend to think of Mary Cassatt as merely one of the Impressionists, of interest principally to students of that school.

She was destined to become known as America's best woman painter. Yet the man who understood her best, Forbes Watson, in 1954 as an old man scoffed at such a description of her position on the American art scene. "Much more interesting and revealing," he wrote, "would be a list of the men who painted better than Mary. It would be a very short list."

On one of the lowest days Mary ever had she repeated, in a letter to a friend, lines which conveyed her despair: "The day of my destiny is over, the star of my hope has declined." But it was not true. Like some purring, undying dynamo, her destiny has continued to fulfill itself. The history of Mary Cassatt's achievement is the history of how her talent dealt with successive blows as if each had been a problem for art to solve, an exercise in seeing.

One blow, it would seem, Mary never did recover from; and that the last enemy, which is death, was not the first to triumph over her. Of all her blows, the Egyptian experience was most basic to the conception of sex which, penetrating her precociously, never germinated or, to put it differently, healed. Indeed, because for her bliss came from toiling at her art, it seemed she kept it open, like the fakir whose skill lies in turning the dagger in his wound in the bazaar; because she was thus flouting the pattern for creation new mothers know when, of their great joy, conception played the pleasure part, and only labor was pain. It is a pattern which, it would seem, slipped past the life of Mary Cassatt.

EPILOGUE

WHERE THE DRIVEWAY divides to make a circle in front of the Châ-
teau de Beaufresne, a stone bearing a bronze plaque, set between the seals
of the United States and of the Moulin Vert, reads:

<div align="center">

Mary
Stevenson Cassatt
Artiste-Peintre
née à Pittsburgh, U.S.A.
le 22 mai 1843
Décédée à Beaufresne
le 14 juin 1926
A Habité cette Propriété
De 1894 à 1926
Ce Domicile a été Donné
en souvenir d'elle aux
Oeuvres de Moulin-Vert
par sa nièce Ellen Mary Cassatt Hare
le mai 1961

</div>

for it was "my niece"—the favorite, the beloved—who inherited Beau-
fresne. When I went to see it I had already formed a vivid picture of its
artist-owner. I remember lying on a cot after work in my studio at the
MacDowell Colony, when I first suddenly saw the sharp-featured face, the
lips moving, heard the harsh voice speak.

I had been driven through a cold March countryside of partly
bombed-out, still-beautiful pink brick villages. As we approached the châ-
teau its two brick towers stuck up, stark, out of the landscape. All the old
trees, in photographs of the front of the place in Mary Cassatt's day, had
been cut down except for one huge ash tree with five trunks, to the right
of the entrance. Nothing screened the house or its outbuildings from the
road.

I was met at the front door (under the left-hand tower; in Mary Cas-
satt's day carriages swept around to the entrance under a central portico)
by a warm and hospitable Madame Matière, directrice of this one of the
fifteen Moulins Verts that care for familyless or broken-homed children.
Down a vista of bare-looking rooms I saw children—they were very little
children—sitting in class, craning their necks to see who the visitor was.

Madame Matière led me upstairs and down the long corridor I already knew as if from dreams, to where a meeting of the Moulin Vert board was being held. Those present included M. Dupays, Directeur Générale of the organization. After I was introduced around, the conference resumed; M. Dupays had been so kind as to arrange to leave and take me to see people in the neighborhood who were supposed to have known Mary Cassatt.

On our way out I was shown Mary Cassatt's bedroom, the central one of a long string. It had originally had its own boudoir and bath; now it, like all the other bedrooms, was partitioned into much smaller dormitories. Each one held three low, somehow humble little cots and along the wall of the corridor stood a row of miniature sinks, placed low for the children to wash in. M. Dupays told me there were thirty-six children at the present moment.

While we were getting into the car he explained that the Moulin Vert at Beaufresne is used for what he called an observation post; children accepted by the organization are sent first to Beaufresne to diagnose whatever psychological ills they may have arrived with. The Moulin Vert as a whole harbors only deprived children, not feeble-minded ones. Any children found to be retarded are sent to institutions equipped to help them.

The reason all the trees had been cut down, M. Dupays said as we turned out of the driveway and up the hill toward Mesnil-Théribus, was that they were already falling down. The place did look denuded, he added, and that was not a good country atmosphere for children. He hoped that with the help of the Department of Agriculture they could soon replace them with young trees. After Mary Cassatt died, he went on, caretakers left in charge turned Beaufresne into a roadhouse, one of those places motorists stop at for a meal or a night on their way to and from Paris. According to M. Dupays, Mrs. Hare knew nothing about the use that was being made of the place till a woman poet named Dolan wrote her about it, and put her in touch as well with the Moulin Vert. Only the latter is true, according to Mrs. Madeira. The restaurant at Beaufresne was entirely aboveboard, run by heroes of the Resistance. A Miss Rose Dolan did, in her version, supply the name of the Moulin Vert. One of Miss Anne Morgan's ladies in World War I, after the second War she had set up her own orphanage in France, and so came to know of it.

For the rest of the morning we talked to a variety of locals—peasants in wooden sabots standing deep in barnyard muck, old women wrapped in the ubiquitous black shawl of France as they leaned against a cold wind sweeping down the village street. An hour was spent with the granddaughter of Reine, the cook-model Mary Cassatt painted so often. Again and again I was struck, less by the fact that so few of them had in fact met the

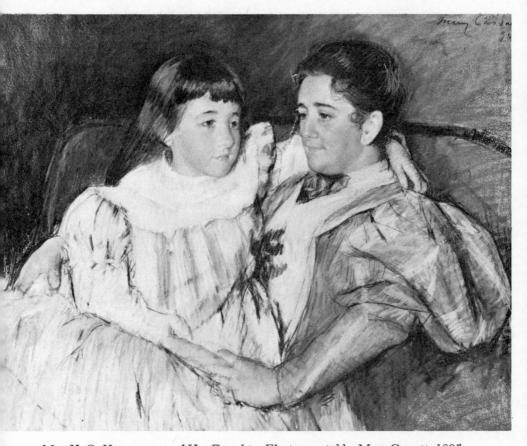

Mrs. H. O. Havemeyer and Her Daughter Electra, pastel by Mary Cassatt, 1895.
PRIVATE COLLECTION.
"Of all the women friends whose company Mary sought after the death of her mother,
Louisine Havemeyer was most intimate."

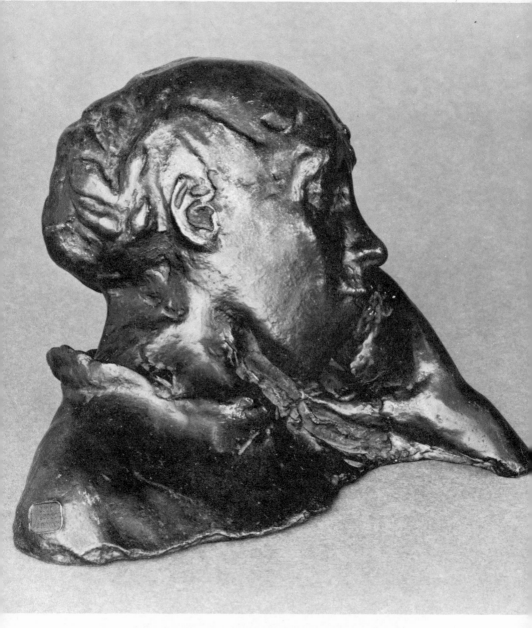

Portrait Bust of Mary Cassatt by Edgar Degas.
COURTESY OF THE MUSEUM OF FINE ARTS, BOSTON.
PROMISED GIFT OF MARGARETT SARGENT MCKEAN.
Whether of Mary Cassatt or another friend is not fully established, but this is one of the
sculptures Degas turned to increasingly as his eyes failed him. His hands, like horses, knew
the way.

Château de Beaufresne, Département de l'Oise, in 1909.

Mary Cassatt's house in the country, showing the now-vanished pond where "the little Durand-Ruels, the little Sailly boy, fished; the pond Mary Cassatt painted."

Left to right: Ellen Mary Cassatt (Mrs. Horace B. Hare), Eugenia Cassatt (Mrs. Percy C. Madei
J. Gardner Cassatt, Mrs. J. Gardner Cassatt, Mary Cassatt.
Photographed at Versailles in 1910 by James Stillman.
COURTESY OF THE ART INSTITUTE OF CHICAGO.
"When Stillman next saw Mary she would be a much altered person."

Mary Cassatt on a houseboat on the Nile, 1911.
COURTESY OF THE ART INSTITUTE OF CHICAGO.
An observer of the Cassatts' trip wrote: "We were glad we had not taken a private dahabeah when we saw how everyone who had one got on each other's nerves."

Mary Cassatt standing in front of the Villa Angeletto, Grasse, 1912.
The villa where Mary Cassatt spent winters near Cannes after 1912.

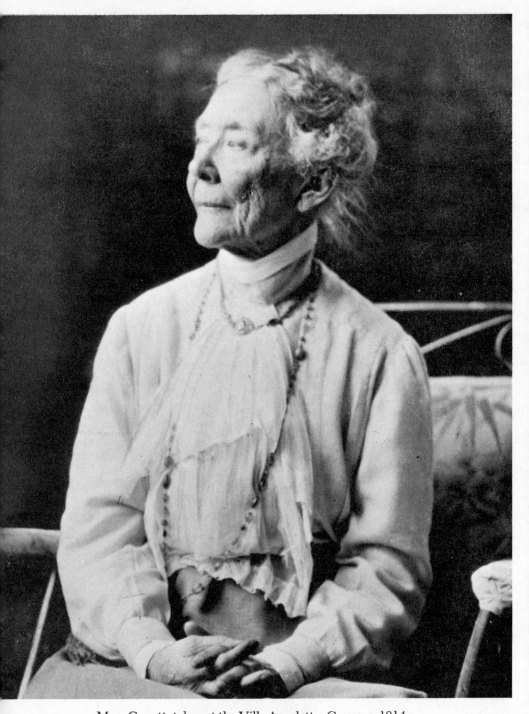

Mary Cassatt, taken at the Villa Angeletto, Grasse, c. 1914.
COURTESY F. A. SWEET.
The artist, by then almost blind, was able to escape to the South of France after
Beaufresne became too near the World War I firing line.

Mary Cassatt taken at Beautresne, 1925.
The year before Mary Cassatt died she had come to look, as a young art-editor friend put it, "like an old wife gone blind after years of incessant domestic drudgery."

artist, than by the way their faces would fall as they themselves became aware that, no, they never actually spoke with l'Impératrice; but Yes!—the faces would brighten—they had seen her often, out in front of the château among the rose bushes. All were of one mind that they had, without doubt, known Mary Cassatt, known her well. For all the unsentimentality of the French, it was plain that Mary Cassatt was a living presence, like the images in religion, a sort of local saint. In speaking of her they seldom used her name; she was the Benefactor, the Lady of the château, the American. She was l'Impératrice.

As we drove back to Beaufresne for lunch their voices made a chorus in my mind, repeating that they could still feel her spirit around Beaufresne. Turning into the drive again it seemed to me I, too, could see the ramrod back, standing among all those roses. When we walked into the château the children were having their lunch and they were laughing. Some sat at tables in the inner rooms; the younger ones were out on the glassed-in gallery where Mary Cassatt used to take her distinguished guests to drink coffee out of fragile after-dinner coffee cups. In a moment, the children at one of the tables began singing some French song.

They all looked so happy—infinitely happier than the forlorn little girl Mary Cassatt painted in a blue pinafore. It was true the interior of Beaufresne was now totally graceless. Nothing but cheap reproductions were tacked onto walls where Degas and Cézanne and Japanese prints used to hang. Nothing but crude, utilitarian furniture filled rooms where once Mary Cassatt entertained so elegantly. It was, I thought, the difference between the life in art and the life of motherhood. Every good mother puts her best things away out of reach while the children are growing up. Better a happy child than an unblemished specimen of priceless Sèvres.

I remembered Saint-Gaudens saying that Mary Cassatt wanted what she wanted when she wanted it and, what was more, got it; and how Mary said to Adolphe Borie, "My mistake was in not having children." By hook or crook, in unfathomable ways, her desire had fulfilled itself: little children were growing up happily in her house. It was not true to say she had nothing to do with it. She had everything to do with it. If she had not loved "my niece" deeply, and made Ellen Mary so happy as a child at Beaufresne that when she grew up she cared about its future, what was before me here would not have come to pass.

The Moulin Vert board had finished its meeting, and with the members—some of them teachers, others down from Paris—I went in to luncheon, served in a room at the end of the château; it was not the original dining-room but Mary's old "salle de peinture." I was put beside Madame Matière, who talked of contradictory dates that are advanced for

the building of the château; most probably she said it was begun in 1783 and completed in 1816. Only chickens were raised on the place by the Moulin Vert; that was true in Mary Cassatt's day too . . . During the 1939 War truckloads of German explosives blew up the château just across the river. That was, of course, before the children came to Beaufresne, but it had been a real problem (continued Madame Matière, as a third course was brought in) to know how to clean out the river . . . She launched into the mystery of the roses: "I have never been able to get a single rose to grow here and no one else has. But for Mademoiselle Cassatt there were hundreds."

In my American way I was braced for lunch to be over shortly; already a great quantity of delicious food had been consumed. Gradually I became conscious that this was a French lunch, an affair of timelessness. Better settle back in my chair and enjoy it. The meal did go on, delightfully, for hours.

Afterward the Moulin Vert people went back to work and I went out on the long glassed-in gallery. The children had left it and, like the rest of the house, it was completely stark; there was not one beautiful object on which to rest the eye. I felt that something else was missing: Mary Cassatt. I pretended I was sitting out here after one of her lunch parties, and that she had left the room for a minute. Indeed, the view outside the gallery is much the same as it must have been. The land on either side rises to form a sort of bowl, or deep plate. Many of the great trees of Mary Cassatt's time are still standing; to the right, one of them leans over the stream that runs through Beaufresne. Many country-houses in the English counties have just such a setting. Ruins of a windmill, now armless, stood in the center of the field, which could no longer be called a lawn; Madame Matière had told me the plan was to restore this so-appropriate little building . . . But it was no good: remembering the present owners put an end to my fancy Miss Cassatt was somewhere about. She wasn't anywhere, at least not here. I got up and wandered into the chilly March outdoors.

On the far side of the field the stream meandered along, gently trickling. The land on the other side of it was confined by a zigzag fence; it must belong to a different property. As I stood thinking of the morning, an old man in *bleu de travaille* came hobbling up. I *think* he said he was the caretaker; the generation he belonged to had to be taught their French at school, was one of the things Madame Matière told me at lunch.

As best I could I praised the beauty of the grounds back here. He seemed pleased, and said that the stream used to feed a pond, now filled in, farther along the field. That would have been the pond where the little Durand-Ruels, the little Sailly boy, fished; the pond Mary painted in

Mother and Child in a Boat and *Summertime* . . . Encouraged perhaps by my compliments, the old man remarked poetically that by the stream the pheasant can still be heard to sing both day and night, and the tourterelle to be heard from the trees; at that moment a mourning dove did sound its soft, complaining note. We stood there for a while in a silence compounded in equal parts of peace and the language barrier, and then the old man, with grimaces of cordiality, limped away toward an open shed on the rise to the left. From the direction of Mesnil-Théribus, up the hill, a church bell rang a very sweet, cracked note in the afternoon stillness.

On the near side of the stream stood an old tree that, I had been told, came from California and had thorns said to resemble the thorns in the crown of Christ. The shed into which the caretaker had disappeared revealed a large, exposed manger, of hay, or perhaps straw . . . I checked my thoughts. What was my imagination trying to put together *now?* Some image that involved the shed, the thorns, the humble little cots upstairs? Was it something about the birth of love in great humility? No, that was not it, but there *was* something about this outdoor scene in which I found myself—something not quite earthly either.

I stood staring into the water, watching the wild watercress as it swayed in the current, on this and on the other side of the stream. Something about the great tree leaning over the water, the zigzag fence . . . Something about the birds mounting into the sky . . . It came to me that what haunted my fancy was the pattern on a Blue Willow plate. Not any debased, modern dish, but one of those that English craftsmen at old Staffordshire originally brought, like Mary Cassatt her aquatints, out of a purely Oriental conception. I was contained in the living landscape of just such a Willow plate. This was the pattern my surroundings were cast in; this was the pattern of Mary Cassatt's life.

Look at any Willow plate, and she is there. She is in the larger of the two houses, and in the tree that protects the house on the near shore, filling the greater part of the design. She is in the willow that leans so far over the stream that a limb has been cut off it to maintain its balance; just so she bridged the division by what Degas called, "Feeling as I feel." A vessel comes sailing over, laden with riches—his, but hers also—from the mysterious island she never did visit, far out in the picture, behind the shore that a pedestrian bridge does reach. High in air, the spirits of both sides approach each other, never quite to meet above the stream designed to look like a crack down the middle of the plate, dividing it in two unequal parts.

I thought of the Impressionists' way of looking at dividing lines. They were much concerned with what they called the edges; getting the

edges right. Even color mattered chiefly in terms of what one color became when placed against another. The understanding of form, for them, lay in seeing where the light fell, where the edge of the shadow came. As for line itself, one great Impressionist teacher used to say, "Line *is* the study of edges." He was talking about the kind of line in an Ingres drawing, or Degas' line, or that superb, long, supple line of the nude back in Mary Cassatt's aquatint, *Woman Bathing*, before which even Degas had to ask, "That back, did you model it?" Line like that is not so much what separates different spaces and tones as it is the relation between them.

I remembered how angry I was, when I was beginning the book I was now so deep in, at the young museum man who said, "I see the real value of her life in terms of the enormous benefit to mankind in helping to create great collections of art." I was filled with unreasonable rage— Mary's rage, Degas' rage at the relative valuelessness of doing anything but paint. Yet why was painting so wonderful? What were they all so excited about? Why did they get so angry, when their work meant so much suffering, too?

I had wanted to say then to the young man, "Painting one picture —even a mediocre picture—is more important than collecting a hundred." I'd wanted to say, "You couldn't have any collections at all unless you first had pictures." It had seemed too elementary to say, but I knew I was right. If I had been brave enough to say it, even he might have agreed that, whatever their right relation to him, for Mary Cassatt, things had to be different. For it would be as much of a mistake to regard the artist's wound dividing Mary Cassatt's life as a flaw in it, as to think that about the brook running through Beaufresne. Her division was what gave rise to the impenetrable, spontaneous act of painting pictures, that, like the action on a Blue Willow plate, put life into the pattern.

BOOKS CONSULTED

Atkinson, Caroline P. (editor), *Letters of Susan Hale*, Boston, 1933

Baedeker, K., *Paris*, London, 1867, 1878
Baltzell, E. Digby, *Philadelphia Gentlemen*, Glencoe, Ill., 1959
Bell, Clive, *French Impressionists*, New York, 1952
Biddle, George, *An American Artist's Story*, Boston, 1939
Boggs, Jean Sutherland, *Drawings by Degas*, St. Louis, 1966 (catalogue)
Bowen, Catherine Drinker, *Family Portrait*, Boston, 1970
Breeskin, Adelyn D., *The Graphic Work of Mary Cassatt, A Catalogue Raisonné*, New York, 1948
—— *Mary Cassatt, A Catalogue Raisonné of the Oils, Water-Colors, and Drawings*, Washington, 1970
Breuning, Margaret, *Mary Cassatt*, New York, 1944
Bullard, E. John, *Mary Cassatt, Oils and Pastels*, New York, 1972
Burr, Anna Robeson, *Portrait of a Banker: James Stillman*, New York, 1927
Burt, Nathaniel, *The Perennial Philadelphians*, Boston, 1963

Cabanne, Pierre, *Degas*, Paris, 1957
Canaday, John, *Lives of the Painters*, Vol. III, New York, 1966
Carson, Julia M. H., *Mary Cassatt*, New York, 1966
Cortissoz, Royal, *American Artists*, New York and London, 1923
—— *Personalities in Art*, New York, 1925

Degas, Edgar, *Degas Letters*, tr. Marguerite Kay, New York, 1948
—— *Huit Sonnets de Edgar Degas*, Paris and New York, 1946
Delacroix, *The Journal of Eugène Delacroix*, tr. Walter Pach, New York, 1937.
Dewhurst, Wynford, *Impressionist Painting, Its Genesis and Development*, London, 1904

Faure, Élie, *History of Art: Ancient Art*, tr. Walter Pach, New York, 1921
Fèvre, Jeanne, *Mon Oncle Degas*, Paris, 1949
Fosca, François, *Degas*, tr. James Emmons, New York, n.d.
Fourreau, Armand, *Berthe Morisot*, tr. H. Wellington, London, 1925
Franzosischt Impressionisten, Hamburg, 1970–71 (catalogue)
French Paintings from the Collections of Mr. and Mrs. Paul Mellon and Mrs. Mellon Bruce, Washington, 1966 (catalogue)

Galignari, *New Paris Guide*, Paris, London, 1852, 1868

Gammell, R. H. Ives, *The Shop-Talk of Edgar Degas*, Boston, 1961

Gimpel, René, *Diary of an Art Dealer*, tr. John Rosenberg, New York, 1966

Goncourt, E. and J., *Journals, 1851–1896*

Halévy, Daniel, *My Friend Degas*, tr. Mina Curtiss (editor), London, 1966

Havemeyer, Louisine W., *Sixteen to Sixty, Memoirs of a Collector*, New York, 1930

Kysela, John D., S.J., "Mary Cassatt's Mystery Mural," *Art Quarterly*, 1966

Leymarie, Jean, *Les Dessins de Degas*, Paris, 1948

Lowe, David, "Mary Cassatt," *American Heritage*, New York, 1973

Lynes, Russell, *The Art Makers of Nineteenth Century America*, New York, 1970

Manson, J. B., *Life and Works of Edgar Degas*, London, 1927

Mary Cassatt, Washington, 1970–71 (catalogue)

Mary Cassatt Among the Impressionists, Omaha, 1969 (catalogue)

McKown, Robin, *The World of Mary Cassatt*, New York, 1972

Moore, George, *Reminiscences of the Impressionist Painters*, Dublin, 1906

Myers, Elizabeth P., *Mary Cassatt, A Portrait*, Chicago, 1971

Orienti, Sandra, *Degas*, tr. Rosalind Hawkes, London, 1969

Origo, Iris, *Images and Shadows: Part of a Life*, New York, 1971

Piatt, Louise (Kirby), *Bell Smith Abroad*, New York, 1855

Pool, Phoebe, *Degas*, London, 1963

Renoir, Jean, *Renoir: My Father*, Boston, 1962

Rewald, John, *The History of Impressionism*, New York, 1946

—— *Pierre Bonnard*, New York, 1948

Rich, Daniel Catton, *Degas*, New York, 1953

Rivière, Georges, *Le Maître Paul Cézanne*, Paris, 1923

Rothenstein, William, *Men and Memories*, 3 vol., New York, 1931–40

Rouart, Denis (editor), *Correspondence of Berthe Morisot*, tr. Betty R. Hubbard, New York, 1959

Saarinen, Aline, *The Proud Possessors*, New York, 1958

Saint-Gaudens, Homer, *An American Artist and His Times*, New York, 1941

Sargent, Whistler, and Mary Cassatt, Chicago, 1954 (catalogue)

Ségard, Achille, *Un Peintre des Enfants et des Mères, Mary Cassatt*, Paris, 1913. Unpublished translation by Mary Faith Pusey

Smith, Logan Pearsall, *Unforgotten Years*, Boston, 1939

Sweet, Frederick A., *Miss Mary Cassatt, Impressionist from Pennsylvania* Norman, Okla., 1966

Thoizan, Elizabeth, *Berthe Morisot*, London, 1961 (catalogue)

Townsend, J. W., *The Old "Main Line,"* Philadelphia, 1922

Trevor-Roper, Patrick, *The World Through Blunted Sight*, Indianapolis, 1970

Valerio, Edith, *Mary Cassatt*, Paris, 1930

Venturi, Lionello, *Italian Painting*, Paris, 1951

—— *Impressionists and Symbolists*, tr. Francis Steegmuller, New York, 1950

Vollard, Ambroise, *Recollections of a Picture Dealer*, London, 1936

Wainwright, Nicholas B. (editor), *Philadelphia Perspective, The Diary of Sidney George Fisher*, Philadelphia, 1967

Walker, John, *French Paintings from the Chester Dale Collection*, Washington, 1953

Watson, Forbes, *Mary Cassatt*, New York, 1932

Wechsler, Herman J., *French Impressionists*, New York, 1953

Weyle, Harry B., *Art Treasures of the Prado*, New York, 1954

Wilson, Ellen, *American Painter in Paris, A Life of Mary Cassatt*, New York, 1971

Numerous other articles and catalogues.

A NOTE ABOUT SOME OF
THE BOOKS CONSULTED

Atkinson, Caroline P. (editor), *Letters of Susan Hale*, Boston: Houghton
 Mifflin Co., 1933

Witty letters that reflect a spinster's life lived contemporaneously with
Mary Cassatt's, and from roughly the same point of view. A strong-minded,
opinionated woman of character, Susan Hale was also talented. The let-
ters are amusingly illustrated by the author.

Baedeker, K., *Paris*, Leipzig, Paris, London: Baedeker, 1867, 1878

The way to experience life in a nineteenth-century European city is
to read Baedeker for the appropriate year—as fascinating as and more con-
temporaneously accurate than a historical novel. From the Paris Baedeker
of 1867, when the city had undergone Louis Napoleon's gigantic trans-
formations in appearance, one may learn also where to buy parasols, where
to go to get a tomb decorated, or obtain a list of conjurers (admission 1½
francs). Not least rewarding, in any Baedeker, is its Outline of History—
letting one in on the way history looked at the time. By 1878, the year af-
ter Mary Cassatt met Degas, there had been the "fiendish proceedings of
the Communists during the second 'Reign of Terror' [of 1871] but the visi-
ble traces of these outrages," the traveler is assured, "have since to a great
extent been obliterated."

Baltzell, E. Digby, *Philadelphia Gentlemen*, Glencoe, Ill.: The Free Press,
 1958

Not snobbish or self-congratulatory, as its title would suggest, this
objective sociological study of a social phenomenon has considerable
value, and views its subject from many angles, using innumerable tables
with headings like "Class Language Usage in America as of 1940" or

"Philadelphians in *Who's Who* in 1940—Religious Affiliations as Related to Social Class." Curiously entertaining.

Bell, Clive, *The French Impressionists in Full Color*, London: Phaidon, 1952

Bell (Virginia Woolf's brother-in-law) was one relatively modern critic who thoroughly grasped Impressionism—from the modern perspective. "Impressionist doctrine boils down to this," he writes: "Sensational truth [truth as perceived through the senses] is the only proper study of artists. That of course is nonsense, like all exclusive doctrines. Presumably the proper study of artists is to create art. And what is art? Nobody knows. But the doctrine served its turn; it kept at the highest pitch of excitement a group of prodigiously gifted painters who have enriched mankind with enchanting pleasures." The "full color" of the plates is, as usual, unsatisfactory; compare any one of them with the original.

Biddle, George, *An American Artist's Story*, Boston: Little, Brown and Co., 1939

A long and fascinating account of a twentieth-century painter's attempts to escape, and not only from the elegantly philistine Philadelphia to which he was born. Traces of the rich, swell young Grotonian, throughout the book, suggest that himself was what Biddle was most anxious to be free of. Though factually inaccurate in many places, it is excellent for its portrait of an established Mary Cassatt in her old age; Biddle looked up to her.

Boggs, Jean Sutherland, *Drawings by Degas*, St. Louis: 1966 (catalogue)

Valuable.

Bowen, Catherine Drinker, *Family Portrait*, Boston: Little, Brown and Co., 1970

The Drinker family of Philadelphia, of which this is a loving record, would have been the despair of a psychoanalyst. All of them were driven

by super-egos, all (like, in this, Mary Cassatt) motivated by liberalism at the same time that they drew the most stringent personal distinctions. The ineffable thing about the Drinkers (and a few others in the old cities of America) was that they did not feel superior, or that other people were inferior. In fact their very essence was high-mindedness and not feeling superior. They just *were*—in character and in achievement—superior.

Breeskin, Adelyn D., *The Graphic Work of Mary Cassatt*, A Catalogue *Raisonné*, New York: H. Bittner & Co., 1948

Breeskin, Adelyn D., *Mary Cassatt, A Catalogue Raisonné of the Oils, Water-Colors, and Drawings*, Washington: Smithsonian Institution Press, 1970

Taken together these two monumental works contain in reproduction everything Mary Cassatt ever painted, drew, or etched that is still in existence. The reproductive process is excellent; the ingenuity of presentation is a marvel; and, throughout, the text is illuminating and informed as only Mrs. Breeskin, a ranking authority on her subject, could make it.

Breuning, Margaret, *Mary Cassatt*, New York: Hyperion Press, 1944

This particular study of Mary Cassatt contains one of the most interesting of the selections from the artist's work in any such volume, and those better reproduced than most.

Bullard, E. John, *Mary Cassatt, Oils and Pastels*, New York: Watson-Guptill, 1972

Mr. Bullard's book reproduces, as excellently as can be expected of color, most of the best-loved of Mary Cassatt's pictures. Its text, moreover, introduces biographical material gleaned from the Havemeyer collection of Mary Cassatt letters, now at the National Gallery in Washington, that Bullard was first to use. The book would make a perfect introduction, attractive and reliable, for anybody with an interest in Mary Cassatt.

Burr, Anna Robeson, *Portrait of a Banker: James Stillman*, New York: Duffield & Co., 1927

The author, in her day well known as a biographer, here produced an informative life of the rich, elderly admirer whom Mary Cassatt attracted in her later years. A descendant of James Stillman's describes the book as "a rather breathless, ladylike job," and it is true the author is sometimes hair-raisingly naïve (as about mirrors in ceilings), but there is much to learn here of the Capitalist, so much studied at the turn of the century. Mrs. Burr asserts that the type was a composite of Morgan and Stillman; it is to Stillman's everlasting glory that, in cultural matters, he so far transcended Morgan and all Morgan stood for.

Burt, Nathaniel, *The Perennial Philadelphians*, Boston: Little, Brown and Co., 1963

Mr. Burt's book is a model of all that a study of a city, its history and its character, should be. It searches out, it epitomizes, it deduces from, it intuits, it anecdotalizes, it understands, it remembers, it ridicules, it caresses, it honors, it exposes, and it glorifies Philadelphia. More readable reading was never writ.

Cabanne, Pierre, *Degas*, Paris: Pierre Tisne, 1958

This modern art historian's view—sometimes tender, sometimes exasperated; part biography, part critique—of a painter whose greatness he always bears firmly in mind, makes a long book. Packed with anecdote, association, and insight into one of the hardest to understand of artists, it seems a pity the book is not yet translated into English. For an all-around knowledge of Degas it would seem essential.

Canaday, John, *Lives of the Painters*, Vol. III, New York: W. W. Norton & Co., 1966

Mr. Canaday's sprightly annals, in this volume covering the Neoclassic to the Post-Impressionist periods, are at their most anecdotal, informative, discerning, and wise. Like Vasari before him, the author gives "historian of art" a good name by the way he tells about his subjects, over

the ages, as neither saints nor sinners, marvels or disasters, but a special kind of people called painters.

Carson, Julia M. H., *Mary Cassatt*, New York: David McKay Co., 1966

A thoughtful and carefully researched biography containing many interesting or unexpected bits of information not easily found elsewhere.

Cortissoz, Royal, *American Artists*, New York: Charles Scribner's Sons, 1923

An invaluable guide to the American art scene by one who was perhaps the most highly respected American art critic in the early years of this century.

Cortissoz, Royal, *Personalities in Art*, New York: Charles Scribner's Sons, 1925

Cortissoz's view of the Impressionist movement benefits from his closeness in time to that epoch. Although in his analyses, say of Cézanne (about whom he remarks, "The mission of the painter is to create beautiful pictures. It is a function which Cézanne pathetically misses"), he sometimes seems light-years away from us, his insights into Degas are rewarding. "This denizen of theatres never brought into his art the faintest trace of theatricality . . . He has little sympathy, no identification, with the suffering jockey fallen, the laundress, etc. . . ." (evoking the surgeon's art as another that would suffer dangerously from sentimental indulgence). Part of understanding the past in art is to identify with it: to feel, for example, with Cortissoz.

Degas, Edgar, *Degas Letters*, edited by Marcel Guérin, with an introduction by Daniel Halévy, tr. Marguerite Kay, New York: B. Cassirer, Studio Publications; New York: Oxford University Press, 1948

A priceless resource for understanding the artist. Halévy points out that the image of the misanthropic Degas was not true to reality; what reality was, again and again is poignantly revealed in the letters. Explain-

ing how Degas concealed even his work (whole boxes were full of secret drawings) just as he concealed his true self, Halévy tells the story of his crying to a young hostess on entering her salon, "What is this I hear? You are saying everywhere that I am not bad! If you talk that way what is left to me?" Degas used to admonish his model Pauline to represent in other studios where she posed that he was sinister. As Halévy says, Degas' letters reveal what was, in fact, the nobility of Degas' nature.

Degas, Edgar, *Huit Sonnets de Edgar Degas*, Paris: Jeune Parque; New York: Wittenborn, 1946

The results of an extraordinary few months when Degas turned his formidable talents to writing poetry. It was his belief that through writing sonnets, he could prove the origin of all works of art to lie in the will.

Delacroix, *The Journal of Eugène Delacroix*, tr. Walter Pach, New York: Covici-Friede, 1937

The nearest a non-painter can ever get to a painter's mind is by reading a painter's memoir. This is one of the very best.

Dewhurst, Wynford, *Impressionist Painting, Its Genesis and Development*, London: G. Newnes, Ltd., 1904

To understand the past art scene, even dreadful critics should be consulted. Dewhurst was English and makes clear that the Impressionist movement stemmed almost entirely from English sources like Constable and Turner. Scathing in his criticism of Degas' knowledge of horse-flesh, he also terms him "lacking in all feeling." He suggests that Mary Cassatt and Berthe Morisot typify their sex in that they "cannot create, can only assimilate and reproduce . . . But they introduced into the stern methods of the Impressionists a feminine gaiety and charm which were reflected upon the canvases of their confrères." There is some truth, however, in almost everything Dewhurst says, and he gives a complete, detailed survey of Impressionism.

Faure, Élie, *History of Art: Ancient Art*, tr. Walter Pach, New York: Harper & Co., 1921

An American painter once said that the way to understand Faure, in his monumental art history, is simply to relax and let the words flow passively across one's mind, which will nevertheless end up with a vivid and unforgettable image. Faure's psychological interpretations of art can be extraordinarily ruthless, touching on aspects of art which could not have been wholly accessible even to the most relaxed lady-reader's mind in 1921.

Fèvre, Jeanne, *Mon Oncle Degas*, Geneva: P. Cailler, 1949

Degas' niece was uncritical to the point of worshiping him. Yet from these family stories, legends, adoring personal anecdotes, praises of him as artist, poet, family man, friend, patriot, whatever, does emerge an indispensable picture of Degas in the flesh. Even adulation of him is more realistic than the total misunderstanding contemporaries entertained.

Fosca, François, *Degas*, tr. James Emmons, New York: Skira, n.d.

A minuscule biography and critical study, accompanied by innumerable color plates of fair quality. Part of a useful series, "The Taste of Our Time."

Fourreau, Armand, *Berthe Morisot*, tr. H. Wellington, London: 1925; New York: Dodd, Mead and Co., 1925

A little-known study that renders with sympathy, knowledgeably, the charming, melancholy story of Berthe Morisot. She, perhaps, is the art world's true heroine. Inheritor of a painterly tradition, nothing blocked her progress—neither family nor circumstances. Her whole life was lived in and for art, yet with humanity, and without sensationalism.

Franzosischt Impressionisten, Kunstverein in Hamburg: 1970–71 (catalogue)

This is the fascinating record of an exhibition of Impressionist pictures held in Hamburg in 1970–71—anniversary year of those proto-Impression-

ist painters like Monet who fled to London during the Franco-Prussian War exactly a hundred years before. Dedicated "Hommage à Durand-Ruel," it pays honor to the Paris dealer who, more than any other commercial factor, was responsible for the survival and victory of the Impressionists. Mary Cassatt, who stuck to Durand-Ruel as they to her until the end, was represented in Hamburg by two pictures of Durand-Ruels: one the marvelously urbane 1899 portrait of Madame Aude, sister of the brothers Durand-Ruels, and her two, very French, little girls; the other a portrait of a little Anne-Marie Durand-Ruel, done ten years later, which reveals signs of the painter's failing powers.

French Paintings from the Collections of Mr. and Mrs. Paul Mellon and Mrs. Mellon Bruce, Washington: 1966 (catalogue)

Angels could do no more than Mellons, in collecting great pictures (also Stubbses). This catalogue displays what superb Impressionist, among other, French paintings were in the possession of art-minded Mellons by 1966.

Galignari, *New Paris Guide*, Paris: Galignari, 1852, 1868

Galignari was to Baedeker what other Paris guidebooks are to today's Michelin: a supplement, not a substitute. It too is helpful for spending an imaginary Victorian few weeks in what both guides love to call the metropolis. One learns that in 1868, as in 1852 (same wording), "The visitor . . . who is inclined to go to a boarding-house should be very careful to choose one of respectability" as disreputable ones "are very prevalent since the abolition by law of public gaming houses. Many persons have opened . . . boarding houses under cover of which card-playing is carried on in the evening, and the unwary visitor may . . . lose sums to a large amount. They are frequented by persons of both sexes, of fashionable exterior, but of very indifferent character." As to "social intercourse," "the greater part of the resident families in fashionable, official or professional life . . . *receive*. In addition . . . are numberless private balls and suitable parties to which personal respectability and suitable acquaintance ensure easy access . . . More public and advantageous are the evening receptions [of public figures in government, the theatre, etc.]. A request suffices for the formation of a cursory acquaintance which is often improved into an agreeable intimacy. At these as-

semblages, long visits and long 'talks' are not *bon ton*." But this promising social picture has a flaw: "The number of ladies that figure at the Ministerial soirées is comparatively small . . . A passing bow, or a few sentences . . . is the most that politeness or gallantry can bestow." Both volumes (and those dated in between, of course) describe travel outside "the metropolis" as by railroad, when in existence; by steam packet, and by diligences, or stagecoaches—for which one needed a reservation (inside or outside? below or on top?). "Fee to the postilion, 2 fr. per myriametre (about 6½ miles) if he has behaved well; legally, 1 fr."

Gammell, R. H. Ives, *The Shop-Talk of Edgar Degas*, Boston: Boston University Press, 1961

Mr. Gammell is a painter, alive today, who remembers some of the Impressionists. "In our student days," he writes, "our masters were wont to back up their precepts by quoting the old artist living in retirement, half blind": Degas, whose sayings Gammell continued assiduously to collect for years. They are here compiled with a commentary, in which the editor points out more than one basic truth, about "the age-old incomprehension which separates painters from men of letters in matters pertaining to art." "The non-painter bases his premises on assumptions [perfectly reasonable and analytically accurate] that he obviously cannot verify through his senses." "Degas himself continually stressed the fact that it was only to painters that he could express himself about painting." A cornucopia of a book.

Gimpel, René, *Diary of an Art Dealer*, tr. John Rosenberg, New York: Farrar, Straus & Giroux, 1966

A chatty, convivial journal giving the reader the illusion he shares the life of this busy, successful art dealer whose complex business affairs took him back and forth across channel and ocean, and into the houses and clubs of most prominent art collectors and fanciers over half a century. Filled to the brim with anecdote—spicy, telling, personal, vivid.

Goncourt, E. and J., *Journals, 1851–1870*, Garden City, N.Y.: Doubleday & Co., 1958. *Journal Mémoires de la Vie Littéraire*, Monaco: Les éditions de l'Imprimerie Nationale de Monaco, Fasquelle et Flam-

marion, 1956 (integral text). Unpublished translations by Joan St.
C. Crane

The Goncourts (Jules died in 1870) like Saint-Simon before them
reflected as in a mirror all that was most characteristic of their place and
time: the literary-artistic life in which they moved as men of letters. It is
true that they (or probably only Edmond) never lost a chance to get in
a nasty dig when (also true) a nasty dig was there to be got in, but the
result of this makes lively reading.

Halévy, Daniel, *My Friend Degas*, ed. and tr. Mina Curtiss, Middletown,
 Conn.: Wesleyan University Press, 1964

A paragon of the translator's and editor's skills, this work is, in addi-
tion, something perhaps unique: the record of a warmhearted yet highly
intellectual man's experience of a family friend with a ferocious reputa-
tion as misanthrope, which this journal Halévy kept after 1888 totally
dispels. No one can doubt the beauty, simplicity, and delicacy of Degas'
nature after Halévy. Mrs. Curtiss' preface gives an account of her own
charming friendship with Halévy. It is followed by Halévy's Introduction
to the French version (*Degas Parle*, 1960), then by those evocative, ten-
der, ineffable entries that end after Degas' death when, to Forain's
remark, "How handsome he was in the end, walking through the
streets—" Halévy replies, "Yes, wasn't he? In his Inverness cape, tapping
his cane, feeling his way. Yet he walked quickly, always alone . . . How
extraordinary is the magic of greatness. It shows in every step."

Havemeyer, Louisine W., *Sixteen to Sixty, Memoirs of a Collector*, New
 York: Metropolitan Museum of Art, 1930

This account, privately printed for family and friends, of the forma-
tion of one of the world's greatest art collections, gives in the course of
it an indispensable portrait of Mary Cassatt, although Mrs. Havemeyer
was as uncritical of her friend as Degas' niece was of him. In other
ways a sort of mirror image of Mary Cassatt, she was a warm, motherly
woman with starry eyes for art. The influence Mary Cassatt exerted
over Mrs. Havemeyer's taste has often enough been remarked, the Have-
meyer collection standing as its best monument and proof; the little-

noted converse influence is equally striking. Valuable chapters are de-
voted to Courbet, Manet, Degas, and Whistler, as well as to the travels
beyond Paris that Mr. and Mrs. Havemeyer made in pursuit of great
pictures.

Kysela, John D., S.J., "Mary Cassatt's Mystery Mural," *Art Quarterly*,
 1966

A first-rate account of one of the unsolved puzzles of Mary Cassatt's
life: what happened, or what she did, with the murals she painted for
the Columbia Exposition of 1893 in Chicago.

Leymarie, Jean, *Les Dessins de Degas*, Paris: F. Hazan, 1948

Lowe, David, "Mary Cassatt," *American Heritage*, New York: 1973

Lynes, Russell, *The Art Makers of Nineteenth Century America*, New
 York: Atheneum, 1970

All that anyone but a specialist needs to know of the art of nine-
teenth-century America, presented with a discriminating taste, and un-
failing wit.

Manson, J. B., *Life and Works of Edgar Degas*, London: The Studio,
 1927 (limited edition)

Manson, another to explode the myth of Degas' misanthropy, held
the Goncourts' opinion "cantankerous." Speaking of Degas in the com-
pany of colleagues at the Café Guerbois, in the old days, Manson ob-
serves that "discussion with other painters disturbed him. He remained
aloof, feeling the need for reflection. He wanted to think it [art] out
and work it out." Manson notes that the excellence of paintings of ballet
by Degas is proven by the banality of those that have been attempted
by other painters.

Mary Cassatt, Washington: National Gallery of Art, 1970–71 (catalogue of retrospective exhibition at the National Gallery)

Record of a great exhibition that was a sort of visual biography, this catalogue itself makes such an impression.

Mary Cassatt Among the Impressionists, Omaha: 1969 (catalogue)

An exhibition was held in 1969 at the Joslyn, Omaha, Art Museum which had as its nucleus the museum's own *Portrait of Lydia Cassatt*, around which was built a show that included Degas, Manet, Monet, Renoir, Pissarro, Berthe Morisot, Toulouse-Lautrec, Sargent, Hassam, and Whistler. The catalogue's fair-quality reproductions are reinforced by one of Adelyn D. Breeskin's rewarding essays on the great woman painter she comprehends so well.

McKown, Robin, *The World of Mary Cassatt*, New York: Thomas Y. Crowell Co., 1972

Part of a series called "Women of America," this biography is a readable, necessarily derivative account of the artist.

Moore, George, *Reminiscences of the Impressionist Painters*, Dublin: Tower Press Booklets, 1906

The Impressionist painters laughed at Moore. But the ridiculous, red-bearded, would-be painter-writer was meanwhile watching them; and he was remembering everything they said. What they said is recalled, with Anglo-Irish wit and occasionally venom, in these memoirs.

Myers, Elizabeth P., *Mary Cassatt, A Portrait*, Chicago: Reilly & Lee, 1971

A short biography intended for younger readers.

Orienti, Sandra, *Degas*, tr. Rosalind Hawkes, London: Thames & Hudson, 1969

Origo, Iris, *Images and Shadows: Part of a Life,* New York: Harcourt
 Brace Jovanovich, 1971

A present-day writer, who has an international family and marriage,
here recalls her extraordinarily diverse early experiences.

Piatt, Louise (Kirby), *Bell Smith Abroad,* New York: J. C. Derby, 1855

A semifictional, guidebook-type account of an early Victorian trip
to Paris. If Baedeker and Galignari tell what and where things were in
"the French metropolis," this lady (the book was published anonymously)
tells how it smelled and sounded and looked. "I" slept on the train
from Rouen to Paris after the ocean voyage, and dreamt of home. "Oh,
how clear and sweet the visions do start up in those seconds of feverish
sleep! One instant I was listening to the loved ones at home . . . the
next, the cry of 'Paris!' awakened me to a sight of a clear sunlight
bathing the roofs of a vast city, above which towered the Arch of Tri-
umph. A plunge into a tunnel, a shrill shriek from the locomotive, and
we were in the gay city of a thousand associations and one great name."
That's how it felt to get there in 1855.

Pool, Phoebe, *Degas,* London: Spring Books; New York: Marlboro Books,
 1963

A first-rate book for both text and pictures. It is Miss Pool's opinion
that Degas "almost certainly had an affair with Mary Cassatt . . . of
whom he wrote that they had 'identical intellectual dispositions and an
identical predilection for drawing,'" (although that statement has also
been attributed to others than Degas). She cites a number of characteris-
tic Degas observations on art, like: "A painting is an artificial work
existing outside nature, and it requires as much cunning as the perpetra-
tion of a crime."

Renoir, Jean, *Renoir: My Father,* Boston: Little, Brown and Co., 1962

A great painter seen through his great film-maker son's eyes.

Rewald, John, *The History of Impressionism*, New York: Museum of
 Modern Art, 1946

Rewald, John, *Pierre Bonnard*, New York: Museum of Modern Art, 1948

 Both invaluable.

Rich, Daniel Catton, *Degas*, New York: Harry N. Adams, 1955

 A modern view.

Rivière, Georges, *Le Maître Paul Cézanne*, Paris: 1923

 A good, fat study of the Impressionist who was not, really, an Im-
pressionist. He was Impressionism's ugly duckling who became a swan.

Rothenstein, William, *Men and Memories*, 3 vols., New York: Coward,
 McCann, 1931–40

 A gregarious, "clubbable," English artist and great draftsman's highly
readable memoirs.

Rouart, Denis (editor), *Correspondence of Berthe Morisot*, tr. Betty
 Hubbard, New York: E. Weyhe, 1959

 Rouart, distinguished French art critic, is himself the son of Julie,
daughter of Berthe Morisot, whom the artist painted over and over. In
his preface to this collection he says his grandmother "was in no sense a
writer, she could not communicate in her letters the poetry with which
she endowed all things in her paintings." Nevertheless in the letters there
is that mysterious, poignant ring of truth for which the letter, as a human
document, has no equal. The joy with which some of the Impressionists
lived is not here, but there is a certain very feminine, very French, not
unbarbed, feeling.

Saarinen, Aline, *The Proud Possessors*, New York: Random House, 1958

By way of becoming the classic work on great art collectors of modern times, at least of the Midas-like ones, this book makes understandable not only what makes collectors want to collect, but the varying ways they have gone about it, and what came, or failed to come, of their efforts.

Saint-Gaudens, Homer, *The American Artist and His Times*, New York: Dodd, Mead & Co., 1941

One of the great accounts of an artist's life by one of the great American sculptors.

Sargent, Whistler, and Mary Cassatt, Chicago: 1954 (catalogue)

In the year 1954 the Art Institute of Chicago and the Metropolitan Museum exhibited, in that order, an assemblage of outstanding paintings by three artists who had much in common in curiously differing ways. Planned and executed by Frederick A. Sweet, then Curator of American Painting at the Art Institute of Chicago, the show displayed one tour de force after another—among them Sargent's *Boit Children* and *Mr. and Mrs. Phelps Stokes*; Whistler's portraits of Theodore Duret and of Thomas Carlyle; Mary Cassatt's ten top-notch aquatints and her paintings *Woman and Child Driving* and *Mother [Emmy] and Her Child*. The catalogue of the Chicago show reproduces its wonders with fair success, with a foreword by Sweet entitled "The Expatriates Return" that makes clear with which artist Sweet's own heart lay. "Mary Cassatt . . . is the most adaptable of the three and fits into the present world without seeming out of date."

Ségard, Achille, *Un Peintre des Enfants et des Mères, Mary Cassatt*, Paris: P. P. Ollendorff, 1913. Unpublished translation by Mary Faith Pusey

This is a sample of work done in the early years of this century, and as such, fairly slow reading in its analytical sections, which run to statements like: "Before the spectacles of life her emotion was not purely

visual, it was intellectual and sentimental . . . A questioning intelligence . . . was particularly attached to problems of feeling, desiring to elevate itself from the particular subject to general ideas." When it came to direct impressions, however, Ségard had them. "She was delicate, energetic, and scrupulous" might have been set down on her grave.

Smith, Logan Pearsall, *Unforgotten Years,* Boston: Little, Brown and Co., 1939

Starting off as written from the yacht of Edith Wharton (which sets the general tone) this memoir of an intelligent, aesthetic Philadelphian, well-known in the early years of the century as a writer of aphorisms, catches the nuances of rich collectors, dilettantes, and artists. It is excellent as well for background to the American migration to Paris in the nineteenth century, of which Smith was a part. He knew everyone: Wilde, James, Max Beerbohm, the beautiful Kinsella sisters. Mrs. Wharton, he had the wit to discern, hid an inner shyness behind her society manner. One valuable chapter is devoted to quite a different kind of Philadelphian, of artist: Walt Whitman, whose example (of all anomalies) was what first made Smith "aspire" to write.

Sweet, Frederick A., *Miss Mary Cassatt, Impressionist from Pennsylvania,* Norman: University of Oklahoma Press, 1966

Mr. Sweet's is the most thorough and most knowledgeable of all the full-length Cassatt biographies. He brought to it years of activity as a distinguished "museum man"—having served in turn at the Brooklyn Museum, the Portland, Oregon, Art Museum, and at the stellar Art Institute of Chicago, where he became Curator of American Painting and Sculpture. Add to this Sweet's special and devoted interest in Mary Cassatt, and it is obvious why *Miss Mary Cassatt* will stand as a definitive investigation of the artist.

Thoizan, Elizabeth, *Berthe Morisot,* London: 1961 (catalogue)

Written to accompany an exhibition of Morisot held in Boston in 1960–61, the illustrations to the Thoizan catalogue reveal that for all Morisot's exquisite painting, she always drew badly; as in the drawings *Girl with Violin* or *Berthe Morisot and Julie.*

Townsend, J. W., *The Old "Main Line*," Philadelphia: 1922

Not exactly a professional study but one printed by a so-called "vanity publisher," this book does yield interesting nuggets of Philadelphia anecdote, interesting even if not true.

Trevor-Roper, Patrick, *The World Through Blunted Sight,* Indianapolis: Bobbs-Merrill Co., 1970

An eye-opener of a book that should on no account be missed simply because many of the conclusions it draws must of necessity remain hypothetical. A distinguished London ophthalmologist sets down his lively personal researches into visual peculiarities of painters over the ages and today, with fascinating and startling results. Both scientist and psychologist, and sympathetic to the artist's subjectivity, Trevor-Roper (brother of the historian) for example relates the drug culture to the artist and the mystic in a most convincing fashion; and fills his book with insights like: "The eye . . . might readily become the organ of projection from the genitals whenever fear, guilt, inertia, impotence, or despair barred a normal sexual outlet."

Valerio, Edith, *Mary Cassatt,* Paris: G. Crès et Cie., 1930

Venturi, Lionello, *Italian Painting,* Geneva: Skira, 1951

Venturi's is the intellectual's view of art, or, rather, his idea of art. Such a statement as "the prime condition of every truly artistic culture consists in an attention to form apart from content, in the vitality imposed into form-in-itself, in a work of art for art's sake" is no doubt true but an alien approach to something visual. Nevertheless Venturi is—here as in all his work—packed with valuable insights.

Venturi, Lionello, *Impressionists and Symbolists,* tr. Francis Steegmuller, New York: Charles Scribner's Sons, 1950

Manet, rebelling against family tradition to paint at all, felt alien to Courbet's realism yet, in a more worldly way, he was a thoroughly realistic painter. The autonomy of vision Manet introduced into art Venturi

calls the basis of all modern art; he "created images, in and for themselves . . . [that] parallel the life of natural things but are not to be confused with it."

Vollard, Ambroise, *Recollections of a Picture Dealer*, London: Constable, 1936

An indispensable fund of anecdote, jokes, psychology, and general feeling for the Impressionists, set down by a picture dealer who arrived in Paris, young, in 1894. Realizing he could make a good thing in a business way out of all Impressionists (whom he hero-worshiped) he was looking in particular for one of them who might be an unsung genius, to develop in the public's consciousness. Pissarro introduced him to Cézanne, Vollard held Cézanne's first one-man show in 1895, and the rest is history.

Wainwright, Nicholas B. (editor), *Philadelphia Perspective, The Diary of Sidney George Fisher*, Philadelphia: Historical Society of Pennsylvania, 1967

A long (1834-71) daily journal of a Philadelphian, of impeccable origins and refined tastes, as they used to say, edited by the director of the Pennsylvania Historical Society. For its picture of both period and social milieu as they in fact were, it ranks with such diaries as Charles Francis Adams'. When the journal first began appearing in 1952, in the *Pennsylvania Magazine of History and Biography*, it is said to have fluttered the dovecotes (as they also used to say) of Philadelphia families whose same-name ancestors are discussed in Fisher's candid annals. Yet such is the worth of the diary as a whole that Philadelphia came around, by the time serialization was completed in 1959, to asking for its publication in book form.

Walker, John (editor), *French Paintings from the Chester Dale Collection*, 6th edition, Washington: National Gallery of Art, 1953

A compilation of great pictures by one who knew this collection well, having been Director of the National Gallery for many years, to its vast gain and benefit.

Watson, Forbes, *Mary Cassatt*, New York: Whitney Museum, 1932

If no other memoir of Mary Cassett existed, the loss would not be irreparable as long as this short monograph, by one who knew her well in her old age and who knew, understood, and loved her art and herself, remained. The author presided for years as editor of *Art News* and as such was influential in the art worlds of America and Europe.

Wechsler, Herman J., *French Impressionists*, New York: Harry N. Abrams, 1952

Weyle, Harry B., *Art Treasures of the Prado*, New York: Harry N. Abrams, 1954

Wilson, Ellen, *American Painter in Paris, A Life of Mary Cassatt*, New York: Farrar, Straus & Giroux, 1971

This biography, while brief, is full of life and feeling. Mrs. Wilson is excellent at setting a scene, sketching a character, establishing, without long descriptions, a milieu. She comes closer, in fact, to a visual approach to art than most writers can.

INDEX

INDEX

C. always means Mary Cassatt